VOYAGE DRAMA AND GENDER POLITICS 1589–1642

MANCHESTER
UNIVERSITY PRESS

CLAIRE JOWITT

Voyage drama and gender politics
1589-1642

Real and imagined worlds

Manchester University Press
Manchester and New York

distributed exclusively in the USA by Palgrave

Copyright © Claire Jowitt 2003

The right of Claire Jowitt to be identified as the author of this work has been asserted by her in accordance with the Copyright, Designs and Patents Act 1988

Published by Manchester University Press
Oxford Road, Manchester M13 9NR, UK
and Room 400, 175 Fifth Avenue, New York, NY 10010, USA
http://www.manchesteruniversitypress.co.uk

Distributed exclusively in the USA
by Palgrave, 175 Fifth Avenue, New York, NY 10010, USA

Distributed exclusively in Canada
by UBC Press, University of British Columbia, 2029 West Mall,
Vancouver, BC, Canada V6T 1Z2

British Library Cataloguing-in-Publication Data
A catalogue record for this book is available from the British Library

Library of Congress Cataloging-in-Publication Data applied for

ISBN 0 7190 5451 6 *hardback*

First published 2003
10 09 08 07 06 05 04 03 10 9 8 7 6 5 4 3 2 1

Typeset in Bulmer
by Koinonia, Manchester
Printed in Great Britain
by Bookcraft (Bath) Ltd., Midsomer Norton

CONTENTS

LIST OF ILLUSTRATIONS

ACKNOWLEDGEMENTS

This book is based on my thesis on travel writing, which was supervised by
Jonathan Sawday. It is fitting, then, that my first acknowledgement should be
to him for the care and patience he showed in helping me to formulate my ideas.
Whilst working and studying in the English Department at the University of
Southampton, I accrued many other debts: I would particularly like to thank
Kate McLuskie, John Peacock, Kevin Sharpe and Chris Woolgar. Fellow post-
graduates also helped me immeasurably, but especially Anthony Archdeacon,
Amanda Boulter, Steve Dorney, Ruth Gilbert, Katrina Hall, Sîan Jones, John
McArdle, Sebastian Mitchell, Carola Scott-Luckens, Kevin Sullivan, and
Francis Wenban-Smith.

Whilst writing this book, I have worked in various libraries: I would like to
thank the staff of Southampton University Library, the British Library, the
Hugh Owen Library, Aberystwyth, and the National Library of Wales. The
team at Manchester University Press have been consistently helpful to me and
I gratefully acknowledge them for their faith in the project. The press reader,
Tony Parr, provided an incisive and detailed report on the book that enabled
me to reshape my arguments in places. I also wish to thank Richard Maber,
Liz Herbert McAvoy and Teresa Walters, and Sue Wiseman for giving me the
opportunity to offer papers taken from this project at the University of
Durham, Gregynog, and Birkbeck College respectively. I am also pleased to
acknowledge *Parergon* for permission to reproduce some of an article on *The
Sea Voyage* and *The City Madam* in Chapter 5; and *Renaissance Studies* for
allowing me to reproduce my article on *Fortune by Land and Sea* in Chapter 4.

In the last years my colleagues in the English Department at the Univer-
sity of Wales, Aberystwyth have been of immense support. I am grateful to
Aberystwyth's Research fund for awarding me a grant to support this project
and to the Department's Research Committee for giving me study leave at a
crucial point. I would particularly like to thank my friends and colleagues Peter
Barry, Helena Grice, Alison Hadfield, Christoph Lindner, Sean Matthews,
Rebecca Moss, Sarah Prescott, Damian Walford Davies, Diane Watt and Tim
Woods: they have contributed hugely to this project in so many ways. David
Ransome usefully commented on Chapter 5 of this book. Paulina Kewes read
the entire typescript at draft stage and weeded out numerous infelicities of style
and argument. For splendid guidance, reading several versions of my manu-
script, and for their good humour, I wish to thank Andrew Hadfield and Greg
Walker. All remaining inaccuracies are, of course, my own.

My final debt is to my parents, whose belief in me and consistent support
has been invaluable and wonderful.

Introduction

T his study focuses on the use of allegory in travel drama. Allegory entails the composition of a story that suggests, and simultaneously works at a distance from, another story. As Angus Fletcher argues 'in the simplest terms, allegory says one thing and means another' and 'it is a fundamental process of encoding our speech'.[1] Men and women in the Renaissance – well versed in the traditions of allegoresis associated with texts such as the *Aeneid*, the *Iliad* and the *Odyssey* and the 'wisdom of the ancients' more generally, and intimately familiar with Biblical parables through religious teaching and exegesis in sermons – were used to reading and writing allegorically.[2] Fletcher's analysis of what he terms an allegorical 'mode' of writing finds expression in a diverse range of literary genres from chivalric or picaresque romance to apocalyptic visions.[3] Imaginary voyages, the subject of this book, have long been associated with allegoresis. There is a tradition of allegorical readings of travel writing that dates back at least to the second century CE with Lucian's *The True History*.[4] I argue in what follows that Renaissance travel drama, as much as any other discourse or genre, is rich in allegorical interpretations. Indeed, metaphor's etymology – meaning 'to carry across' – implies its usefulness as a rhetorical device for accounts of foreign experiences.[5]

In fact, recent scholarly work on travel writing has demonstrated that colonial discourse particularly encourages this mode of writing. Thomas Scanlan, for instance, has shown that colonial writing always 'tells two stories', because it describes what happens in the colony and, at the same time, also speaks to the ambitions and wishes of the home nation.[6] When arguing for the importance of this allegorical dimension to colonial texts, Scanlan writes:

The object of most [colonial texts] was to encourage readers to forge … a connection between a distant colonial scene and their own immediate circumstances. In the case of England in particular, whose entry into the competition for colonies in the New World was much later than that of its Catholic rivals, the task of generating interest in and commitment to the colonial enterprise was an especially urgent one. The authors of these colonial texts, although they do not explicitly announce their writings as allegories, do require their readers to draw a connection between the two apparently distinct narratives of colonial adventure and national advancement.[7]

For Scanlan, colonial writing is a tool by which English writers attempted to articulate and define their own emerging sense of nationhood. More specifically, by comparing English colonists' relationships with indigenous Americans to Iberian colonists' treatment of Native American peoples, Scanlan argues that England sought to define itself as a Protestant nation distinct from Catholic European rivals. For instance, the translation into English in 1583 of Bartolomé de Las Casas' 1552 exposé of Spanish atrocities in the New World, *Brevíssima relación de la destrucción de las Indias*, justified English Protestants' hostile foreign policy towards Spain and competitive colonial policy in the New World.[8]

Put another way, allegoresis in travel writing can be seen as an important component in the formation of English national identity. Andrew Hadfield and Claire McEachern have recently suggested that English nationhood is an earlier phenomenon than as has often been argued.[9] Though, as McEarchern argues, nationhood can never be fully achieved ('the nation is an ideal of community that is, by definition, either proleptic or passing, ever just beyond reach'), nevertheless this view allows us to see its forces in action during the Renaissance.[10] This sense of nationhood was predicated on an assumption that the English nation was significantly different from other national identities. Henry VIII's 'founding gesture' in his statement in the Act of Appeals of 1533 that 'This realm of England is an empire' was followed up the following year with a rejection of the foreign jurisdiction of papal sovereignty over affairs of the English church in the Act of Supremacy.[11] Henry's power was licensed by the Act without reference to the 'restraint or provocation to any foreign princes or potentates of the world'.[12] In other words, Henry's 'empire' defined itself as sovereign 'as much in a competitive, mimetic resemblance to foreign authority as in a rejection of it'.[13] Empire for Henry was a vehicle by which a notion of Englishness might be articulated that was simultaneously independent of and indebted to the European political arena. In the same

way that Richard Hakluyt used accounts of Spanish atrocities in the New World to justify English territorial interests there, here English empire was being articulated in contradistinction to foreign interference.[14]

By contrast, Nicholas Canny describes Henry's assertion of empire in a different, though related, way. Canny emphasises how Henry's favouring of this term after his breach with Rome 'called to mind the relative isolation of England through the centuries rather than its dominion over foreign territories'.[15] Canny's point is that conceptions of what 'empire' meant changed in the sixteenth and seventeenth centuries. In the mid-sixteenth century, 'empire' did not inevitably mean colonial expansion since there was no necessary connection between exploration and exploitation, and the establishment of overseas empire was not a certain consequence of 'Discovery'.[16] In the period which this book covers philosophies of empire, and the relationship between exploration and exploitation, altered. Milton's *Paradise Lost* (1658) shows the changes in the concept of empire between the mid-sixteenth and mid-seventeenth centuries. In Book IV, when Satan hears about God's creation of the Garden of Eden, and of Adam and Eve, he aims to have his 'Honour and Empire ... enlarged by conquering this new world' (390–391).[17] In other words, Satan reveals a desire to exploit the New World and its inhabitants as he wants to live with Adam and Eve in Paradise, or if that is not possible then they must relocate to Hell. 'I with you must dwell, or you with me' (377) he says, promising that 'hell shall unfold, / To entertain you two, her widest gates ... there will be room, / Not like these narrow limits, to receive / Your numerous offspring' (381–385). For Satan Paradise clearly does not represent just a new discovery or region to be explored: his agenda is orientated to the expansion of his dominion into this 'new world' as he embraces 'Evil' because 'at least / Divided empire with heav'n's King I hold / By thee, and more than half perhaps will reign; / As man ere long, and this new world shall know' (110–113). Milton's attitude to empire can, as David Armitage has shown, be seen as hostile since Satan's aggressive exploration and colonisation of a 'new world' is persistently expressed in unfavourable terms.[18]

In *Paradise Lost*, definitions of empire do not appear to be stable. There are still traces of the mid-sixteenth-century definition of empire within Satan's desires: in Book V, for instance, Raphael argues that Satan wished for 'imperial titles' because they 'assert / Our being ordained to govern, not to serve' (800–802). Raphael's descriptions construct Satan as favouring imperial designs of a kind that resonate with Henry VIII's since

both desire a kind of empire characterised by its mimetic resemblance to a foreign authority rather than as a rejection of it. In other words, Satan's ambitions are conditioned by God's empire in a way that is similar to Henry's desire both to imitate papal sovereignty and to create his 'empire' in contradistinction to Rome.

In Renaissance England, 'empire' clearly possessed meanings that were dependent on context but, by the end of the sixteenth century, the connection between discovery and settlement in overseas ventures began to be asserted more regularly. The work of the two Richard Hakluyts and their associates to promote trade and colonisation in America in particular helped raise awareness of the benefits to the English nation to be gained from transoceanic exploits.[19] They argued that colonisation and trade would be the means to simultaneously strengthen the standing of Protestant monarchs while impeding that of Catholic rulers. The English experience of settlement in Ireland in the sixteenth century (England's 'domestic' colony) was also an important antecedent for the nation's imperial ambitions.[20] James I's national project for the Union of England, Scotland and Wales as Great Britain after his accession to the English throne in 1603 further added to the debate over the meaning of the nation's imperium.[21] Also significant in the nation's desire for colonial empire was the fact that all educated Europeans were conscious that colonisation was a method of asserting authority over 'foreign' peoples that 'had been employed in ancient times by the Romans ... throughout much of Europe, and in medieval times by the Anglo-Normans to extend their influence, including their involvement with England, Scotland, Wales and Ireland'.[22]

These complex and shifting conceptions of empire and nation are reflected in the travel dramas discussed in this book. The texts focused on here all engage with foreign locations, yet are diverse in terms of their choice of settings and their treatment of exotic tropes. Some of the 'geographic' dramas I discuss, for instance Fletcher and Massinger's *The Sea Voyage* (1622), are 'colonial' in the sense that they focus on the problems and trials of settlement in unfamiliar terrain. Contemporary Virginia is thus an important context against which to read the play. Others, such as *The Island Princess* (1619–22) set in the Spice Islands of the Moluccas, are clearly more focused on trade than settlement. However, because the play's central concern is the marriage of Princess Quisara to a European man we are shown the ways trade and settlement can become intimately related. In yet other plays, the colonial context is more nuanced. Fletcher's Roman play *Bonduca* (1611–14) describes the defeat of the British by the

Romans: this ancient history becomes, I argue, a way of discussing the ambiguous merits of processes of acculturation, as a less technically accomplished people succumbs to the authority of the Romans. The anonymous play *The Famous Historye of the life and death of Captaine Thomas Stukley* (1596) is also less explicit in its use of colonial contexts than some of the other geographic dramas explored in this study. However, it includes scenes set in the English 'domestic' colony of the Pale. The difficulties Stukley experiences in his relations with superior English officers in the battles with the native Irish are, arguably, the root cause of his subsequent betrayal of his English allegiance. Hence, the later scenes in the drama, set in Spain and North Africa, are the direct consequence of behaviour in English colonial environs.

In other words, the plays covered by this study all engage with colonial discourse, but in different ways, to different degrees and for divergent purposes. This book concentrates on the ways travel drama does domestic work, yet the nature of that work – the two stories told – varies. Indeed, allegorical writing does not necessarily limit itself to telling just two stories. Thomas More's political satire *Utopia* (1515) is a case in point. More described a fantasy island that was both 'Eutopia' (good place) and Utopia (no place); this oscillation between the ideal and its cancellation usefully reveals the ability of allegorical writing to possess more than one interpolated secondary meaning in addition to the primary literal level of meaning of the story.[23] Many of the dramas that this book interprets strongly reveal bifurcated or polyvalent allegorical meanings. Broadly speaking, most of the geographic dramas discussed in this study not only engage with issues raised by colonial and other foreign experience, but also use exotic tropes in an opportunistic way as they comment upon problems and iniquities at home. For instance, my reading of Massinger's *The Renegado* (1623/24) sees this play as offering a disguised comment on court politics that is related to the condemnatory lampoon of the proposed Spanish match for Prince Charles evident in Middleton's *A Game at Chess* (1624). In Massinger's text the parallels are far less simple, and the text refuses to offer a straightforward message or conclusion. Yet in the sexual hothouse atmosphere of the Tunis court, and in the status characters accord to the counsel of a Jesuit priest, Massinger's play teases out complexities and indeterminacies as it dramatises arguments that can be found at the heart of shifting circumstances. The power of the range of references employed, but their refusal to conform to a stable or univocal interpretation suggests that this play, like many others discussed in this book, is

perhaps best seen as conforming to the branch of allegory known as aenigma. Henry Peacham in *The Garden of Eloquence* (1577) defined aenigma as 'a kind of Allegorie, differing only in obscuritie, for Aenigma is a sentence or form of speech, which for the darknesse, the sense may hardly be gathered'.[24] Indeed, as Fletcher argues, 'most allegories of major importance have ultimately very obscure images, and these are a source of their greatness' and readers should not 'assume that clarity is an un-clouded aim of most allegory'.[25] The ambivalence of the play's conclusions consequently might be seen to serve an 'oppositional' political agenda by the fact that reigning authorities are unable to perceive the secondary meaning of the aenigma.

The power of Renaissance theatre to make coded comments about governing individuals and institutions has been the subject of much critical debate in recent years.[26] As Jonathan Dollimore argued in *Radical Tragedy*, 'we find in the drama not simple denunciation of religious and political orthodoxy (though there is that too) so much as underlying sub-version' which 'takes many forms'.[27] Dollimore's position has, however, been qualified by Paul Yachnin's arguments about 'powerless theater'.[28] Yachnin suggests that though 'the stage persistently represented the issues of the moment ... these representations were usually seen to subsist in a field of discourse isolated from the real world' and 'were seen as incapable of intervening in the political arena'.[29] According to this view the increased independence of theatrical companies from aristocratic sponsors (the Red Lion was opened in 1567 and The Theatre in 1576), and the commercial-ism that this change created, made pleasing their audiences the first concern of playwrights and players. In fact:

> Players were no longer expected to promulgate a particular view of political affairs; on the contrary, the players were now only constrained to stay within the changeable bounds of the permissible. The acquisition of their own theaters had the peculiar effect, therefore, of reducing the playing companies' dependence upon their aristocratic sponsors and so freeing them to address a variety of topics in an objective spirit, and at the same time, of diminishing the power of the theater to influence the political issues about which it was now free to speak.[30]

As a result, as this study shows in relation to travel drama, plays emerge that have the ability to accommodate a variety of topical allegorical read-ings but do not necessarily authorise any one particular interpretation. In a sense, then, the topicality of these plays – their potential to excite in their audiences a belief that they are witnessing the imparting of privileged

information or dangerous, perhaps anti-establishment views – which ensured a full audience (and hence a profit) might be seen as the point. The range of references, the variety of allegorical interpretations and the 'functional ambiguity' of the play can, as a result, be seen as a shrewd commercial marketing device enabling the play to maximise its appeal to a heterogeneous audience.[31]

Though knowledge of the composition of audiences in this period is partial, and information about frequency of peoples' attendance play-houses incomplete, Andrew Gurr's work on early playgoers makes it possible to speculate with a little more certainty about the sort of audience to which geographic drama might have appealed.[32] For instance, the King's Men performed Fletcher's *The Island Princess* between 1619 and 1621 at the Blackfriars Theatre.[33] In this period the Blackfriars theatre, situated in the wealthiest district in London, attracted the richest audience since it was close to the Inns of Court, and between the City of London and the City of Westminster. Indeed the acquisition of the Blackfriars Theatre in 1609 as the company's winter playhouse (the Globe was used in summer) made considerable changes to the social strata of the company's clientele. Though performances were held six afternoons a week, the theatre was relatively small and the price of tickets was much higher than at other theatres of the day.[34] Hence *The Island Princess* – concerned with trade and its connections to colonial settlement and the dynastic implications of royal marriages – was likely to appeal to the merchants and gentry that made up a larger part of the audience at this theatre than they did at, for example, the less prestigious venue of the Red Bull (one of the 'citizen playhouses', which tended to attract an audience of artisans and apprentices).[35] In the chapters that follow I pay attention to the theatrical context of the geographic plays I discuss, in order to address the role theatre performed in public debate and the articulation of ideas.

One of the aims of this book is to develop further our understanding of the allegorical nature of colonial discourse by focusing on the negotiations between gender and monarchy in geographic drama. In addressing this debate I am influenced by Louis Montrose's analysis concerning the importance of the work of gender to the discourse of discovery. He outlines the way in which, as a category of historical analysis, concepts of gender are as much about power relations as they are about the historically variable categories of Man or Woman.[36] In his reading of the discourse of discovery prevalent in Western Europe in the Renaissance, Montrose shows the way that representations of gender and sexual conduct stood in

for a larger set of colonial ambitions. In other words, this argument
stresses that travel writing works allegorically, since one set of concerns is
expressed in terms of another, or one power dynamic is phrased in terms
of another. In many Renaissance accounts of encounters with the New
World, America is represented as sexually available: 'Guiana is a country
that hath yet her maydenhead' said Ralegh invitingly in *The Discoverie of
the Large, Rich and Bewtiful Empyre of Guiana* (1596). Donne's excited
representation of his mistress as his 'America', to be explored and owned
through the poet's sexual possession, in 'Elegy 19' is another well-known
example of the ways sex and America could be linked together.[37] In I. A.
Richards' terminology here America is the vehicle not the tenor, since
America stands in for sex.[38] In fact, Donne's representation reverses the
allegorical process at work in Ralegh's description where sex meta-
phorically represents the New World. The work of discovery hence might
be seen as important to the discourse of gender as the other way around.
When the ruler in whose name discoveries are performed is a woman, the
power relations inherent within gendered colonial discourse are dis-
rupted. As both a ruler and a monarch, Elizabeth simultaneously occupies
ideologically contradictory positions of power. On the one hand she is the
ruler who controls and licenses the actions of her subjects, yet as a woman
her status is subservient to the maleness of her explorers.

Chapter 1, then, explores some of the complexities involved in the
responses of England's empire builders to the *femaleness* of the monarch
in whose name their activities were undertaken. I focus on the work of
several of the most important publicists and actors in the theatre of empire
– Hakluyt, Ralegh, Chapman. Their competing, and sometimes contra-
dictory, representations of Elizabeth are considered in order to show how
these men accommodated the gender of the queen, and the ways in which
their portrayals changed over the course of the reign. The historically
contingent nature of the intersection between representations of female
rule and colonial discourse is further revealed in the latter half of that
chapter, which focuses on Thomas Heywood's two-part drama *Fair Maid
of the West* (Part I 1596–1603; Part II 1630).

The first part of Heywood's text is read in terms of an allegory of
Elizabeth, and as a consideration of the impact of the rule of a female
monarch on the project of empire. Since Part I was written in the last years
of Elizabeth's reign, and the continuation about thirty years later, the
difference (indeed transformation) between 'Bess' in the two parts is a
useful barometer of the modifications to ideological formulations of

queenship articulated through colonial discourse. In Part I Bess swash-
buckles better than any male character, but the text fails to celebrate
wholeheartedly her seaborne triumphs in her ship *The Negro*. It seems that
the epic potency of England's queen has some unpleasant consequences
for the masculinity of her male subjects. Heywood questions whether Bess's
transgressive behaviour is the source or the result of the flawed and inade-
quate masculinity of 'Goodlack', Clem and the men represented in the text.
This debate concerning gender-appropriate behaviour is significantly
revised in the continuation of Bess and Spencer's story in Part II of *The
Fair Maid of the West*. Bess has, as Millamant later puts it in *The Way of the
World*, 'dwindle[d] to a wife', and I read this change against contemporary
views of queencraft in relation to Charles's consort, Henrietta Maria.[39]

Chapter 1 establishes the ways that the gender behaviour of characters
in voyage drama can be read as political allegory. In Chapter 2, I continue
to explore this theme by concentrating specifically on the ways rebellious
forms of conduct in male characters (for instance piracy and treason) are
used in the drama of empire. Rather than focusing on the coded portrayal
of Elizabeth in geographic texts, I examine the ways a woman ruler influ-
enced the gender behaviour of her male subjects involved in the nation's
empire formation. This chapter focuses on two representations of the
adventurer and rebel Captain Thomas Stukley, first Peele's *The Battle of
Alcazar* (1588/89) and then the anonymous *The Famous Historye of the life
and death of Captaine Thomas Stukley* written less than ten years later. In
both versions of Stukley's life, he demonstrates a kind of rampant indivi-
dualism often associated with pirates and privateers, traitors, rebels or
tyrants. Hence, it seems to me that what these texts ask their audiences to
consider is whether individualistic traits should be seen as strengths or
weaknesses. Both texts try to identify the point at which individual self-
identity transforms into something threatening to national identity. And
both are united in questioning exactly who should be identified as the
party responsible for the evolution of transgressive individualism: the man
concerned or the state, or indeed monarch, that failed to satisfy his needs?
This chapter also considers the extent to which the Queen's gender was
important in the development and depiction of the individualism of her
subjects.

The last three chapters of this study focus on voyage dramas written
in the reigns of the Stuart kings. Chapters 3 and 4 consider how the change
from a female to a male ruler was negotiated in allegories about monarchy
embedded in drama about empire. In Chapter 5, I switch my focus from

courtly politics to explore some of the other ways in which travel drama
was made to do domestic work.

Chapter 3 focuses on two dramas written by John Fletcher in the reign
of James I. I explore the ways in which Fletcher's treatment of colonialism
impacts with Jacobean political anxieties. My reading of Fletcher's Roman
play *Bonduca* (1611–14) reveals the way the defeat of the ancient inhabitants
of 'Briton' resonates with contemporary problems in the Virginia colonies
and, at the same time, constructs a political allegory that can be seen as
questioning the merits of James's *Rex Pacificus*. *Bonduca*, then, allegori-
cally manipulates colonial contexts to serve (at least) two aims. Firstly, the
process of Romanisation described in the play chimes with the accul-
turation problems the British experience in North America. Secondly, the
text's debate over the relative merits of the leaders of the ancient Britons in
their responses to Romanisation is read as a reflection of the respective
foreign policies of Elizabeth and James.

My analysis of Fletcher's later text, *The Island Princess* suggests that
he was more severe in his allegorical representation of the political
difficulties caused by James's foreign policy and his domestic behaviour.
However, because the criticism is coded – Fletcher focuses particularly
harshly on the sexual behaviour of Princess Quisara from the royal house
of Tidore – Fletcher's careful screening obfuscates the vehemence of the
allegory. Both dramas, then, dispute the merits of some of the policies and
patterns of behaviour most closely associated with the King. *The Island
Princess*, in particular, makes available a hostile allegorical meaning since
James's own sexual behaviour appears to receive satirical treatment. But
the text simultaneously contains other allegorical levels which allow other
topical interpretations. Fletcher's play encourages audiences to allegorise
in terms of both the Palatinate debate and Charles's prospective marriage
plans with a Catholic bride (at this time, the Infanta Maria of Spain).

In Chapter 4, I return to the theme of masculine unruliness in travel
drama, but this time concentrate on texts written in the reigns of the early
Stuart kings. In particular I focus here on representations of pirates and
renegades, again arguing that the difficulties and indeterminacies in
depictions of unruly male characters can be interpreted politically. In
other words, specificities such as the reasons for the men's rebellions, the
exact motives behind their conduct, and the emotions their situations
create in other characters, all determine whether their unruliness is seen as
their own fault, the responsibility of the state, or both. The texts focused
on are Thomas Heywood and William Rowley's *Fortune by Land and Sea*

(1607–9), Robert Daborne's *A Christian Turned Turk* (1612), and Philip Massinger's *The Renegado* (1623/24). As in Chapter 2 – where the anxieties about the Queen's leadership were represented through her undisciplined male subjects – I will be arguing here that descriptions of increasingly serious anti-establishment activities (described in terms of sexual conduct) in these plays operate as a way of commenting upon the perceived success of Stuart rule.

In the final chapter I shift my focus from the negotiation of courtly politics in travel drama to return to some of the other allegorical themes embedded in geographic texts. In my reading of *Bonduca* in Chapter 3, for instance, it is clear that several levels of allegory operate simultaneously: *Bonduca* tells more than just two stories. The polyvalent nature of the allegories available in travel drama is my focus in this final chapter. I read three travel dramas against different contemporary debates, concentrating on Fletcher and Massinger's *The Sea Voyage* (1622), Massinger's *The City Madam* (1632) and Richard Brome's *The Antipodes* (1638). All of these texts are read allegorically, but the nature of the domestic work undertaken is different, since their focus is on broader social targets than courtly politics. In my reading of *The Sea Voyage* and *The City Madam* I explore the ways in which representations of gender behaviour and sexual conduct in colonial environs allegorically substitute for British colonial and commercial endeavour. Both texts feature information (and misinformation) about remote geographical areas, and the setting up and maintenance of economic, social and sexual contacts with these locations and inhabitants. Appetites, and the management of sexual and other desires in particular, are central in these dramas. Though this theme has been important in many of the other travel dramas this study explores, as it was used to measure royal performance, in these plays the correct management of sexual appetite is used more generally to figure as a gauge of national colonial performance.

The Antipodes is also concerned with the management of sexual appetite. In Brome's play, in contrast to other geographic dramas discussed in this study, there is only a negligible engagement with colonial and foreign experience. For Brome, the antipodes is a concept or idea rather than a working colony – significantly it is an 'unknown' but speculated-about land to which the play's characters imaginatively journey. This distinction, and the fact that the play represents only imaginative travel, allows him to place the emphasis of his text upon allegorical interpretations of the antipodes as Caroline London. Brome's text is paradoxical, since it is a voyage drama that is indifferent to New World experiences. It is uninterested

in the project of empire, the acquisition of New World riches, colonial experiences, or 'virtuous conversion' of native peoples, that travel and empire formation offered. In Brome's drama the allegorical meanings of the text are supreme: the bizarre, antipodean patterns of behaviour the play represents only function as satiric reflections of several aspects of 1630s London. Consequently, Brome's engagement with colonial discourse is purely allegorical, as the concept of an antipodean world offers a means to critique English domestic conduct. Brome's work, therefore, extends the range of allegorical interpretations available. My aim in this study, then, is to explore what, and how many, stories are told by geographic drama written in the period when, for the first time, England attempted to make serious colonial and trading interventions on a global scale.

Notes

1 Angus Fletcher, *Allegory: The Theory of a Symbolic Mode* (Ithaca and New York: Cornell University Press, 1964), pp. 2–3.

2 On the history of classical allegoresis and its influence on Renaissance writers, see Kenneth Borris, *Allegory and Epic in English Renaissance Literature: Heroic Form in Sidney, Spenser and Milton* (Cambridge: Cambridge University Press, 2000), pp. 13–53.

3 For an alternate analysis that sees allegory in more literary terms, emphasising its generic aspects, see Maureen Quilligan, *The Language of Allegory: Defining the Genre* (Ithaca: Cornell University Press, 1992).

4 See for instance Mary Baine Cambell, *The Witness and the Other World: Exotic European Travel Writing 400–1600* (Ithaca: Cornell University Press, 1988).

5 See David Armitage, 'Literature and Empire', in Nicholas Canny, ed., *The Origins of Empire: British Overseas Enterprise to the Close of the Seventeenth Century* (Oxford: Oxford University Press, 1998), pp. 99–123 (p. 105). See also Andrew Fitzmaurice, 'Classical Rhetoric and the Promotion of the New World', *Journal of the History of Ideas*, 58 (1997), 121–144.

6 Thomas Scanlan, *Colonial Writing and the New World, 1583–1671* (Cambridge: Cambridge University Press, 1999), p. 3.

7 Scanlan, *Colonial Writing and the New World*, pp. 14–15.

8 See Scanlan, *Colonial Writing and the New World*, pp. 8–37; on Protestant artist Théodore De Bry's 1598 illustrated edition of Las Casas's text, see Tom Conley, 'De Bry's Las Casas', in René Jara and Nicholas Spadaccini, eds, *Amerindian Images and the Legacy of Columbus* (Minneapolis: University of Minnesota Press, 1992), pp. 103–131.

9 Andrew Hadfield, *Literature, Politics and National Identity: Reformation to Renaissance* (Cambridge: Cambridge University Press, 1994), pp. 11–22; Claire

McEachern, *The Poetics of English Nationhood 1590–1612* (Cambridge: Cambridge University Press, 1996), p. 5.

10 McEachern, *The Poetics of English Nationhood*, p. 6.

11 McEachern, *The Poetics of English Nationhood*, p. 1.

12 McEachern, *The Poetics of English Nationhood*, p. 1.

13 McEachern, *The Poetics of English Nationhood*, p. 2.

14 See Scanlan, *Colonial Writing and the New World*, pp. 29–32.

15 Nicholas Canny, 'The Origins of Empire: An Introduction', in Canny, ed., *The Origins of Empire*, pp. 1–33 (p. 1).

16 Canny, 'The Origins of Empire', p. 3.

17 John Milton, *Poetical Works*, Douglas Bush, ed. (Oxford: Oxford University Press, 1966), p. 284. All subsequent references are to this edition. See Canny, 'The Origins of Empire', pp. 1–2.

18 David Armitage, 'John Milton: Poet Against Empire', in David Armitage *et al.*, eds, *Milton and Republicanism* (Cambridge: Cambridge University Press, 1995), pp. 206–225.

19 See David Armitage, *The Ideological Origins of the British Empire* (Cambridge: Cambridge University Press, 2000), pp. 61–99.

20 See Jane H. Ohlmeyer, '"Civilizinge of those rude partes": Colonization within Britain and Ireland, 1580s–1640s', in Canny, ed., *The Origins of Empire*, pp. 124–147.

21 See Tristan Marshall, *Theatre and Empire: Great Britain on the London Stages under James VI and I* (Manchester: Manchester University Press, 2000), pp. 9–151.

22 Canny, 'The Origins of Empire', p. 7.

23 For a recent reading of More's text, see Amy Boesky, *Founding Fictions: Utopias in Early Modern England* (Athens and London: University of Georgia Press, 1996), pp. 23–55.

24 Henry Peacham, *The Garden of Eloquence* (London: H. Jackson, 1577), p. 27.

25 Fletcher, *Allegory: The Theory of a Symbolic Mode*, pp. 72–73.

26 See for instance Stephen Orgel, *The Illusion of Power: Political Theater in the English Renaissance* (Berkeley: University of California Press, 1975); Jonathan Dollimore, *Radical Tragedy: Religion, Ideology and Power in the Drama of Shakespeare and His Contemporaries* (Chicago: University of Chicago Press, 1984); Jean E. Howard, *The Stage and Social Struggle in Early Modern England* (New York and London: Routledge, 1994); Louis Montrose, *The Purpose of Playing: Shakespeare and the Cultural Politics of the Elizabethan Theatre* (Chicago: University of Chicago Press, 1996).

27 Dollimore, *Radical Tragedy*, p. 25.

28 Paul Yachnin, *Stage-Wrights: Shakespeare, Jonson, Middleton and the Making of Theatrical Value* (Philadelphia: University of Pennsylvania Press, 1997).

29 Yachnin, *Stage-Wrights*, p. 3.

30 Yachnin, *Stage-Wrights*, p. 12.

31 See Annabel Patterson, *Censorship and Intepretation: The Conditions of Writing and Reading in Early Modern England* (Madison: University of Wisconsin Press, 1984), pp. 3–23

32 See, in particular, Andrew Gurr, *Playgoing in Shakespeare's London* (Cambridge: Cambridge University Press, 1987); Andrew Gurr, *The Shakespearian Playing Companies* (Oxford: Clarendon Press, 1996).

33 Andrew Gurr, *The Shakespearean Stage, 1574–1642* (Cambridge: Cambridge University Press, 1980).

34 See Gurr, *Playgoing in Shakespeare's London*, pp. 169–175.

35 Gurr, *Playgoing in Shakespeare's London*, pp. 175–182.

36 Louis Montrose, 'The Work of Gender in the Discourse of Discovery', *Representations*, 33 (1991), 1–41.

37 John Donne, *Complete English Poems*, C. A. Patrides, ed. (London: Everyman, 1994), p. 121.

38 I. A. Richards, *The Philosophy of Rhetoric* (London: Oxford University Press, 1936).

39 William Congreve, *The Way of the World* (London: A & C Black, 1994), IV, i, 197–198.

Elizabeth I and travel writing

The assumption of the English throne in 1558 by Elizabeth Tudor, second daughter of Henry VIII and the third of his children to inherit the throne, coincided with an emerging sense on the part of her subjects that England deserved to be more influential in European politics. England, it was believed, was destined to control more colonial territory, and hence enjoy more wealth than it had hitherto enjoyed. Henry VIII's announcement, for instance, in the Act of Appeals that 'This realm of England is an Empire' foreshadows these desires as early as 1533.[1] Here, the King uses proleptic rhetoric that helped to create the climate of, as Benedict Anderson terms it, 'nation-ness', where emerging English national identity and empire formation go hand-in-hand.[2] But, it was not until the reigns of his children, and particularly Elizabeth's forty-five-year rule, that Henry's rhetoric started to be matched by, for want of a better term, action. By the start of the seventeenth century, England possessed the beginnings of an overseas empire as the nation attempted to establish and consolidate territorial footholds in Ireland, the New World, the South Seas, Africa and Asia, and to increase diplomatic and trading connections with many other regions.[3] Though the nation's territorial possessions in no way matched its ambitions, colonial discourses that justified, defended and proved England's Protestant right to empire – against the claims of European rivals, particularly Catholic Spain – were well developed. For the first time, then, the nation seriously attempted to make interventions within the more established colonial activities and settlements of other European nation states.[4]

English writers' expressions of determination to rival, in particular, Spanish and Portuguese colonial possessions and riches have been

extensively analysed by recent scholarship.[5] Richard Hakluyt's *Epistle Dedicatory ... To the Right Honourable Sir Francis Walsingham* in his 1589 *Principal Navigations, Voyages, Traffiques and Discoveries of the English Nation*, for example, describes how the English are 'ignominiously reported, or exceedingly condemned' by foreign commentators for their 'sluggish security, and continual neglect' of 'discoveries and notable enterprises by sea'.[6] Similarly, Francis Bacon, in *Advertisement touching an Holy War* (1622), ruminated jealously on Spain's rewards from colonial dominions: 'We see what floods of treasure have flowed into Europe by that action ... Besides infinite is the access of territory and empire by the same enterprise'.[7] As Thomas Scanlan has argued, the translation into English of Bartolomé de Las Casas's *Brevíssima relación de la destrucción de las Indias* in 1583 marked a turning point in the development of national identity through colonial endeavour and competition with Spain.[8] Not only did the availability to English readers of de Las Casas's account of Spanish treatment of indigenous Americans begin the 'Black Legend' of Spanish overseas tyranny, it also enabled English Protestants to represent their colonial ambitions and treatment of colonised peoples as significantly different from those of their Catholic rivals. As a result, English commentators sought, imaginatively at least, to insert themselves and the nation into other cultural and geographical spaces.[9]

This book is not, however, an in-depth examination of why mid-sixteenth-century Englishmen and women felt the nation deserved an enhanced status as a world power. The reasons behind these ambitions and the evolution of new senses of, and changes to, English national identity have been dealt with extensively elsewhere.[10] Nor is the focus on exactly how successful Englishmen were in the fight for empire. Even giving a precise date for the onset of this complex cultural process is problematic and contested, but this too has been thoroughly explored in other studies.[11] Rather, in this chapter, my interest will be in the ways in which the gender of the Queen played itself out in colonial writing of the period, and the uses to which the Queen's femaleness was put by writers and propagandists for the colonial project.

Recent scholarship has shown the importance of gender to the political culture of Elizabeth's reign. A. N. McLaren, in particular, has comprehensively demonstrated the ways in which Elizabeth's femaleness prompted her parliament, councillors and preachers to debate and contest authority relations and Protestant monarchy.[12] For example, McLaren shows the way that, following the Reformation, the *sine qua non* of the

period became the 'naturalness' of a Protestant, imperial, and male model
of monarchy. The king was thus styled 'Supreme Head of the Church of
England' and he took his authority, in part, from his shared maleness with
Christ: 'him by whom Kings reign'.[13] As a result, theorists and apologists
in Elizabeth's reign were forced to modify this male-centred model to
accommodate a female ruler. A revised notion of 'mixed monarchy' was
developed where political authority was divided between the Queen and
her male councillors and parliament, in which the latter groups represen-
ted themselves as having a more significant share of political control that
they would enjoy under a king.[14] As McLaren argues, '"mixed monarchy"
was defined as a corporate body politic; one in which the wisdom of the
many (a contested, but gender-specific identity during this period)
"bridled" and imparted grace to a female prince'. Furthermore, this model
'conjoined the three estates – now queen, lords and commons … – in a
mystical marriage effected at the queen's coronation; a marriage in which,
during Elizabeth's reign, both halves vied for the role of "head" in a
cultural context that defined headship as a male role and marriage as a
means by which women were made whole through their incorporation in
their husbands'.[15] The terms of the relationship between the Queen and
her lords and commons were significantly politically distinct, then, from
the ones between a king and his advisers, due to culturally perceived gender
differences. These contrasts are graphically shown, for instance, in the
different terminology used to describe a male and female monarch's relation-
ship to the Church of England: where Henry was 'Supreme Head', Eliza-
beth's claim was to be 'Governor', a distinctly less self-assertive position.[16]

In the first part of this chapter, I want to bring together these new
understandings of the gendered political culture of Elizabeth's reign, with
recent work on English colonial endeavour. I will be tracing the ways in
which the Queen's gender was deployed by the writers of colonial material,
and the way it influenced their writings. In this I will be seeking to revise a
number of current orthodoxies about the period. Jeffrey Knapp, for example,
has suggested that the femaleness of the Queen was important in defining
what he sees as England's dismal colonial failure at this time.[17] He argues
that, despite all the propaganda, the nation signally failed to increase its
territory and that everyone knew it. Paradoxically, however, the nation
revelled in such seemingly unpalatable weaknesses. He suggests that:

The strange truth about this apparently depressing picture of an England as
other-worldly as the New World, however, is that the English themselves
loved to highlight it …What would otherwise have appeared dispiriting

tokens of England's weakness – its littleness, its circumscription by enemies, its female monarch – could signify instead England's abjuration of material or wordly means to power and its extraordinary reliance on God.[18]

In what follows, I challenge the accuracy of Knapp's analysis that the English celebrated their colonial inadequacies and their 'weak', female monarch as signs of divine support. Yet, his argument that the Queen's female, and hence inferior, gender was appropriated as a tool with which to celebrate the nation's colonial failure, does usefully point up the central importance of allegory to colonial discourse. Indeed, the prominence of allegory in colonial writing has been further highlighted by Thomas Scanlan:

If allegory involves the construction of a narrative that points toward, and yet operates at a distance from, another narrative, then almost by its very nature, colonial activity would seem to encourage allegorical writing. Colonial endeavor is never an end in itself. It is always a means to an end. As such, the narration of the events in the colonial space always must connect itself to some ultimate goal, which is inevitably removed from the colony. Colonial writing therefore tells two stories: It narrates events in the colony, while referring to the desires of the nation.[19]

In other words, 'colonial writing can be made to do domestic work'.[20] It is precisely this bifurcated aspect of colonial writing that I will be focusing on in what follows, as I explore the ways in which these texts reflected, constructed, and shaped, political perceptions of the Queen.

When Elizabeth inherited the kingdom, England possessed no foreign territory (even Calais, the last remaining continental outpost, had been humiliatingly lost during the reign of her sister Mary), and, as a result, during the new Queen's reign there was increased commitment – even if imperfectly executed – to empire formation in her name. In this chapter, I focus on some of the key writers in this process: Hakluyt, Ralegh, Chapman – all men engaged directly, or indirectly as propagandists, in the project of empire. Their competing representations of Elizabeth, as monarch, as symbol for the colonial project, as financial backer, and, significantly, as *female*, are explored here. This chapter argues against Knapp's analysis that Elizabeth's gender weakness matched the nation's colonial accomplishments. Instead, it explores new, and sometimes surprising, developments in the gendered representations of Elizabeth in the intensely allegorical genre of colonial writing, to reveal the complexities, inconsistencies and changes over the course of the reign, in the ways English writers imagined the project of empire and, as a consequence, the nation's destiny.

'Elizabeth's Virginia': The Virgin Queen and gendered colonial discourse

There yet remains for you new lands, ample realms, unknown peoples; they wait yet, I say, to be discovered and subdued, quickly and easily, under the happy auspices of your arms and enterprise, and the sceptre of our most serene Elizabeth, Empress – as even the Spaniard admits – of the Ocean. But to what end do I apply the spur to the racer, or panting behind, urge on the headlong leader? To what end do I exhort you or admonish you to persist in your project, when only recently you sent me letters from Court in which you freely swore that no terrors, no personal losses or misfortunes could or would ever tear you from the sweet embraces of your own Virginia, that fairest of nymphs – though to many insufficiently well known – whom our most generous sovereign has given you to be your bride? If you persevere only a little longer in your constancy, your bride will shortly bring forth new and most abundant offspring, such as will delight you and yours, and cover with disgrace and shame those who have so often dared rashly and impudently to charge her with barrenness. For who has the just title to attach such a stigma to your Elizabeth's Virginia, when no one has yet probed the depths of her hidden resources and wealth, or her beauty hitherto concealed from our sight?[21]

So wrote Richard Hakluyt in his 1587 *Epistle Dedicatory to Sir Walter Ralegh*, which was included in the English edition of *De Orbe novo Petri Martyris … Decades octo.* This quotation has received considerable scholarly attention in recent years. It is the imagined *ménage à trois* between Ralegh, Elizabeth I and Virginia that has been commented upon because it can be read as evidence of the gendered discourse available to and promulgated by Elizabethan courtiers and commentators in their attempts to further an English policy of colonial exploitation and, simultaneously, to persuade the Queen of the merits of their schemes. Louis Montrose, in particular, in his essay 'The Work of Gender in the Discourse of Discovery', sees as 'imaginative liberties' Hakluyt's descriptions of 'your Elizabeth's Virginia'. The region is represented as Ralegh's fecund bride in need of sexual penetration, terms which Ralegh himself would not have dared to take in his correspondence with the Queen.[22] Elizabeth's naming of Virginia in her own image meant, according to Montrose, that Ralegh would be 'impolitic' to talk of the 'plantation of Virginia in the same terms he uses to represent the conquest of Guiana. If Ralegh cannot write explicitly of Virginia's rape, this is because the queen and her courtier share a common discourse of discovery, grounded in the territorial conception of the female body'.[23] What Montrose means, then, is that the connections between Elizabeth and Virginia preclude the use of rapacious terms for the plunder of the eastern seaboard of North America whereas, by contrast, Ralegh's own

The Discoverie of the Large, Rich and Bewtiful Empyre of Guiana (1596) calls on all patriotic Englishmen to emulate the Spaniards – particularly Charles V who 'had the maidenhead of Peru' – and to take Guiana in explicitly sexual terms ('Guiana is a countrey that hath yet her maydenhead').[24]

Similarly, Mary C. Fuller in *Voyages in Print* argues for the importance of metaphorical representations of Elizabeth I in both Hakluyt's 1587 dedications and Ralegh's *Discoverie*.[25] Fuller's argument is that Ralegh constructs a vision of Guiana as a sexually available maiden whose charms he is able to resist in order to redress the political marginalisation resulting from his recent 'incontinent' marriage to the Queen's lady-in-waiting Elizabeth Throckmorton. Furthermore, Fuller argues, Ralegh is trying to recreate in the *Discoverie* Hakluyt's earlier image of Virginia as a sexually available, though incestuous, bride for Ralegh as a way of appeasing his monarch. Hakluyt had, for example, in 'Preface to the English translation of Laudonnière. Epistle Dedicatory to Sir Walter Ralegh by Richard Hakluyt, 1587', represented Virginia as his bride as well as his child. Indeed, in this dedication, Virginia needed the attentions of a caring godmother (Elizabeth) since Ralegh is not able to rear her alone:

> Moreover there is none other likelihoode but that her Maiestie which hath Christned and given the name to your Virginea, if neede require, will deale after the maner of honorable god-mothers, which, seeing their gossops [friends] not fully able to bring up their children themselves, are wont to contribute to their honest education, the rather if they finde any towardlinesse or reasonable hope of goodnes in them.[26]

Such representations obviously pleased the Queen since they successfully untied her purse strings and hence those of her courtiers in the late 1580s and early 1590s – despite Ralegh's fall from royal favour after 1592. As a result, they were recycled in modified forms in his promotional literature produced after his 1595 voyage to Guiana.[27]

What both Fuller and Montrose argue for, then, is a shifting and complex representation of sexual and familial relations between the discoverer Ralegh, the patron Queen and the prospective English colonial territories of Virginia and Guiana. Virginia is both bride and child of Ralegh; Elizabeth is marriage-broker, mother and godmother as well as being figuratively represented by the continent; Ralegh is both a caring father and an impatient husband to the still virgin Virginia (but she will soon be deflowered and will, it is clear, prove fertile). Guiana too is imagined in complex sexual, social, and familial positions – she is a fair virgin inviting

sexual violence, but her charms and willingness merely function to emphasise the continence of the English adventurers whose strength of character allows them to resist her allures.[28]

Both critics, then, see key differences between the representations of Virginia in the mid- to late 1580s and those about Guiana produced ten years later. The erotic possibilities of territorial landscapes are still emphasised but, significantly, the relationships of Ralegh and the Queen to these feminised landscapes and to each other have shifted. I begin this book, then, with a consideration of these differences between the relationship of the female monarch to her male courtier, and of each to the gendered colonial landscapes.

As previously stated, Hakluyt's epistle to Ralegh constructs an image of royally sponsored nuptials between the impatient courtier and the fertile American terrain. Moreover, Hakluyt's imagery yokes together Virginia and Elizabeth in the phrase 'your [Ralegh's] Elizabeth's Virginia' since both are represented as, on one level, rhetorically subservient to the active male courtier who is the first term in the grammatically complex phrase. For, as Louis Montrose states, 'Queen Elizabeth ... cannot take maidenheads' and in the gendered discourse of discovery 'Englishmen will necessarily be alienated from their own sovereign, who cannot occupy the position of the agent in such a gendered and sexed discourse'.[29] Hakluyt's epistle, however, seems rather less certain of Elizabeth's lack of penetrative ability than Montrose's analysis would suggest, since it is with 'the sceptre of our most serene Elizabeth' that Ralegh will take possession of 'new lands, ample realms, [and] unknown peoples'. Elizabeth's phallic sceptre gives her a degree of agency here over and above that of benign, and marginalised, female monarch who can only act through the potency of her courtiers. Moreover, Hakluyt had used this image previously in a Latin verse 'In praise of those who have discovered new parts of the world', which was printed in the 1586 French edition of Laudonnière's *L'Histoire notable de la Floride* by Martin Basanier:

> The Portuguese subdued the tracts of China
> And the stout Spaniard the fields of Mexico:
> Florida once yielded to the noble French:
> VIRGINIA now to thy sceptre, Elizabeth!
> The illustrious race of Portugal celebrates its Gama,
> And the land of Spain boasts its Cortes,
> France gives the palm to Laudonnière and brave Ribault,
> But we, noble Ralegh, assign first place to thee.[30]

Here, Elizabeth's 'sceptre' represents a form of sexual agency as it forces Virginia to 'yield'. The celebration of Elizabeth's penetrative prowess, however, is tempered somewhat in the last line of the verse, when it becomes apparent that the 'we' of the poem, in other words all patriotic English, are encouraged to applaud the achievements of the 'noble Ralegh'. Hakluyt's images of sceptres are thus both conformist and troubling. They are entirely conventional since a phallic sceptre can, on one level, be accommodated by the common theory of the King's two bodies. According to this argument (derived from the jurist Edmund Plowden's 1571 *Reports*), a monarch possessed one natural, personal and, in this case, female body as well as one public, symbolic, and male one.[31] Such an analysis allowed, as is well known, Elizabeth to be represented androgynously throughout her reign.[32] But the presence of a sceptre possessed by a woman also disturbs the effectiveness of a gendered discourse of discovery that seeks to emphasise maleness as the defining factor of colonial agency. Ralegh may be 'noble' and he may be accorded 'first place' in the list of English colonial luminaries but, nevertheless, it is still under Elizabeth's auspices – significantly in the poem she is the named representative of her country whereas achievements of other colonial nations are not referenced to their respective monarchs – that Ralegh's actions are framed.

In Ralegh's *Discoverie*, similar uncertainties can also be detected. For example, whilst describing his foray up the Orinoco river in the company of Toparimaca, 'the Lord of that border', Ralegh makes mention of two other 'Cassiques' (Lords) whom he encounters.[33] In terms of gender politics the meeting begins conventionally enough. Ralegh describes how the two men 'laie each of them in a cotton Hamaca, which we call brasill beds' with their women subserviently replenishing their cups as the need arose, '& two women attending them with six cups and a little ladle to fill them'.[34] However, the next paragraph unsettles this conformist demarcation of gender-appropriate behaviour:

The Cassique that was a stranger had his wife staying at the port where we ankored, and in all my life I have seldome seene a better favored woman: She was of good stature, with black eies, fat of body, of an excellent countenance, hir haire almost as long as hir selfe, tied up againe in pretie knots, and it seemed she stood not in aw of hir husband, as the rest, for she spake and discourst, and dranke among the gentlemen and captaines, and was very pleasant, knowing hir owne comelines, and taking great pride therein. I have seen a Lady in England so like hir, as but for the difference of colour I would have sworne might have beene the same.[35]

This passage raises several issues concerning women's behaviour. What Ralegh is doing here is representing a woman who is out of the ordinary – this woman is 'not in aw of hir husband, as the rest'. She is also exceptionally well-favoured which, according to Ralegh, enables her to express her own opinions and take part in the drinking 'at their feasts and meetings' – activities which, it seems, are normally reserved for men in Guianan culture.[36]

However, what is not certain is the extent to which Ralegh endorses this woman's quasi-masculine behaviour. Her beauty seems to allow her these special privileges ('she was very pleasant') without being openly condemned. Ralegh obviously enjoys looking at her, taking appreciative note of her especially long hair 'tied up againe in pretie knots'. Indeed, we might say that the wife's appropriation of masculine activities seems licensed here because – though it might be troubling – her prettiness and the pride she takes in her looks, especially her hair, allow her still to be positioned as a passive object for the attentions of the colonial male adventurer. As Simon Shepherd has argued, hair was an important signifier of gender-appropriate behaviour in this period, with the absence or presence of abundant hair denoting refusal or conformity respectively to the gender role designed for women.[37] And, after all, it is Guianan customs rather than English ideas of appropriate gender behaviour that her presence and speech in all-male preserves are disturbing. However, the last sentence needs to be considered before we can be certain of whether Ralegh is supporting female agency: 'I have seen a Lady in England so like hir, as but for the difference of colour I would have sworne might have beene the same.' Any positive identification of this 'Lady in England' is inconclusive. But it is certainly possible that Ralegh might have meant the Queen.[38] However, the woman is married and she is, therefore, only of special status because she is married to one of the local Lords of the region. Yet, in a text which – as is well attested – sought to regain the Queen's favour, it would be surprising if references to a 'Lady of England' did not, at least on some levels, refer back to the Queen. Points in favour of a comparison would be the woman's beauty, since Ralegh, as has been comprehensively discussed elsewhere, throughout his career as a courtier and a poet, represented Elizabeth in the role of fair beloved despite the inevitable processes of physical aging.[39] Moreover, particularly early in Elizabeth's reign, many writers represented the Queen in terms of married women such as Deborah, the Israelite Judge of the Old Testament, and to a lesser extent Judith, the killer of Holofernes in the Apocrypha.[40] Furthermore, the woman is

singular since she does not behave like other women, in the same way that
the Queen during her reign was consistently represented as unique
amongst her gender. As John Aylmer argued in 1559, God had ordained
Elizabeth to rule since he had provided no male heir: 'it is a plain argument
that for some secret purpose he [God] myndeth the female should reign
and govern'.[41] Finally, and perhaps most importantly, Ralegh's flirtation
with this woman and her ability to defy her gender subservience by mixing
and speaking with her own people and the colonists without causing
hostile comment, might be intended as a reflected compliment on the
Queen's ability to control her courtiers. Given that, as Fuller has pointed
out, Ralegh was trying to emphasise his sexual continence in the face of the
contradictory evidence of his impolitic marriage, the admiration and
respect for the Guianan woman here might be seen as further evidence of
such a reading. Ralegh looks, he admires, but he maintains appropriate
social and sexual distance. He is able to manage his appetites in Guiana,
despite his previous failures to exert such sexual control in England.[42]
Similar sentiments are expressed by Ralegh's proud statement 'I suffred
not any man to take from anie of the nations so much as a *Pina*, or a *Potato*
roote, without giving them contentment', which also has political
resonance.[43] Not only do Ralegh's men show a continence which contrasts
to the Spaniards' greedy and thieving consumption of women and food,
but 'pina[s]' possess a gynaecocratic dimension, since elsewhere he
describes it as 'the princesse of fruits, that grow under the *Sun*'.[44] The fruit
is clearly a royal one, and the Englishmen's respectful treatment is thus
part of the text's ongoing coded representation of the Queen.

Ralegh's reference to an unnamed 'Lady of England', then, seems
tantalising. Ralegh's *Discoverie* – which was dedicated to Elizabeth's coun-
cillors Charles Howard and Robert Cecil – had the Queen as the ever-
present indirect reader in the background.[45] Consequently, any reference
to a 'Lady of England' – and particularly such an elusive one – was, given
Ralegh's situation of an unwise marriage to one Elizabeth and his desire to
reingratiate himself into the favours of another, bound to provoke specu-
lation. Therefore, the ambiguities, or aenigma, of this passage should be
read as deliberate. The reader is not meant to know to whom Ralegh
refers, but Ralegh issues an invitation to speculate on the possibilities.
Consequently the Guianan woman should be read both positively and
negatively: she is beautiful, articulate and admired, but she also unsettles
the accepted traditions of Guianan behaviour and, by implication, English
culture. She has entered male preserves and though Ralegh's description

implies she has done so successfully, her resemblance to the elusive 'Lady of England' also appears threatening to the stability of English patriarchy since her unruliness is both a prophesy of what might happen in England or a reflection of what has already occurred. She symbolises, therefore, Ralegh's desire to ingratiate himself back into the Queen's favour, as well as his unease about the way such a situation reverses accepted beliefs concerning inherent male superiority.

To return once more to Hakluyt's descriptions: his portrayal of Elizabeth's sceptre in 1586 and 1587 appeared just before one of the most crucial events in Elizabeth's reign occurred: the Armada crisis of 1588. Though neither Elizabeth nor Philip II ever openly declared war upon each other, to all intents and purposes England finally went to war with Spain after the treaty of Nonsuch of August 1585 in which Elizabeth promised to help the rebel Protestant Netherlanders against Spanish control in the region. England's aim in this conflict was to restrict Spain's growing influence in Northern Europe which (following the chaos in France after the onset of renewed and intense civil war in the spring of 1585), looked to Protestant English eyes rather too close for comfort.[46] With hostilities between Spain and England escalating in the mid 1580s, Philip's plans to invade England – first seriously and secretly mooted in 1583 by the Marquis of Santa Cruz – became increasingly elaborate (involving the construction, victualling and manning of ships to transport the invasion force). Such activities were, of course, impossible to keep secret for long. Hence, when Hakluyt wrote that Elizabeth was 'Empress – as even the Spaniard admits – of the Ocean' in 1587, his remarks should be seen against the background of Philip's invasion plans by which – as the Duke of Parma wrote to his monarch on 20 April 1586 – Philip intended to 'try to become lord of the Ocean'.[47] Whether Hakluyt actually knew the words used in Parma's plans to describe Philip II's ambitions when he wrote his dedication to Ralegh for the Latin edition of Martyr's *Decades* from Paris on 22 February is immaterial. What is crucial is that the general tenor of Philip's expansionist schemes was well known and meditated upon by English commentators such as Hakluyt, despite Philip's best attempts to keep them secret. The construction and fitting out of such a large ocean-going force had quickly become common knowledge. Indeed, from late 1585 onwards Kent, and indeed much of England, had a warning system of beacons in place, which would be lit in the event of Spanish forces being sighted off the coast.[48] Hence Hakluyt's representation of Elizabeth as supreme in terms of maritime power – a pre-eminent position

acknowledged, he asserts, even by the Spanish – needs to be read in the light of English fears concerning Philip's intended invasion.

With this background in mind, Hakluyt's representations of Elizabeth's phallic sceptre no longer look surprising. In order for England to be successful in the conflict with Spain, the monarch needed to be represented with as much military prowess as possible, despite her gender. An anonymous ballad written to celebrate the Armada victory of 1588 has, for example, as its repeated refrain, the alternate lines of 'Elizabeth to save' and 'Elizabeth so brave'.[49] Indeed, Elizabeth's famous inspection of her troops at Tilbury in August 1588 wearing military costume served to show that her gender did not prevent her from, symbolically at least, commanding her forces. The military aggression such representations reveal was, as we shall see later, frequently recycled and amplified in the years after her death when they were often used to voice implicit criticisms of the less bellicose foreign policies of James I. According to Thomas Heywood's description of Elizabeth at Tilbury (written some years later), she appeared 'habited like an Amazonian Queene, Buskind and plumed, having a golden Truncheon, Ganlet, and Gorget; Armes sufficient to expresse her high and magnanimous spirit'.[50] Furthermore, Heywood also celebrated the Queen's military aggression in his dramatic texts, most notably *If You Know Not Me, You Know Nobody* (1604/5; revised 1633), where Elizabeth magnificently inspires her troops and commanders:

> Know my subjects
> Your Queene hath now put on a Masculine Spirit,
> To tell the bold and daring what they are,
> Or what they ought to be: And such as faint,
> Teach them by my example Fortitude.[51]

Similar sentiments were also represented pictorially. The 'Armada Portrait' of 1588, for example, which shows Elizabeth seated between two windows in which the gazer can see respectively the arrival and defeat of the Spanish fleet, emphasises the Queen's might. The monarch, surrounded by her crown and throne, stretches out an imperial hand to grasp the globe (see Figure 1).[52] Furthermore, in the Parish Church of St Faith, Gaywood, there are two anti-Catholic oil paintings dating from the early seventeenth century, which express similar concerns. One portrays the discovery of the Gunpowder Plot and the nation's fortunate escape. The main panel of the other shows Elizabeth amongst her forces at Tilbury, to the upper left is the fort and assembled battalions of men, and in the background Spanish ships burn fiercely. Above this main panel is a smaller picture depicting

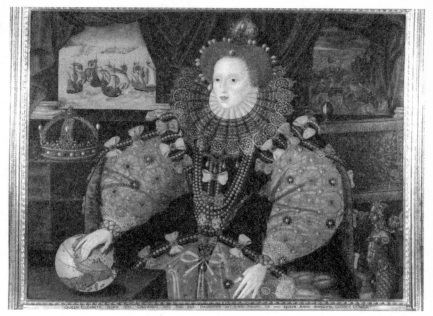

1 *Elizabeth I, Armada Portrait*, attributed to George Gower

the Queen privately reading from a book, presumably the Bible, saying 'Blessed be the great God of my Salvation'. The smaller picture, then, praises Elizabeth's own role in the successful defence of her country and its religion, achieved through her special relationship with God. Below the main panel, flanked by two cherubs, there is written a paraphrase of Elizabeth's speech to her troops, which emphasises the holy Protestant fight against the Romish enemy (see Figure 2).[53] Elizabeth's bravery, courage and belief in the true religion have, it seems clear, saved England from her enemies.

Consequently we can read Hakluyt's fantasy of a sceptre-wielding Elizabeth in the Virginian context as in keeping with other images of the 1580s that celebrate the masculine characteristics and potency of the Virgin Queen. For certain purposes – for example, in times of national defence or in order to criticise her successors – a female monarch was represented (both by herself and by others) as much like a man as possible.[54] As such, Hakluyt's descriptions of Elizabeth's sceptre in Virginia reveal a nationalist ambition to rival Philip's New World empire. Virginia has here become another location in which to attempt to trounce the Spanish. Importantly,

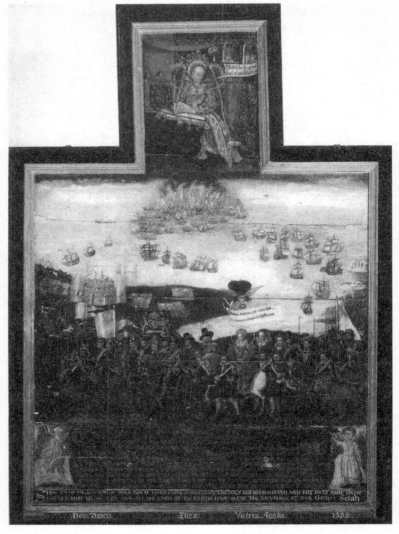

2 *The defeat of the Armada: Elizabeth I at Tilbury*, artist unknown,
Parish Church of St Faith, Gaywood

though, it is the body of Elizabeth herself which is given the kind of agency normally only associated with men.

In Ralegh's descriptions of his activities in Guiana in the 1590s, by contrast, Elizabeth is no longer represented with this penetrative ability. By 1596 the situation had changed. England was still at war with Spain – peace was not finally negotiated until 1604, after Elizabeth's death – and the fear of Spanish invasion lasted long after the immediate crisis of 1588.[55] Yet, as recent studies have shown, Elizabeth's prestige was significantly lower in the last years of her reign. According to John Guy, in the 1590s Elizabeth's 'inaction led to political marginalization' since her persistent dithering over decisions concerning how best to conduct the war with Spain meant that her courtiers and councillors were forced to seize the initiative.[56] Consequently, whilst previously Elizabeth had been vitriolic and punitive in her dealings with those who acted without her permission – for example over the dispatch of the warrant for the execution of her kins-woman Mary, Queen of Scots in 1587 – in the last years of her reign she 'tacitly condoned the fact ... that decisions were taken on her behalf'.[57] Indeed, as Paul E. J. Hammer argues, the factionalism that was endemic to Eliza-beth's court in the 1590s meant that the monarch was vulnerable to being out-manoeuvered by her courtiers.[58] Hammer's reading of the complexities of the rivalry between the Essex faction and that of the Cecils and Ralegh reveals Elizabeth's inability to control the Court.[59] Hammer argues that:

When factional rivals managed to put aside their differences for mutual short-term benefits, the loser, it seems, was their sovereign, for she now had to face pressure from a united front of her most influential servants and courtiers. Moreover, Elizabeth could no longer risk attempting to break up this united front because that only threatened a return to open conflict. In the event, as the courtiers no doubt calculated, she could only delay and then finally give in: Essex and Ralegh got their new expedition against Spain and Cecil got the chancellorship of the duchy of Lancaster.[60]

I want to suggest, therefore, that the differences in the descriptions and metaphors of Elizabeth between the publication of the 1587 *Epistle Dedicatory* and *The Discoverie of the Large, Rich and Bewtiful Empyre of Guiana* in 1596 are both emblematic and symptomatic of the changing perception of the Queen's government between the two decades. Hence, in the light of the political marginalisation of the Queen towards the end of her reign, I want to return briefly to Ralegh's description of the Cassique's wife in *The Discoverie of the Large, Rich and Bewtiful Empyre of Guiana*. His representation of the Guianan woman who resembled 'a Lady in

England ... as but for the difference of colour I would have sworne might have beene the same' starts to look like a darkly ironic and oblique expression of disillusion and dissent. As previously suggested, Ralegh's readers are encouraged to speculate on who this Englishwoman might be and meditate on the possibility of an intentional reference to the Queen. But, implied in the description is a contrast between the way the Cassique's wife appears to negotiate successfully the difficulties of entering domains normally reserved for men and the problems of the Queen's position in the late 1590s.

As many historians have argued, the success of Elizabeth's policies in the earlier decades of her reign were predicated on her skill in the 'game' of courtship.[61] Successful courtiers all adopted the rhetoric of 'love' for their monarch and:

the dithering, prevarication and generally dismissive behaviour which was understood to be archetypical of the conventional 'mistress' provided Elizabeth with her weapons of political manipulation and manoeuvre. In order to beat her male courtiers at their own game, she changed the rules and capitalized on the power granted to her by virtue of her gender.[62]

But, by the last years of Elizabeth's reign she was no longer mistress of the courtship game. During this period there was an increasing gap between the fantasy and reality of articulating sexual desire for the 'fair beloved' monarch since Elizabeth, bewigged and toothless, was no longer sexually appealing to the younger generations of courtiers that now surrounded her. As Helen Hackett reveals in her analysis of what she termed the 1590's 'literature of disillusionment', the texts that were produced in the last years of the Queen's life amidst persistent rumours of ill-health and death seem to be the most effusive in their praise of Elizabeth as a perfect, sacred icon. However these same texts and images also 'produced reactions of negativity and even iconoclasm towards the Queen'.[63] Hackett argues that writers such as Fulke Greville, Edmund Spenser and Ralegh, amongst others, represented the Queen in subtly negative ways even whilst they appeared to praise her. For example, Hackett's reading of *The 21th: and last booke of the Ocean to Scinthia* (which she assumes to have been written at the time of Ralegh's impolitic marriage to Throckmorton) describes how through the course of the poem Cynthia changes from a source of immutability, abundance and beauty to a force of change, inconstancy and woe.[64]

Hackett's analysis of the deep ambivalence concerning the Queen can usefully be applied to Ralegh's description of the Cassique's wife. Her resemblance to the 'Lady of England' who, in turn, seems to represent at

least an oblique reference to the Queen, needs to be seen in terms of both similarity and difference, praise and disquiet. In one way Ralegh's obvious attraction to the unnamed Cassique's wife marginalises the Queen because it highlights what she no longer possesses. It is the Cassique's wife's sexual allure which enables her to defy her gender-subservient position and allows her, albeit in limited ways, to enter all-male domains. The wife is similar to the Elizabeth of the early years of her reign in that she is able to exploit the culture and processes of courtship, using them to gain access to and control of traditionally male spheres of influence. She is dissimilar since, in her mid-sixties in the 1590s, Elizabeth, despite Ralegh's implied flattery, no longer possessed these legitimating sexual characteristics; indeed, as Bishop Goodman baldly put it later, the country was 'generally weary of an old woman's rule'.[65] Political difficulties with the Queen are influencing the ways Ralegh represents the women of Guiana: we have here a clear instance of, as Scanlan succinctly put it, 'the way colonial writing can be made to do domestic work'.

What this analysis shows is the importance of sexual allure in the colonial discourse during the period. Elizabeth was a past-mistress in the art of exploiting her sexuality and using it to out-manoeuvre her courtiers. As Francis Bacon commented after her death, Elizabeth had 'allowed herself to be wooed and courted, and even to have love made to her' and these 'dalliances detracted but little from her fame and nothing at all from her majesty'.[66] These images of colonial territory and England's claim to it should be seen as responses to the Queen's manipulation of the courtship game, which Elizabeth achieved for most of her reign to the detriment of her male courtiers. Early representations of the terrain of Virginia, in particular, which echoed the Queen nomenclatively as well as representing anxieties about her fertility and the succession ('If you persevere only a little longer in your constancy, your bride will shortly bring forth new and most abundant offspring, such as will delight you and yours, and cover with disgrace and shame those who have so often dared rashly and impudently to charge her with barrenness') show the extent to which the Queen's imagined sexuality and generative ability were implicated in the colonialist discourse of her male courtiers at this time. We need to remember that when Hakluyt wrote these descriptions the Queen was in her late forties and it was highly unlikely that she would be able to produce an heir. Indeed, once the negotiations for the proposed Alençon match were finally broken off in 1582 – the Queen was forty-four, and her prospective bridegroom in his twenties – there were no further serious hopes that the

Queen would ever marry and provide an heir from her body.[67] Hence Hakluyt's descriptions carried a certain risk with them as he manipulated images of fertility and barrenness that had dangerous resonances with the Queen's personal situation. In the light of this reading, Hakluyt's fantastic descriptions of the Queen's penetrative ability can be seen as attempts to reduce impolitic suggestions of barrenness. Metaphors of Elizabeth's potency and agency thus operate as compliments designed to negate critical allusions to the Queen's lack of generative ability. Potent masculinity in these images operates as a sugar coating to disguise the unpalatability of the Queen's barrenness: in other words, masculinity is sublimated here.

It is important to remember that Hakluyt's texts of the 1580s are promotional and persuasive. They are designed to attract financial backing from prospective investors, including the Queen. Hence, his colonialist discourse was seeking to find a way of representing the Queen through the terrain of Virginia that would please her. Indeed in his 1584 *Discourse of Western Planting*, these promotional motives are explicitly stated:

God wch doth all thinges in his due tyme, and hath in his hande the hartes of all Princes, stirr upp the mynde of her Mtie at lengthe to assiste her moste willinge and forwarde Subjectes to the performance of this most godly and profitable action wch was begonne at the chardges of Kinge Henry the vij$^{th.}$ her grandfather, followed by Kinge Henry the eighte her father, and lefte as it semeth to be accomplished by her (as the three yeres golden voyadge to Ophir was by Salomon) to the makinge of her Realme and subjectes moste happy, and her selfe most famous of all posteritie. Amen.[68]

Consequently, the anxieties about Virginia's fertility – potential profit for investors was imperative – and the uneasy parallels with the Queen's status that the naming of Virginia and phrases such as 'Elizabeth's Virginia' invoked were tempered by imaginatively representing the Queen with male characteristics. By representing the Queen as fertile and penetrative – both physical impossibilities – Hakluyt was trying to avoid offending the person he hoped would sponsor English colonial activities.

Ralegh's *Discoverie* also, of course, sought the Queen's financial backing and favour, but the metaphors of the Queen in this text can be read as much more critical of Elizabeth's rule. The ambivalent image of the Cassique's wife reveals early modern culture's difficulties with accommodating powerful women. Her appearance and sexual attractiveness are all that allow her to defy her gender-subservient position. But such a description, by implication, begs the question of how a woman who no longer possessed fecund sexual characteristics was culturally accommodated?

The words which Ralegh uses to conclude *The Discoverie*, in particular, with their ambivalent representation of the Virgin Queen, show Elizabeth's declining status and, simultaneously, articulate both servility as well as hostility towards the Queen:

And where the south border of Guiana reacheth to the Dominion and
Empire of the Amazons,
Those women shall heereby heare the name of a
Virgin, which is not only able to defend her
Owne territories and her neighbours, but
Also to invade and conquere so
Great Empyres and so
Farre removed.
To speak more at this time, I feare would be but trou-
blesome: I trust in God, this being true, will suf-
fice, and that he which is king of al kings and
Lorde of all Lords, will put it into her
hart which is Lady of Ladies to pos-
sesse it, if not, I will judge those
men worthy to be kings ther-
of, that by her grace and
leave will undertake
it of them-
selves.[69]

There are several important issues raised here about Ralegh's relationship with the Queen specifically, and gender relations more generally. The poem opens conventionally enough with praise for the Queen who has been successful both defensively against Spain and offensively in attempting to expand her territorial possessions further afield. Noticeably, it is the Queen's virginity to which Ralegh calls attention. Her virginity is used here to act as an impressive contrast to the more voracious sexual behaviour of Amazon women that Ralegh had described earlier in *The Discoverie*, where the women 'accompanie' with men for a month each year in order to conceive children by 'their Valentines'.[70] It also functions as a way of adding to Elizabeth's prestige by connecting her with the Virgin Mary, a parallel which Ralegh draws through the use of the phrase 'Lady of Ladies'.[71] However, he swiftly moves on to circumscribe the Queen's power since her position as 'Lady of Ladies' is clearly shown to be inferior to the omnipotent male 'Lorde of all Lords'. Indeed, Ralegh's poem concludes with something of a dark warning, advising the Queen to be more active in her colonial policies since if she fails to be ambitious

enough in this sphere Ralegh 'will judge those men worthy to be kings
therof, that by her grace and leave will undertake it of themselves'. Ralegh
carefully avoids appearing explicitly treasonable here since his kingly
ambitions and desires for autonomous action are framed and allowed by
the Queen's 'grace and leave'. But, if that permission is witheld, there is a
sense in which Ralegh and other men will (sexually) 'invade and conquere'
the women and land – including Elizabeth? – before them. The half-
hearted reference to Elizabeth's permission in what is otherwise such an
aggressively ambitious and individualistic passage, confirms the sense of
Ralegh's dissatisfaction with his monarch's lack of real commitment to the
Guianan expedition. Indeed, even the shape of the text itself – maybe a
royal emblem, maybe a dagger, or even female genitals – confirms the
ambiguous nature of Ralegh's sentiments (see Figure 3).

OF GVIANA. 101

Spayne enioy it, he will become vnresistable. Her
Maiesty heereby shall confirme and strengthen the o-
pinions of al nations,as touching her great and prince-
ly actions. And where the south border of *Guiana* rea-
cheth to the Dominion and Empire of the *Amazones*,
those women shall heereby heare the name of a
virgin, which is not onely able to defend her
owne territories and her neighbors, but
also to inuade and conquere so
great Empyres and so
farre remoued.
To speake more at this time, I feare would be but trou-
blesome : I trust in God, this being true, will suf-
fice,and that he which is king of al kings and
Lorde of Lords, will put it into her
hart which is Lady of Ladies to pos-
sesse it, if not, I wil iudge those
men worthy to be kings ther-
of,that by her grace and
leaue will vndertake
it of them-
selues.

3 Walter Ralegh, *The Discoverie of the Large, Rich and Bewtiful Empyre of Guiana*

This passage works in several ways, then, since ostensibly it praises the Queen by representing her as an example of singular, quasi-divine womanhood from which other women can learn. However, Elizabeth's virginity here does not possess the potential fecundity that Hakluyt's descriptions of the terrain of Virginia had done in 1587. Elizabeth's virginity in Ralegh's poem associates her with other-worldliness and spirituality rather than sexual or temporal concerns. This is not the virginity of a sexually inexperienced, but potentially willing and fertile, maiden Virginia; rather Elizabeth's virginity in this poem represents a fixed, ossified political choice that frustrates her courtiers who wish her to pursue more forceful policies. Ralegh does not celebrate her virginity, as do other commentators according to Knapp, as a just reflection of England's political integrity as an island ('Ad Insulam') or as an 'otherwordly' metaphor that reveals England's chosenness by God.[72] Virginity here seems associated by Ralegh with a kind of weakness that begs for masculine penetration. The 'Lady of Ladies' needs her 'hart' penetrated by the 'king of al kings', thus inspiring Elizabeth 'to possesse' Guiana. In other words, the gendered discourse of this passage privileges both the male God and the male courtier. Elizabeth's penetrative abilities are compromised and partial – she needs penetrating herself – in her heart – in order for her to be able to perform as a man with Guiana. Though Ralegh prays that God will give Elizabeth enough penetrative ability to possess Guiana, if this does not occur, he argues, those men that do so are legitimate in any actions to realise their territorial ambitions. Elizabeth's virginity is here represented only as a tool for male colonialists to use to subdue the sexually voracious Amazons and school them into more appropriate female behaviour. Indeed, such a policy of female social control is hinted at earlier in the text when Ralegh asserts that the Queen of the Canuri 'asked mee divers questions of her Majesties greatnes, and wondring at such reports as we truly made of her highnes many vertues'.[73]

Elizabeth's power is subtly marginalised at several points in Ralegh's text, and each time it is through privileging the category of maleness that Ralegh subordinates his Queen. George Chapman's poem *De Guiana carmen Epicum*, which was prefixed to Laurence Keymis's 1596 account of Ralegh's journey, continues in a similar vein.[74] Chapman's poem is a celebration of Ralegh's Guianan achievements, which have been accomplished with 'his Eliza-consecrated sworde'. Unlike Hakluyt's 1587 representation of Elizabeth's phallic sceptre which accorded the Queen a degree of agency in the conquest of Virginia, in Chapman's text it is notably Ralegh's prowess that is applauded. In particular, the second stanza of

Chapman's poem – like the earlier images of the relationship between Elizabeth and Virginia – praises the Queen by situating her in multiple gender and familial positions:

> Guiana ... stands on her tip-toes at faire England looking,
> Kissing her hand, bowing her mightie breast,
> And every signe of all submission making,
> To be her sister, and daughter both
> Of our most sacred Maide: whose barrennesse
> Is the true fruite of vertue, that may get,
> Beare and bring forth anew in all perfection,
> What heretofore savage corruption held
> In barbarous Chaos; and in this affaire
> Become her father, mother, and her heire. (p. 447)

Fuller, in *Voyages in Print*, has argued that this text celebrates 'the power of the Queen ... as a power which relegated men to instrumental status' and that 'Elizabeth and Guiana approach each other by a system of (family) relations whose engendering term, or whose engenderment, is suppressed, the impermissible body of a man who engages both of them.'[75] While it is certainly true that in this stanza the power of the Queen is accorded the ability to transcend the normal rules of biology and kinship as she is, simultaneously, 'father, mother', 'sister' and 'heire', nevertheless, the poem as a whole appears to privilege the active male colonisers whose 'swords' Elizabeth has merely consecrated.

In the first stanza Chapman invokes Clio, the muse of history, to open 'most tenderly her aged throte' in order to bestir England from 'the peacefull charme of ... sleepe' and 'powre fresh youth through all her vaines' (p. 446). Sluggish England, it appears, needs awakening to the urgency of colonial endeavour, and it is heroic male English actions, albeit celebrated by invoking a female muse and sponsored by a female Queen, that are and will be the 'worke of honour and eternall name' (p. 446). It becomes apparent through the course of this poem that Chapman's praise of Elizabeth and the power that his images of multiple gender and familial positions accord her are designed to inspire her to action. Chapman then attacks the greedy, gold-obsessed and hence dishonourable brand of colonialism meted out by the Iberian nations under Philip II of Spain ('Iberian Neptune') in order to emphasise the honour and heroism of Ralegh and his 'Patrician Spirites' who 'skorne to let your bodies choke your soules, / In the rude breath and prisoned life of beastes' (p. 448). The Protestant ethos of virtuous conversion is here venerated since male English explorers and

colonists, unlike their Catholic competitors, understand that spiritual wealth is more important than temporal riches. The English, of course, are not averse to gold, but the control of appetite that Ralegh is so keen to emphasise throughout *The Discoverie*, and the Guianans' willing gift of their wealth, are used as justification for English activities.

The poem moves on, in the seventh stanza, to criticise the stupidity of female Nature who, despite her 'ennobled birth' is so 'bereft' 'of Sence' that she has failed to understand that Ralegh's colonial schemes and 'princely valure' are 'gentle applications / For the health, use and honour of her powers!' (pp. 449–450). A reference to the Queen's lack of perspicacity seems embedded in this description of this 'wrong'd soule of Nature' who, thus far, has proved incapable of seeing what is good for her. In the last stanza of the poem Chapman constructs a vision of idealised future colonial relations between England and Guiana. Elizabeth, overwhelmed by admiration at the exploits of 'Th'Industrious Knight' rises 'from her throne' to bless Ralegh's future exploits, England's nobles 'bring him Bridegroome-like ... To his Argolian fleet' amidst feasting and celebration whilst brave volunteers rush ('English valure swarmes') to join his expedition (pp. 450–451). Chapman then provides a fantasy description of English colonial life once Ralegh and his men place 'their glad feet on smooth Guinas breast':

> There Beautie is no strumpet for her wants,
> Nor Gallique humours putrifie her blood:
> But all our Youth take Hymens lights in hand,
> And fill eche roofe with honor'd progenie. (p. 451)

Under Ralegh's care, the husbandry of the correct colonial master, Guiana is sexually tamed and hence rendered both sexually faithful (freed from putrifying 'Gallique humours') and fertile (full of 'honor'd progenie'). The heroic activities of England's male colonial adventurers are thus highly praised, and significantly, their actions are described with a language of masculine virility from which the Queen is noticeably excluded. The last lines of the poem, however, return to complimenting the Queen since new Britannia (Guiana) entreats heaven, the world kneels to Guiana, and both supplicate themselves 'at her [Elizabeth's] blest feet, / In whom the circles of all Empire meete' (p. 451). Importantly, Elizabeth is not invoked by name here, so although a sense of royal veneration is created it is not as strong as if a direct reference had been made.

The whole tenor of Chapman's poem is, then, the celebration of 'heroic' and 'princely' male colonial endeavour which, although it needs to

be licensed by the Queen, clearly operates independently from her in the imagined future of settled English colonies in Guiana.[76] Chapman's poem – similar to Ralegh's concluding lines in *The Discoverie* – criticises the Queen even while it appears to praise her. Elizabeth has not done enough to encourage men like Ralegh in their colonial exploits. Elizabeth, and those courtiers and statesmen who have, because of 'squint-eyd Envies', failed to support Ralegh in his noble, patriotic and virtuous schemes, need to change their policies and support the Guianan enterprise since this is the only way to 'create a golden world in this our yron age' (p. 447).

What this analysis of Chapman's *De Guiana carmen Epicum* and Ralegh's conclusion to *The Discoverie* shows, then, is the way that English colonial texts were just as much a barometer of Elizabeth's prestige as more obviously political material. Like the ostensibly panegyric literature about Elizabeth written in the 1590s that Hackett describes in *Virgin Mother, Maiden Queen*, Chapman and Ralegh's representations of the Queen show a disillusionment with her lack of ambition with regard to colonial policies that is noticeably different to the more optimistic tone of comparable texts written earlier in the reign. But, more than this, the Queen's gender was fundamental to the ways both colonial territory and the relationship between subject and monarch were represented. Both Ralegh and Chapman attack the Queen's lack of support for the Guianan project. Ralegh implicitly threatens her position by attempting to render legitimate male desires for autonomy as he writes of the 'worthiness' of independent action. Chapman represents an ideal future for English colonisation in Guiana in which male potency becomes the key factor in subduing female gendered colonial terrain, activities from which the Queen is marginalised because of her gender. The changes between the 1580s and the late 1590s in the representations of feminised colonial land-scapes, female inhabitants within colonial territory, the actions of English male colonists, and direct references to the Queen all show, then, an increasing hostility towards the female monarch who is failing in her duty to facilitate and enable expansionist and heroic English male colonial endeavour. The gendered discourse of these colonial texts operates at an allegorical level to reveal the marginal nature of the Queen domestically just as much as it does in the project of empire. I now want to continue this analysis by turning to a two-part dramatic text, Thomas Heywood's *The Fair Maid of the West*, which further reveals the ways issues of gender, gender-appropriate behaviour and power were allegorically manipulated by contemporary colonial discourse.

Reflections of Elizabeth: Thomas Heywood's *The Fair Maid of the West, Parts I and II*

In the following pages I shall argue that Heywood's colonial drama *The Fair Maid of the West* offers different political opinions about female rule in Part I and Part II. In the first part of the drama, I read Heywood's character Bess – short, of course, for Elizabeth – as an allegory of Elizabeth I.[77] Jean Howard has argued that Bess 'owes much to representations of Elizabeth I', yet she posits that the character is '*not* simply a screen for Elizabeth'. Her epithet fair maid 'of the West', according to Howard, associates her with a 'particular region of the country, not with the court' suggesting 'a form of nationalism that defined itself in relationship to the land of England and its distinct regions ... as an alternative to the monarch-based ideologies of dynastic statehood'.[78] However, in what follows, I show the centrality of the allegory of both court and queenship to this text. The taverns Bess governs are repeatedly and explicitly represented in courtly terms, for instance, as she negotiates between rival suitors. Indeed, the problems Bess experiences – she is both desired by and threatening to the male characters in Heywood's text – are precisely identical to the oscillating and anxious representations of Elizabeth we have seen in Hakluyt and Ralegh's texts. In the second part of *The Fair Maid of the West*, Bess's character is considerably different from her earlier incarnation and, though still possessing some resonance with Elizabeth, Heywood's revised treatment reveals the historically contingent nature of perceptions about appropriate female 'queenly' behaviour. In the later text Bess abdicates all desire to rule, becoming a reflection of the type of more passive consort-queenship practised by Henrietta Maria.[79] In certain ways, particularly in relation to sexual virtue, both parts of Heywood's text can be read as celebrations of queenship. Yet in others, *The Fair Maid of the West* should be understood as revealing the problems atttendant upon female rule. In part I Bess is far more successful in adventurous and colonialist activities than her male subjects who appear inadequate and weak in comparison: a strong woman threatens to emasculate the men that serve her. In the continuation, through Bess's exclusion from chivalric, male understandings of honour, it is clear that her ability to undertake independent action is severely curtailed.

The exact dating of both parts of Heywood's drama is problematic. They were issued together when the play was first published, and were both entered in the Stationers' Register to Richard Royston on 16 June 1631.[80] Their publication followed a successful performance of both parts

before Charles I and Henrietta Maria, 'with approved liking' as the title
page proudly states, at Hampton Court by Queen Henrietta's Men in
either 1630 or 1631.[81] The play was also performed by the same company
that season at the Cockpit, which in this period was under Christopher
Beeston's management and was rapidly becoming a company and venue of
a prestige to rival the King's Company at Blackfriars.[82] However, though
the second part of *The Fair Maid of the West* is believed to have been
written fairly close to this performance before royalty, recent criticism
dates the composition of the first part 'before the death of Elizabeth'.[83]
Various references in Part I point to an Elizabethan date of composition,
including a discussion of Elizabeth in V. i. 87–102 in terms that indicate
that she is still alive, and a reference to the 'new-made fort' (Part I, I, ii, 170)
at Plymouth upon which construction was started in 1580, and was suffi-
ciently completed in 1596 to install a garrison. The composition of Part I of
The Fair Maid of the West most likely occurred in the last years of
Elizabeth's reign, probably between 1596 and 1603, with the second part
being written by 1630. The temporal gap in the composition of the two
parts is significant since changes in the representation of Bess reveal the
ways that powers of queenship were, after Elizabeth, revised, remodelled
and reduced. The woodcut illustration included on the title page of both
parts of *The Fair Maid of the West* is also decisive in locating the text
against a courtly, specifically Elizabethan context (Figure 4). It shows a
female figure dressed in costume appropriate to the 1590s, with a large ruff
and a close-fitting, stiff pointed bodice, which as R. A. Foakes observes,
suggests the support of a farthingale underneath. She also wears a chain
round her neck, a short cloak, and has hair or a wig elaborately orna-
mented.[84] The figure presumably represents Bess, and consequently her
rich courtly dress in the manner of Elizabeth herself signals the prime
importance of the analogy between Bess and the Queen.

 The Fair Maid of the West Part I follows the adventures of the virtuous
tavern maid Bess Bridges. At the beginning of the play we see Bess
besieged by male customers and suitors in the tavern, 'The Castle' in
Plymouth, where she works. The play is set on the eve of the Islands'
Voyage of the English fleet to the Azores under Essex, and the town 'swells
with gallants' (Part I, I, i, 11). A fight occurs between rivals for Bess's
attentions in which her favourite, Spencer, kills a man, Carrol, who has
been harassing her. Despite Spencer's scruples concerning Bess's lack of
breeding – she is the daughter of a Somersetshire hide seller – the lovers
become engaged and Spencer departs on Essex's mission whilst entrusting

Written by **T.H.**

LONDON,

4 Thomas Heywood, *Fair Maid of the West*, Part I, title page

Bess with his possessions, including his picture and a tavern, 'The Windmill' at Foy. In Spencer's absence Bess successfully runs 'The Windmill', proving herself to be financially and socially shrewd as, again, she is besieged by male sexual attention which she deftly handles. She cross-dresses for the first time in the drama in order to prove that the braggardly Roughman who is sexually bullying her is, in fact, a coward. News then arrives that Spencer has been killed at Fayal – though the audience knows he has actually survived. Spencer's compatriot Goodlack returns in order to test Bess's fidelity to his friend, and as he finds her constant, she inherits Spencer's fortune. Believing Spencer to be dead, Bess determines to rescue his body from the Spanish and fits out a ship for the purpose. After trouncing the Spanish at sea, she rescues Spencer from captivity (though the lovers are still not reunited since Bess thinks she has seen a ghost and Spencer fails to recognise her because she is cross-dressed). The final act finds Bess and her compatriots in the court of the Mullisheg, the King of Fez and, though he tries to court Bess, once Spencer and Bess recognise each other Mullisheg withdraws his attentions and the text ends with the lovers about to be married.

That Bess Bridges, the tavern maid turned avenging national heroine, is supposed to refer, on some levels, to Queen Elizabeth is explicitly indicated by the text. Part I, Act IV, scene iv, describes the defeat of Spanish naval forces by Bess and her men. At Bess's mercy and about to be put into their 'long boat' to row ashore, the Spanish commander and his fellows are commanded by Bess to 'pray for English Bess' (Part I, IV, iv, 120). The Spaniard replies 'I know not whom you mean, but be't your queen, / Famous Elizabeth, I shall report / She and her subjects both are merciful' (Part I, IV, iv, 121–123). The confusion concerning the identity of 'English Bess' is deliberate. As we have seen Bess appears cross-dressed, befitting the sea-fight in which she has been involved, with the result that even her lover Spencer – who has been held captive in the Spanish ship – does not immediately recognise her. The Spanish captain's misunder-standing over the identity of 'English Bess', then, is not unreasonable. However, there is little doubt that Bess alludes to herself since, in an earlier encounter with some captured Spanish, she commanded them, on their release, to 'Pray for Bess Bridges, and speak well 'o'th' English' (Part I, IV, iv, 59). Bess Bridges, as she aggressively but mercifully scuppers the Spanish fleet, acts in a manner reminiscent of accounts of Elizabeth's Tilbury performance. She is an extension of the militaristic Queen involved in a just war against a threatening and treacherous enemy.[85]

The parallels between Bess and the Queen continue to be explicitly drawn until the end of Part I. The Chorus between Act IV and Act V informs the audience of Bess's continued naval success: 'Much prize they have ta'en. / The French and Dutch she spares, only makes spoil / Of the rich Spaniard and the barbarous Turk, / And now her fame grows great in all these seas.' (Part I, IV, v, 6–9). Forced to land in order to reprovision the ship in Barbary and weary of wearing men's clothes, Bess is wooed by Mullisheg, the King of Fez. Mullisheg, on being told Bess's name is Elizabeth, describes the English Queen in terms remarkably similar to those that the Chorus has just used to describe Bess:

> There's virtue in that name.
> The virgin queen, so famous through the world,
> The mighty empress of the maiden isle,
> Whose predecessors have o'errun great France,
> Whose powerful hand doth still support the Dutch
> And keeps the potent King of Spain in awe, is not she titled so?'
> (Part I, V, i, 88–93)

Despite Bess's humble origins, her youth, and her desire to marry Spencer, Heywood's text clearly uses the virtuous and militaristic Bess as a reflection of England's Virgin Queen.

Elizabeth I's position as Queen was a singular one. As most monarchs were not women, Kate McLuskie's argument that it is Bess's relationship with Spencer which 'establish[es her] credentials as a woman' early on in the drama appears somewhat at odds with the celebration of Bess and her similarity with the unmarried Queen Elizabeth. McLuskie contends that it is Bess's ultimate intention to marry which, though it must be postponed for most of the action, allows her the social freedom to run her tavern and take part in so many adventurous, masculine exploits.[86] Such a reading would suggest that Bess is allowed freedom only temporarily since her future marriage would once more incorporate her within the confines of patriarchy. Any threat to patriarchy represented by her successful entry into male activities – sword-fighting and military aggression against Spain – is neutralised by her womanly desire to achieve an appropriate marriage.[87] The play's implied parallel between Bess and Elizabeth in the 1590s sits uncomfortably with this view. Should we see in Heywood's parallel a criticism of England's Queen who has failed to make such an appropriate marriage and whose unmarried state provokes a crisis in the behaviour of her male subjects, or should we read Bess's adventures as a celebration of all that a virgin can achieve?

In *The Fair Maid of the West* Part I, Bess Bridges is considerably more able than most of the male characters that surround her. Even Spencer – who impetuously kills Carroll, is wounded in Essex's service and is then held captive – appears somewhat helpless for most of the drama compared to the resourceful Bess. Certainly he is swiftly dispatched from the action in England in which Bess finds herself embroiled. Indeed, in the first three acts of the play Bess successfully manages the financial and social problems associated with running a tavern. Both 'The Castle' and 'The Windmill' microcosmically represent the larger worlds of the Court and England under the Queen's control. Despite some of the male characters' persistently hostile desire to label Bess as a whore, the text consistently articulates her virtue. Her management of her domain is such that the Mayor and Alderman of Foy extol her merits, commenting on the way in which she has succeeded in taming all criticism, become wealthy and attracted the best men in the country to her court:

> *Mayor*: Believe me, sir, she bears herself so well
> No man can justly blame her; and I wonder,
> Being a single woman as she is
> And living in a house of such resort,
> She is no more distasted.
> *Alderman*: The best gentlemen
> The court yields become her daily guests.
> Sure, sir, I think she's rich. (Part I, III, ii, 1–6)

Her excellence is such that she is capable of inspiring the men around her to improve themselves. Roughman, the coward and bully she bests while cross-dressed, is inspired to martial bravery through contact with her: 'She hath waken'd me / And kindled that dead fire of courage in me / Which all this while hath slept' (Part I, II, i, 132–134). Furthermore, her conduct is so impressive that the Mayor desires a marriage between Bess and his son; though Bess refuses, she does so with so much tact that the Mayor is still prepared to act as executor of her will. The terms of this will – which the Mayor admiringly comments 'want[s] a precedent', it 'so abound[s] in charity and goodness' (Part I, IV, ii, 45–46) – further make clear Bess's good government and signal her independence and control over her finances. Her will is designed to care for both the helplessly needy and those who require financial support to establish businesses that will strengthen the country's economy:

> To set up young beginners in their trade, a thousand pound.
> To relieve such as have had loss by sea, five hundred pound.

To every maid that's married out of Foy whose name's Elizabeth, ten pound.
To relieve maimed soldiers, by the year ten pound. (Part I, IV, ii, 31–37)

This legal document fosters the sort of policies that reveal both the financial acumen of the tavern owner, as she creates legacies to expand Foy's business prosperity, as well as charitable and sentimental concerns. Bess's largesse will thus help those who cannot help themselves – those maimed through service of their country – and she creates an inheritance for all those who share her own and the Queen's name.[88]

Bess, then, appears as the ideal female ruler in the world of the tavern, as she is able successfully to manipulate and manage the male characters that surround her and bend them to her will despite their own inclinations. Thus Roughman's transformation from cowardly bully to Bess's loyal henchman is testament to her powers of inspiration. Similarly, the Mayor's willingness to act as her legal representative even after she has refused to marry his son also acts as a celebration of Bess's exemplary government. Moreover, it is Bess's ship, *The Negro*, that defeats the Spanish when Spencer, under Essex's command, has fallen into enemy hands. It would seem, therefore, that Heywood's *Fair Maid of the West* is a celebration of female rule and, by implication, of Queen Elizabeth. However, the fact that Bess's abilities are rather better than those of the men in the play – allowing her to manipulate them, as a result making them appear stupid or weak or both – complicates the celebratory reading of the Queen's rule.

Bess's skills are so impressive throughout the play that there is always the potential that she might 'unman' the men before her. The threat becomes literal in Act V where Mullisheg offers to 'honor' Clem with 'geld[ing] to attend on us' as 'our chief eunuch' (Part I, V, ii, 92–93). But, prior to the explicit articulation of these anxieties about English male sexual potency, tensions have been building by accretion about the effects of a powerful woman on the men that both court and serve her. In *The Fair Maid of the West* Bess demonstrates far more prowess in the diverse roles of swordsman, politician, privateer, and diplomat than do any of the men in the play. For instance, Spencer is badly wounded in a sword fight at Fayal while attempting to defuse a quarrel between two Captains (Part I, II, ii, 18–101), whilst by contrast Bess subdues Roughman with ease in the very next scene (Part I, II, iii). The contrast between their fortunes at arms is striking, with Bess's success underlining Spencer's failure. Furthermore, whilst at sea in Act IV, Bess is considerably more accomplished at swashbuckling than either Spencer or Goodlack. Spencer has been humiliatingly incarcerated in a Spanish vessel. Goodlack, despite being in

charge of 'the manage of the fight' (Part I, IV, iv, 86) against the Spanish and trying to stow Bess away from the danger ('Fair Bess, keep you your cabin' (Part I, IV, iv, 90)), is so seriously injured in the fray that he can 'no longer man the deck' leaving Bess to lead the assault ('Advance your targets, And now cry all, "Board, board! Amain for England!"' (Part I, IV, iv, 104–105)). Bess here demonstrates a good deal more military prowess than Goodlack who, in a sexual pun, finds himself, according to Roughman, 'shot i'th'thigh' unable to 'rise to greet your victory' (Part I, IV, iv, 107–108). Bess's prowess appears to undermine the sexual integrity of her male subordinates. Not only is she powerfully eroticised but, simultaneously, she provokes a crisis in the sexual performance and identities of her male subjects. As Howard has usefully argued, the emphasis on Bess's sexuality, which seems to 'magically overcome ... the divisions and antagonisms internal to the body politic of England', also reveals her to be 'a figure of crisis' since she 'continually evokes men's fears of women's power and sexuality'.[89]

These fears are most graphically played out in Act V of Part I of *The Fair Maid of the West*, when Mullisheg's eroticised court (Part I, IV, iii, 27–34), functions as a mirror of Bess's alarming sexuality as 'the Moorish King ... actually *displays* the rapacious sexual appetites so feared in Bess'.[90] For instance, in response to Bess's beauty (she appears in female clothes again) the sexually predatory King becomes effeminised himself. In effect he functions as a mirror, or displaced version, of the gender and sexual anxieties previously solely focused on Bess. He is unable to turn down any of her demands: 'We can deny thee nothing, beauteous maid' (Part I, V, ii, 78) since he is so enthralled by her sexually explicit, wanton, behaviour ''Tis no immodest thing / You ask, nor shame for Bess to kiss a King' (Part I, V, i, 65–66). Furthermore, anxieties about the consequences of Bess's sexuality on the men around her also surface in Clem and Spencer's threatened castration (Part I, V, ii, 86–100), which is to be inflicted as a sign of Mullisheg's favour, and in the way that the Englishmen are scattered and peripheral to the action between Mullisheg and Bess. Mullisheg's 'cutting honor' (Part I, V, ii, 132) here functions as a displaced version of fears about Bess's wanton appetites as she flirts with the King. The threat to the Englishmen's masculinity is, in the end, averted, and they take charge in the last few lines of the play. Spencer, Goodlack, and Roughman finally manage to regroup and successfully persuade Mullisheg to embrace 'an heroic spirit' (Part I, V, ii, 118), and release them unharmed with Bess. Once the Englishmen take charge, Bess and Mullisheg's

influence immediately wanes, but the rapacious sexuality of both the Moorish King and the 'maid of England' who appears 'like a queen' (Part I, V, ii, 7) had, until the last fifty lines of the play, threatened the integrity of English masculinity. This text, then, in its representation of queen-like Bess's sexuality, reveals the problems and limits of Elizabeth's rule. In the character of Mullisheg we have articulated fears about the aggressive, castrating potential of queenship as it is capable of rendering Englishmen literally impotent. That the threat is finally overcome by the men, and Mullisheg and Bess are tamed, does not fully disperse the risk that both these monarchical 'female' characters represent to the integrity of English manhood.

For the rest of this chapter I want to focus on the sequel to *The Fair Maid of the West*, written long after the death of Elizabeth, in order to examine the ways in which the text's representations of colonial locations reveal how discourses of queenship were modified in the period between the first and second part. Part II of *The Fair Maid of the West* picks up the story at exactly the point where Part I ended. It is Spencer and Bess's wedding day. However, instead of being supportive of the English couple, Mullisheg now appears so jealous that he determines to deprive Spencer of the first night with his wife and enjoy her himself. Mullisheg's wife, Queen Tota, becomes infatuated with Spencer and also hatches an adulterous plan. They enlist Bess's followers in their schemes since, through a mixture of bribery and threat, the Queen forces Roughman and the King coerces Goodlack to arrange sexual access to their respective objects of desire. Though initially appearing to be unable to think of a way out of their difficulties, Roughman and Goodlack confer about the situation in which the English find themselves. After informing Spencer and Bess of the Moors' duplicity, the English plan a bed-trick to fool the King and Queen into sleeping together whilst thinking that they are in fact with Bess and Spencer. Whilst the King and Queen are enjoying their night of passion, Roughman, Goodlack and Bess escape to their ship, but Spencer is less fortunate. He is defeated in combat by one of the King's men, Joffer, and only manages to rejoin Bess – who will think him dead unless he meets her on board the ship by a certain time – by promising to return to Mullisheg's court. For the first time in *The Fair Maid of the West* Bess does not appear to advantage since, not understanding the honourable nature of Spencer's promise to Joffer, she violently chastises her husband. When Spencer returns to Mullisheg's palace the King finally understands the integrity of English behaviour and relents; harmony is finally restored

when Bess too returns and is reconciled with her husband. The English depart but are, once more, beset by disaster since they are shipwrecked and dispersed. Husband and wife are separated again. Spencer is washed up in the Marquis of Ferrara's country, where he becomes the Marquis's champion and fights Goodlack, who represents the Marquis of Mantua. Meanwhile, Bess and Roughman find themselves on the coast of Florence where, about to be raped by one of the 'banditties' of that region, Bess is rescued by the Duke of Florence who immediately falls in love with her, while Roughman disappears chasing the lascivious bandit. The Duke takes her to Florence and showers her with jewels and clothes in order to persuade her to become his mistress. Roughman, Goodlack and Spencer also make their way to Florence where they are reunited. However, despite a chance encounter in the street, neither Spencer nor Bess initially recognises the other, though Bess casually tosses Spencer one of the precious jewels that the Duke has given her. When Spencer and Roughman arrive at the Duke's court, the Duke notices the jewel and, seeing this as evidence of Bess's partiality, becomes jealous. He exacts a promise that Spencer will woo Bess on his behalf but will not endeavour to press his own suit. Hence, when confronted with each other, Spencer is forced to deny he has feeings for Bess with the result that she becomes incensed at such treatment. She accuses Spencer of stealing the jewel and by exacting a promise herself from the Duke to do with the thief as she pleases, she threatens to have him killed. Tragedy is averted only when Bess thinks better of her vengeful actions and all the misunderstandings between the couple are finally explained. The Duke and Spencer are reconciled and the last action of the play is to bring in the noble Moor Joffer (who has meanwhile been captured by the Italians) allowing the men to admit him into their honourable group.

There is a considerable difference in the overall tone as well as in the treatment and actions of Bess between the two parts of *The Fair Maid of the West*. As McLuskie observes, the focus of Part II is on 'women and their chastity' and 'sexual exchange', and, as she also notes, 'Bess has lost her active role, and is the subject of others' passions'.[91] But the shift is more significant than McLuskie allows. In Part I Bess was a 'girl worth gold' because she possessed many virtues including honour, bravery, skilful management and diplomacy as well as chastity. By contrast, in Part II Bess has lost all these qualities except chastity. These changes are revealed by her consistent helplessness through Part II as the male characters make decisions for her and rescue her from difficult situations. Bess is reduced

to a damsel-in-distress, passively awaiting rescue by, as Charles Crupi has argued, chivalric heroes.[92]

However, the shift in Heywood's conception of Bess is most strikingly revealed through her lack of understanding of and hostility towards ideas of chivalric male honour. At two points in Part II, Bess reveals herself as utterly unable to appreciate these male codes and standards of honour. Firstly, after fleeing Mullisheg's court, Spencer is only able to join her on *The Negro* because he has promised to return to Joffer in Fez once Bess is assured that he has not been killed in his escape attempt. When Spencer informs her that he intends to return and give himself up because of this commitment, Bess is at first incredulous:

> Prize you my love no better than to rate it
> Beneath the friendship of a barbarous Moor?
> Can you, to save him, leave me to my death?
> Is this the just reward of all my travels? (Part II, III, ii, 127–130)

Spencer attempts to explain that he cannot break his word to the Moor since such behaviour would be tantamount to allowing the Moors to appear to be superior to Christians: 'I prize my honour and a Christian's faith / Above what earth can yield' (Part II, III, ii, 131–132). He states that he would rather 'die a hundred thousand deaths' than allow Islam to appear nobler than Christianity (Part II, III, ii, 135–136). Such honourable, if partisan, reasoning does not convince Bess, as her next speech, which dwells on her personal satisfaction rather than national or religious pride, reveals: 'Was ever maid thus cross'd, that have of / Been brought to see my bless and never taste it? / To meet my Spencer living after death, / To join with him in marriage, not enjoy him?' (Part II, III, ii, 137–140). Indeed, when he refuses to take her with him, Bess sulkily abandons him:

> Then, false man, know
> That thou hast taught me harshness. I without thee
> Came to Mamorah, and to my country back
> I will return without thee. I am here
> In mine own vessel, mine own train about me.
> And since thou wilt forsake me to embrace
> The queen of Moors, though coining strange excuse,
> E'en at thy pleasure be it; my way's into
> My country. Farewell, I'll not shed one tear more.
> (Part II, III, ii, 149–157)

Bess and Spencer's respective understandings of the necessity of his return to Mullisheg's court are presented as utterly at odds in this scene.

For Spencer, failure to return would be a violation of his own sense of identity which is based on the innate superiority of Christian, English, chivalric and male honour. Bess has no such code of honour here and, indeed, fails to understand Spencer's reasons, even after they have been explained, preferring to see his return as inspired by adulterous desires for Tota, Fez's Queen. For Bess the honourable intentions Spencer outlines appear too ludicrous ('strange excuse') to be believed. Furthermore, it is her jealousy that at this point inspires her desire to behave as the independent woman ('I am here in mine own vessel, mine own train about me') that was so admirable in Part I. But the context in which she now articulates this desire for independence – based on irrational jealousy and a failure to understand male honour – makes clear that her pretensions are not to be applauded.

Though this misunderstanding between Spencer and Bess over conceptions of honour is overcome as Bess too returns to Mullisheg's court, the problems are not fully resolved and they resurface towards the end of the play. When Spencer denies his feelings for her because of his prior promise to the Duke of Florence, Bess again sees this as evidence of sexual betrayal. She faints with grief at Spencer's treatment of her and when she regains consciousness, she desires revenge. She sees Spencer's denial of her as evidence of his inconstancy ('Hath some new love possess'd him and excluded / Me from his bosom?' (Part II, V, ii, 75–76)) and determines to make him pay for his neglect:

> But I'll be so reveng'd
> As never woman was. I'll be a precedent
> To all wives hereafter how to pay home
> Their proud, neglectful husbands. 'Tis in my way;
> I've power and I'll do it. (Part II, V, ii, 78–82)

To this end, as we have seen, she allows her husband to think she is prepared to become the Duke of Florence's mistress as well as claiming that the jewel that she casually threw at Spencer earlier had been stolen and that the thief, when discovered, will pay with his life. Bess acts with great ceremony in this scene, entering in a regal manner and imperiously complaining that 'a company of base companions', that is Spencer, Goodlack, Clem and Roughman, trespass too close to her and 'trouble the presence' (Part II, V, iv, 45–47). Spencer's group comment on the change in her demeanour: 'This cannot be Bess but some fury hath stol'n her shape' (Part II, V, iv, 47) and 'This cannot be Bess Bridges, but some Medusa / Chang'd into her lively portraiture' (Part II, V, iv, 87–88). Bess's

resemblance to a tyrannical queen is explicitly drawn in the text by Clem who satirically comments on courtiers' fears concerning the waywardness of royal favour: 'Now if she should challenge me with the purse she gave me / and hang me up for my labour, I should curse the time that / ever I was a courtier' (Part II, V, iv, 97–99).[93] We have here, then, a mirror for princes(ses) as it is clear that queenly interference in male domains is not to be encouraged. As the Hampton Court Prologue makes clear, Henrietta Maria, shall 'be sovereign[s] ever' due to her 'beauty' rather than the characteristics of 'majesty' and skills of 'best govern[ment]' possessed by her royal husband (Prologue, 5–12). Consequently, Bess's gender-specific failures of chivalric behaviour can be seen as pointers for Henrietta Maria, designed to school her into the role of consort, rather than encouraging forms of 'queenly' behaviour where she might actively interfere in matters of state. As Kevin Sharpe has argued, after the difficult early years of the marriage, Charles and his wife were settling into a companionate and loving relationship by 1630, but earlier problems had been caused by the Queen's Catholicism, her jealousy over the influence of Buckingham, the war with France, and the Queen's 'headstrong' temperament.[94]

Though Bess relents at the moment at which she might exact revenge on Spencer and have him put to death, by acknowledging that he is her husband, her earlier behaviour remains unsettling. At other points of crisis in the play the audience has been aware, through prior knowledge, that everything will turn out well even though the characters were not in possession of such comforting information. For instance, the audience knows that Spencer is safe and will make his appointment with Bess on *The Negro* even though Bess does not. Similarly when Spencer fears that Bess is dead following the shipwreck off the Italian coast, the audience knows she has survived. But, like Spencer and his compatriots, the audience is kept in suspense at this point about whether Bess will fully enact her revenge. The swiftness of her retreat from avenging monarch to loving wife is also unsettling, since it is not based on the possession of any new information or knowledge. It merely appears that she has been toying with Spencer and wants to make him suffer. Indeed, her last remark in the play confirms the conceptual difficulties her behaviour represents as she states 'Had my Spencer / Been an Eurydice, I would have play'd / The Orpheus, and found him out in hell' (Part II, V, iv, 141–143). In this speech, by imagining herself as the male Orpheus and Spencer as the female Eurydice in need of rescue, Bess implicitly continues to challenge gender-appropriate roles and behaviour.

Though Bess appears to embrace once more the role of dutiful wife, the challenge to patriarchal control her despotic and tyrannical behaviour represented – as she appeared as a kind of avenging 'fury' or 'Medusa' to the male characters – remains embedded in her Orpheus and Eurydice simile. Implicit in her description is a privileging of herself as the active participant in the relationship, since she represents Spencer as the passive agent in need of rescue. In Part II of *The Fair Maid of the West* it is clear that the text attempts to rebut and neutralise queenly behaviour. The play opened with Queen Tota revealing herself to be both despotic and lascivious as she tried to force Clem and Roughman to enact her adulterous schemes. At this point in the play it seemed that Queen Tota was intended as a foil for the virtuous and honourable Bess of Part I, representing all that was antithetical to 'the girl worth gold'. However, through the course of Part II Bess is revealed to behave in similar ways to Queen Tota since, as we have seen, in times of crisis Bess also places her personal satisfaction above the honourable claims of nationality or religion. Indeed, Tota's speech at the beginning of Part II in which she meditates on how to be revenged for her husband's neglect of her in favour of Bess, is remarkably similar to Bess's later vengeful speeches:

> It must not, may not, shall not be endur'd.
> Left we for this our country? To be made
> A mere neglected lady here in Fez,
> A slave to others, but a scorn to all?
> Can womanish ambition, heat of blood,
> Or height of birth brook this and not revenge?' (Part II, I, i, 1–6)

Tota's unhappiness with her royal marriage for which she left her own country can be seen to chime with Henrietta Maria's situation. Both royal brides have been married for dynastic considerations, and have left their home country to take up consort positions in the kingdom of their husband. Just as Tota is jealous of Bess, so too was Henrietta Maria of the influence Buckingham exerted over her husband. The contrast between the letter the King wrote to Buckingham when separated from him in July 1627 ('No man ever longed so much for anything as I do to hear some good news of you') and the 'dry, ceremonious' letter he received from his wife in February 1628 which he 'answered accordingly' clearly reveals the different tenor of the relationships.[95]

The end of the play – where the men align themselves together as an honourable elite and reject Bess – is consequently crucial for reading this play's attitude to queenship. When Joffer appears, having also been

coincidentally captured by the Italians, Spencer immediately abandons Bess to go to him: 'Bashaw Joffer? – Leave my embraces, Bess, / For I of force am cast into his arms, – / My noble friend!' (Part II, V, iv, 155–157). Ferrara, Spencer and Joffer recognise in each other virtuous, masculine honour of a kind that marginalises Bess. Ferrara's concluding speech – though it celebrates Bess as 'the mirror of your sex and nation, Fair English Elizabeth' – ends with Bess rendered as a possession since she is now 'a chaste wife' (Part II, V, iv, 190–200). Bess has effectively been silenced through language that objectifies her by constructing her in terms of her relationship with Spencer. The focus of interest, then, in these last speeches is firmly on the honourable male elite as Spencer is prepared to embrace Joffer in preference to Bess.

Part II of *The Fair Maid of the West* is considerably more limited in its conceptions of the parameters of queenship than Part I. In the earlier drama, written under Elizabeth, the military and financial competence of Bess was celebrated, even though it is clear that Bess's success threatened to undermine the masculinity of her followers. In Part II, by contrast, Bess is represented as potentially fickle, tyrannical and misguided in contrast to the male characters, whose code of honour she is unable to understand. It becomes clear through the course of Part II that Bess must learn to be guided by her husband (as Henrietta Maria had done). When her last lines imperfectly correspond to patriarchal conceptions of appropriate female behaviour – since she imagines herself still in the active, dominant role – then Spencer punishes her through aligning himself principally with the other male characters on stage. Bess's judgement in Part II is consistently undermined by the text as she is shown to need schooling and guidance by the male characters. Independent action on the part of females is, it is clear, not to be tolerated because, as Tota and Bess both reveal, it is invariably personally motivated and potentially disastrous. What Part II reveals, then, is a patriarchal fantasy concerning the reduction of female power as national and religious values are successfully promulgated solely by men. Thus the Moor Joffer is converted to Christianity because he is so impressed by Spencer and the Duke of Ferrara, and loads the English down with gold because he recognises the value of the Englishmen's chivalric honour. Bess, though gratulated as a motivating factor for this gift, has, in fact, had little to do with it since she has, noticeably, not been able to embrace these male standards of honour.

In the course of this chapter we have seen the conceptual difficulties queenship caused male writers and courtiers, and the ways in which

representations of women in power in colonial texts were shaped by the precise historical moment of production. The thirty-year gap between the two parts of *The Fair Maid of the West*, and the divergent depictions of queenship and masculine responses to Bess, alert us to the historical sensitivity of the ways colonial allegories could be deployed by writers of this time and the ways these sensitivities shape allegorical representations of foreign adventure. In what follows, I will examine in a selection of voyage dramas – written over a fifty-year period and set in very different locations amongst a wide variety of indigenous inhabitants – the political ramifications of the colonial allegories embedded in these texts, and the polyvalent ways in which colonial writing was made to do domestic work.

Notes

1 Act of Appeals of 1533 (24 Henry VIII c.12) in Alan G. R. Smith, *The Emergence of a Nation-State: The Commonwealth of England, 1529–1660* (London: Longman, 1984), p. 388.

2 Benedict Anderson, *Imagined Communities: Reflections on the Origin and Spread of Nationalism* (London: Verso, 1983), pp. 12–19. According to Anderson, 'nation-ness is the most universally legitimate value in the political life of our time'. It involves a cultural process of thinking and feeling in terms of a nation, or 'an imagined political community' which is both 'limited and sovereign'.

3 See J. H. Parry, *The Age of Reconnaissance: Discovery, Exploration and Settlement, 1450–1650* (London: Weidenfield and Nicolson, 1973); Boies Penrose, *Travel and Discovery in the Renaissance, 1420–1620* (Cambridge MA: Harvard University Press, 1952); Frank Lestringant, *Mapping the Renaissance World: The Geographical Imagination in the Age of Discovery* (Berkeley: University of California Press, 1994).

4 See K. R. Andrews *et al.*, eds, *The Westward Enterprise: English Activities in Ireland, the Atlantic and America, 1480–1650* (Liverpool: Liverpool University Press, 1979); David Beers Quinn and A. N. Ryan, *England's Sea Empire, 1550–1642* (Boston: Allen & Unwin, 1985).

5 See Jeffrey Knapp, *An Empire Nowhere: England, America and Literature from Utopia to the Tempest* (Berkeley: University of California Press, 1992). See also Richard Helgerson, *Forms of Nationhood: The Elizabethan Writing of England: The Elizabethan Writing of England* (Chicago: University of Chicago Press, 1992), pp. 149–192; Bruce McLeod, *The Geography of Empire in English Literature* (Cambridge: Cambridge University Press, 1999), pp. 11–31.

6 Hakluyt, 'Epistle Dedicatory in the first edition, 1589', in Richard Hakluyt, *Voyages and Discoveries*, Jack Beeching, ed. (London: Penguin, 1972), p. 31.

7 Francis Bacon, *Works of Francis Bacon*, J. Spedding *et al.*, eds, 14 vols (London: Longman, Green and Co, 1857–74), VII, pp. 1–36 (p. 21).

8 Thomas Scanlan, *Colonial Writing and the New World, 1583–1671* (Cambridge: Cambridge University Press, 1999), pp. 19–29.

9 Much recent scholarship has been devoted to English writers' various and complex articulations of the desire for empire. See, for instance, Mary Fuller, *Voyages in Print: English Travel to America, 1576–1624* (Cambridge: Cambridge University Press, 1995); Gesa Mackenthum, *Metaphors of Dispossession: American Beginnings and the Translation of Empire 1492–1637* (Norman and London: University of Oklahoma Press, 1997); Andrew Hadfield, *Literature, Travel, and Colonial Writing in the English Renaissance 1545–1625* (Oxford: Clarendon, 1998); Joan Pong Linton, *The Romance of the New World: Gender and the Literary Formations of English Colonialism* (Cambridge, Cambridge University Press, 1998); Rebecca Ann Bach, *Colonial Transformations: The Cultural Production of the Atlantic World, 1580–1640* (New York and Basingstoke: Palgrave, 2000).

10 See, for instance, Helgerson, *Forms of Nationhood*, pp. 11–18; Knapp, *An Empire Nowhere*, pp. 18–61; Claire McEachern, *The Poetics of English Nationhood, 1590–1612* (Cambridge: Cambridge University Press, 1996), pp. 11–33; Nicholas Canny, ed., *The Origins of Empire: British Overseas Enterprise to the Close of the Seventeenth Century* (Oxford: Oxford University Press, 1998); David Armitage, *The Ideological Origins of the British Empire* (Cambridge: Cambridge University Press, 2000).

11 On this issue see Scanlan, *Colonial Writing and the New World*, pp. 1–7.

12 A. N. McLaren, *Political Culture in the Reign of Elizabeth I: Queen and Commonwealth, 1558–1585* (Cambridge: Cambridge University Press, 1999). See also, Helen Hackett, *Virgin Mother, Maiden Queen: Elizabeth I and the Cult of the Virgin Mary*, (London: Macmillan, 1995); Phillipa Berry, *Of Chastity and Power: Elizabethan Literature and the Unmarried Queen* (London: Routledge, 1989).

13 McLaren, *Political Culture in the Reign of Elizabeth I*, pp. 13–14. See also J. H. Burns, *Lordship, Kingship and Empire: The Idea of Monarchy 1400–1525* (Oxford: Oxford University Press, 1992), pp. 13–14, 97–100.

14 See Patrick Collinson, 'The Monarchical Republic of Queen Elizabeth I', *Bulletin of the John Rylands University Library of Manchester*, 69 (1986–87), 394–424.

15 McLaren, *Political Culture in the Reign of Elizabeth I*, pp. 3–4.

16 McLaren, *Political Culture in the Reign of Elizabeth I*, pp. 15–22. See also G. R. Elton, *The Tudor Constitution: Documents and Commentary*, (Cambridge: Cambridge University Press, 1982), pp. 338–345.

17 Knapp writes: 'the paradoxical literary ebulliance of Elizabethan England derived in the same way not merely from a suppressed recognition of the inconsequence of country and queen, but also, and more definitively, from an embrace of that inconsequence', *An Empire Nowhere*, p. 64.

18 Knapp, *An Empire Nowhere*, p. 4.

19 Scanlan, *Colonial Writing and the New World*, p. 3. On Allegory, see Angus Fletcher, *Allegory: The Theory of a Symbolic Mode* (Ithaca: Cornell University

Press, 1964), and Maureen Quilligan, *The Language of Allegory: Defining the Genre* (Ithaca: Cornell University Press, 1992).

20 Scanlan, *Colonial Writing and the New World*, p. 8

21 Richard Hakluyt, *The Original Writings and Correspondence of the Two Richard Hakluyts*, E. G. R. Taylor, ed., 2 vols (London: Hakluyt Society, 1935), II, pp. 367–368.

22 Louis Montrose, 'The Work of Gender in the Discourse of Discovery', *Representations*, 33 (1991), 1–41 (13).

23 Montrose, 'The Work of Gender', pp. 12–13. On the naming of Virginia after the Queen's 'hardest-held attribute' see *Virginia Voyages from Hakluyt*, D. B. Quinn and A. M. Quinn, eds (London: Oxford University Press, 1973), p. xi.

24 Walter Ralegh, *The Discoverie of the Large, Rich, Bewtiful Empyre of Guiana*, Neil L. Whitehead, ed. (Manchester: Manchester University Press, 1997), pp. 127, 196; all subsequent references will be to this edition. See Montrose, 'The Work of Gender', pp. 30–31.

25 Fuller, *Voyages in Print*, pp. 73–79.

26 Hakluyt, 'Preface to the English translation of Laudonnière. Epistle Dedicatory to Sir Walter Ralegh by Richard Hakluyt, 1587', *The Original Writings*, II, pp. 374–375.

27 See Anna R. Beer, *Sir Walter Ralegh and his Readers in the Seventeenth Century* (London and New York: Macmillan and St. Martin's Presses, 1997), pp. 9–10, 35–36.

28 See, for example Laurence Keymis's 1596 description of the way Guiana's 'shires of fruitful rich grounds, lying now waste for want of people, do prostitute themselves unto us, like a faire and beautifull woman, in the pride and floure of desired yeeres'. Laurence Keymis, *A Relation of the Second Voyage to Guiana: Performed and written in the yeere 1596* in Richard Hakluyt, *Principal Navigations*, 12 vols (London: J.M. Dent and Sons, 1927–28), X, p. 487.

29 Montrose, 'The Work of Gender', p. 31.

30 Hakluyt, *The Original Writings*, II, p. 349.

31 'The king has in him two Bodies, viz. A Body natural, and a Body politic. His Body natural (if it be considered in itself) is a Body mortal, subject to all Infirmities that come by Nature or Accident, to the Imbecillity of Infancy or old Age, and to the like Defects that happen to the natural Bodies of other People. But his Body politic is a body that cannot be seen or handled, consisting of Policy and Government, and constituted for the Direction of the People, and the Management of the publick-weal and this Body is utterly void of Infancy, and old Age, and other natural Defects and Imbecilities which the Body natural is subject to.' Edmund Plowden, *The Commentaries and Reports of Edmund Plowden, originally written in French, and now faithfully translated into English* (London, 1779); as quoted in Hackett, *Virgin Mother, Maiden Queen*, p. 22. See also Ernst H. Kantorowitz, *The King's Two Bodies: A Study in Mediaeval Political Theology* (Princeton: Priceton University Press, 1957); and see Berry, *Of Chastity and Power*.

32 See Catherine Belsey and Andrew Belsey, 'Icons of Divinity: Portraits of Elizabeth I', in Lucy Gent and Nigel Llewellyn, eds, *Renaissance Bodies: The Human Figure in Renaissance Culture c.1540–1660* (London: Reaktion, 1990), pp. 11–35.

33 Ralegh, *The Discoverie*, pp. 167–168.

34 Ralegh, *The Discoverie*, p. 168.

35 Ralegh, *The Discoverie*, p. 168.

36 Ralegh, *The Discoverie*, p. 168.

37 See Simon Shepherd, *Amazons and Warrior Women: Varieties of Feminism in Seventeenth-Century Drama* (Brighton: Harvester, 1981), pp. 9, 69.

38 Neil Whitehead, in his recent edition of Ralegh's *The Discoverie*, lists this passage as one of the references to Elizabeth I.

39 See, for example, Stephen J. Greenblatt, *Sir Walter Ralegh: The Renaissance Man and His Roles* (New Haven and London: Yale University Press, 1973), pp. 57–98. See also Hackett, *Virgin Mother, Maiden Queen*, pp. 155–197.

40 See Susan Doran, *Monarchy and Matrimony: The Courtships of Elizabeth I* (London and New York: Routledge, 1996), pp. 11–13; see also McLaren, *Political Culture in the Reign of Elizabeth I*, pp. 12–45.

41 Quoted by Doran, *Monarchy and Matrimony*, p. 10.

42 On the management of appetite and its relationship to effective masculinity in this period see Anthony Fletcher, 'Manhood, the Male Body, Courtship and the Household in Early Modern England', *History*, 84 (1999), 419–436.

43 Ralegh, *The Discoverie*, p. 165.

44 Ralegh, *The Discoverie*, p. 172

45 Indeed, the dedication to Cecil can be seen as significant since Elizabeth's chief minister was instrumental in reshaping the role of male councillors in this period and, as Anne McLaren argues, his emphasis on men as 'citizens' only in the context of female rule. Hence the ambivalences in Ralegh's text might be seen as designed to appeal to him. For further details see McLaren, *Political Culture in the Reign of Elizabeth I*, p. 8.

46 For a history of this conflict see R. B. Wernham, *After the Armada: Elizabethan England and the Struggle for Western Europe 1588–1595* (Oxford: Clarendon Press, 1984); see also M. J. Rodríguez-Salgado, *Armada 1588–1988: An International Exhibition to Commemorate the Spanish Armada* (London: Penguin and National Maritime Museum, 1988), pp. 12–39.

47 Archivo General de Simancas, E.590 f.126. Cited in Rodríguez-Salgado, *Armada*, p. 19.

48 The *Map of the beacon system in Kent* dated August 1585, for example, which was also included in William Lambarde's *Perambulation of Kent*, shows the lines of sight for passing information from the alerting beacon at Fairlight in Sussex through Kent and into London. *Map of the beacon system in Kent*, 1585, British Library, London (Add. MS 62935); reprinted in Rodríguez-Salgado, *Armada*, p. 148.

49 'A proper new ballade wherin is plaine to be seene how god blesseth englande for love of our Queene: Soungs to the tune of tarletons caroll', Bod. MS Rawl. Poet. 185, ff.13r–14r.

50 Thomas Heywood, *The Exemplary Lives and Memorable Acts of Nine of the Most Worthy Women of the World* (London: Tho. Cotes, 1640), p. 211.

51 Thomas Heywood, *If You Know Not Me You Know Nobody*, 2 vols, Madeleine Doran, ed. (Oxford: Malone Society, 1934–35), II, Kv. Heywood's text was itself a feminised response to Samuel Rowley's *When You See Me, You Know Me* (London: N. Butter, 1605). For a fuller discussion see Claire Jowitt, 'Imperial Dreams? Margaret Cavendish and the Cult of Elizabeth', *Women's Writing*, 4 (1997) 383–399; see also Anne Barton, 'Harking Back to Elizabeth: Ben Jonson and Caroline Nostalgia', *English Literary History*, 48 (1981) 706–731.

52 See Roy Strong, *The Cult of Elizabeth: Elizabethan Portraiture and Pageantry* (London: Thames and Hudson, 1977), pp. 43–46.

53 For further details see Rodríguez-Salgado, *Armada*, p. 282.

54 At Tilbury again Elizabeth is supposed to have said 'I know I have the body but of a weak and feeble woman; but I have the heart and stomach of a King, and of a King of England too'. Cited by Shepherd, *Amazons and Warrior Women*, p. 29.

55 For further details see Wernham, *After the Armada*, pp. 4–15.

56 See in particular John Guy, ed., *The Reign of Elizabeth I: Court and Culture in the Last Decade* (Cambridge: Cambridge University Press, 1995), p. 4.

57 Guy, *The Reign of Elizabeth I*, p. 4.

58 Paul E. J. Hammer, 'Patronage at Court, faction and the earl of Essex', in Guy, *The Reign of Elizabeth I*, pp. 65–86.

59 These rivalries came to a head in the execution and aftermath of the Cadiz expedition of 1596, but was then temporarily assuaged during their combined plans for the Azores expedition the following year. See Hammer, 'Patronage at Court', p. 83.

60 Hammer, 'Patronage at Court', pp. 83–84.

61 See Catherine Bates, *The Rhetoric of Courtship in Elizabethan Language and Literature* (Cambridge: Cambridge University Press, 1992), pp. 45–88. In contrast, others have argued for other, less playful, reasons for Elizabeth's single state. On whether Elizabeth *chose* to remain unmarried, see Doran, *Monarchy and Matrimony*, pp. 210–218.

62 Guy, *The Reign of Elizabeth I*, p. 3.

63 Hackett, *Virgin Mother, Maiden Queen*, pp. 163–197 (p. 163).

64 'Ralegh's poem builds up an intense atmosphere of bitterness and frustrated desire, expressed in cryptic, disjointed language. This finally breaks down into outright self-contradiction and incoherence: "She is gonn, Shee is lost, shee is found, shee is ever faire!" (l. 493). Elizabeth is lost to Ralegh; yet her image, her allure, endures. This phantasmagoric poem opens up fractures between the Queen's divinity and humanity: she is a changeless, idealised dream-like vision, but she is also a changeable, blameworthy woman'. For further details see Hackett, *Virgin Mother, Maiden Queen*, pp. 184–186.

65 Cited by Barton, 'Harking Back to Elizabeth', 714.

66 Quoted by Guy, *The Reign of Elizabeth I*, p. 3

67 On the queen's ability to bear children see Doran, *Monarchy and Matrimony*, pp. 158–159.

68 Hakluyt, *Discourse of Western Planting*, in *The Original Writings and Correspondence*, II, p. 289.

69 Ralegh, *The Discoverie*, p. 199.

70 For a fuller description of the Amazon women in this text see Ralegh, *The Discoverie*, p. 146. For a discussion of the ways images of Amazons and Elizabeth were yoked together in the period see Winifried Schleiner, '"Divina Virago": Queen Elizabeth as an Amazon', *Studies in Philology* 75 (1978), 163–180.

71 See Hackett, *Virgin Mother, Maiden Queen*, pp. 235–241.

72 See Knapp, *An Empire Nowhere*, pp. 66–70.

73 Ralegh, *The Discoverie*, p. 192.

74 George Chapman, *De Guiana carmen Epicum*, in Richard Hakluyt, *Principal Navigations*, X, pp. 446–451. All quotations are taken from this edition and subsequent page references will be given parenthetically. For alternative discussions of this text see Fuller, *Voyages in Print*, pp. 75–78; Peter Hulme, *Colonial Encounters: Europe and the Native Caribbean* (London and New York: Routledge, 1986), p. 159.

75 See Fuller, *Voyages in Print*, pp. 75, 78; Walter S. H. Lim, *The Arts of Empire: The Poetics of Colonialism from Ralegh to Milton* (London and Newark: Associated University Presses and University of Delaware Press, 1998), pp. 59–63.

76 Indeed, Fuller's contention that the male bodies of Ralegh and his men are excluded from *De Guiana carmen Epicum* is misguided given the way the latter half of the poem in particular dwells so extensively on male potency.

77 On this issue see Jean E. Howard's excellent, 'An English Lass Amid the Moors: Gender, Race, Sexuality, and National Identity in Heywood's *The Fair Maid of the West*', in Margo Hendricks and Patricia Parker, eds., *Women, 'Race' and Writing in the Early Modern Period* (London and New York: Routledge, 1994), pp. 101–117 (pp. 107–109).

78 Howard, 'An English Lass Among the Moors', p. 107.

79 A similar point concerning the changes to Bess's character is made by Charles Crupi, 'Subduing Bess Bridges: Ideological Shift in the Two Parts of *The Fair Maid of the West*', *Cahiers Elisabethains*, 54 (1998), 75–87.

80 See Robert K. Turner, 'Introduction', in Heywood, *The Fair Maid of the West* (London: Edward Arnold, 1968), pp. ix–xx, p. xviii. See also Gerald Bentley, *The Jacobean and Caroline Stage*, 4 vols (Oxford: Clarendon, 1956), pp. 568–571. All subsequent references to Heywood's text will be to Turner's edition and will be given in the text.

81 Turner, 'Introduction', p. xix; see also Andrew Gurr, *The Shakespearean Stage, 1574–1642* (Cambridge: Cambridge University Press, 1980), p. 222.

82 See Andrew Gurr, *The Shakespearian Playing Companies* (Oxford: Clarendon Press, 1996), pp. 416–436.

83 For details of this debate see Turner, 'Introduction', xii–xiii. For arguments in favour of a later composition for part I, see Arthur Melville Clarke, *Thomas Heywood: Playwright and Miscellanist* (Oxford: Blackwell, 1931), pp. 110–112.

84 R. A. Foakes, *Illustrations of the English Stage, 1580–1642* (London: Scolar, 1985), pp. 130–131.

85 For a similar reading see Shepherd, *Amazons and Warrior Women*, pp. 105–106.

86 Kathleen E. McLuskie, *Dekker and Heywood: Professional Dramatists* (New York: St Martin's Press, 1994), pp. 138–144 (p. 138).

87 On Bess's appropriation of male activities see Roxana Stuart, 'Dueling on Travestie: Cross-dressed Swordfighters in Three Jacobean Comedies', *Theatre Studies*, 38 (1993), 29–43, especially 34–36.

88 For an alternate, mercantile reading of these transactions see Howard, 'An English Lass Among the Moors', pp. 108–109.

89 Howard, 'An English Lass Among the Moors', p. 109.

90 Howard, 'An English Lass Among the Moors', pp. 115–117.

91 McLuskie, *Dekker and Heywood*, pp. 140–141; see also Turner, 'Introduction', pp. xvii–xviii.

92 Crupi argues for the similarities between Heywood's text and the ideologies expressed by Rubens's 1630 painting of Charles and Henrietta Maria as St George and a princess in need of rescue, 'Charles and Henrietta Maria in a Landscape' or 'St George in a Landscape'. See 'Subduing Bess Bridges', pp. 81–84. See Per Bjurström, 'Rubens' St. George and the Dragon', *Art Quarterly*, 18 (1955), 27–42.

93 See also Clem's speech Part II, V, iii, 64–65.

94 Kevin Sharpe, *The Personal Rule of Charles I* (New Haven and London: Yale University Press, 1992), pp. 168–173.

95 See Sharpe, *The Personal Rule of Charles I*, pp. 46–48.

Rebel or hero? Treason, masculinity and the Queen in late sixteenth-century drama

In Chapter 1, we have seen Heywood's *Fair Maid of the West*, Part I, celebrate female piracy when Bess – in her role as stand-in for Elizabeth I – took to the oceans in *the Negro* and trounced the Spanish. Bess, as a figure for England's Queen, was able to attack the Spanish successfully in ways that the Queen's male subjects were not consistently represented as achieving in contemporary travel drama. I suggested in the last chapter that Bess's piracy in *The Fair Maid*, Part I, should be read as part of a debate about the merits of the epic potency of England's Queen as well as exploring the consequences of such a powerful female figure for the masculinity of her male subjects. We are asked to consider whether Bess's transgressive behaviour is a cause or an effect of the effeminised attitudes and compromised masculinity of 'Goodlack', Clem and the other male characters in the text. We have seen too the ways in which Heywood revisited and modified these debates concerning gender-appropriate behaviour in his continuation thirty years later of Bess and Spencer's story in Part II of *The Fair Maid of the West*.

In this chapter, I want to explore in more detail the ways anti-establishment patterns of behaviour (such as piracy and other forms of rebellion) are used in early modern dramatic texts about empire. My focus shifts from a concentration on the coded representations of Elizabeth herself in voyage drama, to a focus on some of the ways a female monarch affected and influenced the gender identity and performance of the men engaged in empire building. Of course, ideals of masculine and feminine behaviour were contested, debated and often contradictory in this period.[1] Bruce R. Smith, for instance, in a study of Shakespeare's attitudes to masculinity, has shown the ways in which different models of masculinity

competed and overlapped with each other.[2] But, Smith argues, some ideals were more popular than others: the 'chivalric knight' and the 'merchant prince' models, for instance, were used more frequently than the 'saucy Jack' or 'Herculean hero' types. Furthermore, Shakespeare's plays (including even his earliest play, *The Comedy of Errors*) are often concerned with the fusion of courtly values (chivalric knight) with commercial ones (merchant prince). Smith's analysis of these categories of early modern masculine ideals, and his identification of certain models as particularly apposite, can usefully be applied to voyage drama. The masculine identity of the men engaged in the project of empire building is one of the key concerns of many travel texts. Captain John Smith, in his accounts of life in the Jamestown Colony, is persistently determined to represent himself as a better man than his companions. And he measures his superior masculinity by his heightened ability to endure privations and survive the hostilities of an unfamiliar landscape.[3] Smith represents himself as a conflation of the 'Herculean hero', who, with superhuman strength, is able to battle his way up unknown rivers, and the 'merchant prince', who is better equipped to find and manage resources – specifically food – than his starving companions ('yet what he carefully provided the rest carelessly spent').[4] Likewise Ralegh, in *The Discoverie of the Large, Rich and Bewtiful Empyre of Guiana*, constructed himself in the mould of the chivalric hero: like Timias' struggle to remain faithful to Belphoebe in Spenser's *Faerie Queene* Book IV, Ralegh has to labour to resist the sexual lure of other females (native women) and 'Guiana' herself in order to remain true to his Queen.[5] His continence in the face of temptation becomes a mark of his successful masculinity.[6]

However, these contemporary ideals of masculine behaviour also had their negative counterparts; there were *others*, or binary opposites (such as women, sodomites, social inferiors, or foreigners), that helped to define masculinity. And, as Jonathan Dollimore has argued, binary oppositions are inherently unstable. There is a 'perverse dynamic' in them that means the boundary between supposed opposites keeps threatening to, and sometimes does in fact, collapse: there is 'a fearful inteconnectedness whereby the antithetical inheres within, and is partly produced by, what it opposes'.[7] T. Cockson's broadside image, *The Right Honourable Robert Devereux, Earl of Essex* (1595–1598) is just such a case in point (see Figure 5), since the picture's celebration of the Earl's chivalric prowess can, simultaneously, be seen to possess a darker, 'perverse' side.[8] The Earl is shown on horseback against a background of scenes celebrating his martial

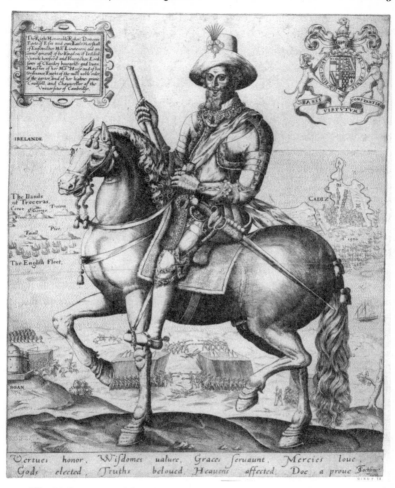

5 *The Right Honorable Robert Devereux, Earl of Essex*, T. Cockson

triumphs: Cadiz, Rouen, Ireland and the Treceras Islands. The caption at
the bottom of the picture describes Essex as in possession of every
chivalric attribute, 'Virtue's honour, Wisdom's valour, Grace's servant,
Mercy's love, God's elected, Truth's beloved, Heaven's affected'. Yet,
there is a sense in which this picture is self-conscious about its own status
as representation: details in the image emphasise that verisimilitude is not
what is important here; instead we see an ideal type of chivalric hero.
Essex's clothes are ceremonial rather than serviceable; the battle in the

middle distance is being fought with lances, not guns; and, perhaps most importantly, the image represents not one battle, but the culmination of Essex's achievements over several years. As Bruce Smith comments, 'the image hovers somewhere in between romantic fiction and empirical possibility'.[9] In this uncertainty, then, there is a sense in which such a lionising image might become available for less positive readings: the chivalric hero might become the devious rebel. The very qualities that make Essex ideal and which are explicitly celebrated in the broadside, might also make him dangerous to the Elizabethan state, and to Elizabeth herself. Certainly after Essex's rebellion against the Queen in 1601, his abundance of chivalric qualities, which make him just as much a natural leader of a coup d'état as they qualify him to rule a country, might be seen to be less desirable. Within this earlier celebratory representation of the chivalric Essex, there is a 'perverse dynamic' which hints – no more than that – that these qualities might not always be so serviceable to the state.

My view of male unruliness and treason, and rebellion more generally, in the drama of empire, is coloured in what follows by Dollimore's analysis of the 'perverse dynamic' in which oppositional, seemingly antithetical, positions promiscuously mingle. In this chapter, I will be exploring the status that the male anti-establishment activities of piracy and rebellion are accorded in voyage dramas, in order to assess whether they are wholeheartedly condemned. Should the examples of masculine potency in these texts be seen as seductively potent or dangerously threatening, or perhaps both simultaneously? My discussion of the complexities inherent in representations of masculine unruliness in the theatre of empire is divided into two parts. In this chapter, I focus on the political implications of the representations of these 'adventurous', difficult to control, male subjects in dramas written while Elizabeth was England's monarch; in Chapter 4, I return to similar themes, but focus on dramas written under the Stuart kings. In both chapters, I will argue that the complexities and ambivalences in the representations of male characters need to be read politically: that is, such factors as the men's motives for their riotousness, the precise qualities of their behaviour, and the sympathy their situation might generate, all affect whether the audience sees their unruliness and general dissatisfaction with the English government as justified. Male unruliness in dramas of empire, then, operates as a yardstick with which to measure the perceived success or failure of English rulers. And, as we shall see, the gender and perceived sexuality of the monarch in question determine the precise nature of a character's unruliness and the extent to which such

patterns of behaviour are condemned. In other words, the gender of the authority figure behind the scenes in specific English colonial dramas (and in whose name a nation's empire building is undertaken), affects the type, the form and the characteristics of the anti-establishment behaviour a particular character demonstrates.

In this chapter, I will be looking at representations of the figure of Captain Thomas Stukley (variously spelled in contemporary sources as Stuckley, Stukeley, Stucley, Stewtley, etc.) since commentators' varying, often contradictory, descriptions of this troublesome adventurer, pirate and rebel offer access to larger ideas concerning the ways men were expected to behave in the period. Though Stukley was a privateer in the service of Elizabeth, it is not this aspect of his biography that is singled out directly in the texts discussed here. However, the rampant individualism associated with pirates and privateers in this period is precisely what, as we shall see, motivates Stukley in the two dramas to be discussed. Hence what these texts ask their audiences to consider are the limits of individualism; at what point does individual self-identity become threatening to national identity? Who is responsible for transgressive individualism: the individual con-cerned or the state that failed to satisfy his needs? I shall also be exploring the extent to which the gender of the monarch was significant in the formation and representation of the individualism of her or his subjects.

Both the Stukley texts focused on here, Peele's *The Battle of Alcazar* and the anonymous *The Famous Historye of the life and death of Captaine Thomas Stukeley*, were written in the years following the Armada crisis, perhaps the most significant event in the formulation of English national identity in this period. Peele's play is thought to have been composed in 1588/89 and the anonymous Stukley play in 1596, though *The Famous Historye* seems not have attracted large audiences during the 1596–97 season and was not published until 1605.[10] Both plays pay scant attention to the known details of the biography of Stukley's life, yet in their differing representations of this dashing but traitorous figure we can see a debate about appropriate early modern male behaviour specifically with regard to masculine swashbuckling and unruliness, and its relationship to good governance and trade. Indeed, the Stukley plays were performed by the Admiral's Men at the Rose playhouse and their subject matter was likely to have been of interest to the company's patron, Lord Charles Howard, Lord Admiral after 1585 (whose annual income from naval commitments and piracy has been estimated to have been between £12,000 and £15,000 in the years of war with Spain).[11]

Captain Thomas Stukley, soldier of fortune, led an exciting life.[12] In 1551, after the failure of the Duke of Somerset's rebellion, he fled to France and managed to secure the favour of Henry II. Yet, when he learned of French invasionary plans against his native land he returned home to inform the Privy Council (and was jailed for his information). He then married Anne Curtis, the daughter of a rich alderman. In order to improve his relationship with the Queen, he agreed to take part in a supposed colonising mission to Terra Florida (though the real purpose of the expedition was to harass French shipping). His piracies were so successful that, following repeated French complaints, the Queen censured him: but it is likely that it was his failure to secure massive profit from his activities that resulted in enduring royal disfavour. Stukley then went to Ireland where he became a friend of the Queen's deputy, Sir Henry Sidney, and took part in the negotiations between the English and the rebel Irish leader, Shane O'Neill.[13] Yet Elizabeth's displeasure followed him even here, since she blocked his attempts to buy valuable Irish lands and had him imprisoned for alleged sympathy with rebel Irish nationalists and for using coarse language against the Queen ('I care not a f—t for her (hoore) nor yet for her office').[14] He was paroled and – his friend Sidney alleged – set sail for England to attempt a reconciliation with the Queen. In fact, he sailed for England's enemy Spain (with whom he had been secretly negotiating) to offer his services by organising an invasion of Ireland for Philip, and he was fêted in the court of the Catholic King. However, when Elizabeth and Philip's relations temporarily thawed, she demanded that Philip abandon Stukley and so, once more, Stukley sailed away – but this time to Rome. Here he negotiated permission from Pope Puis V to conquer Ireland and free it from Protestant rule, but was prevented from the mission through enforced participation in the Battle of Lepanto in 1572. Though winning further glory for his bravery, Stukley still desired the conquest and rule of Ireland and finally persuaded the new Pope, Gregory XIII, to equip him with an expeditionary force. On the way to Ireland, he put into port at Lisbon and was persuaded (or coerced) into helping Sebastian, King of Portugal, in his Crusade against Islam in Alcazar and here, with three kings, he met his death on the battlefield on 4 August 1578.

Stukley's extraordinary biography, then, offered a rich source for dramatists and writers since the variety of affiliations he possessed allowed him to be represented, sometimes simultaneously, as both patriot and traitor to the English nation and its Queen. Peele's editor, John Yoklavich,

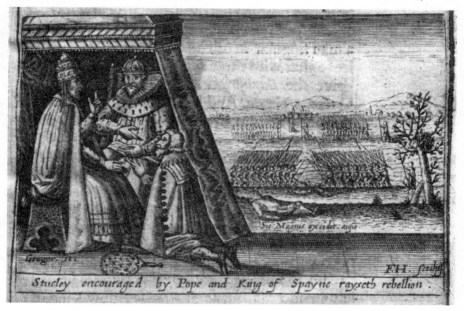

Stucley encourage by Pope and King of Spayne rayseth rebellion within image

6 *Stucley encourage by Pope and King of Spayne rayseth rebellion*, Frederik
van Hulsen, in George Carleton, *A Thankfull Remembrance of God's Mercy*

summarises both the characteristics of Stukley and contemporary
chroniclers' and commentators' attitudes to him:

> He may have been a roisterer, but he was certainly a brave captain, beloved by
> his own soldiers and generally esteemed for his military virtues. By some he
> was called thriftless; by others, magnanimous. It was admitted by all that he
> was extremely generous with other people's money. Proud he may have been,
> and ambitious, but never petty. A man of agreeable presence, aspiring mind,
> and ready wit, in many ways Thomas Stukley was a typical child of
> Renaissance England. Although he was once a pirate and at last a renegade,
> Englishmen did not judge him harshly for it.[15]

Most dramatists and ballad-makers, critics and historians have found in
Stukley an endearing portrait of a swashbuckling and brave, if not love-
able, rogue.[16] The ballad *A Commendation of the adventerus viage of the
wurthy Captain. M. Thomas Stutely Esquyer and others, towards the Land
called Terra florida* (1562–63), for example, describes him as 'A yung
Eneas bolde, / With hart and courage stout'.[17] Some, though, emphasise
the dishonourable and traitorous aspects of his actions. George Carleton,

Bishop of Chichester, for example, describes the 'rebel Stukley' in *A Thankfull Remembrance of Gods Mercy* (1624). He catalogues how the 'bare-worne deceiver' was killed at Alcazar, observing that 'Stucley had too honorable an end of a dishonourable life'.[18] The popularity of Carleton's text is demonstrated by the fact that in the following year a second edition was printed, and a third in 1627. This last edition included a picture of Stukley kneeling before Gregory XIII and Philip II. Behind them is pictured a battle scene, presumably the field of Alcazar. A dead soldier, presumably Stukley, lies in the foreground over the inscription: *Sic Magnis excidit ausis* (see Figure 6). In Carleton's version, in a clear case of cause and effect, Stukley's betrayal of his country through ignominious supplication to Catholic powers is punished by death.

The official Elizabethan view of Stukley as expressed in, for example, *The Execution of Justice* (1583), was that he was a prodigal and traitor: 'And out of Ireland ranne away one Tho. Stukeley, a defamed person almost through all Christendome, and a faithless beast rather than a man, fleeing first out of England for notable piracies, and out of Ireland for trecheries not pardonable.'[19] Here, Stukley is less than human since his unpardonable crimes render him beast-like and monstrous. In contrast, both Peele and the author of the Stukley play appear to reduce the traitorous aspects in their versions of Stukley, apparently concentrating, like the anonymous ballad-makers who describe 'Stout Stukley', on his more palatable, even endearing, qualities. However, as we shall see, there are strong tensions underlying his behaviour, values and masculinity in both *The Battle of Alcazar* and *The Famous Historye*. Both plays test and debate the limits of male unruliness, questioning whether anti-establishment behaviour should be seen as caused by character defects in the individual concerned or as a failure of the government and rulers that he serves. The story of Stukley is not only a rip-roaring tale of adventure: attitudes to Stukley and his rebelliousness in these plays express broader anxieties about legitimate forms of masculine behaviour in Elizabethan England.

Moors and mercenaries: Peele's *The Battle of Alcazar* and masculine unruliness

Peele's *The Battle of Alcazar*, written the year after Marlowe's *Tamburlaine* (1587–88), is clearly indebted to the earlier play, since, like Tamburlaine, Stukley is represented as both overweening and expansionist as he seeks to 'raigne sole king of thy desire' (II, ii, 467).[20] His preference to be 'King

of a mole-hill' rather 'Than the richest subject of a monarchie' (II, ii, 464–465) is both impressive and troubling. It demonstrates a threatening yet seductive kind of rampant individualism. Men of ambition and vision were needed by Elizabethan England to further the nation's expansionist policies, but those same qualities made them potentially, if not always actually, unmanageable. Marlowe's Tamburlaine is a prime example. His relentless hunger for conquest reflects, as Stephen Greenblatt has argued, 'the acquisitive energies of English merchants, entrepreneurs, and adventurers'.[21] Yet Tamburlaine and Stukley's energies only problematically reflect legitimate merchant-trading interests. Both men operate on the hinterland between licit and illicit commercial endeavour. Tamburlaine, for instance, condemns the Barbary Muslim pirates, calling them 'the cruel pirates of Argier, / That damned train, the scum of Africa,' who 'make quick havoc of the Christian blood' (*Tamburlaine*, Part I, III, iii, 56–58). He even promises to punish the pirates so severely that they will curse the time he set foot in Africa (Part I, III, iii, 59–60).[22] Yet, as Tamburlaine's enemies' descriptions of him persistently make clear, he is no different in his 'pillage and murder' (Part I, IV, i, 67) from the Barbary pirates who disrupt England's legitimate trade in the Mediterranean.[23] In Marlowe's play, then, Tamburlaine's unmanageable and excessive appetite for conquest and consumption make him tyrannical and, ultimately, a failure, since his greed is both endless and, in its lack of discrimination, renders the objects of his desire meaningless.[24]

Stukley's obsessive assertion that kingship is his only ambition operates in a similar way to Tamburlaine's all-consuming, but ultimately self-defeating, greed:

> There shall no action passe my hand or sword,
> That cannot make a step to gaine a crowne,
> No word shall passe the office of my tong,
> That sounds not of affection to a crowne,
> No thought have being in my lordly brest,
> That workes not everie waie to win a crowne. (II, ii, 452–457)

Clearly here his monarchic ambitions are intended to appear relentless as he vows that all his actions, words and thoughts will be solely directed towards the gaining of a crown. Yet in the next scene in which he appears, the self-styled 'Marquis of Ireland' is comparatively easily diverted from his monarchic aims. In II, iv, when the Portuguese King Sebastian asks him to accompany him to 'fruitfull Barbarie' (656), Stukley replies that he 'Did bend our course and made amaine for Ireland' (666). However, on

hearing Sebastian's impassioned extended celebration of England's Queen – she is, for example, 'Shining with wisedome, love and mightines' (679) – Stukley agrees to abandon the Pope's mission to wrest Ireland from the Protestant Elizabeth as long as his companions agree. Peele thus treats Stukley, as Marlowe treats Tamburlaine, with a considerable degree of irony.

But should we unequivocally applaud Stukley's change of plan? In one way, it seems clear that his decision to intervene in North Africa is infinitely to be preferred to a Catholic plot to attack English dominion in Ireland. Peele, like all patriotic Protestant Englishmen of the time, would hardly have supported an attack on England. Sebastian's representation of the natural world wishing to 'serve her roiall majestie' through 'The wallowing Ocean [that] hems her round about, / Whose raging flouds do swallow up her foes, / And on the rockes their ships in peeces split' (685–688) refers implicitly to the rebuffed invasionary force of the 1588 Armada. Moreover, Peele was a supporter of Drake and Norris' plans in 1589 to attack the remnants of the Catholic invasionary force, the 'counter-Armada', and put Don Antonio on the Portuguese throne.[25] Yet Stukley's volte-face ('Saint George for England, and Ireland now adue, / For here Tom Stukley shapes his course anue') sits rather uncomfortably with celebrations of Stukley as a strong-minded, heroically ambitious figure. His obsession with monarchy revealed in previous speeches now looks like mere empty rhetoric since, at the whiff of a swashbuckling adventure, he abandons his planned Irish mission. Similar to Marlowe's ironic treatment of Tamburlaine, a man whose indiscriminate appetite renders differences between regions, people and objects meaningless, Peele's irony here undermines Stukley. Excessively and obsessively he has asserted his monarchic ambitions, but on the offer of easy riches and the company of kings he changes his mind and becomes a hired mercenary for a foreign king.

Peele's attitude to Stukley in this text is complex: Stukley is, for example, clearly Catholic since Peele's initial description of him is as part of a band of 'Valiant Catholikes' (II, ii, 384). Yet Stukley also ridicules the Roman faith, calling the Irish Bishop 'the reverent lordly bishop of saint Asses' (II, ii, 432).[26] Here Stukley's mockery of the Irish prelate is obviously intended by Peele to raise a cheap anti-Catholic laugh from his Protestant audience, but the fact that it is Stukley who is given the line suggests contradictory attitudes towards him. In fact, this balance between praise and blame in the text's treatment of Stukley is mirrored by similarly

ambivalent descriptions of all the leading male characters. The situations and characters of the four main figures mirror one another in a variety of ways. For example, Peele, as a Protestant Englishman writing in the late 1580s, uses Stukley to reflect post-Armada patriotic antagonism to Philip II.[27] Stukley's scheme to invade Ireland mimics Philip II's recent plans to do exactly the same in England. Unlike Philip, however, Stukley is distracted from this invasionary plan. In order to help the Portuguese King's mission to restore a displaced monarch in Barbary (Muly Mahamet), Stukley changes his plans. But Sebastian's motives, like Stukley's, are morally dubious. Though claiming his help is motivated by missionary zeal to plant the Christian religion in Africa, Sebastian's help will in fact be given in exchange for the 'kingdome of Maroccus' (II, iv, 584) becoming Portuguese. Furthermore, the text tells us from the beginning that Muly Mahamet's loss of his kingdom was deserved – he himself was previously a usurper – and hence Sebastian's support is, like Stukley's Irish scheme, misguided. Hence Stukley in the play reflects Philip in 1588, and Sebastian's motives for helping Muly Mahamet are, like Stukley's, mercenary. The real reason for Sebastian's and Stukley's actions is greed as, despite their monarchical status or ambitions, they both become mercenary hirelings.

As Simon Shepherd has argued, one of the central concerns of this play is royal succession.[28] The competition between Muly Mahamet and Abdelmelec for the Barbary throne in *The Battle of Alcazar* by raising questions about illicit and lawful succession, articulates key concerns in the debate about who should succeed Elizabeth. Though Elizabeth prohibited her subjects from explicitly discussing this contentious issue, by 1589 there was no possibility that the queen would produce an heir from her body, and hence royal succession was a central concern for English and foreign commentators alike. The rival Moorish factions both claim to support legitimate monarchs, yet they organise royal succession in very different ways. Muly Mahamet claims that monarchy should pass directly from father to son, whilst Abdelmelec believes that the throne should be passed between siblings in turn. Given that Elizabeth inherited England as the last of three siblings but that the English throne was normally inherited by the eldest son on his father's death, clearly both Moors have claims that should be taken seriously. In the play Muly Mahamet has seized power and persuaded Sebastian of the justice of his title, and Muly Mahamet's uncle, Abdelmelec, also attempts to enlist foreign aid to wrest the throne from his usurping nephew: 'To sow the lawful true succeeding seed / in Barbary' (98–99). We have here an argument about the legitimacy of

armed intervention as Abdelmelec attempts to represent it as 'natural'. In the light of late sixteenth-century English debates concerning the establishment of 'right' of succession as something distinct from the natural line (such as Peter Wentworth's 1598 pamphlet *A Pithy Exhortation to Her Majesty* – where he urged Elizabeth to name a successor), the struggle between Muly Mahamet and Abdelmelec has clear resonance with the English situation.[29] Furthermore, both Abdelmelec and Muly Mahamet lead their forces personally in their campaigns to establish their claims as 'natural'. England's queen was perpetually reliant on her male subjects to enforce her will.

Indeed, in these complex patterns of similarities between characters and situations we have another parallel to the political disputes current in late 1580s Europe. Sebastian, Portugal's monarch in the 1570s, is duped in the play by the Machiavellian schemes of his uncle King Philip II of Spain. Through his ambassadors, Philip promises to send troops to support Sebastian's expedition to aid Muly Mahamet and offers marriage with his daughter – with the Moluccas as her dowry – to the Portuguese king, but the help never arrives and secretly Philip helps Mahomet's uncle, Abdelmelec. Hence Philip is in an enviably strong position: if Sebastian's plans succeed he will be rewarded with territory in Africa, if they fail and Sebastian dies (as did happen), he will be able to annex the Portuguese throne. The duplicitous Philip of *The Battle of Alcazar* should be seen as part of the contemporary debate concerning Philip's treatment of Don Antonio, the claimant to the Portuguese throne, and Elizabeth's attempts to regain Don Antonio's throne through Drake and Norris's counter-Armada, which used Morocco as a point of victualling.[30] Nevertheless, Sebastian's motives for agreeing to help Muly Mahamet (gaining the promise of a royal wife and the Spice islands from Spain and the kingdom of Morocco from Muly Mahamet), are just as mercenary as Stukley's.

Peter Hyland has recently argued that 'Peele's primary interest ... [was the] complex of competing religious and political positions centred on the figure of Sebastian'.[31] Muly Mahamet and Abdelmelec, Hyland notes, are given approximately the same number of lines (respectively 162 and 165) in the play, Stukley has 132, and the Presenter 174, but Sebastian has 218. Hyland's argument is that this line allocation is designed to focus audience attention on a European character rather than the Moorish villain Muly Mahamet. Although he is not mentioned in the full title of the drama, *The Battell of Alcazar, fought in Barbarie, betweene Sebastian king of Portugall, and Abdelmelec king of Morocco. With the death of Captaine*

Stukeley, many recent critics have seen Muly Mahamet as the most important character since, they argue, his villainy spawned an Elizabethan theatrical stereotype of black men.[32] However, both Hyland and Jack D'Amico argue that not only does the text's representation of the good Moorish character of Abdelmelec ameliorate the negative representation of Muly Mahamet, but, more importantly, the play's central attack is on Catholic Spain represented by the pervasive and treacherous influence of Philip II.[33]

Muly Mahamet's villainy is not contingent upon his Moorishness or his religion, and comes as much from the stage history he inherited as from the cultural and political contexts in which he operates. By an act of displacement his villainy alerts Peele's audience to Catholic villainy. The true dark villain of this play, who never appears, is Philip of Spain, who stands silently outside the play but whose influence is felt everywhere in it.[34]

D'Amico and Hyland are correct to identify Philip and Catholic Spain as the central threats in this play: the explicit power struggle between Muly Mahamet and Abdelmec, between a nephew and an uncle, are mirrored by the relationship between Philip and his nephew Sebastian in the play which, in turn, reflects the dispute over the Portuguese throne between Philip and Sebastian's heir Don Antonio in the late 1580s. Indeed, Muly Mahamet and Philip are explicitly paralleled by the fact that they both intend to dupe Sebastian, Philip through promises of aid and Muly Mahamet through 'shew of friendship, promise, vow and sweare' so that 'the vertue of his faire pretence' encourages Sebastian to trust 'his integrite' (II, iii, 526–528). Philip does not, however, intend to give him 'Marocco' in return for his support. Yet if we accept that this play is fundamentally concerned with values and debates within Europe – rendering the representation of Moorish characters important primarily as an amplification of European political disputes rather than directly discussing the relationship between Christianity and Islam – we still need to address the question of where precisely Peele wants his audience to situate English Stukley in relation to these religious and political debates.

As previously stated, although he is Catholic, Stukley still ridicules his religion as personified by the Irish prelate. Furthermore, it is clear from his advice to Sebastian that Stukley has the measure of Philip:

> For Spaine disguising with a double face,
> Flatters thy youth and forwardnes good king,
> Philip whome some call the catholike king,

I fear me much thy faith will not be firme,
But disagree with thy profession. (III, i, 808–812)

Indeed, the scene ends with a dark warning to Philip that in the end such
treacherous behaviour will be punished: 'Assure thee king, twill light on
thee at last, / And when proud Spaine hopes soundly to prevaile, / The
time may come that thou and thine shall faile' (III, i, 824–826). Stukley is
represented by Peele as a sound judge of character; he is, in fact, rather
better at reading the political situation than the Portuguese King. Clearly,
then, Peele intends his audience to respond positively to Stukley at these
points in the drama. But how far was this sympathy intended to go?
Should it extend to Stukley's rebellion against Elizabeth, which, after all,
comprises the audience's first introduction to him in the drama?

The answer to these issues can be found at two points in the text:
Sebastian's quasi-hagiographic praise of Elizabeth which seems, at first
glance, to dissuade Stukley from his rebellion, and in Stukley's dying
speech where he summarises his life. Sebastian's long speech in praise of
Elizabeth stands out in this otherwise action-packed and male-dominated-
play. At an obvious level a celebration of England's Queen by a Portuguese
monarch is designed to appeal to the most patriotic elements in Peele's
post-Armada audience as well as referring to the special relationship that
existed between Elizabeth and Portugal in the late 1580s. England's Queen
is represented as inviolable. According to Sebastian, even if 'everie ship
ten thousand on the seas, / Mand with the strength of all the Easterne
kings, / Convaying all the monarchs of the world' (II, iv, 672–674) were to
converge on England, it would be to no effect since 'heavens and destinies
… wait upon … [England's] Sacred, imperial, and holy' Queen (II, iv,
676–678). However, this panegyric praise of England's Queen comes
from a character whom we have just seen being duped by Spanish
Machiavellian plans. Since Sebastian has already failed in his character
judgements, his eulogy of Elizabeth consequently appears to be somewhat
ambivalent in its implications.[35]

In fact, it is not at all clear that it is Sebastian's praise of Elizabeth and
his attempts to appeal to Stukley's patriotism that succeed in recruiting
him to his Barbary campaign. Sebastian concludes his speech to Stukley
with a warning as well as a request:

Advise thee then proud Stukley ere thou passe,
To wrong the wonder of the highest God,
Sith danger, death and hell doth follow thee,
Thee and them all that seeke to danger her.

> If honor be the marke wherat thou aimst,
> Then followe me in holy Christian wares,
> And leave to seeke thy Countries overthrow. (II, iv, 699–705)

Stukley's response to Sebastian's assertion that all those who attack Elizabeth end up in 'danger, death and hell' is noticeably ambiguous. He does not acknowledge either Elizabeth's power or any patriotic feelings (which would prevent him from attacking England's Irish territory). It is Sebastian's skill with words that he finds impressive: 'Rather my Lord, let me admire these wordes, / Than answere to your firme objections,' (II, iv, 706–707). Sebastian's praise of England's Queen, then, fails to solicit the response that it should, since Peele makes the praise of Elizabeth unsuccessful in changing Stukley's course of action. Instead, Stukley's admiration for Sebastian's eloquence – an implicit reference to his masculine skills of leadership – is what persuades him to 'die with honor for Sebastian' (II, iv, 712) so long as his companions agree to the new adventure. He asserts 'I am but one' (710), arguing that the Bishop and his fellow Captains, Jonas and Hercules, made by 'His holynes Pope Gregorie the seventh, / ... leaders of the rest' (708–709), need to agree to the plan before he will commit himself. It becomes clear in the following discussion between the men that alliances are formed that supersede those of either national identity or loyalty to a female monarch. The Bishop, Hercules and Jonas initially refuse to change their course of action despite Sebastian's appeal to their patriotism: 'leave this enterprise, / Against your countrie and your countrie men' (714–715). Importantly, Hercules responds to Sebastian with the claim 'Our countrie and our country-men will condemne / Us worthie of death, if we neglect our vowes' (722–723). Here Stukley's fellow captain clearly expresses a conception of honour that is not based on patriotic support of England's Queen as he argues that Englishmen would condemn them if they neglected their vow to the Pope to attack Ireland. Honour, then, is based on a masculine value system of keeping one's word, not on patriotic support for the land of one's birth. Stukley and his compatriots only agree to follow Sebastian because he commands them to do so: as Stukley's other captain, Jonas, says, if they were 'voluntary men' (729) they would continue with their Irish expedition, but they are prepared to fall in with Sebastian's plans since they are 'captives to [his] roil will' (727). It is not praise of England's Queen that changes Stukley's mind; rather he is influenced by a value system based on masculine leadership skills and the successful manipulation of chivalric language. Sebastian here shows how well he can rally troops and assert his command over Stukley and his men: 'Follow

me Lords, Sebastian leads the way' (733). Implicitly, then, a masculinist ideology of male companionship, prowess and loyalty is created in this scene which counterbalances the power of England's Queen. Stukley's exit lines confirm this reading when he bids farewell to 'Saint George for England'. The nation is here represented by the masculine symbol of St George, not by anything to do with the country's female ruler.

What this scene represents, then, are Stukley's attempts to operate independently from the country of his birth. He refuses to recognise that his Englishness should be the most important factor of his identity. Rather, as his first speech in the play makes clear, he has no sense of national allegiance.

> Lord governour of Lisborne understand,
> As we are Englishmen, so are we men,
> And I am Stukley so resolved in all,
> To follow rule, honor and Emperie,
> Not to be bent so strictly to the place,
> Wherein at first I blew the fire of life,
> But that I may at libertie make choise,
> Of all the continents that bounds the world,
> For why? I make it not so great desert
> To be begot or borne in anie place,
> Sith that's a thing of pleasure and of ease,
> That might hath bin performed else-where as well. (II, ii, 409–420)

Stukley tries to assert that he is a 'citizen of the world' rather than of England; the value system he operates by is one based on the masculine, swashbuckling values of 'rule, honor and Emperie' rather than patriotic loyalty.[36] We thus need to explore the extent to which the text is in sympathy with Stukley's value system here or, alternatively, whether Peele is encouraging his audience to see Stukley's rampant individualism – and his desires for status and wealth – as excessive and illegitimate.

The text presents us with contradictory responses to this problem. Stukley's assertion of individual rather than national loyalty in the speech quoted above is immediately rebutted by the Irish bishop with whom he is travelling: 'We must affect our countrie as our parents, / And if at anie time we alianate / Our love or industrie from doing it honor, / It must respect effects and touch the soule, / Matter of conscience and religion, / And not desire of rule or benefite' (II, ii, 425–430). Yet the prelate's articulation of orthodox values of national allegiance sits uncomfortably with his Catholic rebelliousness against England's Protestant control of Ireland. Stukley and

Hercules notice the Bishop's hypocrisy: Stukley, as we have seen, calls him 'bishop of saint Asses' (II, ii, 432) and Hercules comments directly upon his changeable and inconsistent views (II, ii, 433–437). What Stukley and Hercules notice here is the way that the Bishop's Catholicism, with its allegiance to the Pope, undercuts his loyalty to a particular national identity despite his assertion that 'we must affect our countrie as our parents'. It might seem, therefore, that in this exchange (in which the two men nearly come to blows), Stukley's individualistic position is the one that is supported by the text since the Bishop is shown to be the hypocritical possessor of a 'double conscience' (II, ii, 439). However, although Stukley does come off better in this exchange, this is not because the text supports his rampant individualism. Rather, the Bishop expresses the orthodox view of national allegiance; the problem is that his Catholicism means that he himself fails to live up to such standards of behaviour.

In his dying speech, Stukley acknowledges his mistaken value system as he describes the ways in which 'a discontented humor' (V, i, 1334) has led him to abandon the 'wealth and ease' (1332) of his 'golden dayes' (1330) in England. In the 48-line long speech that follows we have, as Joseph Candido argues, an important milestone in English dramatic history: 'For the first time … a Tudor character appears on the stage to direct the attention of the audience to his life, exploits and personality; and with his appearance, despite its artistic imperfections, the seeds of Tudor biographical drama begin to take root'.[37] Stukley's speech is also important because it acknowledges that his previous emphasis on individualism – which led him to desert England and become a mercenary – was misguided. Hindsight allows him to see how he abandoned the golden life of England for the false 'glitter' (1338) of the favour of Philip of Spain and the Pope. His speech ends with a plea that his 'countrie' remember him well ('kindely ring thy knell', 1368):

> Stukley, the story of thy life is tolde,
> Heare breathe thy last and bid thy freindes farwell.
> And if thy Countries kindnes be so much,
> Then let thy Countrie kindely ring thy knell.
> Now goe, and in that bed of honor dye
> Where brave Sebastians breathles Course doth lye.
> Here endeth Fortune, rule, and bitter rage:
> Here ends Tom Stukleys pilgrimage. (1365–1372)

What has become of value to Stukley is his posthumous reputation in England: this is an implicit acknowledgement that his earlier individualistic

and mercenary refusal to acknowledge the importance of patriotic feeling and be a 'citizen of the world' was wrongheaded. In effect, the views expressed in this dying speech – noticeably the only one in the play since other characters' deaths (even those of kings) occur either much more quickly or offstage – are identical to those of the Bishop regarding the importance of patriotism earlier in the play. Furthermore, Stukley is murdered by the Italian mercenary troops who were originally part of the Pope's invasion force against Ireland.[38] They attack Stukley because, they believe, through 'forwardnes to follow wrongfull armes' (1303) he has 'fouly ... betraide ... our famous expedition earst' (1304–1306). Stukley's death at the hands of the doubly traitorous mercenary Catholics who turn against their own would appear to English Protestant eyes as fitting punishment for his betrayal of his country. His death should be seen as both a celebration and a reprimand. Unlike the other male characters in *The Battle of Alcazar*, Stukley dies in an impressive and dignified manner; but he is killed by his own men who turn upon him because they are hired mercenaries rather than loyal English troops. This shows the seriousness of his error. If Stukley had not betrayed his own country, he would not be in the position of being accused of betrayal by England's Catholic enemies.

Stukley in this play represents the limits of appropriate masculinity. His military prowess, skills of leadership and ambition are precisely the kind of qualities that England needed. Yet his fate offers a warning to all those adventurous individuals who value their own ambitions and status above those of their nation. Even so Stukley is not treated harshly by the text: compared to Sebastian, for instance, Stukley's death is impressive. Stukley learns by his mistakes: his dying speech shows him acknowledging his national identity and the inadequacies and failures of the mercenary life. But it does not show him acknowledging the power of England's queen. Elizabeth is not mentioned in this scene, and her absence might hint at certain dissatisfaction, or at least a tacit acknowledgement, of the problems presented to adventurous male subjects by a female ruler. The absence of any reference to Elizabeth in Stukley's dying words spoken on the battlefield of Alcazar reflects her inability to take any direct part in this domain. Her gender precludes her presence in this masculine sphere, and Stukley's failure to mention her gestures towards her political and military inadequacy.

In the Queen's absence from Stukley's dying words, then, and in the text's ambivalent portrait of his adventurous and ambitious character, it is possible to detect the tensions generated by female rule at this time.[39] In

times of war, an adult male monarch would normally head the national army and Elizabeth's inability to fill this role weakened her absolutist status. Absolutist rule was traditionally maintained by propaganda that linked a monarch's person and body with the fate and situation of the nation. Under Elizabeth, as A. N. McLaren has shown, these ideas of the body politic had to be modified since the 'natural' gender of rule, masculinity, was compromised by the female monarch.[40] However, the strained nature of these compromises was starkly revealed in times of national emergency. If England was at war – for instance in the campaigns in the Netherlands in the 1580s – a national army was needed to fight abroad and, of course, the commander of that army became an extremely powerful figure. Leicester's acceptance of the governorship of the Netherlands – a position only Elizabeth should have held – reveals just how vulnerable a female monarch could become to ambitious male subjects. Leicester did not take advantage of his command in the Netherlands, but a conquering national hero at the head of an army could easily have done so by attacking what he was supposed to be defending.[41] By the time Peele wrote *The Battle of Alcazar*, Leicester was dead, and propaganda about Elizabeth stressed her 'kingliness' (for instance her 1588 speech at Tilbury claimed she possessed 'haughtiness of stomach', a conventional quality of true, kingly, nobility).[42] In 1589, as well as *The Battle of Alcazar*, Peele also wrote texts in favour of Drake and Norris's Portugal expedition *A Farewell. Entituled to the famous and fortunate generalls of our English forces* which included an account of the founding of Troy, and a celebration of Essex's Portuguese mission, *An Eglogue. Gratulatorie. Entituled: To the right honorable, and renowmed shepheard of Albions Arcadia: Robert earle of Exxex and Ewe: for his vvelcome into England from Portugall*.[43] In both these texts, Peele praises the masculine military prowess of Albion's champions in their heroic deeds which Elizabeth can only license, having then to await the results from the sidelines. In Peele's ambivalent representation of Stukley, then, there is clearly a degree of sympathy with his expansionist ambitions. In Stukley, and in Muly Mahamet, Abdelmelec, and Sebastian, we encounter male leaders who can back up their absolutist claims by direct action rather than being marginalised through gender-specific passivity. In Peele's play, then, there is an implicit acknowledgement of the limits of queenly rule: Sebastian might praise her in hagiographic terms, but her gender means she must always leave the defence of her kingdom to others.

Traitor or hero? The representation of masculinity in *The Famous Historye of the life and death of Captaine Thomas Stukeley*

Similar issues concerning male ambition, prowess and rebelliousness are explored in the anonymous *The Famous Historye of the life and death of Captaine Thomas Stukeley*, which was entered into the Stationers' Register by Thomas Pavier on 11 August 1600 and published in 1605.[44] Judith Levinson, in her introduction to the Malone Society edition of the text, argues that it represents a complicated blending of other dramas, including *The Battle of Alcazar* and at least one other work now lost (a play called 'Stewtley' which Philip Henslowe recorded as a 'new' play acted by the Admiral's men on 11 December 1596). Levinson also outlines which dramatists are thought to have had a hand in its composition – favourite candidates include Peele, Dekker, and Heywood.[45] This theory is dependent on seeing *The Famous Historye* as significantly reworking the earlier play, but, as Yoklavich argues, the scope and exact nature of the changes are by no means certain and have been the subject of considerable critical debate.[46] Indeed, the current consensus is that the first three acts of 'Stewtley' – the London, Irish and Spanish sections – were reworked from, but fairly similar to those published in *The Famous Historye* of 1605, but that the fourth act – about Rome – has been lost from the later version. The final scenes – the Alcazar passages – in *The Famous Historye* are thought to have been interpolated from a variety of sources, including Peele's play, another lost play putatively titled *Sebastian and Anthony*, and also to have been significantly influenced by popular oral traditions, ballads, chapbooks and tracts.[47]

In contrast to Peele's *The Battle of Alcazar*, this later text follows the fortunes of Stukley from young blade in London to his death in Africa. The first act finds him financially embarrassed, and disciplined by his father for the dissolute, 'gallant' life he has been leading rather than studying in the Inns of Court. He bypasses this fatherly reprimand through an advantageous marriage with the rich daughter and heir of Alderman Curtis, displacing his friend Vernon from Nell's affections in the process and quarrelling with another friend, Captain Jack Harbert, over whether his marriage will prove a blessing for the Curtis family. After paying off his many creditors with his father-in-law's money, Stukley swiftly abandons his new wife in order to join the mission in Ireland to subdue the rebel Shane O'Neill. Harbert and Vernon also form part of Elizabeth's Irish mission and when Stukley arrives at Dundalk he finds Harbert in charge of

the garrison town and Vernon in the position of deputy. Harbert and Stukley renew their quarrel, but their fight is interrupted by the rebel Irish attack and both captains sally forth with their men. Stukley becomes so embroiled in the battle that he fails to respond to the sounding of the retreat and when he returns to the town he finds the gates shut against him by Governor Harbert who has decided to teach him a lesson in military discipline. After angry exchanges with Harbert concerning the booty and honour Stukley has won in the skirmishes, the latter is forced to camp outside the town gates overnight and, in his wrath, determines to leave Ireland the next day to seek his fortune in the service of Philip of Spain. Meanwhile, invading Scotsmen kill the Irish rebels.

The action then switches location once more. With the horses he captured from the Irish, Stukley sails for Spain, but falls into the hands of Hernando, the Governor of Cales, who demands his horses and throws him in prison. Hernando's wife feels sorry for the handsome Englishman and has him released after he promises to return to his captors by an appointed time. Stukley hastens to the court of Philip of Spain, informing him that Hernando has appropriated the intended present of the horses. Philip promises to sort out the problem and Stukley rushes back to Cales to make sure that the Governor's wife does not get into trouble with her husband for releasing him. In the meantime, Vernon arrives on Spanish soil, having been tricked by Spaniards into abandoning the ship he was on so that they could, according to established maritime custom, claim it as booty. Stukley appears to be in such high favour with Philip that the confiscated English ship is restored, and the monarch dispatches him to Rome as his ambassador in order to secure the Pope's approval for Philip's support of his nephew Sebastian of Portugal's scheme of aid for Muly Mahamet against Abdelmeleck in North Africa. However, Philip is disingenuous since he is really hoping for Sebastian's defeat and death in Africa, leaving him to seize the Portuguese throne despite Sebastian's explicit wish that his heir should be Don Antonio. Once in Africa, Sebastian insists against Stukley's advice on attacking Abdelmeleck's forces even though his own troops are weary and ill. Sebastian, Abdelmeleck and Muly Mahamet are killed, and Stukley and Vernon are reconciled at the moment at which Stukley's Italian troops attack and kill their leader. The play ends with Stukley and Vernon's deaths.

This is a play of considerable historical and geographical scope: we move from London to Ireland, then to Spain, and finally to Africa, and the text charts Stukley's life from his early manhood to his death in his late

fifties in 1578. It also takes considerable licence with the known details of Stukley's life since, although the audience sees Stukley in many different guises, several important episodes are redacted or omitted from the narrative altogether. For instance, in scenes i–vi Stukley appears as an impecunious young gallant about town; but we do not witness his thievery and piracy, or his imprisonment in the Tower at the suit of an Irish gentleman he allegedly robbed, all of which occurred prior to his courtship and marriage.[48] Instead, the play documents the evolution of a rebel. We witness an escalating scale of excessive behaviour as Stukley moves from greed and aggression to treason. In scenes vii–xii he is impressive militarily but dangerously rebellious; in scenes xiii–ixx he gets the best of the Spanish men and, in contrast to the opening scenes, appears gallant to women, but he is duped by Phillip's Machiavellian politics; and in the final scenes (xx–xxvii) he is ferociously brave and a good military tactician but is fighting for a doomed cause. In each part of the play different aspects of the myth of Stukley are focused and meditated upon. The effect of this historical and geographical sweep is to allow the audience to assess different masculine characteristics, enabling an evaluation of their serviceableness to the English state. The central concern of this drama is to debate the limits of appropriate male behaviour.

In the London scenes in the early part of the play we hear contrasting views concerning Stukley from the other characters and each, it appears, wants him to behave in certain ways. His father, Old Stukley, arrives in London from his house in Hampshire in order to check up on his son.[49] In a bluntly comic scene, we see Old Stukley waiting at his son's lodgings for over two hours while Stukley's page tries to prevent the old man from finding out exactly what his prodigal offspring has been up to whilst, financed by the father for five years, he should have been studying the law. Old Stukley is outraged to discover an impressive array of armaments in his son's study: he finds 'long sword, short sword and Buckler' instead of the legal books of 'Littleton, stamford and Brooke' (239–240). In the debate that ensues between father and son it is soon apparent that Old Stukley is chiefly concerned with money. His whole frame of reference is derived from either the counting house or mercantile economics. He requests an 'account' (297) from his son, mourns the fact that young Stukley's 'infancies did flatter me, with expectation of so many goods' that have failed to materialise (304–305), and compares what he has done for his son financially with what his own father did for him (313–318). Old Stukley cannot see the value of the kind of swashbuckling activities in which his

son has been engaged. He is only pacified when Stukley informs him of his expectations based on his prospective marriage to dowry-laden Nell Curtis:

> but hark you
> Father there is a neerer way to the wood then all
> This. A neerer cut, then scratching for things out
> Of a standish all a mans life, which I have found
> Out, and if you will stick to me, I doubt not but
> You shall thinke I have bestowed my time well
> And this it is. I am in possibility to marry Alderman
> Curtesses Daughter, now father if you will
> Open the Bagg of your affection and speake but
> A few good words for me to the old Alderman
> Shees mine horse and foote. (319–329)

The language Stukley uses to describe his impending marriage is, then, like his father's, derived from an economic register. He wants a shortcut to financial security, requesting his father to open the moneybag of his affection in order to put in a good word with his prospective bride's father. Rather than working to make his fortune Stukley desires easy riches. Noticeably, the girl in question is not referred to by her name; to Stukley her identity as the heir of Alderman Curtis is all that is important. The economic nature of the match, and Stukley's lack of feelings for his future wife, are further confirmed when Nell is represented in equine terms. Stukley, at this point in the play, appears to blend mercantile and elite chivalric patterns of behaviour: his swordsmanship marks him out as possessing aristocratic prowess, but his financial concerns reveal a strongly mercantile instinct. Potentially, then, he might be an example of the new type of hero Hakluyt imagined in *Principal Navigations*, where merchants perform as valiantly as gentlemen, but also act as skilful and diplomatic English ambassadors before foreign princes.[50] For Hakluyt, the warrior-merchant successfully mixes the best values of mercantile and aristocratic ideologies.

However, the speech quoted above by Stukley is one of his first of any length and it confirms the audience's impression of him as a morally ambiguous character. His blend of concern for money with swordsmanship, contra Hakluyt, does not make him an admirable man. In the opening scenes we see him depriving his friend Vernon of his bride and, unusually in such circumstances, Vernon arranges and supports the match, acknowledging that Stukley is the superior man ('he is the substance of my shadowed love, / I but a Cipher, in respect of him' (60–61)). Vernon calls

Stukley his 'friend, my deere, esteemed frend' (67), and acts with
scrupulous honour in 'resigne[ing]' the 'right' he has 'In faire Nell Curtes'
(99–100) despite the loss to himself of both the woman he cares for and
her rich dowry. Yet Stukley's behaviour encourages the reader to question
whether he deserves either Vernon's emotional sacrifice or his friendship.
Stukley's first speech in the play reveals him to be arrogant and financially
motivated: 'looke on me, / not with disdainfull lookes, or base contempt. /
I am a Gentleman, and well deriv'de, / equall I may say, in all true respects,
/ with higher fortune then I aime at now' (76–79). Clearly he believes
himself to be above his future bride in station, and though he asserts the
marriage is based on 'mutuall love' (84) thanking his 'deare frend' (82) for
allowing his suit to prosper, at the end of the scene his pecuniary motives
become apparent as he congratulates himself in the style of a Barabas on
the marriage: 'I feele thee comming fortune' (129).

 In these early scenes, then, we are presented with contrasting views of
Stukley. Vernon sees him as a close friend, but Stukley's loyalty to Vernon
is, to say the least, questionable. Nell sees him as a worthy husband ('his
vertues in the publick worlds repute, / deserveth one more worthy then my
selfe' (93–94)) but Stukley has obviously duped her into believing he loves
her. Indeed, the debate concerning the merits of Stukley's character is
made explicit by Alderman Curtis and his wife as they speculate on what
kind of man he is. The wife initially describes him as 'A handsome proper
man' (73), and both parents believe he is 'much beloved' in 'Citty' 'Court
and country too' (107–108). Yet negative information concerning his
character and behaviour is also starting to circulate: Alderman Curtis
claims that he 'heard last day, / hees very wilde, a quarreller, a fighter, / I,
and I doubt not a spend good too' (113–115). In the first few scenes of *The
Famous Historye* the audience is presented with a complex and morally
ambivalent character. Clearly, high expectations and hopes are invested in
him by his father, his friends, his wife and her family, which Stukley is not
able to fulfil: but questions remain as to whether these expectations are
legitimate – meaning Stukley is at fault – or whether the expectations
placed upon him are unreasonable and therefore Stukley's conduct is, to
an extent, exonerated.

 Stukley's personal ambitions here are considerably different from
those expressed in *The Battle of Alcazar*. In Peele's drama, as we have
seen, Stukley was driven by political ambition since he desired sovereignty
and, if he could not achieve monarchy himself, he was prepared to satisfy
his ambition through associating with other male monarchs. In this later

play, Stukley's motives appear even more transitory. His reasons for marry-
ing Anne Curtis are clearly pecuniary as he extols the merits of her 'forty
thousand pound', calling it 'the right Philosophers / stone,' and boasting
'true multiplication I have found it' (346–348). Desires for political power
and a crown are not the driving forces here as money alone appears to
dictate his actions. Yet no sooner does Stukley secure her 'joynter' (336),
than he despises it: 'I scorne this trash, betrayer of mens souls: / Ile spurne
it with my foote' (695–696). The moneybags which Stukley dismissively
kicks here and subsequently gives away to other men can be seen
metaphorically to refer to the wife whom he no longer wants. Instead, as he
declaims in a speech later in this scene, 'honour' is now what he seeks:

> I must have honour, honour is the thing
> Stukley doth thirst for, and to clime the Mount
> Where she is seated gold shall be my footstoole. (771–773)

But we need to consider how we should read Stukley's desire for this
specifically female honour. In order to possess this female honour it seems
that he must demonstrate a kind of hypermasculine behaviour. Instead of
pursuing his wife, he begins chasing female honour through his demon-
strations of masculine prestige and glory as he plans, as his friend Vernon
has done, to join an expedition to Ireland to put down a rebellion against
Elizabeth.

 In terms of its representation of the 'honour' of the Irish mission itself
(undertaken in the service of England's female monarch) the text is notice-
ably ambiguous. Stukley does not want to be 'thought / a traitor to her
Maiesty' (819–820) and his father-in-law appears to support his desertion
of his wife in the service of Elizabeth. 'I am not grieved that thou shoudst
serve thy prince' (840) Curtis says, giving tacit permission for the under-
taking 'So long as honor is thy object Tom' (842). What has upset him has
been the secret nature and unseemly speed of Stukley's desertion: 'But
that without our knowledge thou departs, / And on[e] the sudden: body of
me, tis that / That striks a discontentment in us all' (843–845). However,
neither of these ostensibly supportive representations of Elizabeth's rule
are as unequivocal as they might at first appear. Curtis' belief that honour
motivates Stukley in his Irish expedition is at odds with his analysis of his
son-in-law's haste and deception in rushing to sign up. And earlier in
the play Curtis has already acknowledged how deceived he has been in
Stukley's character, 'ah son, son, thou hast deceived / my opinion, my
daughter cast away, and I have / bequeathed my mony to a prodigall'

(688–690). Curtis's judgements are uncertain, and hence his belief in Stukley's honourable support of Elizabeth is not without its contradictions. Furthermore, Stukley's preference for Elizabeth rather than his wife here has wider implications. Most of Elizabeth's favourite courtiers – Leicester, Raleigh, Essex – got into serious trouble with the Queen at some point for getting involved with other women. Here, Stukley, a well-known traitor, appears to value the Queen's service more than his personal happiness. Hence Stukley's rather excessive loyalty, which the audience knows will later mutate to treason, might be seen as a coded comment on the unreasonable demands Elizabeth placed upon her favourites. Stukley's choice of Queen over wife represents for Elizabeth ideal patterns of behaviour on the part of her favourite courtiers. Yet Stukley is disingenuous and self-interested, and will turn against Elizabeth – deserting his national allegiance – in the same way that he casually abandons his wife.

The honour of the mission is also addressed in another, more revealing, way. Stukley's comment to his father about not wanting to be thought a traitor to Elizabeth comes in a dialogue concerning whether he should listen to outside advice about his Irish campaign. He would only listen to his father if by not listening he would be thought a traitor: in other words he is concerned about his public honour – how he seems rather than what he is in actuality. This, then, is rather different than saying he is not a traitor to Elizabeth. Furthermore, and most seriously, Stukley's presence clearly creates an unhealthy and intolerable atmosphere in London, for Vernon at least:

> yet whilst I breath this native ayre of mine,
> Methinks I sucke in poison to my hart:
> And whilst I tread upon this English earth,
> It is as if I set my carelesse feet
> Upon a banke, where underneath is hid
> A bed of crawling Serpents. (520–525)

England has become full of poison; it is full of hidden serpents and at this point in the text it is not clear whether such a situation is Stukley's fault or if it is a more widespread condition. Either way, Vernon has to leave a country that has become so unnatural and corrupt, but the audience remains uncertain at this point as to the extent and real cause of the nation's problems.

In these first scenes, this markedly ambivalent representation of Stukley encourages audiences and readers to ask some rather searching moral questions concerning the relationship between his individualism

and his value to the English State. By the end of the London scenes we have seen a man who asserts that he seeks honour in the service of his prince; ostensibly Stukley is a loyal supporter of Elizabeth. Yet his intentions are questionable: his self-interest and rampant aggression have already been revealed, acting as harbingers of his later notorious failure to conform to military orders, his rebellion and treason. As he marches off to Ireland to put down an actual rebellion fomented against Elizabeth, Stukley's own beliefs, as we have seen, do not appear to be orthodox. In the Irish scenes that follow – where the audience are introduced to 'real' traitors to the English state in the characters of the Irish rebels O'Neill and O'Hanlon and the previously rebellious but now repentant Scots leaders Alexander Oge and Mac Gilliam Buske – an implicit comparison is being drawn between Stukley and these men, in which Stukley's rebelliousness starts to appear as little different from that of England's enemies. Indeed, as we shall see, in the Spanish scenes which follow the Irish expedition in *The Famous Historye*, the consequences of Stukley's rebelliousness become manifest, as Stukley moves from rebelliousness, through treachery, to treason as he consorts with and becomes indistinguishable from England's greatest enemies, Philip II and Catholic Spain.

In the Irish scenes, which take place in and immediately outside Dundalk, a garrison town north of Dublin, in 1566–67, the text probes the nature and significance of rebellion and treason. Most of the characters in these scenes are perpetrators of a rebellion of one form or another, and we are invited to compare and contrast the relative seriousness of their deviations from the values of the English polity. The most obvious rebel, Shane O'Neill (fêted by the English government in the early 1560s in London as attempts were made to untangle the complexities of Irish lordship and English control through conquest to the mutual satisfaction of Cecil and Elizabeth as well as O'Neill), had by the middle years of the decade become once more openly mutinous against England.[51] This campaign described in *The Famous Historye* obviously refers to the one undertaken against Shane O'Neill in 1566–67 by Sir Henry Sidney, viceroy of Ireland, and Edward Randolph, lieutenant of the ordnance, after Elizabeth had decided in March 1566 that she wanted this 'cankred Irish rebel ... utterly extirped'.[52] Randolph brought 1,000 men by sea from Bristol to Lough Foyle that autumn and the English reinstated the Irish lord Calvagh O'Donnell in Tyrconnell, against the wishes of Shane O'Neill. The English forces garrisoned at Derry did not fight with O'Neill's men until November 1566 when, despite the death of Randolph, the victory went to

the English. The following April, however, with the garrison sick, their powder blew up and they were forced to evacuate Derry and withdraw to Carrickfergus.[53] The dispute between the O'Donnells and O'Neills continued and Shane O'Neill was defeated on 8 May 1567. In the wake of this battle, with his forces scattered and depleted, he tried to make an alliance with the Highland Scots. However, in a previous encounter at Glenshesh in Antrim he had murdered one of the Scottish leaders, and following a quarrel on 2 June they cut him to pieces. The English at Carrickfergus acquired his head from the Scots and it was displayed on the walls of Dublin castle.[54] This, then, is the historical background against which the Irish scenes in *The Famous Historye* operate. Yet there are significant differences between the historical record and its textual representation, as well as noticeable ambiguities in the text's representation of both the rebels and those putting down the rebellion.

This section of the play begins with the O'Neill and his forces circling Dundalk as they wait for a sign to attack from their spies inside the garrison town. However, Dundalk was not significant in the mid-1560s campaign against Shane O'Neill since the encounters between the Irish and English took place further North in Derry and Carrickfergus (a fact well known in the 1590s from the narrative of the Irish campaigns in Holinshed's *Chronicles* (1587)). The play's references to rebellion in Dundalk strike a much more topical note, since Dundalk was important in terms of Anglo-Irish relations in the summer of 1593 and again in spring of 1596, and the 'Stewtley' play was first acted in December 1596. Between 14 and 28 June 1593 Hugh O'Neill, second Earl of Tyrone, met with the Irish council, in particular the lord deputy Sir William Fitzwilliam, in Dundalk. Furthermore, during the Nine Years' War (1594–1603), specifically between 8 and 14 March 1596, Hugh O'Neill, and other Irish lords, including O'Donnell and O'Rourke, negotiated a brief peace with the Queen's representatives Sir Geoffrey Fenton, Chief Secretary, and Sir John Norris, Lord President of Munster, in and around the garrison town of Dundalk.[55] But the context of the Tyrone rebellion, and of Hugh O'Neill in particular, is more important for understanding *The Famous Historye* than is indicated by the play's setting in Dundalk. In the mid-1590s Hugh O'Neill represented a curiously liminal figure to the English authorities. He was both recognisably 'savage' and, simultaneously, dangerously indistinguishable from the English. As Andrew Hadfield and John McVeagh argue, 'O'Neill troubled and enraged ... not just because of the danger and disruption he caused, nor simply for the audacity of his nearly successful war, but

because he was a transgressive and hybrid figure who in many ways resembled them [the English], having acquired courtly values, an English wife, [and] diplomatic skills'.[56] As such, *The Famous Historye*'s representation of the wild Irishman Shane O'Neill, and the rebellious Englishman Tom Stukley, appear indebted to contemporary anxieties revised by the Tyrone rebellion. In the play, rather than O'Donnell securing the victory over Shane O'Neill, it is the English – specifically Stukley – who scatter and trounce him, though it is the Scots characters who actually murder him. Yet, Stukley's behaviour is by no means unequivocally celebrated by a text in which he appears both arrogant and ill-disciplined. He successfully puts down the rebellion, only to become a rebel and traitor himself.

In the play, Shane O'Neill describes the masculinity of the English soldiers inside the town as compromised by drink and sensual living. The problems the English face are, according to the Irish, compounded by their inability to digest native Irish products and delicacies: 'These English churles die if they lack there bed' (911) and 'our strong butter, … our sweild otmeale, and drinking water brings them to the flixe' (915–916). When we see the English officers, Harbert and Vernon, it is clear that this verdict is not completely mistaken. As Harbert admits 'our garryson … is but weake' (1005) and some of his men are sick through over-indulgence: 'theres no soldier sik, / But he that drinkes or spende his thrift at dice' (1008–1009). Not only are Shane O'Neill's views of the English proved to be partially accurate, but when Stukley swaggers onto the stage expecting to be greeted as a saviour by those in the beleaguered garrison we see further fissures within the English camp.

In his first appearance in Ireland Stukley's vanity is immediately apparent. He is annoyed that the commanders of the garrison do not immediately rush out of Dundalk to greet him as he expects ('what Lord is governor of this towne, / That comes not forth to welcome Stukley in' (1022–1023)). More significantly, Stukley's expectations reveal him to have fundamentally misunderstood the nature of the conflict into which he is entering: if the English came out of Dundalk they would, of course, be vulnerable to ambush by the O'Neill. Stukley's arrogance undermines his ability to adapt to the needs of particular military situations and to render worthy service to the English state.

His military inadequacies soon loom large. Once he discovers that Harbert is in charge of Dundalk he focuses solely on his personal antagonism to him rather than the job at hand, immediately challenging Harbert to continue the duel that they began at his wedding celebrations.

Stukley's antagonism is distinctly reprehensible since he challenges
Harbert despite the Governor's argument that the 'discipline of war' (1145)
and the presence of 'the publique enemie at hand' (1149) should mean that
any 'private brall' (1150) is postponed. Furthermore, as Harbert points
out, his insulting comments about Stukley not being worthy of his bride –
the reason they are at odds with one another – have been borne out by his
subsequent treatment of her ('I spake those words, and thou hast provd
them true' (1134)). We have just seen Stukley positively exalting in his
'unkind' (1086) treatment of his wife, boasting to Gainsford and her previ-
ous suitor, Vernon, how he has literally asset-stripped her (even to the
'clothes belonging to her back, / Save one poore gowne') and challenging
them that 'he that can makemore, / Of one poore wife let him take her for
me' (1091–1093).[57] Stukley's callousness as he celebrates his cruel exploita-
tion is striking here, as is his arrogance when he shamelessly congratulates
himself in front of Vernon. As Stukley revealingly commented on seeing
Vernon emerging out of Dundalk, 'is that Vernon … / Is he a Souldier:
then the Enimies dead' (1031–1032). Stukley's warped value system is such
that he is incapable of distinguishing between friend and foe: Vernon has
done nothing to him except abdicate his claim to an heiress in favour of
Stukley, and yet Stukley, as he does in his attitude to Harbert, places more
emphasis on the presence of his personal 'enimie' than he does on the real
foe, the rebellious Irish. Stukley's contaminating presence soon has a
profound effect on Vernon in the same way that it did in London:

> I hate the clymate where he lives,
> as if his breath infected all the aire,
> And therefore Ireland now farwell to thée,
> For though thy soile no venime will sustaine,
> There treads a monster on thy fruitfull brest. (1107–1111)

Though Vernon has been previously naïve in his attitudes to Stukley, his
status as a good-hearted and moral character means that his responses to
his rival are clearly supported by the text. Stukley contaminates everything
with which he comes into contact. Whereas in the London scenes Vernon's
unease with England was not decisively seen as Stukley's fault, *The
Famous Historye* is now rather more certain of the cause of the contagion.
Both England and Ireland have become sullied, and it is now apparent that
it is Stukley that is the origin of such corruption. His presence is so
pervasive as to force Vernon from England – represented as an unnatural
home sheltering 'crawling Serpents' – and now Ireland has become
similarly 'infected' through the presence of such a 'monster'.

Stukley's presence forces Vernon from his duty as an English soldier protecting the nation's colonial territory from Irish rebellion. His arrival sets the garrison at odds, as he fights with its commanding officer and the second-in-command deserts his post intending to flee to England's traditional enemies Spain or France. Stukley, then, seems to be represented as a more serious threat to the integrity of the English forces than the rebellious Irish. Just as Harbart was concerned about the presence of 'spies within the towne' who 'helpe and store them [the Irish] with provision' (994, 996), Stukley's disruptive presence endangers the garrison. When the Irish attack the garrison and the English sally forth, Stukley fails to heed the sounding of the retreat as he is too busy ('he is so eager to pursue the foe, / And flesh his soldiers that are new arrivde, / that he forgot or heard not the retreat' (1195–1197)). The debate that follows over whether Stukley should be allowed back into the garrison is one of the most complex and important in the text. Stukley and his men are highly successful in their attack, 'we have slaine / Two hundred Irish since yo left the chace, / And brought a prey six hundred cowes at least / forty chiefe horse, a hundred hackney Jades' (1222–1225). Yet, despite Stukley's booty, and his massacre of O'Neill's men, Harbart refuses to allow him back into the garrison.

The central issue that the play addresses here is whether it is Harbart's or Stukley's position that is correct. Indeed, the moral authority of the situation seems precariously balanced between them. Stukley's first attack on O'Neill proves successful in a way that Harbart's governorship has not been. The Irish have to this point circled ever closer around Dundalk – indeed, they have started to attack the garrison in daylight, having previously only dared to do so at night. In the play it is Stukley's foray – not a fight with Hugh O'Donnell – that defeats the O'Neill rebellion.[58] In fact, O'Neill puts a halter about his neck – symbolic of defeat – and prepares to surrender in the wake of his encounter with Stukley (1280–1316). This episode – which is resonant of the submission of another Irish rebel, James Fitzmaurice Fitzgerald, to Sir James Perrot in January 1572 with a token halter round his neck – reveals the ways this text conflates and blends figures and situations.[59] Yet Stukley failed to heed the retreat when it was sounded and his attitude to Harbart, his superior officer, is clearly insubordinate. Harbart is quite within his rights to punish Stukley for his behaviour, but *The Famous Historye* does question Harbart's judgement in his decision to exclude Stukley from the fort. As Stukley comments it is rather dubious to be prepared to accept Stukley's spoils but keep out the men that won them: 'Dost thou respect a bullock or a jade, / More than a

man to Gods owne liknes mad' (1247–8), and he sees Harbart's attitude as 'a simple piece of small revenge' (1238).

Brave, generous, but at times uncontrolled, Stukley also possesses significant resonance with another Englishman of the period: Robert Devereux, Earl of Essex, who in his military campaigns of the 1590s tested the limits of independent action whilst in the service of the queen. Throughout this period Essex, Elizabeth's military leader in the campaigns at Rouen (1590–2), Cadiz (1596), the Azores (1597) and Ireland (1599), repeatedly got into trouble with his Queen for what she saw as exceeding his command (whether by rewarding his soldiers with booty that should have gone to the crown or conferring knighthoods on men who fought well).[60] Essex, like Stukley, led from the front in any campaign, performing exploits of outrageous bravery: at Cadiz, for instance, he helped the first troops over the city walls, and subsequently – according to contemporary accounts – led the attack in the city's marketplace 'in his doublett and hose with his rapier drawen'.[61] Like Stukley, he also attracted a band of loyal followers – a kind of personal entourage who, certainly by the mid-1590s, loitered about Essex House hoping to secure further employment to the point where the place was 'continually haunted and barricaded with cavaliers'.[62] Finally, like Stukley in this scene, Essex repeatedly exceeded his command. On 8 October 1591, for example, he created twenty-four new knights notwithstanding Elizabeth's instructions that such things should be left to her: ('we will ourselves at your request upon your returne reward such persone with the dignity which their desertes shall deserve').[63]

Stukley's exclusion from Dundalk, as he is forced to make his 'Tabane underneath the wall' (1253), literally positions him in the hinterland between rebel and patriot. Certainly he appears to view his own exclusion in this way and it is the crucial factor in his decision to abandon his national allegiance: 'I vow who shut me out by night, / shall never see me enter heere by daie' (1239–1240). He determines to defend overnight the bridge to the garrison from attack by the Irish and, in the morning 'to seke a better coast' (1268), specifically Spain, asserting that 'I scorne to be contrould, / Of any man that's meaner then a king' (1275–1276). The gender of England's Queen is here implicitly invoked as Stukley's desire to serve a male monarch means that Elizabeth cannot keep him 'contrould'. Furthermore, rather ironically, he argues that if he had not left to become a traitor, he would have been successful in defeating a traitor: 'Oneale, if Stukley here had staid, / thy head for treason, soone thou shouldst have

paied' (1278–1279). In other words, Stukley in the service of England's Queen would have been able to kill the traitor O'Neill. Instead, rather than one of the English expedition having the honour of personally defeating Shane O'Neill, it is left to the Scots to despatch him, using his head as a 'gratefull present to procure [their] peace' (1367) with the English as they send it to 'that most noble English deputie, / that ministers Justice as he were a God, / and guerdons vertue like a liberal king' (1364–1366). Indeed, Stukley is – as the next scene shows us – rather more successful in his battle with O'Neill than even he realises since following Stukley's assault Shane O'Neill is preparing to surrender.

The Irish scenes in *The Famous Historye* focus on various manifestations of rebellion. O'Neill is, of course, the most obvious rebel and the use of Gaelic and broken English in his scenes (more Gaelic words are used in this play than in any other contemporary drama) marks his alien status.[64] But rebellion is more pervasive in the world of this play, and it cannot be contained within just one figure. Just as Hugh O'Neill represented to the English imagination in the 1590s a troubling and blurred conflation of 'wild' Irishman and 'civilised' Englishman, so in this play we are shown several revolts, and the most obvious treason, that of Shane O'Neill, is clearly not the most destructive. As we have seen, Stukley's presence in Ireland compromises Vernon's national allegiance. Furthermore, though Harbart and the English forces are revealed as somewhat ineffective in dealing with O'Neill, and it is Stukley that gets the better of him, it is also Stukley that deserts his national allegiance. Stukley is personally brave and successful in his one foray, but whether his abilities are suited to long-term military success is questionable since he sets the men in the Irish garrison at odds with each other. Stukley becomes a traitor as he deserts England in order to serve Spain, merely England's rival in 1566, but by the 1590s the nation's enemy. By contrast, the rebellious Scots use their murder of O'Neill as a way of appeasing English authority and counteracting their earlier rebellion. There is also, of course, an extra frisson in the text's use of the repentant Scottish rebels. In the last years of Elizabeth's reign, James VI of Scotland was the Queen's most likely successor – though he was not formally named as such – and in the Scots' machinations here, there is a sense of both surrender and further potential rebellion that resonates with the troubled relationship between the two monarchs.[65] Even within their apparent return to obedience there is a certain element of disquiet, since they describe themselves as attempting to submit to the English deputy (Sidney?) who is described in terms evocative of a male monarch.

Noticeably, then, their rhetoric excludes England's female monarch as their surrender is framed as a transaction between men. Hence we have a complex series of representations of rebellion and submission where the categories do not appear discrete. A seeming return to obedience still contains discordant elements such as the desire for a male leader which are identical in both Stukley's and the Scots' descriptions.

How, then, should we read these passages? It seems that there is within England's command structure a failure to offer the kind of leadership which would control either the nation's subjects or England's enemies and rivals. In such a climate, even Harbart, the most orthodox of the characters in the play, has not the resources successfully to lead and control his men, or to deal with threats to the nation's integrity. And Stukley's treason seems as much motivated by failures of military government as by his own inadequacies. Audacious, aggressive characters such as a Stukley or an Essex need to be controlled by a 'chivalric' male monarch. Hence fault appears to lie further up the chain of command, since Elizabeth's gender precludes her from taking personal control of the situation. In the representations of unnatural and monstrous London and Ireland we see the consequences of the government of a woman. The men – directly or implicitly – mourn the lack of a male leader who will take control of the situation. Stukley's response is to seek employment in the service of King Philip of Spain; the Scots' response is to represent Ireland's deputy as a king. Both solutions implicitly mark the absence of a male monarch in England.

The text's search for good leadership is continued in the last two geographical locations of the play, Spain and North Africa. Similar to the London and Irish scenes, we see staged in the latter half of the play several different styles of male leadership. The text debates and compares the success and worth of various authority figures, including Sebastian of Portugal, Philip of Spain, Stukley, and Hernando, Governor of Cales. In the first Spanish scene, Stukley swiftly bests Governor Hernando. Imprisoned and with his Irish horses confiscated by Hernando, once the Governor's back is turned Stukley is quickly released by Hernando's wife, who appears to find the handsome Englishman irresistible. However, once in Philip's court, although Stukley appears to be successful in effecting the release of his horses and in gaining Philip's favour – he even rescues Vernon from difficulties with a Spanish *lantado* (coastguard) over whether the ship he was travelling on was a 'wreck' – it is clear that he is completely duped by the Spanish King's manipulative schemes. As soon as Philip appears on stage he unambiguously assumes the role of the villain of the play.

King Philip appears to go along with his nephew Sebastian's desire to help Muly Mahamet regain his throne, yet he is really plotting his brother-king's downfall as, like the Philip of *The Battle of Alcazar*, he wants Sebastian to die in North Africa ('many years have wisht that portingall, / And fruitfull Castile being one continent, / had likewise bin the subiect of one Scepter' (1669–1671)). Philip's duplicity is fully revealed prior to Stukley's arrival at court and hence the Spanish king's charm and generosity to Stukley are inevitably viewed with suspicion by the audience. Philip's delight in his own duplicity is revealed immediately prior to Stukley's entrance as he questions his counsellors explicitly about whether his 'plot' is 'too severe, ambitious / and more deceitfull than becomes a king' (1694–1696). His counsellors, given their inferior position, of course represent his scheming as an asset, claiming 'that which in meane men would séeme a fault, / as leaning to ambition or such like, / Is in a king but well beséeming him' (1699–1701). In the scenes that follow, Philip courts Stukley: he enters rooms physically leaning on him, seems to take his part in his quarrel with Hernando, and releases Vernon, and the ship and goods he was sent on, from seizure as spoil by the Spanish coastguard. Yet such behaviour is all show, and Philip – like the stereotypical stage Machiavel – soon congratulates himself on fooling Stukley.

> Are not these English like their country fish
> Cald gudgeons: that will bite at every bate:
> How easily the credulous fooles beléeve,
> The thing they fancy, or would wish of chaunce,
> Using no preceptes of art prospective. (2160–2164)

Hernando reinforces Philip's derisory opinion of the English: 'generally I censure the English thus, / hardy, but rash, wittie, but overweaning / Els would this English hot braine weigh thintent / Your highnes hath in thus imploynyng him' (2172–2175). Finally, and even more damningly, Philip reveals the full scope of his plan:

> It is not for love,
> We beare this nation that we grace him thus,
> But use him as the agent of our guile,
> For if the matter were of great import,
> Or that we would kéepe touch with Portingall,
> And aide his voyage into Barbarie,
> Stukley should have no hand in these affaires…
> So are we rid of a fond Englishman. (2176–2190)

Was the late sixteenth-century audience supposed to react to this scheming monarch only with distaste? Or is the text's representation of Philip rather more complex?

At one level the text's hostile depiction of a corrupt Philip II is undoubtedly indebted to widespread distrust and anxieties in the England of the 1590s concerning Spanish ambitions. Throughout the decade it was believed that Philip's growing fleet was only awaiting an opportune moment to launch a second invasion attempt, probably from Ireland (hence giving an added resonance to the play's earlier representation of rebellion in Ireland). In the summer of 1595, for instance, there were acute fears that at attack was about to be launched, fears seemingly confirmed in July by a Spanish raid on Cornwall and the circulation of 'certain knowledge' that 'the preparations in Spaine' were 'farre greater than in the year 1588'.[66] Consequently, the scheming Philip in *The Famous Historye* is entirely in keeping with contemporary hostility to Spanish designs. According to Essex, for instance, the Spanish were 'an insolent, cruell and usurping nation that disturbed the common peace, aspired to the conquest of my countrey, and was a generall enemie to the liberty of Christendome', and their territorial designs should be aggressively rebuffed through continued military support of the French king Henry IV's campaign against Spain and of the war in the Netherlands.[67]

However, the text's representation of Philip also has its more troubling aspects, since the Spanish king might be seen as possessing significant similarities with England's own monarch. Indeed, in Philip – as in Elizabeth – we have another monarch who does not take an active part in the military activities to which he commits himself, instead remaining safely at his own court while the men whom he employs and misleads undertake the military campaigns. Like England's Queen, he promises a great deal in terms of soldiers and arms, but then fails to deliver them. In the mid-to-late 1590s, in particular, as Paul E. J. Hammer has argued, there was a sizeable and influential group of gentlemen, headed by Essex, who felt that Elizabeth's war policy was too weak. Such men believed 'that England's natural role was as the champion of a Europe freed from the domination of Spain, that martial endeavour was a sign of the nation's vitality, and that 'merit' must not go unrewarded'.[68] The Queen's vacillation, for instance over whether to support the projected expedition of Sir Francis Drake and Sir John Hawkins against Panama in September 1595 (which eventually grew into Essex's Cadiz expedition of the following year), can be seen reflected in Philip's behaviour. Indeed, in 1596 a heated debate raged

amongst the Queen's council over whether Essex should be allowed to establish a permanent English presence in Cadiz rather than merely sacking the town. Philip's failure to deliver the promised military support as well as 'his nigardice' (2280) with money – he does not initially give Stukley the full 5,000 ducats he promises him for undertaking the mission to Rome – are clearly resonant of Elizabeth's behaviour as she failed to be expansionist, aggressive or generous enough to match the ambitions of the Essex war party.

Such a reading also explains the subplot in *The Famous Historye* concerning the Spanish *lantado*'s attempt to claim as a wreck the ship Vernon is on. Duplicitously, he lures Vernon and the ship's master off the ship onto Spanish soil in order to claim, according to maritime law, the deserted ship, *The Pelicane*, for Spain. Such acquisitiveness on the part of the king's civil servants as they scheme to seize booty in contravention of the natural justice of the case operates as a coded comment on English bounty laws and the state's seizure of plunder at the time. In the Cadiz and Azores expeditions, for example, Elizabeth's instructions were that any plunder was to enrich the treasury, not her commanders, and booty was supposed to be taken from the fighting men to boost the finances of the crown.[69] In *The Famous Historye*, the *lantado* claims that Vernon has a personal financial concern in the fate of the ship ('I am no Owner nor yet venturer, / I came but in her as a passenger' (2089–2090)), attempting to make Vernon's behaviour appear financially motivated rather than disinterested as he claims. That Vernon is here honest – as Stukley attests ('heare me great king, / If you beléeve this brest have any spark, / Of honor or of Vulger honestie, / Then credite me this gentleman that speaks, / Was never owner of a ship in's life. / Nor Marchant venturer though both trades be good' (2097–2102)) – shows up the state as avaricious. It is clear that neither Vernon or Stukley (since he 'spurned [the] abridged bounty' of the king with his 'foote' (2281)), are motivated by personal greed, but Philip and his council obviously are. Thus the Spanish State's greed here represents both a standard anti-Spanish sentiment but also, more dangerously, a possible reflection of contemporary attitudes to the English crown.

In Stukley, and in Philip, we see articulated two very different interpretations. Since he is the king of England's enemy Spain, Philip's treachery and niggardliness appeal to the most patriotic elements in a contemporary audience; but simultaneously, in so far as he alludes to Elizabeth, his penny-pinching and deception appear much more politically subversive. *The Famous Historye*'s treatment of Stukley also works in this double-

edged way. He is treasonous and self-seeking, but in contrast to *The Battle of Alcazar*, his ambitions are not monarchic. Here his bravery and (certainly in the Spanish and African locations) his personal conduct are both impressive and applauded. Indeed, his ambitions are not significantly out of kilter with those expressed by the Queen's more audacious and swashbuckling subjects in the 1590s such as Essex. In the play's ambiguously sympathetic representation of this treasonous figure, then, we have both an obvious warning of where such failings lead – ignominious death on a foreign battlefield at the hands of one's own mercenary men – but also a word of caution to the English monarch. Despite all the rivalries between them, after fighting gloriously on the battlefield, Stukley and Vernon die together reconciled as friends. Such a death at the hands of Italian troops is a mark of the Englishmen's treason, yet, paradoxically, it is also patriotic as the African adventure prevents war nearer to England. Stukley's bravery and skills act as an indictment of the English regime and leadership that have not been better able to accommodate his talents.

Furthermore, in the triumphant Barbary king's desire to skin and stuff his nephew Muly Mahamet's body 'to be borne about, / through all the partes of our Dominions, / to terefie the like that shall pursue, / to lift their swords against their soverayn' (2905–2908) we have another gruesomely ambiguous image. Since Muly Mahamet was a traitor, such a bloody display against usurping royalty is conformist. However, similar to *The Battle of Alcazar*, the claims of both men to the throne were justifiable ones (the losing side's based on inheritance from father to son, the winner's on siblings inheriting in turn). This open display of contempt for the royal body (Muly Mahamet), coupled with the representation of a seductive and potent traitor (Stukley), as well as a traitorous monarch (Philip), indicates that *The Famous Historye* should be seen as a coded criticism of both the person and policies of England's Queen. The bloody civil war between Muly Mahamet and Abdelmeleck for the Barbary throne can be seen as a geographically displaced rehearsal of contemporary anxieties about the English succession. In the latter years of Elizabeth's reign, with the issue of succession still formally unresolved, and with her subjects forbidden from explicitly discussing the situation, it is in dramas such as Peele's *Battle of Alcazar* and *The Famous Historye* that we find an outlet for these concerns. Of course, despite the official ban on discussion of Elizabeth's successor, texts on the issue were still circulated or published (often abroad, or illegally). For instance, Spanish propaganda by the Jesuit Robert Parsons, entitled *A Conference about the Next Succession to the Crown of England*

(1594), argued that James's claim was inferior to that of Philip of Spain and the Infanta Isabella Clara Eugenia, descendants of John of Gaunt.[70] Parson's attack on James's hereditary claim to the English throne provoked robust responses from James, and soon, half-surreptitiously, some verses, books, pamphlets, anagrams and prophecies, many of them never printed, began to make their appearance.[71] The clandestine nature of the debates about the English succession in the last decade of Elizabeth's reign find their echo in the secret and treacherous diplomacy and unstable alliances in these two plays. On one level, Moorish and Spanish intrigues are unequivocally condemned in the plays; but on another, there is a 'perverse dynamic' in which the failures of government can appear as an indictment of the English Queen. It is Stukley's ambiguous masculine unruliness that connects the two antithetical readings.

Notes

1 On conduct literature for women in this period see Merry E. Weisner, *Women and Gender in Early Modern Europe* (Cambridge: Cambridge University Press, 1993), pp. 117–145; Suzanne Hull, *Chaste, Silent and Obedient: English Books for Women 1475–1640* (San Marino CA: Huntington Library, 1982); on conduct manuals for men, and the differences between those for men and women (for instance Richard Braithwait's *The English Gentleman* (1630) and *The English Gentlewoman* (1631), see Eve Rachel Sanders, *Gender and Literacy on Stage in Early Modern England* (Cambridge: Cambridge University Press, 1999), pp. 11–56.

2 Bruce R. Smith, *Shakespeare and Masculinity* (Oxford: Oxford University Press, 2000), pp. 39–66; see also, Mark Breitenberg, *Anxious Masculinity in Early Modern England* (Cambridge: Cambridge University Press, 1996); Anthony Fletcher, 'Manhood, the Male Body, Courtship and the Household in Early Modern England', *History*, 84 (1999), 419–436.

3 See Mary Fuller, *Voyages in Print: English Travel to America, 1576–1624* (Cambridge: Cambridge University Press, 1995), pp. 85–140

4 John Smith, *Generall Historie*, in *The Complete Works of Captain John Smith*, Philip L. Barbour, ed., 3 vols (Chapel Hill: University of North Carolina Press, 1986), II, p. 146.

5 See Jonathan Goldberg, *Endlesse Worke: Spenser and the Structures of Discourse* (Baltimore: John Hopkins University Press, 1981), pp. 49, 132.

6 See Fuller, *Voyages in Print*, pp. 74–79.

7 Jonathan Dollimore, *Sexual Dissidence: Augustine to Wilde, Freud to Foucault* (Oxford: Clarendon Press, 1991), p. 33.

8 For a similar reading see Smith, *Shakespeare and Masculinity*, pp. 46–47.

9 Smith, *Shakespeare and Masculinity*, p. 47

10 See John Yoklavich, ed., *The Battle of Alcazar*, in *The Dramatic Works of George Peele* (New Haven and London: Yale University Press), 1961, p. 221; Judith C. Levinson, ed., *The Famous Historye of the life and death of Captaine Thomas Stukeley* (Oxford: Malone Society, 1975), viii. All references, unless otherwise stated, will be to these editions and are given parenthetically in the text. See also Carol Chillington Rutter, ed., *Documents of the Rose Playhouse*, (Manchester: Manchester University Press, 1999), pp. 107–111.

11 See Andrew Gurr, *The Shakespearian Playing Companies* (Oxford: Clarendon, 1996), pp. 230–257.

12 On Stukley's biography see Yoklavich, 'Introduction', pp. 247–273; Richard Simpson, *The School of Shakespeare* (New York: J. Bouton, 1878), pp. 1–156; Joseph Candido, 'Captain Thomas Stukeley: The Man, the Theatrical Record and the Origins of Tudor "Biographical" Drama', *Anglia-Zeitschrift fur Englische Philologie*, 105 (1987), 50–68; Richard Bagwell, *Ireland under the Tudors*, 3 vols (London: Longman, Green and Co, 1895–1890), II, pp. 196–206.

13 Simpson, *The School of Shakespeare*, pp. 39–48.

14 Simpson, *The School of Shakespeare*, p. 59.

15 Yoklavich, 'Introduction', p. 250.

16 Yoklavich, 'Introduction', p. 252.

17 Robert Seall, *A Commendation of the adventerus viage of the wurthy Captain. M. Thomas Stutely Esquyer and others, towards the Land called Terra florida*, in *Roxburgh Ballads and Broadsides*, Herbert L. Collmann, ed. (New York: Burt Franklin, 1971), pp. 326–239.

18 George Carleton, *A Thankful Remembrance of God's Mercy* (London: Printed by I.D. for Robert Mylbourne, 1624).

19 Anon., *The Execution of Justice in England* (London: Christopher Barker, 1583), reprinted *Harleian Miscellany*, 8 vols (London: T. Osborne, 1744–46), II, pp. 137–155.

20 For readings of Peele's play see Candido, 'Captain Thomas Stukeley', pp. 54–58; Mohamed Hassan Abu-Baker, ' Representations of Islam and Muslims in Early Modern English Drama from Marlowe to Massinger', unpublished PhD thesis, University of Glasgow, 1997, pp. 107–141.

21 Stephen Greenblatt, *Renaissance Self-Fashioning: From More to Shakespeare* (Chicago and London: University of Chicago Press, 1980), p. 194. See also Simon Shepherd, *Marlowe and the Politics of Elizabethan Theatre* (Brighton: Harvester, 1986), pp. 142–177.

22 On *Tamburlaine*, see Abu-Baker, 'Representations', pp. 51–106.

23 The Muslim threat to English ships and trade in the Mediterranean only subsided around 1622 when England's ambassador, Sir Thomas Rowe, signed an agreement in Constantinople with representatives from Tunis and Algiers. The treaty states that 'the hostility and enmity between them and the English should be annulled and blotted out of memory, and conuerted into a good peace and commerce'. For further details see Richard Knolles, *The Generall*

Historie of the Turkes, from the first beginning of that Nation to the rising of the Othoman Familie: will all the notable expeditions of the Christian Princes against them. Together with the Lives and Conquests of the Othoman Kings and Emperours. Faithfully collected out of the best Histories, both auncient and moderne, and digested into one continual Historie until this present yeare 1603, (London: Adam Islip, 1603), pp. 1439; see also Paul Coles, *The Ottoman Impact on Europe* (London: Thames and Hudson, 1968); Norman Daniel, *Islam, Europe and Empire* (Edinburgh: Edinburgh University Press, 1966); Albert H. Hourani, *Europe and the Middle East* (London: Macmillan, 1980); Daniel Goffman, *The Ottoman Empire and Early Modern Europe* (Cambridge: Cambridge University Press, 2002).

24 Greenblatt, *Renaissance Self-Fashioning*, p. 19. For alternative readings of space in this play see Bernhard Klein, *Maps and the Writing of Space in Early Modern England and Ireland* (Basingstoke: Palgrave, 2001), pp. 15–20; Mark Thornton Burnett, 'Tamburlaine and Marlowe – An Elizabethan Vagabond', *Studies in Philology*, 84 (1987), 308–323; Emily C. Bartels, *Spectacles of Strangeness: Imperialism, Alienation and Marlowe* (Philadelphia: University of Pennsylvannia Press, 1993).

25 See Peter Hyland, 'Moors, Villainy and *The Battle of Alcazar*', *Parergon*, 16 (1999), 85–99, p. 90.

26 On the identity of the Irish Bishop – as either Bishop of Cashel, Killala or St Asaph – see Yoklavich, 'Introduction, pp. 267–268.

27 On Peele's biography see *Dictionary of National Biography*, Sir Lesley Stephen and Sir Sidney Lee, eds (London: Smith, Elder, 1885–1900), XV, pp. 670–674.

28 See Shepherd, *Marlowe and the Politics of Elizabethan Theatre*, pp. 146–147.

29 Peter Wentworth, *A Pithy Exhortation to Her Majesty* (Edinburgh: Robert Waldegrave, 1598).

30 On the history of England's Moroccan connections in this period see Jack D'Amico, *The Moor in English Renaissance Drama* (Tampa: University of Florida Press, 1991), pp. 7–40, p. 30.

31 Hyland, 'Moors, Villainy and *The Battle of Alcazar*, p. 96.

32 See, in particular, Emily C. Bartels, 'Making More of the Moor: Aaron, Othello, and Renaissance Refashionings of Race', *Shakespeare Quarterly*, 41 (1990), 433–454, p. 434; see also Ania Loomba, *Gender, Race, Renaissance Drama* (Manchester: Manchester University Press, 1989), p. 46.

33 See Jack D'Amico, *The Moor in English Renaissance Drama*, pp. 81–84.

34 Hyland, 'Moors, Villainy and *The Battle of Alcazar*, p. 99.

35 For a similar reading see Shepherd, *Marlowe and the Politics of Elizabethan Theatre*, pp. 145–148.

36 The phrase 'citizen of the world' is one used by Joseph Candido in 'Captain Thomas Stukeley', 55.

37 Candido, 'Captain Thomas Stukeley', 58.

38 In the Quarto edition (1594) of the text it is Jonas and Hercules that kill Stukley.

W. W. Greg and Yoklavich have convincingly argued that this edition
represents a condensed version of the original play performed, they believe, by
a smaller cast. Hence Hercules and Jonas double up as the Italians in this
edition. However the longer, original version (which has not survived) would
have differentiated between the English captains and the Italian soldiers. See
W. W. Greg, *Two Elizabethan Stage Abridgements* (Oxford: Malone Society,
1923), pp. 11–77; Yoklavich, 'Introduction', pp. 277–292.

39 For an excellent study of this issue see A. N. McLaren, *Political Culture in the
Reign of Elizabeth I: Queen and Commonwealth* (Cambridge: Cambridge
University Press, 1999).

40 McLaren, *Political Culture in the Reign of Elizabeth I*, pp. 105–133.

41 See Derek Wilson, *Sweet Robin: A Biography of Robert Dudley, Earl of Leicester,
1533–1588* (London: Hamilton, 1981).

42 See Susan Frye, 'The Myth of Elizabeth at Tilbury', *Sixteenth Century Journal*,
23 (1992), 95–114.

43 George Peele, *A Farewell. Entituled to the famous and fortunate generalls of our
English forces: Sir John Norris and Syr Frauncis Drake Knights* (London: John
Charlewood, 1589); *An Eglogue. Gratulatorie. Entituled: To the right
honorable, and renowmed shepheard of Albions Arcadia: Robert earle of Exxex
and Ewe: for his vvelcome into England from Portugall* (London: J. Windet for
Richard Jones, 1589). I am grateful to Paulina Kewes for this reference.

44 See Yoklavich, 'Introduction', p. 254.

45 Levinson, 'Introduction', pp. v–x.

46 See Yoklavich, 'Introduction', p. 254.

47 For the complexities of these scholarly arguments see Yoklavich, 'Intro-
duction', pp. 254–263.

48 For further details see Bagwell, *Ireland under the Tudors*, II, p. 196.

49 In fact the Stukley family were from Devon. See Bagwell, *Ireland under the
Tudors*, p. 196.

50 See Richard Helgerson, *Forms of Nationhood: The Elizabethan Writing of
England* (Chicago: University of Chicago Press, 1992), p. 170.

51 See Ciaran Brady, 'Shane O'Neill Departs from the Court of Elizabeth: Irish,
English, Scottish Perspectives and the Paralysis of Policy, July 1559 to April
1562', in *Kingdoms United? Great Britain and Ireland since 1500: Integration
and Diversity*, S. J. Connolly, ed. (Dublin: Four Courts, 1999), pp. 13–39; for an
earlier influential account of Shane O'Neill's visit see James Hogan, 'Shane
O'Neill comes to the court of Elizabeth', in *Féilscríbhinn Tórna: Essays in Honour
of Tadhg Ua Donnchadha*, Séamus Pender, ed. (Cork: Cló Ollsoile, 1948), pp.
154–170.

52 Tomás Ó Laidhin, ed., *Sidney State Papers 1565–70* (Dublin: Irish Manuscripts
Commission, 1962), p. 18.

53 T. W. Moody *et al.*, eds, *A New History of Ireland*, 10 vols (Oxford: Clarendon,
1976), III, pp. 84–86.

54 Moody *et al.*, *A New History of Ireland*, p. 86.

55 Bagwell, *Ireland under the Tudors*, II, pp. 265–267. On the meetings in Dundalk see also Hiram Morgan, *Tyrone's Rebellion: The Outbreak of the Nine Years War in Tudor Ireland* (Woodbridge, Suffolk: Boydell and Brewer, 1993), pp. 147–154, 161–165. On Hugh O'Neill see Andrew Hadfield and John McVeagh, eds., *Strangers to that Land: British Perceptions of Ireland from the Reformation to the Famine* (Gerrard's Cross: Colin Smythe, 1994), pp. 88–96.

56 Hadfield and McVeagh, *Strangers to that Land*, p. 89.

57 These lines seem to be a version of those of a contemporary balladmonger '"Make much of me, dear husband," did she say. / "I'll make much more of thee," said he, / "Than any one shall, verily:" / And so he sold her clothes, and went his way'. Quoted by Bagwell, *Ireland under the Tudors*, II, p. 197. For a full copy of the ballad see Simpson, *The School of Shakespeare*, pp. 144–148.

58 Calvagh O'Donnell was killed in 1566 and Hugh O'Donnell succeeded him.

59 See Morgan, *Tyrone's Rebellion*, p. 29; Moody *et al.*, *A New History of Ireland*, p. 92.

60 See Paul E. J. Hammer, *The Polarisation of Elizabethan Politics: The Political Career of Robert Devereux, 2nd Earl of Essex, 1585–1597* (Cambridge: Cambridge University Press, 1999), pp. 222–234.

61 See Hammer, *The Polarisation of Elizabethan Politics*, pp. 231–232.

62 Quoted by Hammer, *The Polarisation of Elizabethan Politics*, p. 221.

63 See Hammer, *The Polarisation of Elizabethan Politics*, pp. 223–224.

64 See Levinson, 'Introduction', *The Famous Historye*, p. vii.

65 On the relationship between James and Elizabeth and on the issue of succession see D. H. Willson, *King James VI and I* (London: Jonathan Cape, 1956), pp. 138–158.

66 Quoted by Hammer, *The Polarisation of Elizabethan Politics*, p. 247.

67 Samuel Purchas, *Hakluytus posthumus: or Purchas his Pilgrimes: Containing a History of the World in Sea Voyages and lande Travells by Englishmen and others*, 20 vols (Glasgow: James Maclehose & sons, 1905-7), XX, pp. 68–69. See also Paul E. J. Hammer, 'Patronage at Court, faction and the earl of Essex', in John Guy, ed., *The Reign of Elizabeth I: Court and Culture in the Last Decade* (Cambridge: Cambridge University Press, 1995), pp. 65–86.

68 Hammer, 'Patronage at Court', pp. 85–86.

69 Hammer, *The Polarisation of Elizabethan Politics*, p. 223.

70 See Willson, *King James VI and I*, p. 140.

71 See Willson, *King James VI and I*, p. 141.

Gender and colonialism in John Fletcher's *Bonduca* and *The Island Princess*

This chapter focuses on two Jacobean dramas written by the critically neglected, but prolific and successful, playwright to the King's Men, John Fletcher. Only recently have Fletcher's dramas about mercantile and colonial expansion begun to be considered within their historical context, and this attention is long overdue. Previously, as Michael Neill comments, Fletcher has been seen as 'an essentially frivolous theatrical opportunist' who promoted the values of the Stuart court; it is only in recent work by Shankar Raman, Gordon McMullan, Andrew Hadfield and Neill himself that the complexities of Fletcher's treatment of geographic fantasies have started to be explored.[1] In what follows, I also focus on Fletcher's handling of geographic material in order to explore the ways in which Fletcher's treatment of colonialism interacts with Jacobean political anxieties.

My reading of Fletcher's Roman play *Bonduca* (1611–14) reveals the way the defeat of the ancient inhabitants of Britain is indebted to contemporary colonial concerns and, simultaneously, constructs a political allegory that can be seen as questioning the merits of James's policy of *Rex Pacificus*. In my analysis of *The Island Princess* (1619–22), I argue that Fletcher makes available a hostile representation of the difficulties of the monarch's foreign policy, though the displaced nature of the criticism (which is centred on brother and sister royal siblings of Tidore) allows the allegory to remain enigmatic. As we shall see, in both plays Fletcher debates the wisdom of some of the most dearly held orthodoxies of James's reign, but in *The Island Princess*, which was performed before the Court on 26 December 1621, it is possible to detect a level of coded didacticism. In this later play, Fletcher's mirror for princes makes available allegorical

meanings which seem to refer to three contemporary debates about royal policy and conduct. At one allegorical level, James's own sexual behaviour appears to be censured, but the text can also be seen to intercede in debates concerning the Palatinate – where James's daughter, Elizabeth, was ruler (following her marriage to Elector Frederick V of the Palatinate in February 1613), as well as expressing anxieties about Charles's prospective marriage plans with a Catholic bride.

Colonialism, politics and Romanisation in *Bonduca*

In what follows, I explore the ways that John Fletcher's Roman play *Bonduca* engages with early seventeenth-century British colonial ambitions. The play ends with the defeat of the Britons by a more powerful civilisation and the establishment of the Roman occupation in the British Isles. The rout of the Britons described in this text might, initially, seem unpromising material for Fletcher to use to question the merits of contemporary colonial policies. Yet, through a series of resemblances between contemporary Virginia and pre-Christian Britain, between ancient British characters and contemporary or near-contemporary monarchs and through the dramatisation of questions concerning the benefits and drawbacks of 'Romanisation', this is exactly what the play achieves.[2]

The difficulties the Romans face in the hostile environs of pre-Christian Britain in *Bonduca* possess considerable similarities to those experienced by the British on the northern seaboard of America in the early seventeenth century. Furthermore, the internal differences in the camps, especially that of the Britons (where Caratach and Bonduca have antithetical styles of leadership), can be read in terms of the colonial policies of James I and his predecessor Elizabeth I. Fletcher's representation of the Britons works in several ways. On one level, they represent indigenous inhabitants in a colonial terrain inevitably succumbing to the power and control of a more advanced civilisation. At the same time, the factions within the Britons' camp, the personalities of rival leaders, and the attitudes of individual Britons to invasion and processes of Romanisation, all act as ways of measuring the success of the colonial policies and leadership of the current monarch and his immediate predecessor. The Romans represent an alien and hostile conquering force finally defeating the Britons, but they also imaginatively stand in for the British in contemporary Virginia. From the beginning of Act I we are invited to think of *Bonduca* as a colonial text. Petillius, one of the Roman captains, discusses with his commanding

officer the reasons why the Roman occupation of Britain is not secure. He suggests that the problems the Romans currently face – of ill discipline and lack of food – have 'lost the Colonies, and gave Bonduca / (With great shame we must record it) time and strength / To look into our Fortunes' (I, ii, 176–178). Indeed, as we shall see, because of the difficulties the Virginia colony experienced in its dealings with Algonkian Indians in the early decades of the seventeenth century, the Romans' relatively easy defeat of the ancient Britons in *Bonduca* can be seen as a potent fantasy of colonial success in terms of current British ambitions. Yet the rout of the Britons also represents the end of independence from foreign control. Since these conflicting views are articulated by the text at the same time, *Bonduca* continuously questions their merits without offering easy solutions to the moral conundrum as to whether the Romans or Britons possess more honour.[3] As the ancient Britons represent native Americans in the play, the audience is invited to support their subjugation: as they represent 'British' independence, their defeat is, of course, a mournful affair.

In the critical debate about *Bonduca* there has been disagreement concerning which of the warring sides is shown to deserve the victory. Until recently most commentators argued that in the military conflict between the ancient Britons and Romans, Fletcher consistently revealed the Romans to be more honourable, masculine and virtuous.[4] Paul Green, in particular, suggests that although the play's structure presents alternate scenes in the camps of the two sides, nevertheless the Roman characters are more numerous and more individualised than their British counterparts.[5] Fletcher's apparent support for the Romans is read as the 'impugning [of] the values of English society' as Fletcher 'contrast[s] the heroic life of a soldier with the corrupt ease of what can readily be construed as the Jacobean court'.[6] However, Andrew Hickman persuasively argues that Fletcher's sympathies were not unequivocally on the Roman side.[7] In his view Fletcher presents his audience with a puzzle concerning which side possesses the most honour. The play 'alludes to an ideal standard by which both sides have shortcomings' and these 'ambiguous contrasts ... become the subject of a catechism ... which the audience is encouraged to answer'. But the mystery is impossible to solve since upon 'meticulous inspection' the play's 'façade[s] of antithesis ... turn instead into ambiguous parallels'.[8] Building on Hickman's analysis, Ronald Boling and Julie Crawford have shown, respectively, that Fletcher's representation of Caratach should be recognised as satiric and that Caratach's vacillation to Rome at the end of the play – which casts doubt over his ability to serve

Britain – can be seen as a reference to similar uncertainties concerning James's rule (based on anxieties about his relationships with male favourites and concerns over his Scottish or Catholic sympathies).[9]

Extending the analysis by Hickman, Boling and Crawford, I want to suggest here that in *Bonduca* virtue is not located solely on the Roman side. The similarities between the situation of early seventeenth-century Virginian colonists and that of the Romans in Britain complicate a topical reading of Caratach's weaknesses as a reflection of James's monarchical inadequacies. Indeed Caratach's, Bonduca's and Hengo's attitudes to Romanisation can be seen as contributing to an extended discussion of the relative merits of the colonial policy of the reigning monarch, the previous incumbent and the hopes that had been vested in Henry, Prince of Wales until his death. In other words, Fletcher's views are not as unequivocally hostile to James as Boling or Crawford suggests. In this play, as we shall see in my discussion later of Fletcher's subsequent colonial dramas such as *The Island Princess* (1619–22) and *The Sea Voyage* (1622), he was persistently concerned with exploring larger questions concerning interactions between coloniser and colonised as well as intervening in contemporary political debates.

Fletcher's *Bonduca* portrays the triumph of Rome over Britain. Fletcher conflates documentary sources by marshalling three famous, but historically diverse, figures of British resistance against Rome into one play. Nennius fought Julius Caesar in single combat, and Caratach and Bonduca put up resistance in different phases of the subsequent Claudian campaign against Britain.[10] *Bonduca* opens with Bonduca, Nennius and Caratach celebrating the successful defence of their homeland against Roman invasionary forces. The play then switches to the Roman army camp, and we see the hungry, war-weary Romans and find that a Roman captain, Junius, has fallen in love with one of Bonduca's daughters, Bonvica. It is soon clear that there are as many divisions in the Roman camp as there are in the Britons' one: Penius, one of the commanders, fails to marshal his troops when the General requests them, and Roman foot-soldiers break ranks to go foraging for food. When the Romans are caught by the Britons, instead of having them executed, as Bonduca desires, Caratach feeds and releases them. Furthermore, when Bonduca's daughter hears of Junius's love she lures him into their camp and ambushes him. Caratach berates Bonvica and her sister for their lack of honour and again releases the Romans. When the opposed forces finally meet they do so in Roman battle formation since Caratach sees only this kind of warfare as 'a Battell worthie of

our winning' (III, v, 64). Though fighting bravely, the Britons are defeated; Caratach and Hengo are forced into hiding while Bonduca refuses to submit to Roman rule and, with her daughters, kills herself. While in Caratach's care, Hengo is killed by the Romans and, in his grief, Caratach surrenders, and the play closes with him about to depart for Rome as a 'noble friend' (V, iii, 185).

The exact dating of *Bonduca* is difficult to identify, since the play was not printed until 1647 when the Beaumont and Fletcher folio was published by Humphrey Moseley, though an earlier manuscript copy in the hand of Edward Knight, book-keeper of the King's Company from the late 1620s, also survives.[11] Andrew Gurr dates the first productions of Bonduca as some time between 1611 and 1614, when it was performed by the King's Company at the Globe and/or Blackfriars theatres.[12] Most recent critics, then, date the composition of the play between 1609 and 1616, that is after Shakespeare's *Antony and Cleopatra* (1606/7) to which Fletcher's play is thematically and structurally indebted. *Bonduca* was most likely written after *Cymbeline* (1609–10) which, similar to Fletcher's play, also ends with apparent harmony between Britons and Romans ('let / A Roman, and a British ensign wave / Friendly together' (V, v, 480–482)).[13] Indeed, Hickman argues for a date after the death of prince Henry (November 1612), suggesting that, like Shakespeare and Fletcher's *The Two Noble Kinsmen* (1613), *Bonduca* was designed through its representation of the character Hengo – described as 'the hopes of Britain' – as a tribute to the late heir to the throne.[14]

Such a time frame makes the play coterminous with, or slightly later than, the setting up of two new British colonies in America, between 34° and 45° north, under royal charter in April 1606.[15] The more southerly regions within these latitudes were colonised under the control of a joint-stock company established in London which financed the first Jamestown voyage and sent three ships to America in December 1606. The founding and early years of the Jamestown colony are documented in the surviving accounts of the first colonists, which were speedily published both separately and in later editions of Hakluyt's compendium, and by Samuel Purchas in his continuation of Hakluyt's work. Captain John Smith, for example, who spent twenty-nine months between May 1607 and October 1609 in Jamestown, published three accounts of the first years: *True Relation of such occurrences and accidents of note as hath happened in Virginia since the first planting* (1608), *A Map of Virginia* published with *Proceedings of the English Colony* (1612), and *General Historie of Virginia, New-England and the Summer Isles* (1624).[16]

A vast number of texts that imagined and celebrated the Virginia project were published in Britain during the first years of the colony. William Symonds, for example, in his 1609 sermon about Virginia described the terrain as 'a Land more like the Garden of Eden: which the Lord planted, than any part else of all the earth'.[17] Michael Drayton's 1606 'Ode to the Virginian Voyage' argued that colonists could expect three overabundant harvests per year from Virginia since the soil was so 'fruitfull', and that they should also expect to find 'pearle[s] and gold'.[18] As we have already seen, dramatic texts of the period frequently include references to the Virginia project or other mercantile and commercial enterprises, and use them to express support for or dissatisfaction with current colonial policies or their advocates. In the first edition of Jonson, Chapman and Marston's *Eastward Ho* (1605), for example, Seagull praises Virginia whilst simultaneously attacking the Scots – and hence implicitly the King – who are 'disperst over the face of the whole earth' even into Virginia.[19]

In Fletcher's *Bonduca*, the key problem the Romans face in their invasion of Britain is the adequate victualling of their army. At the beginning of the play the Roman troops are starving, arguing that they are too hungry to to fight:

> For mine own part, I say, I am starv'd already,
> Not worth another bean, consum'd to nothing,
> Nothing but flesh and bones left, miserable. (I, ii, 81–83)

The troops' complaints are harshly and unsympathetically received by their commanding officers. Petillius, one of the captains to whom the troops complain (described in the dramatis personae as 'somewhat wanton'), sarcastically advises the hungry soldiers to do as his own troops do and consume the indigestible:

> Ye rogues, my Company eat Turf, and talk not;
> Timber they can digest, and fight upon't;
> Old matts, and mud with spoons, rare meats. Your shoes, slaves,
> Dare ye cry out of hunger, and those extant?
> Suck your sword-hilts, ye slaves, if ye be valiant. (I, ii, 105–109)

Fletcher here refers to the perennial problems of establishing and maintaining lines of supply for invasive and colonising forces, and of maintaining discipline when food ran short. Petillius's unsympathetic response to the soldiers' plight does not represent the Roman command in a positive light. Indeed, just moments earlier he had been trying to cajole his fellow captain Junius out of his obsessive love for Bonduca's youngest daughter

with promises of feasting and carousing with the General's 'new wine, new come over' (I, ii, 46). The soldiers' response – which is to desert their posts and forage for victuals in the Britons' camp – is certainly not supported by the text, but it is partially explained by the Roman command's lack of care for their foot soldiers.

The early years of the Jamestown colony were characterised by a chronic shortage of food, which lasted until the colony was able to feed itself (which did not occur until the 1630s). In the first thirty years, then, starvation was a continual problem as the colonists had to await supplies sent from Britain to supplement their own crops or trade with the Algonkian or other Indian tribes for food. This concern over the maintenance of adequate food supplies is repeatedly revealed in both the instructions dispatched by the London administration of the Virginia Company and in the accounts of the early settlers themselves. For example, the stringent *Lawes Divine, Moral and Martial* were implemented in 1610 to control the recalcitrant colonial population who persisted in searching for gold rather than growing crops.[20] Such behaviour had led to what has become known as the 'starving time' in Jamestown during the winter of 1609–10. When Sir Thomas Gates arrived in the colony in 1610 with supplies he was greeted by the pitiful sight of endemic malnutrition:

those wch weare Liveinge were so maugre and Leane that itt was Lamentable to behowlde them for many throwe extreme hunger have Runne outt of their naked bedds beinge so Leane thatt they Looked Lyke anotamies Cryeinge owtt we are starved We are starved.[21]

Temperance in the face of such deprivation became, as we have already seen, one of the key ways in which either national or individual superiority was asserted.[22] For instance, Captain John Smith's 1612 account of his activities in Jamestown (*Proceedings of the English Colony*) rhetorically manipulated his survival skills – both to provide food for other colonists through successful hunting or trade and to manage his own hunger – as signs of his own supremacy.[23] The Algonkians so esteemed Smith that 'every other day brought such plenty of bread, fish, turkies, squirrels, deare, and other wild beasts, part they gave him as presents from the king; the rest, hee as their market clarke set the price how they should sell'.[24] Smith's pre-eminence is both cultural, that is a reflection of European mastery, and individual, since Smith has special qualities that the other colonists do not possess and the Algonkians appear to recognise.

Access to food is essential to the plot of *Bonduca*. Judas and his cohorts desert their posts in order to satisfy their hunger. When they are

captured during their foray, the reactions of different Britons to their plight act as indicators of their captors' relative moral standing. Bonduca and her daughters see their Roman prisoners merely as enemies, treating them like animals by putting halters round their necks. Bonduca intends to hang the Romans without feeding them after ordering her daughters first to 'Torment 'em' (II, iii,14). In the lines that follow, appetite for food is replaced by sexual appetite as the daughters tease the Roman soldiers with promises of sexual fulfillment prior to death (II, ii,17–32). The sexualised nature of this interchange (which reflects well on neither group), shows the way contact with women is associated with corruption and, ultimately, death in this play. When Caratach enters, he is disgusted by the treatment meted out to the soldiers by the women and swiftly orders that their hunger be satisfied with 'wine and victuals' (II, iii, 57). Caratach's sense of honour demands that hospitality be offered to the Romans in order to ensure a good battle when the armies do meet. That such a policy is admirable does not seem to be questioned by the text. Yet though Caratach obviously does not seek a dishonourable 'easie conquest of 'em' (II, ii, 114) (which the women seek through their plan to lure Junius and his cohorts into the camp), the military wisdom of Caratach's scrupulous conception of honour is questioned. First Nennius demands 'Are they not enemies?' (II, iii, 37) and then Hengo asks Caratach whether the Roman soldiers he is so generously feeding share his conception of honour: 'Do not the cowards eat hard too?' (II, iii, 76). The idea that Caratach's generosity to enemies will not be matched when he, following the Britons' defeat, is starving, is prepared for by Nennius's and Hengo's circumspection. Caratach blithely tells Nennius 'I'll answer all, Sir' (II, iii, 53), which indeed he does, though not in the way he intended. In different ways, then, both British leaders' attitudes to satisfying Roman appetites are shown to be misguided: Fletcher uses both Caratach's generosity with food and Bonduca's conflation of food and sex as indications of their respective inadequacies as military commanders and tacticians.

 After the Britons' defeat, the lack of food is also crucial in bringing about Hengo's death and Caratach's final submission to Rome. Even though they are hidden in the hills of their own country, Caratach and Hengo are unable to feed themselves. Caratach expects that he will find stashes of food secreted by the 'valiant charitie' of a 'gentle Britain' (V, iii, 11). However, Judas and Macer appear to know the Britons' tactics, presumably through their foray into the Britons' camp earlier and Caratach's obliging treatment. Hence, their baited trap – with meat and a bottle hung over a

rock 'as though the Britains stole hither to relieve him' (V, iii, 1–2) – is successful since Caratach believes it to be the action of some 'blessed Britain' (V, iii, 100). The Romans' successful reading of their tactics here negates the advantages the Britons should expect to enjoy – better access to food supplies based on superior knowledge of the landscape and help from other indigenous inhabitants.

Both the difficulties the Romans experience in the early scenes concerning the victualling of their invasion force, and the starvation Hengo and Caratach suffer at the end, are similar to those experienced by the British in Jamestown during this period. George Percy describes the desertion of colonists during the famine: 'To eate many oure men this starveinge Tyme did Runn away unto the Salvages whome we never heard of after'.[25] In terms of access to food, then, both Romans and Britons have similar problems. Fletcher, in his representation of starvation for both coloniser and colonised, is showing the unstable nature of the boundary between them. Indeed, Caratach who in the early scenes of the play had been so open-handed with supplies to his enemies, by the end of the play contemplates eating them as he offers Hengo 'a Romane's head' provoking Hengo to reply 'Good provision. Before I starve, my sweet-fac'd Gentleman, / I'll try your favour' (IV, ii, 78–81). The Britons' threatened cannibalism is similar to that believed to be endemic amongst indigenous American inhabitants as well as, more troublingly, referring to the recent outbreak amongst Jamestown colonists who turned cannibal in the starving time.[26] Here Caratach's and Hengo's contemplation of cannibalism encapsulates their liminal status as they simultaneously represent both coloniser and colonised.

Petillius and Junius find discipline impossible to maintain in the face of starvation; their troops leave their posts, and both captains become at different points in the play lovesick for Bonduca's daughters. Junius wants to marry Bonvica and by keeping an assignation with her almost misses the battle; Petillius finds himself sick with the 'love-bots' (V, ii, 10) inspired by the brave death of Bonduca's eldest daughter. Colonists' desires for indigenous women were believed to represent a dangerous threat to the integrity of the colony since 'going native' in such a way meant that the men's loyalties were likely to be divided. Such was the perceived seriousness of the problem that in 1620 the Virginia Company in London was busily advertising for English women to be sent over to Virginia to be wives to the colonists (each woman would cost her prospective husband 150 pounds of tobacco).[27] Furthermore, when the colonist John Rolfe was

contemplating marriage to the Algonkian princess Pocahontas, he was clearly concerned whether the union was beneficial. Rolfe describes his feelings for Pocahontas in a letter to Sir Thomas Dale of early 1614 as 'intangled & inthralled in soe intricate a Laborinth, that I was even aweried to unwynde my selfe therout' and expresses his worries concerning the consequences of miscegenation through 'marrienge of strange wyves'.[28]

Rolfe obviously overcame his scruples with the help of 'Almighty God whoe ... opened the Gate and ledd me by the hande that I might playnely see and dicerne the safest pathes wherein to treade' since the marriage was designed to improve the cultural harmony between the colonists and Algonkians. As Ralph Hamor records in his account of the marriage (not published until 1625), 'ever since we have had friendly trade and commerce'.[29] That Rolfe had the permission of the Governor before undertaking a marriage with Pocahontas (and that James I was consulted) marks this particular union as different from the promiscuous intermingling feared by the colonial administrators and government. Nevertheless, Rolfe's soul-searching and the soliciting of opinions from notable concerned parties reveals the depth of the anxiety regarding marriage between people of different races. Certainly Junius's and Petillius's feelings for Bonduca's daughters have detrimental effects on their military prowess, making their judgement and bravery uncertain. In order to shock Junius out of his intemperate desire for Bonduca's daughter, Petillius persuades the herald to read out a mock-order from the General stating that 'lovers must not come neer the Regiments, for fear of their infections' and 'If any common soldier love an Enemie, hee's whipped and made a slave: If any Captain; cast, with losse of honours, flung out o'th'Army, and made unable ever after to bear the name of a Souldier' (II, ii, 58–62).

A Virginian context for this play is also suggested by the way in which the Britons are described by the Romans as able to blend in with their environment, take advantage of their superior knowledge of the terrain and prevent the Romans from using their favoured military tactics of open battle:

> The hills are wooded with their partizans,
> And all the valleys over-grown with darts,
> As moors are with rank rushes: no ground left us
> To charge upon, no room to strike ...
> They are so infinite, so ever-springing,
> We shall be kill'd with killing. (I, ii, 192–198)

After the introduction in 1610 under Lord de la Warr of more aggressive instructions from the Virginia Company in London, colonists' relations

with native Americans were much more hostile and the Indians were fre-
quently described as 'treacherous' ('a daily daring treacherous people').[30]
Smith's description in the 1612 *Proceedings of the English Colony* of the
origin of his Algonkian captivity shows the way the Indians were able to
take advantage of their superior knowledge of the terrain, using sniping
tactics to pick off his men rather than confronting them in open battle.
When his boat became too large to travel up the Chickahominy river,
Smith continued with two English men and two Indian guides in a smaller
canoe, leaving the boat in a safe place 'out of danger of shot' and instruc-
ting the remaining men that 'none should goe ashore till his returned'.
Despite Smith's command the remaining men disobeyed his orders, 'went
ashore' giving 'both occassion and opportunity to the Salvages to surprise
one George Casson, and much failed not to have cut of the boat and all the
rest'. Meanwhile, further up the river Smith and his companions also
suffered from an ambush attack. While Smith and an Indian guide went
searching for food, the two men he left guarding the canoe were 'slaine (as
is supposed) sleeping'; Smith himself was captured not through lack of
military prowess but because of the inhospitability of the terrain ('slipping
into a bogmire they tooke him prisoner').[31]

In *Bonduca* the Romans defeat the Britons precisely because the con-
flict is conducted under European warfare conventions of open pitched
battle. As Petillius's speech quoted above makes clear, if the war continued
without such a meeting, then the advantages of familiarity of terrain and
superior numbers were all on the side of the Britons. It is only because
Caratach obligingly insists on fighting using European methods of war-
fare, rather than relying on a slow war of attrition gradually wearing down
the starving Romans, that the invaders are successful in their campaign.
His adoption of Roman military tactics, which leads to defeat, shows the
text questioning the merits of the process of Romanisation. Like his later
contemplation of cannibalism, Caratach's Romanisation here shows the
categories of coloniser and colonised – Roman and Briton or Briton and
indigenous American – collapsing into each other. Bonduca and her
daughters' rather more devious military tactics – which rely on deception,
treachery and attrition – represent the only way that the Britons could have
successfully defended their territory. Indeed, it is precisely such
treacherous tactics which Judas, a Roman, employs in order to overcome
Caratach by flushing out the starving Hengo with the baited snare.

The Romans' descriptions of the marauding Britons as 'painted
wasps' (I, ii, 215) also suggests an American context. Five engravings by

John White of ancient British inhabitants (three pictures of body-painted Picts, two of Britons) were appended to White's pictures of Algonkian Indians. These were included in Theodor de Bry's 1590 edition of Thomas Hariot's *A Briefe and True Reporte of the New Found Land of Virginia*.[32] The ancient Britons' art of body painting, which Fletcher refers to in *Bonduca*, was used by other contemporary commentators to indicate similarities between Native American cultures and those of the early inhabitants of Britain. Given Fletcher's link with Sir Henry Hastings – a keen supporter of the Virginia enterprise who was admitted as a member of the Company in 1612 – it is tempting to speculate that Fletcher was aware of the parallel.[33]

This play, then, asks important questions concerning whether the Romans or the Britons deserve to win the conflict and comes, I believe, to only a provisional conclusion. We are shown divisions within both camps – between Bonduca and Caratach on the Britons' side and between the Roman leader Suetonius and his tribune Penius, as well as between the leaders and the troops on the Roman side. These internal divisions are never binary in the sense that neither side is represented as wholly correct in its conception of 'virtus'.[34] The ambivalence of these internal divisions mirrors the instability of the larger divide between the Britons and the Romans, where honour is not shown as the exclusive moral property of either side. Furthermore, the way in which that honour is so precariously balanced between the Romans and the Britons resembles the kind of descriptions colonists were producing about Native American culture in the Virginia colonies. Gabriel Archer's 1607 comment about the Algonkians captures this ambivalence well: 'They are naturally given to trechery, howbeit we could not find it in our travell up the river, but rather a most kind and loving people'.[35] Similarly, as Peter Hulme points out, colonists were unable to understand gifts of food as simple kindness on the part of Algonkians but instead saw it as an example of endemic inconstancy that was just as likely to prophesy future attack as continued future support.[36] Hence the conclusion to Fletcher's play – where Caratach is taken into the Roman fold and he and Suetonius reach a sort of rapprochement of shared values and mutual appreciation – can be read as a kind of fantasy concerning accommodation between different cultures which attempts to harmonise differences. Bonduca's final lines prior to her suicide foretell this positive cultural miscegenation: 'If you will keep your Laws and Empire whole, / Place in your Romane flesh a Britain soul' (IV, iv, 152–153). Ostensibly, then, this is what does occur at the end of the play but the neat ending does

not answer the central question of whether Romanisation should be celebrated or mourned.

Throughout the play Caratach has been revealed to be the most consistently honourable character. Yet the idea that he might fulfil Bonduca's call for a 'Britain soul' to strengthen 'Romane flesh' is a mistaken one if Britishness is associated with the maintenance of staunch independence from foreign interference (which is what Bonduca's policies represent). In fact, Caratach out-Romans the Romans in terms of honourable and civilised behaviour. He consistently behaves with more Roman 'virtus' than do the Romans; that is, he is more 'soldierly, severe, self-controlled [and] self-disciplined'.[37] The conclusion of the play where Caratach is embraced as 'the valiant Britain' (V, iii, 174), 'Excellent Britain' (V, iii, 178) and described as 'the onely soldier' (V, iii, 192) by the Romans would seem to harmonise all differences as he prepares, paradoxically, to be carried off to Rome in triumph to be treated as a 'friend' (V, iii, 179). Yet the play encourages us to ask both whether Caratach should succumb so readily to the process of Romanisation and what it might mean for the future of the Britons. Suetonius's and the other Romans' rhetoric of honour has not been matched by their actions in the play. For example, Judas's treacherous murder of Hengo is tacitly condoned by the Roman commanders who take full advantage of Caratach's vulnerability in the wake of his nephew's death. Furthermore, the divisions and petty jealousy between the commanders Suetonius and Penius, as well as those between Junius and Petillius, prevent the audience from trusting in the integrity of Roman civilisation. Caratach's transfer of allegiance to Rome at the end of the play presents the audience with something of a problem, as he appears to be deserting his own culture for one which the audience is not convinced is superior. This ending, then, gestures towards anxieties concerning the ambiguous status of 'Romanisation' and its effects on British national identity. Similar concerns are also raised if we read *Bonduca* as a political allegory about the colonial and foreign policies associated with James I, Elizabeth I and the recently deceased Prince Henry, represented by the characters of Caratach, Bonduca and Hengo respectively.

I now want to focus on the ways in which the gender of native British leaders relates to the play's ambivalent dramatisation of whether Britain should be autonomous or acculturated to foreign ways. *Bonduca* has been seen as one of the most 'subtly misogynist' of all the Beaumont and Fletcher plays. Sandra Clark, for instance has argued that it concentrates on a male 'world of honour and glory which is closed to Bonduca' and

shows 'the elimination of the woman who claims power and enacts violence' which 'reinforces values which are definitively gendered male'.[38] However, the topical allegory embedded in Fletcher's play complicates a wholly negative reading of Bonduca and her policies. Although for his representation of the Iceni warrior queen Fletcher rejected the more positive 'victorious Conqueresse' tradition (shown for example in Jonson's *Masque of Queenes* and by Spenser in *The Ruines of Time*), and made his Bonduca militarily incompetent, nevertheless, when compared to Caratach's transfer of allegiance to a Roman power that lacks integrity, Bonduca's staunch independence starts to appear more praiseworthy.[39]

Bonduca might be misdirected in her tactics since her gender precludes her from understanding military matters (Caratach berates her for 'shameful' boasting about her previous victories and tells her, at various points, to go home and spin), but she bravely refuses to submit to Roman control even unto her death. Suetonius offers Bonduca anything ('Make up your own conditions' (IV, iv, 136)) if she will only not kill herself, but she taunts him with his fear of death, asserting that it is she who has the victory since she has no such fears (IV, iv, 140–153). Fletcher's Bonduca evokes nostalgia for the military prowess associated in the second decade of the seventeenth century with Elizabeth and the defeat of the Armada in the 1580s.[40] Though Bonduca's independent Britain fails in Fletcher's play, her policies do not possess the connotations of weakness associated in the second decade of the seventeenth century with the *Rex Pacificus*. Caratach's surrender to Roman control can hence be seen as staging anxieties concerning James's maintenance of independence from foreign control.

The resemblance between Elizabeth and Boadicea had been made explicitly in James Aske's celebration of Elizabeth's Armada victory *Elizabetha Triumphans* (1588). In Aske's epic the bravery of 'Voada, once England's happie Queene' is described as similar to Elizabeth's action of surveying her assembled troops at Tilbury.[41] In Aske's text, Elizabeth – unlike Fletcher's Bonduca – abdicates her right to speak directly to her troops. She authorises her sergeant major to relate her words after she has departed and she is not present during the battle, thus, as Jodi Mikalachki argues, 'protect[ing] her chaste persona from public military engagement, both active and rhetorical'.[42] In Aske's celebration, then, Elizabeth preserves her silence and chastity in the male military environment and her side emerges victorious. Fletcher's Bonduca, by contrast, interferes in inappropriate ways in activities to which her gender gives her only limited access.[43] Though her indomitable spirit is admirable (signalled by the

bravery of her suicide), her bellicosity and the active role she plays in the conflict result in defeat. Fletcher's representation of Bonduca should not be seen as a direct or unambiguous celebration of the late Queen; rather it is only Bonduca's persistent refusal to compromise her own or her country's integrity in the face of invasion that is applauded and also acts as a contrast to Caratach's policy of rapprochement.

Both Caratach's and Bonduca's policies, then, are for different reasons inadequate in maintaining Britain's independence. Like James, Caratach embraces foreign values too easily and is too attached to preserving the peace rather than furthering his kingdom's interests. Anthony Weldon's summary of James as a king that 'lived in peace, dyed in peace, and left all his kingdomes in a peaceable condition', though apparently a compliment in an otherwise vituperative attack, in fact reveals the inadequacy of James's policy since it preserved peace at all costs.[44] As Sir Henry Neville wrote in 1606, 'the Kingdom generally wishes this peace broken, but *Jacobus Pacificus* I believe will scarse incline to that side'.[45] In the second decade of the reign James's foreign policy was even further out of kilter with those courtiers and statesmen who wished to pursue policies of military glory, and the King was frequently attacked for attempting to preserve peace in Europe when, as a Protestant King, his subjects wanted him to be more aggressive against Catholic rivals.[46] Caratach's rather too easy switch of allegiance to those that have proved his relations' enemies and murderers appears then as an analogy with a monarch that might seem to staunch Protestants to vacillate rather too close to Catholicism, the religion of Rome, and promote and favour his native Scots at the expense of English interests.[47]

Moreover, if Bonduca transgresses the limits of appropriate actions defined by her gender, so too does Caratach. In *Bonduca*, military images are persistently cast in homoerotic terms by the Roman commanders, but most noticeably by Caratach, who from the first scene onwards represents military conflict sexually and conflates admiration for Roman prowess with desire. For example, as Suetonius's army advances, Caratach marvels at the sight describing it as though it were a beautiful male body: 'Now I see the Body ... a handsome body, / And of a few, strongly and wisely joynted' and 'see how bravely the Body moves, and in the head how proudly / The Captaines stick like plumes' (III, iii, 3–4,10–11). Caratach's desire for Roman militarism here is, like so much else in this play, ambiguous. On one hand it marks an abdication of the style of British independence represented by Bonduca's aggression specifically, and sniper tactics more generally (and it leads to defeat). On the other, it means

that he is shunning the contacts with women which, the Romans continually assert, result in weakness and military incompetence. For instance, Junius, when in love with one of Bonduca's daughters, describes his feelings as 'the plague' and then corrects himself since his situation is in fact more serious: 'tis far worse; Hell' (II, ii, 10–11). In the final scenes, behaviour associated with women is represented as a military liability since such 'female' behaviour is what finally defeats Caratach. As Mikalachki observes, Caratach takes on a female, domestic role since 'his whole concern ... is the nursing and feeding of the boy Hengo'.[48] Caratach's tender behaviour undermines his military prowess as he allows Hengo to attempt to retrieve the food they see left for them rather than going himself. Because he is male, Caratach should not be behaving as though he were a mother. As Coppélia Kahn argues, the demonstration of the 'feminized private realm of emotion' is 'inimical to manly virtue' in Roman plays, and hence Caratach fails.[49] His 'female' emotions make him vulnerable with the result that when Hengo is killed he immediately capitulates to the Romans. Caratch's homoeroticism and his desire for acculturation to Roman values appear to encourage him to behave in a 'feminised' manner. Put another way, Caratach's sexual desire for the Roman military body 'unmans' him, leading him to behave in ways more usually associated with women. Bonduca and Caratach demonstrably swap gender characteristics but it makes neither of them an effective leader. The conflation of 'masculine' and 'feminine' behaviour by Caratach and Bonduca is similar to the categories of Roman and Briton, as well as coloniser and colonised in the play. Just as the divide between Roman and Briton is shown to be unstable, the ambiguities of Caratach and Bonduca's gender behaviour extend and intensify the other cultural ambivalence the play suggests.

By contrast, Hengo does not transgress the boundaries of gender-appropriate behaviour. He is – like Caratach – militarily competent since, though young, he still intimidates Judas into fleeing from the prospect of single combat and – like Bonduca – he refuses to acknowledge Roman superiority. As Caratach says after his death, Hengo represented the 'hopes of Britain' (V, iii, 160) and should be seen as the 'British soul' which the dying Bonduca asserted the Romans needed to preserve their Empire. Hengo's untimely death in the play needs to be seen as a tribute to Henry, Prince of Wales who was associated with Elizabethan Protestant imperialism and from the time of James's accession had been projected as the heir to England's military glory.[50] According to Sir John Holles, in a letter written shortly after Henry's death, the Prince's imperial interests had

been revealed by his involvement in 'all actions profitable or honourable
for the kingdom [which] were fomented by him, witness the North West
passage, Virginia, Guiana, The Newfoundland, etc., to all which he gave
his money as well as his good word'.[51] The loss of Hengo, the 'Royall
Graft' (V, iii, 161), represents the final defeat of the Britons' independence
in the same way that Henry's death represented the loss of a royal
sympathiser and figurehead for the war party opposed to James's pacific
policy. If, as Gordon McMullan suggests, Fletcher was by the beginning of
the second decade of the seventeenth century already firmly associated
with Henry Hastings, fifth Earl of Huntington – who frequently disagreed
with his monarch over matters of religion and state – the coded criticism of
James in *Bonduca* was likely to appeal to the Earl.[52]

 Bonduca dramatises inter-related colonial issues, as both the Romans
and the Britons refer in different ways to the situation of the British in the
early seventeenth century. The problems the Romans experience in their
invasion of Britain are similar to the difficulties experienced by the James-
town colonists. The divisions within the Roman camp and the Romans'
lack of integrity make it clear that imperial expansion is not a glorious
affair, and the Britons' defeat has more to do with the inadequacy of their
leaders than innate Roman superiority. The Romans win the battle because
Bonduca is militarily incompetent, Hengo is killed and Caratach is accul-
turated. In effect, the Romans have to do very little themselves to win and
even Penius' desertion does not seriously jeopardise the victory. As such,
the Roman conquest of Britain is inevitable in the same way that the British
colonial propaganda argued that American land and peoples would
inevitably – if not unproblematically or gloriously – succumb to British
control. Yet, on another level, this is also a deeply pessimistic play: the
'hopes' of Britain are extinguished in more ways than one. Bonduca, the
champion of an independent Britain, commits suicide; Hengo/Prince
Henry is dead; and Caratach, the custodian of British imperial ambitions,
is a Romanophile unable to preserve national autonomy. In a broader
sense, then, these readings – situating the play in geographical, political
and 'Roman' contexts – gesture toward a larger set of anxieties concerning
the extent to which independent British identity can be maintained in the
face of contact with other cultures. The parallels between the British in
America and the Romans in ancient Britain painfully, but inevitably,
defeating the indigenous inhabitants show the difficulties of maintaining
any form of separation between colonist and colonised. The fact that the
ancient Britons in this play represent both indigenous inhabitants in

colonised terrain and, simultaneously, the officers and leaders of a colonising nation, reflects the unstable nature of, and difficulty of maintaining, boundaries between the two. The persistent cultural exchange between Romans and Britons in *Bonduca* points to contemporary anxieties concerning interactions between Virginian colonists and indigenous inhabitants and, at the same time, poses questions concerning whether a specifically British national identity can be maintained in the face of foreign 'Roman' interference. Will the British be able to preserve their cultural identity in America? Similarly, will national identity be maintained in Britain? Fletcher does not provide a coherent answer to either question, but he shows the continued relevance of the Roman conquest to contemporary foreign and domestic policies.

Queenly rule? Political allegory and gender identity in *The Island Princess*

Fletcher returned to the theme of the interaction of gendered behaviour and Jacobean foreign, domestic and colonial policies in *The Island Princess* (1619–22). The main concerns of the plot are the release of the abducted King of Tidore, and the marriage of the non-Christian Princess Quisara of Tidore. More generally, *The Island Princess* focuses on the varying (sometimes harmonious, sometimes antagonistic) relations between native inhabitants of the Spice Islands of the Moluccas and colonialists, represented in the play by Portuguese soldiers and sailors. The plot begins with the capture of the King of the island of Tidore – where the Portuguese have established a garrison and trading relations – by the 'Governour' (described in the cast list as 'an ill man') of a neighbouring island, Ternata. The King's sister Quisara (who is besieged by eager suitors including the Captain of the garrison, Ruy Dias) promises she will marry the man who rescues her brother. Quisara hopes that Ruy Dias will perform the honourable deed, but his prevarication results in the King being rescued by another Portuguese, the recently arrived Armusia who has also fallen in love with the beautiful princess. Once restored, the King tries to hasten the nuptials between his sister and his rescuer, but Quisara stalls for time, simultaneously plotting – as does Ruy Dias separately – a scheme to get rid of Armusia. Both repent their dishonourable plans, but meanwhile the Governour reappears in disguise and, wanting his revenge on the Tidoreans, tries to divide colonist and colonised over the issue of religion. He encourages Quisara to make Armusia's conversion to her religion a prerequisite before

marriage and Armusia's horror at such a thought sufficiently angers the King to imprison Armusia and threaten him with death. Quisara – who now loves Armusia – asserts that she will die with him in the Christian faith – and tragedy is only averted at the end by the Portuguese, now led by a once more honourable Ruy Dias, unmasking the duplicitous Governour which, superficially at least, restores good relations between the Tidoreans and the Portuguese.

Recent critics of *The Island Princess* have highlighted the colonial contexts of the play, arguing that it is 'centrally concerned with the question of the relationship between European and non-European peoples'.[53] McMullan, for instance, suggests that the much-publicised marriage between John Rolfe and Pocahontas in 1614 should be seen as 'thoroughly rehearsed' in *The Island Princess*, since both 'demonstrate through the metaphor of the native woman as object of desire the anxieties which seem characteristic of the colonial'.[54] By contrast, Raman and Neill have located their readings against a specifically East Indian context, since contemporary British rivalry with Dutch commercial interests for the Spice Islands' trade is reflected in many other publications – most notably Purchas's compendious and anti-Dutch *Hackluytus Posthumus or Purchas His Pilgrimes* which, though not published until 1625, circulated in pamphlet form from 1613.[55] According to Neill, *The Island Princess* is implicitly engaging with Anglo-Dutch rivalry which, for politic reasons, is displaced onto the rival factions of Portuguese, and the perfidious Governour, who is endowed with some of more unpalatable 'Dutch' characteristics identified by Purchas as 'pride', 'spite' and 'cruelty'.[56]

Just as McMullan locates this play against a Western context and Raman and Neill locate it against an Eastern one, there are differences between these critics over whether *The Island Princess* celebrates colonial endeavour. Both Raman and Neill see in the Portuguese a 'pattern for the triumph of English mercantile adventure'.[57] Like Philip J. Finkelpearl, who described Fletcher's leading male character (the 'noble brave Portuguese' Armusia) as 'utterly flawless', Raman and Neill believe that Quisara and Armusia are praised (for temperance, and in Quisara 'whiteness') in the play. As positive role models, then, Quisara and Armusia's relationship offers an endorsement for colonial endeavour, and hence, they argue, *The Island Princess* encourages future British colonial initiatives in the region. However, Hadfield and McMullan have argued that both Fletcher's central male character, and colonial endeavour generally, are presented in a much more ambivalent fashion.[58]

The text's unease with colonial expansion is shown, for example, by Armusia's inconsistent reactions to the people, culture and religion of Tidore – which oscillate between desire and loathing – and hence reflect the familiar contradiction in European perceptions of exotic civilisations. In fact, as Hadfield argues, it is Armusia's perception of the inhabitants of the islands as 'devils' that becomes a 'self-fulfilling prophesy' since when he rescues the King of Tidore from captivity at the hand of the King's neighbour and rival, the Governour of Ternata, Armusia's actions force innocent islanders caught up in the fire to appear demonic (II, iv, 12–13).[59] Hence, Armusia's views structure the experience and future of native peoples: in other words, similar to the way the English perceived Algonkians in Virginia to be 'treacherous' and treated them accordingly, here Armusia fixes Timoreans in a 'devilish' incarnation which, albeit ironically, becomes their lived reality. As such, these representations are generative and not merely interpretative. This – and the fact that Armusia's rescue involves cunning and duplicity since he has had to disguise himself as a merchant to effect the escape – suggests to Hadfield that the text should be seen as an anti-colonial one: he argues that Fletcher appears to be 'suggesting that ill-considered projects would only lead to a self-perpetuating cycle whereby European and non-European cultures would view each other with mutual suspicion'.[60] In their creation of a near tragic situation, both the Portuguese adventurers and the native inhabitants of the islands are culpable, though Fletcher preserves contemporary European beliefs in racial and religious hierarchies at the end of the play, since Quisara converts to Christianity as she marries Armusia and it is the efforts of the Portuguese, specifically Ruy Dias and Pyniero, that unmask the treacherous Governour and avert the disaster. In sum, then, according to this reading, Fletcher is only cautious in his support of colonial endeavour, since he shows the problems and contradictions inherent to the project for empire.

In what follows, which concentrates on Fletcher's representation of Quisara, princess of Tidore, I focus on the ways issues of gender, colonialism and British domestic and foreign policies overlap in *The Island Princess*. Specifically, I read Fletcher's text in the light of concerns about James's personal sexual conduct, Stuart attitudes to Catholicism (especially concerning the marriage plans for the heir to the throne), and contemporary perceptions that the King had failed to act decisively enough in the Palatinate crisis. As we shall see, Fletcher's characters in this play often refer allegorically to royal policies and personages in several, sometimes competing, ways.

As with well-established colonial representations of native women, such as Pocahontas, and colonial terrain in terms of sexual assets, the male characters in *The Island Princess* see Quisara as an asset to compete over, and sexual mastery over her becomes a way of articulating the success of their masculinity.[61] Quisara's representation, then, is remarkably similar to the metaphors frequently used by colonial promoters such as Samuel Purchas to inspire English adventurers to support, for example, the Virginia venture:

view her lovely looks (howsoever like a modest virgin she is now vailed with wild Coverts and shadie Woods, expecting rather ravishment then Mariage from her Native Savages) survay her Heavens, Elements, Situation; her divisions by armes of Bayes and Rivers into so goodly and well proportioned limmes and members; her Virgin portion nothing empaired, nay nor yet improoved, in Natures best Legacies; the neighbouring Regions and Seas so commodious and obsequious; ... in all these you shall see, that she is worth the wooing and loves of the best Husband.[62]

Purchas's rhetoric establishes Virginia as a prize to be won by the 'best husband'. The female land is represented seductively: currently she is 'vailed' by her woods and Purchas invites his readers to imagine the removal of this metaphorical clothing. The economic exploitation of woodland resources is represented as proper husbandry since the 'Native Savages' (who do not engage in such activities – hence invoking notions of *res nullius* concerning the improper use of the land) threaten Virginia with the improper sexual advance of 'ravishment' rather than 'Mariage'.[63] The imagery emphasises the urgency of the project since the land remains virgin ('her Virgin portion nothing empaired'), but unless speedy action is undertaken by English colonists Virginia's sexual status may change. The language is designed to foster in Purchas's colonial male readers a sense of chivalry normally associated with romance writing, since Virginia needs protection from rape.[64] Purchas's rhetoric represents the English colonialists' intention as that of honourable marriage with the region and, through this institution, female Virginia will be 'improoved' and rendered 'obsequious' to her husband. In other words, Virginia will respond favourably to chivalric intentions and will be transformed into the bride every man wants: beautiful, rich and subservient. *Virginia's Verger* constructs a potent fantasy of naturalised and legitimate relations between colonist and colonial terrain. By using the notion that the social institution of marriage offered women protection from unwelcome and threatening sexual advances, Purchas here constructs the land as grateful for English colonialists'

attentions: in exchange for protection from rape and the achievement of marriage with the 'best husband', Virginia will give her English bride- groom the freedom of her body (her 'well proportioned limmes') and licence to exploit the natural resources of that body. Purchas employed identical rhetorical tropes in his descriptions of the Dutch conquest of the English spice factory on the island of Banda in 1620, representing the attack in similarly gendered and sexual terms: Banda is 'a rich and beautiful bride [who] was once envied to English arms, and seemeth by the cries on both sides, to have been lately ravished from her new husband, unwarned, unarmed, I know not whither by greater force or fraud'.[65] The English traders are thus constructed sympathetically as grieving new husbands deprived of the caresses of their lawful wife (any problems over the plural number of men involved with a single female are silently occluded).

Fletcher's representation of Quisara is similar to Purchas's descrip- tions of these feminised bodies of land. Quisara's status as a desirable bride is what motivates all the actions in the play. Even before the Governour captures her brother, the opening scene describes how she is plagued by suitors as all the local nobles and kings compete for her hand. The play begins, then, with the possibility of a solution to the vexed question of which man the Princess is going to marry since she decides to use the quest to release her brother as a love-test, and she promises to marry the man who rescues him (I, iii, 135–162). But Fletcher complicates this situa- tion by making Quisara – unlike the passive Virginia – an active participant in the decision as to which of the male characters will be the 'best husband'. It has already been revealed that she has a favoured candidate, the Portuguese captain of the garrison on Tidore, Ruy Dias, whom she attempts to incite to take on the (at that point unnamed) deed with promises of love (I, ii).

Quisara here appears similar to the Duchess of Malfi in Webster's play (1614) who, due to her sexual isolation based on superior rank, transgresses accepted customs of female behaviour and actively woos her chosen erotic partner, the upwardly mobile and ambitious Antonio.[66] Indeed, the similarity between the Duchess and Quisara does not end here; both roles were performed in the early 1620s for the King's Company by the same actor, Richard Sharpe (or Sharp) who, in his portrayal of Quisara, was 'beautiful, proud and overbearing'.[67] Furthermore, and more significantly, Webster's Duchess has been seen as expressing a coded criticism of King James's personal and public conduct. Of course, the gender difference between the Duchess and the King, as well as the geographical and historical distance,

camouflages the allegory, but the way in which the Duchess secretly marries a lowborn servant, and so places herself at the mercy of other servants, possesses affinities with James's behaviour with favourites. The clandestine rendezvous, declarations of love to aspiring courtiers, secret personal messages in public remarks, talk of witchcraft, spying for information about influential people – all had relevance to James's court and conduct.[68]

Like the Duchess, Quisara takes the initiative in the expression of her desires. In this scene, Ruy Dias is more circumspect than Quisara about expressing his feelings, and their respective number of lines (Quisara has 47 to Ruy Dias's 33) emphasises the unequal, female-dominated nature of the power relation between them. Ruy Dias asserts that he is inhibited by feelings of class inferiority, lack of youth, and Quisara's religion:

> I would I were of woerth, of something neare you,
> Of such a royall peece, a King I would be,
> A mighty King that might command affection,
> And bring a youth upon me might bewitch ye,
> And you a sweet sould Christian. (I, ii, 41–45)

Yet when Quisara half-promises to convert, Ruy Dias finds himself tongue-tied and revealingly states that he 'dare not speake' (I, ii, 54). Quisara's immediate rejoinder 'I dare then' reveals just how much traditional gender roles are reversed in this scene. Neither character is supported in their abdication of gender appropriate behaviour as they are both misguided in their judgements here and in their future actions. Ruy Dias clearly aspires to be a monarch himself, since he repeats the term for emphasis: 'a King I would be, / A mighty King', and he desires to 'bewitch' the Princess in the same way that James, as early as 1579, was described by James Melville as being influenced by Esmé Stuart, who was 'a subtle spirit, a merry fellow, very able in body, and most meet in all respects for bewitching of the youth of a prince'.[69]

Ruy Dias's brave words 'Command deare Lady, / And let the danger be as deep as hell, As direfull to attempt' (I, ii, 72–74) are shown, in the play's next scene, to be empty rhetoric, since he retreats to prevaricating concerning his intention to rescue Quisara's brother: 'give me leave to looke about me, / And take a little time, the cause will aske it, / Great acts require great counsells' (I, iii, 165–167). Similarly Quisara's judgement is shown to be questionable when she appears to be taken in by Ruy Dias's superficial appearance of valour: 'you are valiant, / An active man, able to build a fortune' (I, ii, 66–67), despite the fact that his bravery is compromised by his lack of verbal skill. Aspiring or real kings need to be rhetorically

skilful and brave, and Dias's failure here undermines his pretensions and, simultaneously, effeminises him. The romance between Quisara and Dias resonates, then, with contemporary commentators' descriptions of the King's romantic entanglements, since Quisara and Dias's transgressive gender behaviour mirrors that of James with his favourites. For instance, as the scandalised Francis Osborne comments:

No other reason appeared in favour of their choyce but handsomnesse, so the love the king showed was as amorously convayed, as if he had mistaken their sex, and thought them ladies; which I have seene Sommerset and Buckingham labour to resemble, in the effeminateness of their dressings; though in w[horeson?] lookes and wanton gestures, they exceeded any part of woman kind my conversation did ever cope with all. Nor was his love, or what else posterity will be pleased to call it, (who must be the judges of all that history shall informe,) carried on with a discretion sufficient to cover a lesse scandalous behaviour: for the kings kissing them after so lascivious a mode in publick, and upon the theatre, as it were, of the world, prompted many to imagine things done in the tyring-house, that exceed my expressions no lesse then they do my experience.[70]

Dias's somewhat pathetic response to the abduction of the King of Tidore gestures towards a larger set of anxieties about James's leadership. In 1619, Elector Frederick V of the Palatinate was offered the crown by the Estates of Bohemia, who were in rebellion against their designated king, Ferdinand (who almost simultaneously was elected Emperor of the Habsburg empire). Frederick's acceptance provoked disastrous consequences, since on 8 November 1620 the Bohemian army was trounced at the battle of the White Mountain, leaving Frederick without resources or allies.[71] Even before the crisis over the Bohemian throne, James's loyalties had been divided between his son-in-law, the Protestant Elector, and his desire to maintain good relations with Spain (Philip III naturally supported Ferdinand, the eastern branch of the family), since he hoped to marry Charles to the Infanta Maria. In Dias's prevarication, and in Quisara's use of the love-test of rescuing her brother to determine her husband, we have similar circumstances to the ones facing James, who prevaricated, supported one side, then the other, and ultimately floundered in his attempts to resolve the matter. In the play, Quisara is represented as vain and manipulated by flattery. She is pleased by Dias's compliments ('you are my royall Mistris, / And all my services that aime at honour, / Take life from you, the Saint of my devotions' (I, ii, 37–39)), and later the disguised Governour's exorbitant praise ('You are a Saint' (IV, ii, 147)) persuades

her to his schemes to convert Armusia. So too was James's vanity flattered by a Spanish initiative into acting as mediator between the Emperor and the Bohemians in July 1618, a role that would mean he would not immediately or directly intervene to help his son-in-law. The Spanish suggestion that James, represented by them as a virtuous Prince with great prestige in Europe, should act as mediator, targeted James at his weakest point. As Gondomar, the Spanish ambassador commented: 'The vanity of the present King of England is so great that he will always think it of great importance that peace should be made by his means, so that his authority will be increased'.[72]

Throughout the play, then, Quisara is persistently represented as sexual bait for the male characters in the drama; she needs to be courted and as she is royalty – specifically as heir to the throne – the wooing process is, of course, intense. Simultaneously, though, she is represented as possessing sexual appetites of her own. Her desirability has led all the local princes and kings to the brink of declaring war upon each other (I, iii, 43–117) as they jostle physically as well as verbally to be seen as her most appropriate suitor. Even Pyniero, the character with whom the audience identifies most closely since he acts as an ironic commentator on the action, succumbs to desire for Quisara in Act III Scene i, when he allows her kisses, superficially at least, to persuade him to take part in a dishonourable scheme to further Ruy Dias's suit. Quisara's sexuality is a dangerous force in the world of the play as it unleashes actions which, if followed through, would be unjust and corrupt. Significantly, Quisara herself does not seem to be able to control her emotions or exhibit sound judgement in her choice of erotic object. Even after Armusia has freed her brother and has thus won the Princess's love-test, Quisara as well as her other suitors still refuse to accept defeat. The Kings of Siana and Bakam both apologise to the King of Tidore for their lack of action in the manner most fitting to their characters – bombastically and tersely – but only under the threat of becoming the King of Tidore's 'open enemies' (II, iv, 183) do they appear to celebrate Armusia's special status as favoured suitor. The continued objections of Ruy Dias, Quisara and the Governour of Ternata to Armusia's success in the love contest are, however, rather more serious as each comes up with a dishonourable scheme involving trickery, murder or treachery to achieve his aims.

It is clear that Fletcher does not support Quisara's demand to choose her own husband. The love-test that she orchestrates in Act I is satirised and shown to be misguided and corrupt: it is not an open contest, since

Quisara has designed it with a winner in mind though, of course, she has entirely misread the character of her favoured candidate. When Ruy Dias proves inadequate to the task, Quisara attempts to withdraw her promise to marry the victor through prevarication, in the meantime violently scolding Ruy Dias and also attempting to corrupt Pynerio with veiled promises of future sexual favours in return for murdering Armusia. Perhaps most crucial in demonstrating Fletcher's satiric treatment of Quisara (and by implication James) is the fact that the ostensible reason for the love-test – the welfare of her brother – is shown to be utterly subservient to the fulfilment of her erotic desires. At several points in Act I Quisara reveals that Pynerio's dark warning about her in the opening scene – that 'They that observe her close, shall find her nature, / Which I doubt mainly will not prove so excellent' (I, i, 43–44) – is an accurate one. Though she repeatedly asserts that she has no desire to be Queen since if she did she would not seek the King's freedom, questions concerning her integrity are raised within the same speech by her statement 'Therefore that man that would be known my lover, / Must be known his redeemer, and must bring him / Either alive or dead to my embraces, / For even his bones I scorne shall feele such slavery' (I, iii, 148–151).

Just as James was flattered by Spain into taking a mediatory role that suited Catholic interests (pandering to, as Sir Anthony Weldon put it, 'his owne motto: *Beati Pacifici*' ('Blessed are the peacemakers')), Quisara values her brother's life less than the flattering (to herself) escapade to free him.[73] For Quisara, the suitor's accomplishment of this task proves his love for her and thus the quest is designed to appeal to her own vanity. Love for her sibling is subordinate to her own interests in the same way that James himself represented his love for his children – Frederick and Elizabeth – as inferior to his duty to preserve the peace for his other 'children', his subjects. As John Chamberlain commented in a letter to Sir Dudley Carleton in October 1619, the King's sentiments were 'that his subjects were as deere to him as his children, and therefore wold not embarke them in an unjust and needlesse quarrell'.[74] James's abandonment of his own children was adversely commented on by those of the war party who wished to see a more aggressive stand taken against Spanish ambitions. An anonymous pamphlet (thought to be dated 1622), *Tom Tell-Troath: or a Free Discourse Touching the Manners of the Time, Directed to his Majesty*, is outspoken in its censure of James for his lack of paternal support since 'the cause of … your children lyes … a bleeding': if James does not act decisively, the pamphlet warns, his subjects will believe his

inaction to be caused by 'meere impotency and desire of ease' rather than 'Christian piety and love of justice'.[75]

In *The Island Princess*, Quisara is either disingenuous concerning her secret desire for power, or irrational since her determination to find an appropriate quest for Ruy Dias to show publicly his devotion has blinded her to the consequences that her actions might bring. Indeed, her confusion is further revealed when the Governour offers, repeating Quisara's terms ('either alive or dead to my embraces') almost verbatim, to return the King if she will marry him ('but speake / Whether alive or dead he shall be rendred,' (I, iii, 180)). However, because he is not the man she has chosen to pass the love-test, she has no choice but to spurn his offer even though it would seem to fulfil the terms of the competition she established. Her denouncement of the Governour 'I scorne ye' and 'ere I would so basely win his liberty, / I would study to forget he was my brother' (I, iii, 183–186) as well as 'Yet to receive him as thy courtesie ... I had rather ... See him far sunke i'th'earth, and there forget him' (I, iii, 198–202) seems rather more passionate than politic, further revealing that the love-test is solely about Quisara securing the man she wants for her husband rather than the safe return of her brother. This scene, then, undermines any sense of integrity the audience might expect to find in Quisara, since she is playing with her brother's life in order to fulfil her vanity and romantic whims. Furthermore, the fact that such a woman is a Princess, and through this ill-thought-out action, stands to inherit the throne of a country, forces the reader to question whether she would be fit to govern. Just as James was perceived to be failing in his management of affairs of state at this time ('It seems to me that the intelligence of this King has diminished' wrote Tillières the French ambassador), Quisara is not promising monarchic material.[76] She is here making her romantic satisfaction more important than affairs of state. Given that her gender means that whoever she marries will become King should her brother predecease her (and Pynerio has already established for the audience that she is courted for her position when he suggests 'her hopes are fairer' (I, i, 52)), her choice of partner is of immense political concern. Quisara refuses to acknowledge this, acting as though her choice of husband should be a matter of personal preference alone. Politically, the Governour might indeed represent the best choice for her considering the alliance value of such a marriage in healing the tension between Ternata and Tidore and, potentially, in allowing the islanders to resist Portuguese control. Not only, then, does Quisara's behaviour resemble James's, it also suggests a parallel to Charles's Spanish marriage

plans. It was feared by the anti-Habsburg faction amongst James's subjects that, if Charles married the Infanta Maria, the natural consequence of the alliance would be the abandonment of the Protestant League and, more particularly, the desertion of the Palatinate and the Princess Elizabeth.[77]

In the play, then, Quisara makes her marriage of political significance in a completely inappropriate way, for the maintenance of the life of her brother is placed in the hands of suitors that might reasonably be expected to have a vested interest in his death. She is placing her sexual desire for an unworthy man (Dias, who as we have seen in Act I, Scene ii, expressed 'kingly' ambitions) above that of the life of her brother, the King, as well as destroying the possibility of the islands' continued independence from colonial rule. Royal political incompetence is represented here though, of course, Quisara's position is useful for the Portuguese. Indeed, her Portuguese suitors appear to see her rejection of the Governour as admirable – Armusia remarks immediately after her dismissal of the Governour that she is 'A rare woman' (I, iii, 204) – but it is unclear whether this is purely admiration for her spirit or whether he recognises the political and colonial implications of what she is saying. In other words, such admiration might signal the colonialists' recognition that the death of her brother, which she tacitly condones in the rescue attempt, will make her queen and one of them king. Fletcher's alteration of his source material, le Seigneur de Bellan's novel *L'Histoire de Ruis Dias, et de Quixaire, Princess des Moloques* (1615) and Bartolome Leonando de Argensola's *Conquista de las Islas Molucas* (1609) is relevant here. In de Bellan's text, the hero is a young Tidorean aristocrat, Salama, and he performs the roles allotted to Armusia in Fletcher's version (he also succeeds to the throne at the end of the novella). Salama's displacement by a European is significant, since not only does it (as McMullan argues) emphasise the colonial context of the events in the play, but invites an allegorical, political reading of them.[78] In these events, then, there are clear resemblances with the Palatinate controversy as James, like Quisara, was manipulated by the Spanish into following diplomatic policies that suited Spanish interests, rather than those of their own nation. In both cases, royal desires – James's for a Spanish bride for his son, Quisara's for a Portuguese husband – are decisive in constructing a situation in which national independence might no longer be preserved. Quisara's marriage to a Portuguese would mean that the independence of her island home would be lost in the same way that many Protestant English believed that a Spanish Catholic wife for Charles might lead to a renewed toleration of Catholicism.

Such Protestant fears are explored allegorically in the conversion scenes in *The Island Princess*. Not only does Quisara demonstrate a lack of integrity concerning the public implementation of, supposedly, an open competition when in fact she tries to influence the result privately, she also possesses no religious integrity. Her religion, like her love for her brother, is consistently revealed to be subservient to her erotic desires. In the first act, she allows Ruy Dias to believe that she would be prepared to convert to his religion in order to encourage him to undertake the love-test. Similarly, when in Act IV Scene ii, the Governour, in disguise as a Moorish priest, encourages Quisara to convert Armusia to Islam/Sun and Moon worship (the text implies both) as a condition of the marriage, he does so by appealing to her vanity concerning her beauty and the influence she believes it can exert on her suitors: 'You are a Saint esteem'd here for your beauty, / And many a longing heart.' (147–148) and 'Use it discreetly ... fairely bring 'em home to our devotions, / Which will be blessed, and for which, you sainted' (153–166). The Governour's repetition of the idea that Quisara's successful conversion of Armusia would accord her beatific status is designed to appeal to her sense of self-importance, and it is well aimed since Quisara is easily seduced by the notion that the Gods need her 'helpe' (154) and the 'miracle' that her 'heavenly forme' must 'worke' (160–161) on the Portuguese. The Governour seduces her with notions of her own absolutism, which again chimes with James's own, frequently expressed, views on the relationship between religion and the monarch. It is status that Quisara seeks through religion rather than the possession of a stable faith, a fact that is soon revealed in *The Island Princess*. When Armusia expresses horror at the thought of conversion to her 'devillish' religion (IV, v, 136), and she is in danger of losing her admirer, Quisara's religious principles immediately collapse and she soon converts to Christianity. In Quisara's vacillation, then, there are similarities with English Protestants' perceptions that James was prepared to tolerate (or even convert to) Catholicism, or allow his son to convert to the faith. *Tom Tell-Troath* comments that James's inaction in the Palatinate acts as a harbinger for Catholic expectations, 'The very Papists themselves ... satisfy their pernicious hopes, upon your Majesties patience. For seeing how easily you tolerate all thinges abroad, they doubt not, ere long, but they shall also have toleration at home'.[79] James's persistent desire that Charles marry a Spanish bride despite the Palatinate crisis did little to reduce these anxieties. Furthermore, Quisara, an allegory of the Stuarts, fails in her mission to convert the Portuguese, and based on the strength of her erotic impulses is persuaded to abandon her own religion.

Yet the uneasy parable does not stop here: the audience is encouraged to have little faith in the integrity of her conversion to Christianity since it soon becomes apparent that it is being used to provide yet another dramatic role for her, that of Virgin martyr:

> Stand fast sir,
> And feare 'em not; you have stept so nobly
> Into this pious triall, start not now,
> Keepe on your way, a virgin will assist ye,
> A virgin won by youre faire constancy,
> And glorying that she is won so, will dye by ye. (V, ii, 105–110)[80]

Though the tragedy of such martyrdom is avoided because the Governour is unmasked and his machinations revealed, the cultural harmony that the prospective nuptials between Armusia and Quisara represent does not suggest a secure basis on which to build either a colonial, or a nation's future. The allegory, then, works to show that even if Charles or James were actively to support a policy of Catholic toleration, there can be little security in the nation's religious harmony. In the play, the Portuguese have triumphed only superficially since the audience – aware of Quisara's duplicity and superficiality and Armusia's deep-seated hostility to her culture – can have small faith in a harmonious future for either the relationship or the strength of any dynastic and national alliances that their marriage represents.

When Quisara attempts to persuade Armusia to convert to her religion, his reaction is violent in the extreme:

> I hate and curse ye,
> Contemne your deities, spurne at their powers,
> And where I meet your maumet Gods, I'le swing 'em
> Thus o're my head, and kick 'em into puddles,
> Nay I will out of vengeance search your Temples,
> And with those hearts that serve my God, demolish
> your shambles of wild worships. (IV, v, 112–118)

Under pressure, Armusia's knee-jerk reaction is to threaten violent and vengeful cultural annihilation. Furthermore, Quisara's apostasy is motivated solely by the strength of her erotic desires which, given the proven super-ficiality of these feelings, does not appear as a confident statement by Fletcher that cultural harmony is a secure possibility. Quisara may assert that whichever way Armusia will go she 'must follow necessary' sharing 'One life, and one death' (V, v, 41–42), and Armusia may apologise for his 'rashnesse' to the King and the other indigenous rulers: 'for I was angrie, /

And out of that might utter some distemper, / Think not 'tis my nature' (V, v, 72–75). Yet in another crisis it is by no means clear that a peaceful understanding between coloniser and colonised, Portuguese and Tidorean, would or could be maintained. Quisara, the island princess, as an unmarried woman / virgin territory / heir to a throne, is tempting bait for the Portuguese colonialists. But the harmony of the union is presented as by no means certain. The audience is encouraged to see the 'peace' that the King proclaims at the end of the play as more to be hoped for than a certainty, particularly as he himself remains only 'half-converted' to Portuguese values. Clearly, for the Tidorean King, as well as for Armusia and Quisara, a full understanding of each other's cultures has yet to be achieved. In the relationship between coloniser and colonised, just as in any marriage between Charles and the Infanta, there will be (potentially insuperable) barriers that put the dynastic and national alliance under severe strain. In Fletcher's *Island Princess*, then, we have a carefully coded and obfuscated view of Stuart personalities and policies. Fletcher's use of a female, monarchic character, a distant geographical location, and the Portuguese nation as 'heroes', allow him to make available an allegory of considerable force as he confronts some of the most contentious and sensitive issues facing the Stuart dynasty at this time.

Notes

1 Michael Neill, *Putting History to the Question: Power, Politics and Society in English Renaissance Drama* (New York: Columbia University Press, 2000), pp. 311–338 (p. 312); see also Shankar Raman, 'Imaginary Islands: Staging the East', *Renaissance Drama*, 26 (1995), 131–161; Gordon McMullan, *The Politics of Unease in the Plays of Beaumont and Fletcher* (Amherst: University of Massachusetts Press, 1994); Andrew Hadfield, *Literature, Travel, and Colonial Writing in the English Renaissance, 1545–1625* (Oxford: Clarendon, 1998), pp. 254–264.

2 I use 'Britons' to refer to the ancient British and 'Britain' to refer to the geographical terrain disputed with the Romans, and 'British' to refer to both individual leaders and the nation in the Renaissance. On the transition between an 'English' national identity under Elizabeth and a 'British' one under James see Curtis Perry, *The Making of Jacobean Culture: James I and the Renegotiation of Elizabethan Practice* (Cambridge: Cambridge University Press, 1997), pp. 1–12.

3 On the politics of Romanisation see Coppélia Kahn, *Roman Shakespeare: Warriors, Wounds and Women* (London and New York: Routledge, 1997), pp. 11–26, 160–170. See also Clifford Ronan, *Antike Roman: Power Symbology and the Roman Play in Early Modern England, 1585–1635* (Athens and London: University of Georgia Press, 1995); Geoffrey Miles, *Shakespeare and the Constant Romans* (Oxford: Clarendon, 1996).

4 See, for example, Paul D. Green, 'Theme and Structure in Fletcher's Bonduca', *Studies in English*, 22:2 (1982), 305–316; Sandra Clark, *The Plays of Beaumont and Fletcher: Sexual Themes and Dramatic Representation* (New York and London: Harvester Wheatsheaf, 1994), pp. 85–88; Jodi Mikalachki, *The Legacy of Boadicea: Gender and Nation in Early Modern England* (London and New York: Routledge, 1998), pp. 103–105.

5 Green, 'Theme and Structure in Fletcher's Bonduca', pp. 306–307.

6 Green, 'Theme and Structure in Fletcher's Bonduca', p. 308.

7 Andrew Hickman, 'Bonduca's Two Ignoble Armies and The Two Noble Kinsmen', *Medieval and Renaissance Drama in England*, 4 (1989), pp. 143–171.

8 Hickman, 'Bonduca's Two Ignoble Armies', 168.

9 For topical readings of *Bonduca* see Ronald J. Boling, 'Fletcher's Satire of Caratach in *Bonduca*', *Comparative Drama*, 33:3 (1999), 390–406; Julie Crawford, 'Fletcher's *The Tragedie of Bonduca* and the Anxieties of the Masculine Government of James I', *Studies in English Literature*, 39:2 (1999), 357–381.

10 See Boling, 'Fletcher's Satire', 395.

11 For more information see Cyrus Hoy's 'Textual Introduction', in John Fletcher, *The Tragedie of Bonduca*, in Fredson Bowers, ed., *The Dramatic Works in the Beaumont and Fletcher Canon*, 10 vols (Cambridge, Cambridge University Press, 1979–), 4, pp. 151–154; see also John Fletcher, *Bonduca*, Walter Wilson Greg, ed. (Oxford: Malone Society, 1951), pp. ix–x.

12 Andrew Gurr, *The Shakespearean Stage 1574–1642* (Cambridge: Cambridge University Press, 1980), p. 220.

13 William Shakespeare, *Cymbeline*, J. M. Nosworthy, ed. (London and New York: Methuen, 1955); for discussion of *Cymbeline* as an intervention in the debate about the merits of James's and Elizabeth's rule see Leah Marcus, *Puzzling Shakespeare: Local Reading and Its Discontents* (Berkeley: University of California Press, 1988), pp. 122–131; see also Jodi Mikalachki, 'The Masculine Romance of Roman Britain: *Cymbeline* and Early Modern English Nationalism', *Shakespeare Quarterly*, 46:3 (1995), 301–322.

14 Andrew Hickman, 'Bonduca's Two Ignoble Armies', 143; John Fletcher, *The Tragedie of Bonduca*, Cyrus Hoy, ed., in *The Dramatic Works*, 4, pp. 149–259, V. iii. 160. All references are to this edition and will be given parenthetically in the text.

15 A copy of the First Charter is reprinted in Phillip L. Barbour, ed., *The Jamestown Voyages Under the First Charter 1606–1609*, 2 vols (Cambridge, Cambridge University Press/Hakluyt Society, 1969), I, pp. 24–34. For accounts of the early years of the Jamestown colony, see K. R. Andrews *et al.*, eds, *The Westward Enterprise: English Activities in Ireland, the Atlantic and America 1480–1650*, (Liverpool: Liverpool University Press, 1979); Louis B. Wright, 'Colonial Developments in the Reign of James I', *The Reign of James I and VI*, Alan G. R. Smith, ed. (London: Macmillan 1973), pp. 123–139; J. Leo Lemay, *The American Dream of Captain John Smith* (Charlottesville: University of Virginia Press, 1993); David L. Ammerman, ed., *The Chesapeake in the Seventeenth Century: Essays on Anglo-American Society* (Chapel Hill: University of North Carolina

Press, 1979); Edmund S. Morgan, *American Slavery, American Freedom: The Ordeal of Colonial Virginia* (New York and London: Norton, 1975); Karen Ordahl Kupperman, 'Apathy and Death in Early Jamestown', *Journal of American History*, 66 (1979), 24–40.

16 Smith's works are reprinted in *The Complete Works of Captain John Smith*, Philip L. Barbour, ed., 3 vols (Chapel Hill: University of North Carolina Press, 1986). For discussions of Smith's works and the similarities and differences between his accounts see Mary Fuller, *Voyages in Print: English Travel to America, 1576–1624* (Cambridge: Cambridge University Press, 1995), pp. 85–140; see also Peter Hulme, *Colonial Encounters: Europe and the Native Caribbean* (London and New York: Routledge, 1986), pp. 137–174.

17 William Symonds, *Virginia. A Sermon Preached at Whitechapel* (London: I. Windet, 1609), p. 26. For a discussion of the divergent contemporary representations of Virginia see Michael Zuckerman, 'Identity in British America: Unease in Eden', in Nicholas Canny and Anthony Pagden, eds, *Colonial Identity in the Atlantic World, 1500–1800* (Princeton: Princeton University Press, 1987), pp. 115–159.

18 Michael Drayton, 'Ode to the Virginian Voyage', in *The Works of Michael Drayton,*. William J. Hebel, ed., 5 vols (Oxford: Blackwell, 1931–41), II, pp. 363–364.

19 Ben Jonson *et al.*, *Eastward Ho*, R. W. van Fossen, ed. (Manchester, Manchester University Press, 1999), III, iii, 42–46. See Janet Clare, '*Art made tongue-tied by authority': Elizabethan and Jacobean Dramatic Censorship* (Manchester: Manchester University Press, 1999), p. 143. On Jonson's use of colonial contexts more generally, see Rebecca Ann Bach, *Colonial Transformations: The Cultural Production of the New Atlantic World 1580–1640* (Basingstoke and New York: Palgrave, 2000), pp. 113–148.

20 See Zuckerman, 'Identity in British America: Unease in Eden', pp. 115–159; see also Nicholas Canny, 'The Permissive Frontier: The Problem of Social Control in English Settlements in Ireland and Virginia 1550–1650' in *The Westward Enterprise*, pp. 17–45.

21 George Percy, *A Trewe Relacyon*, p. 269; cited in Fuller, *Voyages in Print*, p. 99.

22 On the importance of temperance to colonial discourse see Neill, *Putting History to the Question*, pp. 330–334.

23 See Fuller, *Voyages in Print*, pp. 85–140.

24 John Smith, *Proceeding of the English Colony*, in *Works*, I, p. 214.

25 Percy, *A Trewe Relacyon*, pp. 267; cited in Fuller, *Voyages in Print*, p. 101.

26 See Maggie Kilgour, *From Communion to Cannibalism: An Anatomy of Metaphors of Incorporation* (Princeton: Princeton University Press, 1990), pp. 3–19.

27 See David R. Ransome, 'Wives for Virginia, 1621', *William and Mary Quarterly*, 3rd series, 48 (1991), 3–18; on the social tensions in Virginia see also Ransome, 'Village Tensions in Early Virginia: Sex, Land and Status at the Neck of Land in the 1620s', *The Historical Journal*, 43:2 (2000), 365–381.

28 'Copy of John Rolfe's Letter to Sir Thomas Dale Regarding His Marriage to Pocahontas', in Philip Barbour, *Pocahontas and her World* (Boston: Houghton

Mifflin, 1970), pp. 247–252 (p. 247). See Hulme, *Colonial Encounters*, pp. 143–147; see also Fuller, *Voyages in Print*, pp. 120–122.

29 Ralph Hamor, *A True Discourse of the Present Estate of Virginia* (New York: Da Capo, 1971 [1615]), p. 54.

30 For further details see Peter Hulme, *Colonial Encounters*, pp. 163–168; see also Barbour, *The Jamestown Voyages*, I, p. 438.

31 John Smith, *Proceedings of the English Colony*, in *Works*, I, pp. 212–213.

32 For a discussion of White's drawings and the similarities between early inhabitants of Britain and New World tribes see Hadfield, *Literature, Travel, and Colonial Writing*, pp. 113–126. See also Juliet Fleming 'The Renaissance Tattoo', *Review of English Studies*, 31 (1997), 35–52.

33 For further details of Huntingdon's colonial activities and Fletcher's connection with the Earl see Gordon McMullan, *The Politics of Unease*, pp. 203–206.

34 See Kahn, *Roman Shakespeare*, pp. 11–15, 13.

35 Gabriel Archer, 'The Discription of the Now Discovered River and Country of Virginia', in D. B. Quinn, ed., *New American World: a Documentary History of North America to 1612*, 5 vols (New York: Arno Press and Hector Bye, 1979), V, p. 286.

36 Hulme, *Colonial Encounters*, pp. 163–164.

37 See Kahn, *Roman Shakespeare*, pp. 11–15, 13.

38 Clark, *The Plays of Beaumont and Fletcher*, pp. 85–88.

39 For an analysis of representations of Boadicea in the period see Mikalachki, *The Legacy of Boadicea*; see also Simon Shepherd, *Amazons and Warrior Women: Varieties of Feminism in Seventeenth-Century Drama* (Brighton: Harvester, 1981), pp. 144–145.

40 See Anne Barton, 'Harking Back to Elizabeth: Ben Jonson and Caroline Nostalgia', *English Literary History*, 48 (1981), 706–731.

41 James Aske, *Elizabetha Triumphans*, in J. Nichols, *The Progress and Public Processions of Queen Elizabeth*, 2 vols (London: John Nichols & Son, 1823), II, pp. 570–571.

42 See Mikalachki, *The Legacy of Boadicea*, pp. 126–129.

43 See A. N. McLaren, *Political Culture in the Reign of Elizabeth I: Queen and Commonwealth 1558–1585* (Cambridge: Cambridge University Press, 1999).

44 Anthony Weldon, 'Court and Character of King James', in Sir Walter Scott, ed., *Secret History of the Court of James the First*, 2 vols (Edinburgh: J. Ballantyne, 1811), II, p. 12.

45 Nichols, *The Progress and Public Processions*, II, p. 50.

46 For a consideration of James's pacific policy see Smith, *The Reign of James VI and I*, pp. 3–8.

47 On contemporary concerns about James's attitude to Catholicism see D. M. Loades, *Politics and the Nation 1450–1660* (London: Fontana, 1992), pp. 377–380; Roger Lockyer, *The Early Stuarts: A Political History of England, 1603–*

1642 (London and New York: Longman, 1999), pp. 191–204.

48 Mikalachki sees this tender behaviour as 'an imaginative attempt to construct a native, masculine genealogy preceeding directly from ancient Britain to the Saxon heptarchy, and excluding women and Rome from the national past', *The Legacy of Boadicea*, p. 105.

49 Kahn, *Roman Shakespeare*, p. 19.

50 See Roy Strong, *Henry, Prince of Wales, and England's Last Renaissance* (New York: Thames and Hudson, 1986); see also Perry, *The Making of Jacobean Culture*, pp. 153–187.

51 Cited by Strong, *Henry, Prince of Wales*, p. 8.

52 For further details of the Earl of Huntington's politics and the connections between the Fletcher and Hastings families see McMullan, *The Politics of Unease*, pp. 15–27.

53 Hadfield, *Literature, Travel, and Colonial Writing*, pp. 254–264 (p. 263). Gurr, in *The Shakespearean Stage*, suggests these dates for the first performance of the play by the King's Men at Blackfriars (p. 210). For further details of the colonial context for this play see McMullan, *The Politics of Unease*, pp. 222–235.

54 McMullan, *The Politics of Unease*, p. 224.

55 Neill, *Putting History to the Question*, pp. 315–322; Raman reads the play against accounts of the Spice Islands included in Hakluyt's *Principal Navigations* (1589) in order to argue that Fletcher sees Portugal's waning influence as a chance for British expansion – see 'Imaginary Islands', 139.

56 Neill, *Putting History to the Question*, p. 319.

57 Neill, *Putting History to the Question*, p. 322.

58 John Fletcher, *The Island Princess*, George Walton Williams, ed., in Bowers, *The Dramatic Works*, V, pp. 539–651 (p. 552). All subsequent references are to this edition and will be given parenthetically in the text. For a reading of Armusia as 'flawless hero' see Philip J. Finkelpearl, 'John Fletcher as Spenserian Playwright: *The Faithful Shepherdess* and *The Island Princess*', *Studies in English Literature*, 27 (1987), 285–302.

59 It is their [the Portuguese's] intervention in the islanders' conflict which is shown to create the devils which loom so large in their representation of the natives. See Hadfield, *Literature, Travel, and Colonial Writing*, p. 261.

60 Hadfield, *Literature, Travel, and Colonial Writing*, p. 263.

61 See Patricia Parker, *Literary Fat Ladies: Rhetoric, Gender, Property* (London: Methuen, 1987), pp. 126–154.

62 Samuel Purchas, 'Virginia's Verger; Or a Discourse shewing the benefits which may grow to this kingdome from American English Plantations, and specially those of Virginia and Summer Islands', in *Hakluytus Postumus: or Purchas His Pilgrimes: Containing a History of the World in Sea Voyages and Lande Travells by Englishmen and others*, 20 vols. (Glasgow: James Maclehose & Sons 1905–1907), XVII, p. 242. See McMullan, *The Politics of Unease*, p. 222; Hulme, *Colonial Encounters*, pp. 159–160.

63 On *res nullius* see Walter S. H. Lim, *The Arts of Empire: The Poetics of Colonialism from Ralegh to Milton* (London and Newark: Associated University Presses and University of Delaware Press, 1998), pp. 79–80.

64 On the use of romance conventions in colonial writing see Joan Pong Linton, *The Romance of the New World: Gender and the Literary Formations of English Colonialism* (Cambridge: Cambridge University Press, 1998), pp. 11–12.

65 Purchas: *Hakluytus Postumus: or Purchas His Pilgrimes*, V, p. 237. For discussion see Neill, *Putting History to the Question*, pp. 322–330.

66 For a feminist reading of *The Duchess of Malfi*, see Alison Findlay, *A Feminist Perspective on Renaissance Drama* (Oxford: Blackwell, 1999), pp. 100–105.

67 Sharpe's is the only name given for the role of the Duchess in the list of actors' names included with the first published edition of the play in 1623. For further details see *The Duchess of Malfi*, John Russell Brown, ed. (Manchester: Manchester University Press, 1997), pp. 22–23, p. 42. On the cast list for what is thought to be the first performance of *The Island Princess* see Williams, 'Textual Introduction', p. 541.

68 Brown, 'Introduction', pp. 5–6.

69 For further details see Robert Ashton, ed., *James I by his Contemporaries* (London: Hutchinson, 1969), p. 115.

70 Francis Osborne, 'Traditionall Memoryes on the Raigne of King James the First', in *Secret History of the Court of James the First*, I, pp. 275–276. For a description of James as cowardly see *A Royalists Notebook. The Commonplace Book of Sir John Oglander of Nunwell, 1622–1652*, F. Bamford, ed. (London: Constable, 1936), pp. 193–194.

71 On the Palatinate crisis see Loades, *Politics and the Nation*, pp. 381–385; Lockyer, *The Early Stuarts: A Political History of England, 1603–1642*, pp. 145–151.

72 Quoted by D. H. Willson, *King James VI and I* (London: Jonathan Cape, 1956), p. 411.

73 Weldon, 'Court and Character of King James', p. 12.

74 Letter from John Chamberlain to Sir Dudley Carleton, 2 October 1619, *The Letters of John Chamberlain*, N. E. McClure, ed., 2 vols (Philadelphia: American Philosophical Society, 1939) II, p. 266.

75 Anon., *Tom Tell-Troth: or a Free Discourse Touching the Manners of the Time, Directed to his Majesty* (1642 [?1622]), *Harleian Miscellany*, 10 vols (London: John White *et al.*, 1808–13), III, pp. 428–439 (pp. 431–432).

76 Quoted by Willson, *King James VI and I*, p. 412.

77 See Willson, *King James VI and I*, pp. 399–424.

78 See McMullan, *The Politics of Unease*, p. 224; see also Edward M. Wilson, 'Did John Fletcher Read Spanish?', *Philological Quarterly*, 27 (1948), 187–190.

79 Anon., *Tom Tell-Troth*, III, p. 429.

80 For a similar point see Finkelpearl, 'John Fletcher as Spenserian Playwright', 295.

4

Pirates, renegadoes and masculine unruliness in early seventeenth-century drama

C hapter 2 explored the ways dramas about Stukley asked whether the state or an individual was more responsible for rebellious, even treasonous, behaviour. Both Stukley dramas showed the limits and problems inherent in the sort of state rule that failed to value its adventurous male subjects, and we saw, graphically presented in the image of the displayed dead body of the usurping Muly Mahamet and in Stukley's loss of his sense of national allegiance, the results of the Queen's difficulties. Stukley's masculine unruliness – evident in the last sections of *The Famous Historye* – suggested the coded articulations of the inevitable consequences of royal failure to provide the kind of potent and just leadership for her swashbuckling gentlemanly elite. We also saw the ways the Queen's problems were gendered, since her femaleness prevented her from fully exploiting the masculinist chivalric rhetoric of leadership, making her vulnerable to the appropriation of power by her ambitious male subjects. Furthermore, the chapter revealed the ways in which Moorish dynastic struggle impacted on late sixteenth-century English debates about royal succession. My focus now shifts to debates concerning masculinity in later dramas concerned with travel and empire – specifically those that explore the interactions between piracy, 'turning Turk' and national allegiance. The texts to be focused on are Thomas Heywood and William Rowley's *Fortune by Land and Sea* (1607–9), Robert Daborne's *A Christian Turned Turk* (1612), and Philip Massinger's *The Renegado* (1623/24).[1] As in Chapter 2, where the anxieties about the Queen's leadership were represented through her undisciplined male subjects, I will be arguing here that descriptions of increasingly serious anti-establishment activities in these plays operate as a barometer for the perceived success or failure of Stuart rule.

Piracy and politics in Heywood and Rowley's *Fortune by Land and Sea* (1607–9)

When James I became monarch of England and Wales, Ireland, and Scotland in 1603, it was apparent virtually immediately that continuity with the reign of his predecessor Elizabeth was not going to be one of the most striking features of his regime in England. The contrasts in styles and ideology were acute since, as Curtis Perry summarises, 'the transition from Elizabeth to James was also the transition from a woman ruler to a man, from a Tudor to a Stuart, from a charismatic performer to a more aloof public personality, from a revered national heroine to a foreigner, and so on'.[2] Though the last years of Elizabeth's reign had been difficult ones, after her death her image became available for use as a foil to, and a source of criticism of, the new incumbent.[3] Such differences between Elizabeth and James were soon writ large in the policies of the new regime as James attempted to impose on his realm his absolutist conception of his role as 'God's lieutenant'.[4] Most notably, James reversed many of the assumptions underlying later Elizabethan foreign policy. He secured peace with Spain in 1604 and, as the reign bedded down, continued to maintain his favoured policy of peace in spite of opposition from some of his more warlike subjects.[5]

Chapter 3 explored Fletcher's use of Britain's Roman past and East Indian locations to voice domestic political concerns. In *Bonduca*, in particular, he used the complexities of the Roman invasion of Britain to shadow the contrasts between Elizabeth's and James's diplomatic and foreign policies. I continue to focus on the political allegories embedded in travel drama in this chapter. What concerns me here is one particular transition in that wider shift in foreign policy, the state's attitude to piracy. By focusing on the representation of piracy in a dramatic text, *Fortune by Land and Sea* (1607–9) by Thomas Heywood and William Rowley, I explore the extent to which such sea-borne activities were aligned with oppositional discourses that were critical of Jacobean policies. It has been argued that such criticisms did not find their full voice until the second decade of James's reign in texts such as Fulke Greville's *A Dedication to Sir Philip Sidney* (1610–12, published 1652) and in the chivalric propaganda of Henry, Prince of Wales; yet in the earlier *Fortune by Land and Sea*, we see staged a debate concerning the legitimacy of piracy and its brother activity, privateering, which has significant political resonance when we remember that the text's support of swashbuckling adventurers is at odds with

James's pacific vision of the nation.[6] In a similar way to other contemporary dramatic texts – most prominently Heywood's two-part *If You Know Not Me, You Know Nobody* (1605–6) and Dekker's *The Whore of Babylon* (1607), both of which are set in the recent Elizabethan past and which were, it has been argued, ambiguously available for oppositional readings – *Fortune by Land and Sea* uses values and activities associated with Elizabeth in James's reign as a contrast to those promulgated by the new monarch.[7] In the play we have two spheres repressented – one at sea with young Forrest, one on land with Philip – and the contrasts between the brave and adventurous young Forrest, and the passive, arguably weak, Philip can be seen as tapping into a nostalgia for Elizabethan values that threatens to undermine Jacobean policies. In what follows I test the extent to which Heywood and Rowley's representation of piracy in *Fortune by Land and Sea* should be read as expressing in coded form a growing sense of dissatisfaction with the king.

Under Elizabeth, distinctions between piracy and privateering – the latter being essentially piracy performed with state permission – had been imperfectly maintained. Famously, Elizabeth had retrospectively authorised many of the attacks of her naval captains (Drake, Essex and Ralegh, amongst others) against Spanish ships and ports in the years of the Anglo-Spanish war.[8] Indeed, she rewarded these men with honours for services to the state, as well as taking a percentage of the booty for the crown. Under James, the situation changed. During the first decade of the seventeenth century the state's public attitudes to those who interfered with legitimate trading and commerce hardened considerably. As early as 1603, when the Venetian ambassador complained that the Lord High Admiral was abetting piracy, James was outspoken in his response, exclaiming 'By God I'll hang the pirates with my own hands, and my Lord Admiral as well', and followed up these sentiments by issuing official proclamations against pirates.[9]

In fact, at the beginning of James's reign, as Lois Potter has shown, 'the English had a reputation as the fiercest pirates in the Mediterranean and Atlantic oceans', and it was well known that the Queen had abetted and profited from their activities.[10] As James acknowledged in a proclamation issued at Greenwich in June 1603:

We are not ignorant, that our late deare sister the late Queene of England, had of long time warres with the King of Spaine, and during that time gave Licences and Commissions to divers of her, and our now Subjects, to set out and furnish to Sea, at their charge, divers ships warlikly appointed, for the surprising and taking of the said Kings subjects and goods, and for the enjoying of the same, being taken and brought home as lawful prize.[11]

But, the proclamation continues, the policy has now changed: 'any shippes of warre, by vertue of the said Commissions, and not having notice of our entrance into this Kingdome, have at any time before the four and twentieth day of April last ... thereby taken any Ships, or Goods belonging to any Subjects of the King of Spain, and are already returned to our Dominions, shall quietly enjoy the sayd Shippes'. However, any ships 'now at Sea, having no sufficient Commission as aforesaid ... shall bee reputed and taken as Pirates, and both they and all their accessaries, maintainers, comforters, abettors, and partakers shall suffer death as Pirates'.[12] After a brief moratorium, then, and after James made peace with Spain in 1604, the state's toleration of privateering ended. In subsequent proclamations, James's tone is one of increasing irritation: in September 1603 pirates lost their legal rights of appeal since they were deemed 'beyond his Maiesties protection, and may by anyone be suppressed with extremities'; and in November 1604 James declared 'any person harboring the pirates after having seen this proclamation will be put to death'.[13]

Yet despite these prohibitions piracy continued to flourish because, as C.M. Senior has shown, of the sheer number of people involved in one way or another in the trade; moreover other occupations were not available to these 'men of warre' and their families by which they might earn their living.[14] As Captain John Smith, himself an ex-pirate, commented:

After the death of our most gracious Queene Elizabeth, of blessed memory, our Royall King James, who from his infancie had reigned in peace with all Nations, had no imployment for those men of warre, so that those that were rich rested with what they had; those that were poor and had nothing but from hand to mouth, turnd Pirats; some, because they became sleighted of those for whom they had got much wealth; some, for that they could not get ther due; some, that had lived bravely, would not abase themselves to poverty; some vainly, only to get a name; others for revenge, covetousness, or as ill; and as they found themselves more and more oppressed, their passions increasing their discontent, made them turne Pirats.[15]

Smith's sympathy here is clearly with many of these 'Pirats' who, because James's pacific policy no longer offered them any employment had, he argues, little choice but to turn to the illicit trade. According to Samuel Chew, the problem of piracy was at its worst in about 1608 – when the criminal career of corsair John Ward was at its height – and in the Elizabethan pirates Purser and Clinton who are hanged at Wapping in Heywood and Rowley's *Fortune by Land and Sea* (1607–9) we see punishment enacted upon those who defy the state's laws.[16] However, despite the

expression of what appears to be an orthodox hostility to pirates and the disruption they engender, the portrayal of piracy in *Fortune by Land and Sea* implicitly undermines James's stated policies. Importantly, it is the Elizabethan state that successfully punishes Clinton and Purser, not the Jacobean one, as the play is set in the reign of the Queen.[17]

Barbara Fuchs has usefully suggested that the movement from privateering through to 'the murky lawlessness of piracy to, finally, the absolute break of the renegadoes' should be seen as staging-posts on a continuum of 'increasing independence vis-à-vis the English state'.[18] This trajectory, of course, intersects with and ruptures the prevalent ideological vision of England as a trading nation powerfully encapsulated by Hakluyt's *Principal Navigations*.[19] As Fuchs comments 'the privateer's heroics calls into question the duller ethics of the merchant, ... the pirate's depredations threaten the very possibility of licit commerce [and] the alliance of the renegade subject to the Barbary States produces a highly unstable identity'.[20] Consequently Ward's violent death in Daborne's *A Christian Turned Turk* (1612) can be seen as a straightforward punishment, a kind of textual retribution, for his cultural duplicity as he betrays his religious identity and, as the end of the text makes clear, has created massive wealth for his Algerian masters through the disclosure of navigational information ('the seaman's art'), allowing them to bring 'treasure to your shore' (Scene 16, 299–302).[21] In contrast, Heywood and Rowley's *Fortune by Land and Sea* is a much more complex text which presents piracy far more ambivalently. Piracy here is not necessarily a threat to the integrity of English commercial expansion. Though Purser and Clinton are punished for their transgressions through hanging at Wapping, their nostalgic representation of their ship as a 'parallel state' to England (it has similar cultural practices couched in the same ideological terms) and their elegiac execution speeches, none the less unsettle a triumphalist reading of their deaths. Indeed, the play suggests that their piratical empire has in many ways superseded England's imperial endeavours, as the pirates have been immensely successful in their exploits.

Described on the frontispiece as a 'tragi-comedy', Heywood and Rowley's *Fortune by Land and Sea* was not published until 1655. There are records of performance by Queen Anne's Company at the Red Bull in 1607–9, and again in 1617, a theatre which tended to attract a 'citizen' audience of London merchants and guildsmen, as well as artisans and apprentices in this period.[22] The play runs – as the title implies – two interconnected plots taken from citizen life simultaneously, one in London, the

other on a variety of pirate and merchant ships. Both plots are primarily concerned with the fortunes of two families, the Hardings and the Forrests. Widower-fathers head both families and both have three children, though Harding has produced three sons and Forrest two sons and a daughter, Susan. At some point prior to the action presented, the families have experienced a reversal of fortune since the once wealthy Forrest family is now in reduced circumstances, and the Harding family have been able to buy up most of their lands. The play opens with the situation worsening for the Forrests since the youngest son, Frank, is murdered in a needless quarrel amongst gallants, and the other son, young Forrest, determines to avenge his death personally rather than having recourse to the judicial system. Meanwhile, in the Harding household the paterfamilias remarries and selects as a wife a young, virtuous but poor woman, Anne. Despite his own financially disinterested choice of bride, when Old Harding discovers that his eldest son Philip also intends to marry a poor woman, Susan Forrest, he reacts adversely, threatening to disinherit his heir in favour of his younger sons if he persists in his decision. Philip refuses to renege on his engagement and the now penniless married couple become servants in Old Harding's house, running demeaning errands for the overweening younger brothers. Philip is not legally disinherited, though this is Old Harding's declared intention. The action reverts to young Forrest, who kills his brother's murderer in a duel. While on the run from the authorities, he is hidden by Old Harding's new wife, Anne, who, with the knowledge of Susan and Philip, spirits him away to her brother, a merchant, who is prepared to help him escape abroad in one of his ships.

Whilst at sea the merchant is captured by the pirates Purser and Clinton, but then released following a sea-fight with the ship carrying Forrest, who, through his bravery in a previous encounter in which the Captain was killed, is now in charge of the vessel. Forrest holds the pirates captive and uses them as a way of securing a pardon from the English state for his crime of killing Rainsford. Meanwhile, since Old Harding is now dead – he expired on hearing a report of the loss of his investment in his brother-in-law's ship to the pirates – the way is clear for Philip to regain his status, and for Forrest to marry his widow. The conclusion of the plot of *Fortune by Land and Sea* appears, then, to harmonise any conflict between land and sea that has been staged in the drama, since, superficially at least, the deaths of Purser and Clinton, and the financial reward of the merchant, as well as Forrest's pardon, knighthood, and marriage to a virtuous woman, all show just reward for furthering the nation's legitimate trading

activities. As young Forrest sums up in the play's last couplet, moral justice has been served in his and Philip's situations, 'In us the world may see our fates well scan'd, / Fortune in me by Sea, in you by Land' (V, ii, 2448–2449). Fortune smiles on the most deserving of the characters, and greedy, treasonable or economically unproductive ones are, to differing degrees, punished.

Yet this play is more ambivalent in its attitudes to piracy than a simple reading of the hangings of Purser and Clinton as appropriate punishment for defying the state's laws would suggest. The pirates describe the government on their ship in similar terms to that of England. When Purser and Clinton reminisce about their sea-borne exploits, for example, they do so in language that mirrors descriptions of ceremonies and state activities in London:

> Oh the naval triumphs thou and I have seen,
> Nay ourselves made, when on the seas at once
> Have been as many bonefires as in Towns,
> Kindled upon a night of Jubilee,
> As many Ordnance thundring in the Clouds
> As at Kings Coronations, and dead bodies
> Heav'd from the hatches, and cast over-board,
> As fast and thick as in some common Pest
> When the Plague sweeps Cities. (V, i, 2182–2190)

In this speech, according to Fuchs, 'it becomes obvious just how profoundly they have colonized the symbolic realm of the English state, for they imagine their own dominion as a kind of shadow realm, one which reproduces the trappings of English power while in no way submitting to it'.[23] Indeed, because the pirates reproduce English state polity in their attempts to acquire a sea-borne empire, they of necessity cannot be faithful to the original because they have been creating something that ultimately competes with English aspirations. As Purser makes clear, previously they have 'raign'd as Lords, / Nay Kings at Sea, the Ocean was our realm' (V, i, 2157–2158). Their success, then, increases the ideological stakes of their activities since it questions whether they are merely imitators of an already existing successful government or whether, in fact, in their activities there are things from which the English state might usefully profit if used as a template for social, economic or political changes. In other words, are Heywood and Rowley expressing anxieties about English government through their representation of a form of pirate government that recommends changes to national practices? To answer these questions,

we need to consider what precisely are the ideological conclusions suggested by Purser and Clinton's conflation of monarchical status with piratical endeavours.

As the Merchant makes apparent in Act IV, scene i, Purser and Clinton have previously been involved in licit commercial activities: 'Clinton I know thee, and have us'd thy skil, / Ere now in a good vessel of my own', and he offers to help the pirate in the future 'if now thou do'st me a good office' (IV, i, 1621–1625). Clearly, this dialogue shows that there are routes back from piracy to lawful mercantile enterprise and, as a corollary of this, that there are no insuperable barriers to the resumption of English national identity and state-sponsored activities. In the play, however, the pirates refuse the merchant's offer, and their reasons for doing so are highly revealing. Initially the merchant is horrified at the crime of piracy as he, in pejorative language which echoes James's proclamations, attacks 'men of base condition' (IV, i, 1596) that 'profess wrong' (1597), and dwells on the consequences of their activities which have 'not alone undone me, and in me / all that are mine, but in overwhelming us / Shook the estate of all my creditors' (1601–1603). However, the merchant shifts his line of attack on their answer that they merely 'freely use our trade' and that their current success and the merchant's losses are in fact caused by 'thy fortune, / And not to any injury in us' (1611–1612). The pirates argue that the lack of social mobility in England is what has caused them to turn to piracy 'For he that's born to be a beggar know / How e'r he toyls and trafficks must dye so' (1613–1614). Furthermore, the opening lines of this scene on the pirate ship have already made it abundantly clear that we are witnessing an alternative, possibly superior, social world as Purser declares 'The spoyl of this rich ship we will divide / In equal shares' (1581–1582). In fact, the pirates claim that this egalitarian world is one of 'certain government' in which 'Though Out-laws, we keep laws amongst our selves' (1585–1586). Such praise for the rule of outlaws at sea is a coded comment that, as the play has already revealed numerous times in the land plot – for instance when young Forrest chooses not to invoke the haphazard redress of the law against the well-connected Rainsford – in England social injustice and unequal treatment are rife. Though the pirates in their scaffold speeches describe themselves as having 'raign'd as Lords, / Nay Kings at Sea,' (V, i, 2157–2158) their rule has not been based on securing the lion share of any financial reward. Pirate rule might appropriate the rhetoric of Stuart monarchy, but clearly there are significant differences between their 'royal' descriptions and the actual practices on board their vessel.

As a result of this interchange between the merchant and Purser and Clinton, the merchant's language changes. He now calls piracy, albeit with perhaps a degree of irony, a 'thriving trade' (1615) and takes exception only to the fact that the pirates are attacking their own countrymen rather than foreign nationals when they have 'such choice of store' (1616). Yet again, though, Clinton has a ready answer as he persists in refusing to accept responsibility for his status as pirate, instead blaming England: 'Nay since oure country have proclaim'd us pyrats, / And cut us off from any claim in England, / We'l be no longer call'd English men' (1618–1620). According to Clinton, then, their attack on English subjects began only after they were denied their citizenship: implicitly the text suggests here that there may be other, better, ways of dealing with pirates than making them outlaws since their alienation from England has only exacerbated their activities. It is at this point, as we have seen, that the merchant appeals to his personal relationship with Clinton to try and persuade him to set him and his cargo free and the pirate reiterates that the situation is not of his making, once more singling out Fortune as responsible:

> Troth I wish we had light of any other,
> But since *thy fate* hath cast thee upon us,
> We must neglect no opportunity;
> For they that intermit advantages,
> Must know occasions head is bald behind. (IV, i, 1625–1630, my emphasis)

From Clinton's point of view, the pirates are only taking advantage of a set of events over which they have no control. The merchant's fate was to be captured by pirates and they were, by chance, the ones to do it; though they would wish it was not this merchant they have encountered, none the less they are 'out-laws' and, as we have seen, they cannot afford to be sentimental because they have been 'cut off from any claim in England'. Such an argument would carry little weight except that the play is elsewhere full of references to Fortune, in terms of an allegorical figure of destiny, or financial health, as well as, more generally, a measure of a character's social situation. In all cases, characters represent themselves as helpless in the face of their fortunes and, like the disinherited and passive Philip in the land plot, have merely to wait until their situation changes. In this scene, therefore, there is certainly a considerable degree of ambiguity concerning whether Purser and Clinton are justified in their activities and attitudes.

These ambivalences in the text's representation of piracy make it less obviously the heinous crime James described in official proclamations (in

1609, for instance, pirates were characterised as 'lewd and ill disposed persons, accustomed and habituated to spoil and rapine, insensible and desperate of the peril they draw upon themselves').[24] The merchant is unable to maintain this orthodox hostility to their activities because the 'certain government' the pirates create onboard their ship appears little different, or even superior, to the government of England. Purser and Clinton are not despicable, 'lewd' characters. In contrast, Holinshed's *The Chronicles of England* (1587), for instance, used Clinton's history as a homily against bad living: he was 'an example of degeneration, procured not by euill education (for this Clinton wanted no good bringing up) but by bad companie and libertie, the verie spoile of many a one that otherwise might liue & thriue'.[25] In *Fortune by Land and Sea* the pirates' success against the merchant's ship has been hard-won and they generously pay tribute to the bravery and skill of the merchantmen: 'A sea fight / Was never better managed nor exployted / With more exchange of hostile opposition, / We did not look for such a valiant spirit / In any Merchants breast' (1588–1592). Similar to the ways Hakluyt promoted the heroism of merchants in his accounts of their sea-borne empire-building through trade, Purser and Clinton celebrate the merchant's intrepid qualities in *Fortune by Land and Sea*. In Hakluyt's 'Epistle Dedicatorie in the First Volume of the Second Edition, 1598' to Lord Charles Howard, for instance, mercantile activity is celebrated as merchant ships engage in battle against 'strong and warlike' opponents.[26] Purser and Clinton, significantly, despite being pirates, are not represented as at odds with the merchant or his trade since they appreciate his skills. Indeed, because we have encountered on the ship a sort of settled state where rewards are equally shared amongst all, in marked contradiction to the abuses of the system of government in the land plot, piracy does not appear to be condemned in any obvious way.

The most clearly comic scene in the play precedes the one just described and shows the Clown reading out loud one of the Queen's proclamations against piracy. This scene is notably similar to one which was published in a pamphlet in 1639, possibly by Heywood, where a hoarse Pursevant 'by reason of riding in the wet, and thereby catching so great a cold' employs 'a plaine and crafty Country fellow,' to read his proclamation.[27] In the play version the Pursevant recruits the Clown to read the document after him with the result that the charges against Purser and Clinton are ridiculously garbled. Indeed, the central terms of reward for the capture of the pirates in the declaration are reversed:

Pur: If a banisht man his country.
Clo: If a man he shall be banisht his country.
Pur: If a condemned man liberty.
Clo: If a man at liberty condemned. (III, iv, 1564–1567)

The clown's inversion explicitly undermines the integrity and authority of the monarch's words here.[28] But the text undermines royal authority in another way: the Pursevant's words directly referring to the Queen are also significantly garbled. The herald tries to proclaim 'Notwithstanding her Majesties commission' which is rendered as 'Notwithstanding her majesties condition' (III, iv, 1548–1549) and the Clown entirely omits the proclamation's loyal conclusion 'And so God save the Queen' (1570). Both mistakes undermine the Queen's status, the first by implying she is either diseased or pregnant, and, the second, by the Clown not possessing enough respect for her authority to repeat the standard form of allegiance. Before we even see the forms of government on board the pirate ship, then, the Elizabethan state's relationship to piracy is shown as problematic. Official attitudes – represented by the Pursevant – are satirically undermined through the manner of their dissemination by the Clown. But, there is also another layer to the complexities of *Fortune by Land and Sea*'s attitudes to piracy which is articulated at this point in the text: the explicit use of an Elizabethan time frame by a play from the first decade of James's rule. The Clown's malaprop speeches weaken, indeed reverse, the Jacobean state's often repeated hard-line attitude to piracy since here punishment is offered as reward for the capturing of pirates. The idea of punishment as reward is, of course, nonsensical, but, as I show in what follows, it is important to discover whether the attack implied by the text's ridicule is directed here at the Elizabethan or Jacobean state.

Fuchs has argued that Heywood and Rowley's ambiguous representation of piracy might be seen as 'a veiled critique of Elizabethan expansionism'.[29] In what follows I will suggest an alternative analysis, specifically reading *Fortune by Land and Sea* as a celebration of Elizabethan expansionism at the expense of Jacobean pacific policies. The important issue of whether it is Elizabeth's or James's government that is indicted through Heywood and Rowley's mockery of anti-pirate policies is further addressed in the following scenes of the drama. From the pirate vessel we move directly to young Forrest's ship which, it swiftly becomes apparent, is involved in activities little different to those of Purser and Clinton. Young Forrest has become a privateer making unprovoked attacks on other shipping, and though he persistently attempts to articulate a difference

between his exploits and those of the pirates, in the action that follows there appears to be little to choose between them. Forrest and his men have, it seems, been highly successful in capturing and routing Spanish ships. One of the mariners describes how they have prospered since taking Forrest onboard:

> When we first took you to our fellowship,
> We had a poor bark of some fifteen tun,
> And that was all our riches, but since then
> We have took many a rich prize for Spain,
> And got a gallant vessel stutly man'd,
> And well provided of Ordnance and small shot,
> Men and ammunition, that we do dare coap
> With any Carract that do's trade for Spain. (1682–1689)

It is only once they are fortified with Spanish plunder that they turn their attention to the pirates. Indeed, Forrest makes plain that, as on the pirate ship, any booty has been equally shared between all the crew, 'the riches of their ship / We 'mongst you will divide in equal shares' (IV, v, 1850–1851). This distribution runs counter to the official Elizabethan policy of the prize being divided only on return to England, thus ensuring that the crown was awarded a certain percentage of the spoils. When Forrest describes his motives for attacking the pirates they appear as a contradictory blend of national and self-interest:

> We dare do anything that stands with justice,
> Our countries honour, and the reputation
> Of our own names; but amongst all our spoils
> I wonder we have scap'd the valiant Pirats
> That are so much renowned upon the sea,
> That were a conquest worth the hazarding,
> Besides a thousand pounds reward proposed
> To that adventurer that can bring them in,
> My peace and pardon though a man condemned,
> Is by the proclamation ratified. (1690–1699)

The continued ambivalence of the text's representation of piracy is made manifest through the fact that Forrest is at this point as much of an outlaw – having killed Rainsford – as are Purser and Clinton. Forrest might be behaving as though he were a privateer acting in the service of the Elizabethan state attacking the nation's enemy Spain, but he is not in the state's employ. His distribution of booty to his comrades rather than reserving it for Elizabeth, and his desire to regain 'my peace and pardon though a man

condemned' mark him as a pirate, not a privateer. Though he tries to
assert that he is acting in the service of the state through refusing to attack
other English vessels, seeking only 'lawful spoyl' 'from foes' (1715–1716),
such a distinction is too fine to be convincing in the text.

The confusion in status is made more explicit by the pirates' choice of
flag: like Forrest they also fly 'the Cross of England and St. George' (1759).
As a contemporary commentator, John Brook, observes, ships' crews
frequently had difficulty accurately identifying the allegiance of other
vessels since in the early seventeenth century 'everie shalloppe is a man of
warre and doth carrie the colours of everie nation, and soe, by devices and
trickes doe gett aboarde and take merchante shipps, for it is harde for anie
to escape'.[30] The sequence of events concerning the recognition of the
ships is notable. When Forrest thinks he spies a pirate ship, even before he
has seen the vessel at close-quarters to ascertain its identity, he arms his
ship ready for attack. On seeing the English flag he initially declares 'she's
a friend' (1760) intending to disarm, and only when the ship's Boy tells
him that the approaching vessel – despite the flag – is also preparing to
attack, does he commit himself to the skirmish. There is a clear contra-
diction in Forrest's reading of the signs displayed by the other ship, and in
his own actions. He attacks the approaching ship precisely because it
mirrors his own vessel's behaviour. The pirate ship follows Forrest's
example exactly. Not only, then, is Forrest flying a flag to which he – like
the pirates – has no right, but he attacks them solely because they imitate
his own behaviour and arm themselves. As these events unfold, then, it
becomes evident that Forrest, despite his protestations of loyalty to
England, is just as much of a pirate as Purser and Clinton: there is no clear
blue water between them.

So how should we read Heywood and Rowley's double represen-
tation of piracy – in the activities of Purser and Clinton, and of young
Forrest? Under Elizabeth, the state had attempted to draw a rough and
ready distinction between the nation's privateers and outlaw pirates,
however difficult in practice those differences were to maintain. Hence the
resemblances between young Forrest and Purser and Clinton are rather
more significant than their differences. But James's proclamations made
no distinction at all between piracy and privateering against Spain or any
other nation at this time: both were capital crimes. Therefore *Fortune by
Land and Sea*'s nostalgic representation of the Elizabethan past, where the
distinction was hard to maintain but there was at least some room for
manoeuvre, shows the harshness of James's blanket ban. The celebration

of the 'pirate' Forrest's activities as furthering the national interest (evident in the rewards bestowed on him at the end of the text) in effect acts as a plea for a less draconian and indiscriminate Jacobean attitude to piracy.

Heywood and Rowley's attack on James's hostility to all forms of aggressive sea-borne activities is further revealed by the courageous (even, in some ways, patriotic) speeches made by Purser and Clinton as they await execution.[31] As they prepare to die, they reveal themselves to be impressive and poetic manipulators of language:

> But now our Sun is all setting, night comes on,
> The watery wildernes ore which we raign'd,
> Proves in our ruins peaceful, Merchants trade
> Fearless abroad as in the rivers mouth,
> And free as in a harbor, then fair Thames,
> Queen of fresh water, famous through the world,
> And not the least through us, whose double tides
> Must o'rflow our bodies, and being dead,
> May thy clear waves our scandals wash away,
> But keep our valours living. (2257–2266)

They represent themselves as monarchs of a sea-borne empire here subservient solely to 'Queen' Thames. Her ebbing and flowing tides alone are recognised as a superior form of authority as they describe her as possessing the power to wash away their wrongdoing, their 'scandals', and celebrate their achievements and 'valours'. Their patriotism is associated with a vision of England that is both greater than, and significantly different to, that offered by the nation's ruler. It is built on more enduring foundations such as the Thames which, rather than any particular English monarch, is 'famous through the world'. Indeed, the pirates' value system is based on the recognition of timeless qualities of maritime exploit such as their own buccaneering activities. The use of a speaking river to articulate oppositional politics was further developed in Michael Drayton's chorographic *Poly-Olbion* (1612) where the 'Tames' eulogises Elizabeth's military glory during the river's catalogue of previous monarchs but, significantly, stops short 'suddainly' of including James:

> Elizabeth, the next, this falling Scepter hent;
> Digressing from her Sex, with Man-like government
> This Iland kept in awe, and did her power extend
> Afflicted France to ayde, her owne as to defend;
> Against th'Iberian rule, the Flemmings sure defence:
> Rude Ireland's deadly scourge; who sent her Navies hence

Unto the ether Inde, and to that shore so greene,
Virginia which we call, of her a Virgin Queen:
In Portugall gainst Spaine, her English ensignes spread;
Took Cales, when from her ayde the brav'd Iberia fled.
Most flourishing in State: that, all our Kings among,
Scarse any rul'd so well: but two, that raign'd so long.
Here suddainly he staid ...[32]

In *Poly-Olbion*, written under the protection of Prince Henry, and subsequently dedicated to him, we can see nostalgia for the old queen, and a championing of swashbuckling values designed to appeal to Prince Henry and his 'war party' even as the text pointedly excludes James. Similarly, in *Fortune by Land and Sea*, as Purser and Clinton argue in previous speeches, it is the achievements of 'many a brave Marine souldier', who meets his death in the fatal 'quick sand' of the Wapping harbour where pirates were hanged, that are essential to the nation; it is their 'valour, experience, skil, and Naval discipline' that are here 'Being lost'. They challenge the wisdom of the state's punitive laws since such men are so important: 'I wish this land may never have need' (2236–2241). The execution scene at Wapping is described as an 'unfortunate peece of land' where 'many Captains that have aw'd the sea / shall fall' (2203–2204). These men, Purser argues, have been immensely successful in furthering English interests abroad at the expense of the nation's rivals. Men hanged at Wapping have included, and will continue to number:

Some that command Ilands, some to whom
The Indian Mines pay'd Tribute, Turk vayl'd. (2205–2206)

And, as Purser claims, it is 'no impeachment to [the] ... fame' of these swashbuckling furtherers of England's welfare that the deaths of 'Purser and bold Clinton' who 'have quak'd, nay troubled flouds, / And made Armadoes fly before our stream' (2207–2211) should be added to their number. The pirates' speeches in this scene, then, deny that national allegiance is associated with the monarch. Rather, they represent their own and other men's swashbuckling adventures as the true model of national identity.

The strength of Purser and Clinton's speeches, and their courage throughout, raise questions about the moral justification of young Forrest's actions in bringing them to trial in England. The similarities between the activities on the two ships cause the justice meted out on land to seem arbitrary and compromised. The emotional register of the play is such that the audience is not encouraged to wish young Forrest punished

either for killing the dissolute Rainsford or for bravely besting Spanish ships. He too has suffered at the hands of a justice system that is based on nepotism and corruption: Rainsford would, young Forrest argues, never be brought to law for his killing of Frank Forrest because he has powerful friends; similarly, young Forrest's punishment in the courts if brought to trial would be severe for precisely the same reasons. Nevertheless, the difficulties of clearly distinguishing Forrest's sea-borne exploits from those of the pirates mean that their deaths are a mournful affair. Indeed, the punishment inflicted upon them exceeds any given to even the most morally reprehensible of the characters on land. Rainsford is killed, but he himself murdered Frank Forrest; the greedy, unfilial younger Harding brothers find forgiveness, as do Philip's fair-weather friends; even Old Harding – the most obstructive of all the characters on land – enjoys a peaceful death in his bed. In fact, Old Harding's death is brought on by the shock of hearing of his loss of fortune at sea at the hands of the pirates which, given his unreasonable treatment of his son and daughter-in-law, means the pirates' behaviour is more a cause for celebration than chastisement.

The text attempts to draw a line between the active, productive, deserving characters – on whom Fortune eventually smiles – and those that have been blocking, self-serving and greedy. Yet such a division is imperfectly made: Philip, for instance, succeeds to his rightful inheritance at the play's conclusion, yet he has been curiously passive throughout the text: 'What must be, must be, heaven hath sent it down, / At which they smile, why should we mortals frown?' (II, i, 721–722).[33] His inaction is rewarded, yet it is impossible not to question whether he really deserves such fortune, especially since other more impressive characters – the pirates in particular – feel the rough edge of justice. Certainly, Philip's brothers and his pretended friends get away virtually unpunished with behaviour that has been shown to be far more unpleasantly mercenary than that of the eloquent pirates. Like James, who by the end of the first decade of his reign, was seen as ineffectual in his dealings with his greedy brothers – other European princes – Philip appears weak in comparison to them. Morally Philip is deserving, as James was perceived to be in his desire to preserve peace in Europe, yet neither possesses the drive of the swash-buckling, Elizabethan young Forrest who has the ability to right wrongs. Young Forrest may take moral risks – for instance in his dealings with brother pirates – but he at least has the capacity to act in the face of adversity rather than appearing insipid and helpless as Philip does. Indeed, one of the main ironies of the play is that Philip only achieves his inheritance as a

consequence of the actions of the pirates as they, albeit unknowingly, are
the cause of the death of Old Harding. Philip here was dependent on the
actions of the alternative social and governmental world of the pirates to
effect changes in the land-locked one.

We are faced with a neat, supposedly harmonious conclusion to
Fortune by Land and Sea, but there is no doubt as to the supremacy of the
worth of young Forrest in comparison to Philip. In the play's representa-
tion of the London scene, we are shown arbitrary and nepotistic justice as
the socially elite Rainsford is beyond the reach of the law, and in such a
world of rivalry and corruption individuals such as young Forrest need to
be able to stand up for their own rights. Sir Edward Coke's work on the
importance of law as a supreme force to check the power of the monarch is
resonant here.[34] Coke wrote concerning the importance of common law in
his *Reports* in 1604, 'The King is under no man, but only God and the law;
for the law makes the King'.[35] In the *Reports* of 1605, the law became even
more central to his conception of just government: common law is the
'best inheritance that the subjects of this realm have, for by them he [the
subject] enjoyeth not only his inheritance and goods in peace and
quietness but his life and his most dear country in safety'.[36] In *Fortune by
Land and Sea*, the law needs strengthening along the lines outlined by
Coke in order to prevent the vicissitudes of arbitrary Fortune and corrupt
practice suffered by the pirates and by young Forrest.

The Elizabethan values expressed through young Forrest might not
be perfect, as his actions pose a series of difficult-to-answer moral ques-
tions, yet they appear preferable to the weaknesses and passivity of Philip.
We have here presented divergent masculine responses to complex prob-
lems of leadership and government; young Forrest's swashbuckling is a
nostalgic version of the expansive behaviour and achievements of male
subjects under Elizabeth which, once James' reign was several years long,
started to be appropriated by writers and commentators as vehicles to
voice anxieties about the wisdom and strength of *Rex Pacificus*. In the
figure of young Forrest there are resemblances to Walter Ralegh who,
detested by James, was imprisoned in the Tower for advocating precisely
the kinds of buccaneering activities that Elizabeth rewarded.[37] On James's
accession Ralegh wrote *A Discourse touching a War with Spain*, which
aggressively recommended the continuation of hostilities: unsurprisingly,
neither the tone nor the policy found favour with James, and Ralegh was
arrested for treason, tried and condemned, though the sentence was com-
muted to life imprisonment.[38] Transcripts of Ralegh's 1603 trial – at which

he eloquently defended himself – circulated so widely that the public response to Ralegh changed from vilification to sympathy. Certainly, as Anna Beer argues, his stand-off with the Stuart monarchy later became 'part of his hagiography' and in young Forrest we see the expression of aggressive expansionist policies at odds with James's.[39]

In Philip's passivity, by contrast, we have a version of James in which virtue is rewarded, but his success is achieved only through the intervention of aggressive, war-like forces – young Forrest and the pirates – that are inimical to the values Philip espouses. In the light of this analysis, Heywood and Rowley's *Fortune by Land and Sea* should be seen as a cautious expression of the limits of James's vision of the nation's diplomatic policies. Fortune does smile on Philip finally in this text, but the reversals and changes in characters' situations have shown what an arbitrary force it is, and Heywood and Rowley appear to show much more confidence in the wisdom of young Forrest's aggressive and dynamic actions. In this text's representation of piracy and its connections to privateering, and in the passivity of the land-locked Philip, we can trace an emerging, though somewhat cautious, oppositional politics to the most dearly held Jacobean values. From the beginning of the reign James had made clear his commitment to peace, telling his first English Parliament that the first 'blessing' his 'person bestowed' upon them was peace.[40] Fletcher's *Bonduca* was seen in the last chapter as reflecting the sentiments articulated by Henry Neville in 1606 that 'the Kingdom generally wishes this peace broken, but *Jacobus Pacificus* I believe will scarse incline to that side', and Heywood and Rowley's play voices the same concerns.[41] *Fortune by Land and Sea* should be seen, then, as an early expression of anxieties about James's leadership and, moreover, as one which in its championing of buccaneers might have helped create the oppositional climate of the second decade of the king's reign.

Oppositional politics? Apostasy and counsel in Daborne's *A Christian Turned Turk* (1609-1612)

Daborne's *A Christian Turned Turk*, like *Fortune by Land and Sea*, is full of subtle indeterminacy that makes it ambiguously available for an oppositional reading. A comparison between *Fortune by Land and Sea* and Robert Daborne's *A Christian Turned Turk* in terms of plot reveals the later play to be less light-hearted as it stages an incessant series of betrayals and their often murderous consequences. Daborne's text was written

between 1609 and 1612, and only printed in quarto in 1612; it was probably
performed at Whitefriars – a theatre near the Inns at Court – by Rosseter's
Queen's Revels Children (an adult company) after 1610.[42] Certainly,
Daborne was connected with the company in this period, but full records
of which plays were performed have not survived. *A Christian Turned
Turk* charts the career of English corsair John Ward from pirate to
apostate and ends with his violent dismemberment, which has been read
by Nabil Matar as fit punishment for Ward's betrayal of his national and
religious identity.[43] However, in what follows, I will suggest an alternative,
less conventional reading of Daborne's text in which Ward's conversion is
seen as a reflection of contemporary anxieties about James's religious
policies, specifically his attitude to Catholicism, and concerns over his
susceptibility to influence from his familial and other intimate relation-
ships. In particular I will argue that Ward's suicide and consequent
dismemberment should not be seen as marking an unambiguous triumph
of Jacobean policies over unruly individuals. Instead, in Ward, and in his
piratical foil Dansiker, we find a debate about alternate 'kingly' premises
which might be seen as challenging rather than confirming the foundations
upon which James constructed his rule.

 The figure of John Ward attracted a considerable amount of attention
in the early seventeenth century.[44] John Donne in *Elegy 14*, for instance,
questioned whether 'Ward / The traffique of the Midland [Mediterranean]
seas had marr'd' and Dekker, in *If this Be Not a Good Play, the Devil is in It*
(1612), describes how hell has just received the pirate Dansiker (he died in
1611) but that 'Ward is not ripe for damming yet' (V, iv, 84).[45] Furthermore
in 1609 Andrew Barker, 'Master of a Ship … taken by the confederates of
Ward, and by them some time detained prisoner', published an account of
Ward entitled *A True and Certaine Report of the Beginning, Proceedings,
Overthrows, and now present Estate of Captaine Ward and Danseker, the
two late famous Pirates: from their first setting foorth to this present time*,
and an anonymous pamphlet about Ward, *Newes from Sea, Of Two
Notorious Pyrates, Ward … and Dansiker*, was also published.[46] Though
Barker's text ostensibly condemns Ward wholeheartedly for his activities
(the 'iniurie hee hath done, daily doth, and still indeavoureth to doe, to
rich estats, and provident Sea-farers, to the venturing Marchant, and the
careful Saylor, to poore wives and distressed children; how like a villaine,
and an apostata he lives, and how like a reprobate in persisting, he resolves
to die') in fact, at certain points, there appears to be considerable
sympathy for his situation.[47] Ward is, for example, a charismatic speaker,

successfully persuading other mariners to follow him into piracy because of the lack of either employment opportunities or financial security. He compares the current lean pickings to previous times of prosperity:

Where are the times that wee saylors estéemed Chekeins cheaper than your bumber Hollander doth chéese: where are the Portugall voyages, that put Portugues into our pockets: Zblood ... where are the days ... when we might lawfully doe that, we shall be hangd for and we doe now, when the whole Sea was our Empire ...[48]

Ward's central point here is similar to John Smith's explanation of the increase in piracy which I quoted earlier: under Elizabeth privateering was allowed. But, Ward argues, the shift in policy after the Queen's death has undermined his and other men's manhood. Piracy would not be necessary if 'true resolution were not banckroupt in England, if we had not womens hearts to bearded faces ... of my mind, manhood should not thus subd as it hath béene' under James's leadership.[49] And, of course, as the text makes clear, there is a political dimension to Ward's complaints since the model for his subject's manhood should be the King. English manhood has, according to Barker's Ward, become less masculine under a male monarch than it was under Elizabeth. As a consequence, Englishmen are turning to piracy as an outlet for the expression of their natural 'masculine' aggression.

Barker's text, then, shows some degree of ambivalence in its representation of Ward: his valorous 'manhood', for instance, is celebrated. As Barker reluctantly admits 'for these last thrée yéeres ... he is growen the most absolute, the most resolute, and the most undauntedst man in fight' and 'if his actions were as honest as his valour is honourable, his deeds might be dignified in the Chronicles with the worthiest'.[50] Barker's grudging admiration for Ward – similar to the representation of young Forrest in *Fortune by Land and Sea* – are ambiguously available to be read as comments aimed at James. The text's ostensible purpose is to encourage James to be more aggressive and militant in his suppression of the current unchecked lawlessness at sea. Barker warns that:

if it doe not please God to move the heart of his Maiestie, and other Christian Princes, and states, to ioyne together for their speedy suppression ... It will be discomodious to the state, and so dangerous to the common wealth, in succeeding times, that Christendome must expect no Trafficke at Sea.[51]

Hence, although Ward is condemned by Barker, nevertheless he possesses attributes, specifically potent 'manhood', which James would do well to imitate. For, if his leadership possessed the kind of 'true resolution' Ward

desires for England and Ward himself demonstrates, the problem of piracy would not have reached such a pitch. In Barker's *A True and Certaine Report* there are hints that Ward's success – in his 'absolute' and 'resolute' behaviour, and in the fantastic wealth of his Tunis lair – is a coded comment on what Barker sees as James' paucity of such qualities. Aggressive masculinity, legitimately directed, should be encouraged by James personally and fostered in his subjects. In what follows, I explore the extent to which Daborne's play similarly uses the character of Ward as an allegorical vehicle to anatomise James' government, his leadership qualities and his views on kingcraft.

Daborne's *A Christian Turned Turk* has an intricate plot. It opens on board Ward's pirate vessel as he is recruiting by stealth new comrades to his trade off the coast of Ireland. He hijacks two French merchants, Ferdinand and Albert, who, thinking Ward's ship to be a merchantman, come on board to play cards. The scene is interrupted by the arrival of a real merchant ship looking for help against a third ship, a pirate ship that is pursuing them. Ward's vessel speedily subdues the merchant ship either killing or taking prisoner those on board, including a young Frenchwoman, Alizia, who is on her way to her wedding and has disguised herself as a boy, Fidelio, to prevent the pirates knowing her gender. The pirates murder her brother. The captain of the other pirate ship, Francisco, challenges Ward to single-combat for his share of the plunder, and when Ward loses the two men assert their 'brotherhood' (Scene 4, 148). Meanwhile two of Ward's shipmates, Gallop and Gismund, betray their leader, making off with the ship, cargo and prisoners to sell in Tunis, much to Ward's fury.

The action then switches to Tunis where we see the pirate Dansiker receiving news of his pardon from the king of France and vowing to 'not return into our country with the names / Of pardoned thieves, but by some worthy deed' – specifically he aims 'to ruin all the pirates / [that] lie in the harbor here' through setting their ships on fire (Scene 5, 14–15, 26–27). On arrival in Tunis, Gallop and Gismund repair to the house of the Jewish merchant Benwash and his Muslim wife Agar to sell their booty. Gallop and Agar conceive a passion for each other which Benwash suspects, instructing his servant Rabshake to guard Agar's honour on pain of death. Meanwhile Voada, Agar's maid, desires Alizia who is still disguised as a boy. These flirtations are interrupted with the arrival of Ward and Francisco with new slaves for sale, Ferdinand, Albert, Raymond and his two sons (one of them betrothed to Alizia), and Gallop tries to pretend he was seeking to sell the booty on his captain's behalf, an explanation which

Ward accepts. Benwash then buys the slaves from Ward. Ward falls in love with Voada and fights for her with Dansiker, and, though the arguments of the Governor, Benwash and Voada's brother are not able to persuade him to 'Turn Turk', Voada is more successful as she promises 'Turn Turk – I am yours' (Scene 7, 127). After further prevarication on Ward's part, Scene 8 shows his apostasy in dumbshow.

Dansiker's plan to fire the pirate ships in the harbour proceeds, and he buys Ferdinand and Albert from slavery, intending to set them free. Gallop and Agar's infidelity is interrupted by cries of alarm over the fire that has taken hold of the ships and Benwash's house. To Ward's disgust, Voada renounces Ward in favour of Alizia, and Benwash discovers his wife's adultery but determines to revenge himself on Gallop. Dansiker flees in Ward's ships, and Voada bribes Alizia into promising to have sex with her, but Benwash's servant Rabshake betrays her secret desire to the jealous Ward. The Governor sets his janissaries on Francisco and Ward, while Alizia betrays Voada to Ward, who has started to repent his apostasy and promises Alizia her freedom. A plan is hatched for Alizia to take passage on a ship leaving Tunis but Ward then betrays her scheme to Voada with the intention that she will kill 'Fidelio'. Dansiker arrives in France to find Henry IV has died and, in order to pacify the merchants he has plundered previously, promises to exact revenge on Benwash for their losses.

In some confused plotting in Scene 15, which is set in the dark passageways around Tunis castle, the play represents yet another series of betrayals. Young Raymond has arranged to meet Fidelio, not knowing for sure whether it is Alizia in disguise, but when he calls her name, Voada, led there by Ward, shoots him thinking it is the Captain of the ship upon which Fidelio is due to leave. When Fidelio arrives she finds Raymond dying and, after revealing that she is Alizia, stabs herself. When Ward discovers Fidelio was a woman, he blames Francisco who originally forced Rabshake to betray Voada's secret desire for Fidelio to him. Voada determines revenge on Ward for his part in the tragic events and, trying to stab him, is herself wounded. When the watch enters, Voada accuses Ward of murdering Fidelio, and Ward blames Francisco, but the Watch, apparently unconcerned at the death of a Christian, arrest him, raving, for the injury to Voada

Back at Benwash's house, the Jews plot to take revenge on Gallop, and Benwash instructs Rabshake to murder Agar. With the adulterers dead, Rabshake is ordered to tie up and wound Benwash, and, though suspicious that Benwash is setting him up to take the blame for the murders, he

agrees to put his head in a noose so that it will look as if strangers have
perpetrated the crimes. Benwash then strangles Rabshake and, when
discovered by the Turkish authorities, appears to have been a victim of
crime himself. Dansiker however fulfils his promise to the French merchants
and stabs Benwash, who before he dies confesses his crimes. Dansiker
then kills himself. The play ends with Ward attempting to murder Voada
and, when he is prevented, killing himself. He dies cursing all 'slaves of
Mahomet', repenting his apostasy, and prophesying the overthrow of
Islam by Christians.

There are two issues that I wish to explore in relation to Daborne's *A
Christian Turned Turk*. Specifically, I examine the extent to which
Ward's behaviour and betrayals reflect anxieties about James's rule and,
related to this, whether the character Voada – whose influence, not the
men's, is decisive in turning Ward Turk – should be seen as a coded
representation of unease about both the sway of James's Catholic-convert
queen upon her Protestant husband and the notorious power of James's
favourites in controlling their king. In other words, in what follows I want
to address whether Daborne's play – despite the apparently orthodox
punishment of Ward and the Governor's concluding epitaph '"Ward sold
his country, turned Turk, and died a slave"' (Scene 16, 326) – should be
seen as implicated in the oppositional discourses circulating against James
in the second decade of Stuart rule. As an addendum to this, the politics of
Ward's rival pirate king, Dansiker, will also be explored, in order to
explore *A Christian Turned Turk*'s complex attitudes to kingcraft.

Daborne's Ward, like Stukley in the earlier Elizabethan dramas, is a
complex mix of admirable and culpable qualities. In popular ballads about
Ward of the time (for example *The Seaman's Song of Captain Ward, the
Famous Pirate of the World, and an Englishman Born*, 1609), there is a
sense that Ward's illegal exploits have deprived England in unexpected
ways. Though Ward is condemned for the 'wickedness [that] within his
heart is growen', which renders him 'drunk amongst his drabs, / His
nearest friends he sometimes stabs', nevertheless the ballad mourns the
loss to England of such potentially serviceable men:

> The riches he hath gained,
> And by bloodshed obtained,
> Well may suffice for to maintain a king.
> His fellows all were valiant wights,
> Fit to be made prince's Knights,
> But that their lives do base dishonours bring.[52]

And, if England and the King lack the assistance of these 'valiant wights', the nation also fails to profit from their brave antics: 'Stately Spain and Portugal / Against him dare not bare up sail, / But gave him all the title of a Lord'.[53] In Daborne's play, there is also a considerable degree of ambivalence in the representation of Ward, though it creates rather different effects. In Barker's pamphlet, and in the ballads, Ward is an example of a serviceable and potentially useful Englishman gone wrong: the nation could, these texts argue, have made use of such a potency if the climate had been different, and implicitly, the failure to use Ward in the service of the state is partly James's fault. In *A Christian Turned Turk*, by contrast, Ward cuts a much more uncertain, anxious, and even, as the action progresses, an easily manipulated figure.

When Ward hijacks Ferdinand and Albert in the opening scene, for instance, he attempts to silence their complaints against this treatment and justify his position by claiming that England has failed him. He rails against the lack of adequate reward for men of action at 'home': 'is't not a shame / Men of your qualities and personage / Should live as cankers, eating up the soil / That gave you being' (1, 33–37). He argues that such base servility is inappropriate to their talents, claiming that he does not want their money, instead 'It is the man we want' (1, 33) and that with him they will enjoy new freedom. Ward's officer Gismund declares that 'Heroic Captain Ward' is a 'rewarder of manhood'. The freedom Ward offers to potential pirates, then, is based on an ethos of pan-national male bonding where positions in the hierarchy are maintained through acts of extreme violence. In the play's imagery a connection is made between male same-sex desire, hinted at here, and other patterns of behaviour concerned with male freedom that are practised in the social world onboard the pirate ship. Certainly one of Barker's accusations against Ward and his crew was that they were sodomisers buying Jewish children from their parents to satisfy 'their crying sinnes', but in Daborne's version the implication of male same-sex desire is much more delicately handled, and significantly less hostile.[54] I suggest, then, that male same-sex desire is not condemned outright in Daborne's play.

Indeed, the exact extent of Ward's culpability more generally is a moot point. Lois Potter sees 'in the beginning at least, some attempt to make Ward's character worth watching: he is brave, rough, but capable of reflection' and Nabil Matar has detected in the play an over-writing of Marlowe's *Dr Faustus* (1592) where 'the Faustian necromancer represent[ing] the aetheist of new science' has given over to a vision of the

aetheistic renegade selling his soul to the Turk in place of the Devil.[55]
Matar's identification of Marlowe's text as an influence on Daborne's
Ward is an astute one since, just as Faustus vacillated between the counsel
of the Good and Bad Angels, in *A Christian Turned Turk* the central
concern of the drama is ownership of Ward, body and soul. Ward justifies
his action of hijacking the merchants with a fatalist philosophy: 'the fate of
man is fixed, / Unmoveable as the pole' (3, 32–3) and:

> We have no will to act –
> Or not to act – more than those orbs we see
> And planetary bodies, which in their offices
> Observe the will of fate. The difference is:
> They are confined; we are not. They are stars fixed,
> We wandering. Run on, thou purple line
> That draw'st my life's fate out. (3, 40–46)

Yet, within these speeches, even he acknowledges that there may be
something missing from his philosophy. When mourning the death of his
fellow pirate and friend, Ward denounces the body as 'a coward' since
'with one little prick' it has been destroyed; he again uses the language of
male homoeroticism, but, arguably, not in a condemnatory way, since
Ward is eulogising the dead man. The hijacked Ferdinand uses Ward's
agitation to try and correct his atheistic, fatalist beliefs, arguing that
'Nature ... intended man ... All unoffensive, unarmed' and 'When unto
beasts / She [Nature] gave the means to hurt as to defense, / The armour
she gave man was innocence' (3, 18–22). In the face of Ferdinand's belief
that aggression was given to Man solely as defence, Ward acknowledges
that his philosophy may be wrong: 'True, there was some other end in our
creation / Than to be that which men term valiant' (3, 23–24).

Indeed, Ferdinand makes repeated approaches to Ward to debate the
morality of his actions, and offer counsel, in the early scenes of the drama.
The French merchant's advice chimes with James's pacificism, and his
views on piracy, as he argues 'Piracy, its theft most awful' and that such
actions 'rob the venting merchants, whose manly breast / (Scorning base
gain at home) puts to the main / With hazard of his life and state' (1, 59–64).
We have here, then, a clear statement of James's second-decade foreign
policy as Ferdinand and Ward represent opposite sides of the argument
concerning strength through peace. Yet the text appears more poised
between them than if Ferdinand's position were unambiguously correct.
The merchants' presence on board the ship to play the sexual-innuendo-
laden game of 'Hazard' with men they have failed to identify as pirates in

the first scene has already revealed the inadequacy of their position. Though they, unlike the pirates, try to argue that 'Hazard' is more analogous with mercantile activity ('We came aboard to venture with you: deal merchant-like, put it upon one main and throw at all' (1, 6–7)) than sex (which Gallop's language invokes), their inability to understand the real nature of the peril they face shows the naïveté of their attitudes. Morally, there is no doubt that the French merchants are correct in their position – piracy is a dangerous, bloody and lawless affair – but their blind ignorance in consenting to gamble at 'Hazard' when they do not understand the rules of the game is misguided at best, hopelessly naïve at worst. The opening scenes of the drama, then, are at pains to show how endemic piracy is as, in swift succession, ships approach Ward's vessel. Men, like the French merchants, and perhaps James, who fail to understand the stakes of the game they are playing, are hopelessly out-manoeuvred by men more cut-throat and aggressive than themselves. By their presence and by happily consenting to play 'Hazard' (in fact desiring to continue the game when the pirates want to stop), at one level the merchantmen have already implicated themselves in the social and sexual world of the pirate ship.

The body and soul of Ward in *A Christian Turned Turk* are rendered as territory to be contested by different political, religious and sexual positions and orientations. The first line of the play 'I'll play no more' (1, 1), for instance, establishes Ward as looking for guidance as he wishes to remove himself from the game of Hazard. It situates him at a moral crossroads where, dissatisfied with his philosophy of aggressive male (sexual) bonding, he is seeking counsel as to how best to proceed. His implicit invitation is repeatedly accepted by the characters in the play as they all, either explicitly or by less obvious means, seek to recruit Ward to their own positions. The play's opening scenes establish that the stakes are high; like Faustus, and similar to James's counsellors, those that seek to advise Ward are involved in matters of great weight.

The debate over whether it is better to be aggressive against rivals or seek the establishment of brotherly entente – in other words, James's second-decade foreign policy – is further addressed in the encounter between the two rival pirate captains, Ward and Francisco, over the prize of the merchant ship Francisco is chasing and which, unwittingly, seeks aid from Ward's vessel. Both pirates desire the merchant ship, and Francisco challenges Ward to single combat for it, which Ward readily accepts. Yet, their murderous hatred is swiftly transformed into mutual respect since Francisco's honourable conduct in the fight is such that Ward

acknowledges him as an equal: 'Thus I return thy debt: / Not only in the prize, but in myself / Thou hast an equal share. Henceforth, I vow thee brotherhood' (5, 146–148). It would seem, then, that the text is encouraging its audience to applaud the establishment of accommodation between rivals, to celebrate the kind of network of alliances that James sought to forge with other European princes. Yet, as in the opening scene where Ferdinand's counsel is naïve, the wisdom of the policy of strength through peace is ambiguous here since before this brotherly entente is reached the two men do fight briefly. Furthermore, Gallop and Gismund take the opportunity to steal the prizes whilst Ward is distracted by trying to establish a relationship with Francisco. Whilst Ward is attempting to forge foreign alliances, discontent at home reigns unchecked as his own men rebel against his authority. Gismund, for instance, in Scene 4, has already challenged Ward's authority:

> *Ward*: How dare you, sir, give us directions?
> *Gismund*: How dare I, sir? I am a gentleman
> Equal unto your self.
> *Ward*: Take that now! I am before you.
> *Gismund*: You are, I'll not be long behind you.
> *Ward*: Know that our word shall be a law.
> *Gallop*: [aside] That may be, for he hath had conscience by the ears
> already. (4, 28–35)

Ward's insistence, like James's, that 'our word shall be law' incites his subjects, and they determine to mutiny as 'revenge' (4, 60) or punishment for Ward's despotism, hoping that Francisco will complete their vengeance by cutting Ward's throat (4, 76–80). Gallop and Gismund's plan to seize power by taking advantage of their leader's distraction seems, then, a lesson from which James might usefully benefit. Involved with maintaining a balance of power in Europe with England as a diplomatic buffer between Protestant and Catholic states, and paranoid in the wake of Henry IV of France's assassination in 1610, James feared a similar fate to the one planned for Ward by his officers.[56] Furthermore, like Ward, James sought to represent his powers as absolute as he argued that his royal prerogative placed him above the dictates of the law. In 1610, for instance, in a speech to Parliament, James was forthright in his assertion of the royal prerogative:

Kings are justly called gods for that they exercise a manner or resemblance of divine power upon earth. For if you will consider the attributes to God, you shall see how they agree in the person of a king ... They make and unmake

their subjects, they have power of raising and casting down, of life and of death, judges over all their subjects and in all causes, and yet accountable to none but God only ... And to the King is due both the affection of the soul and the service of the body of his subjects.[57]

When the action switches to Tunis, where Ward pursues his rebel subjects, this debate becomes more significant since 'Heroic' Ward, 'conqueror of the Western world' (1, 22–23) is no longer merely fighting for control of his own kingdom and his word as law; rather, the issue is now theological as it is ownership of Ward's soul that is contested. Significantly, in this battle, Ward's sexual desire for the Tunisian Voada is crucial in determining the outcome of his decision. The Turkish men attempt to woo Ward to turn Turk with promises of influence and riches, emphasising the flexibility of a religion which accepts renegade Christians and Jews and does not prevent them from rising to power (7, 19–26). In the face of these blandishments Ward remains firm, merely undertaking 'What's mine of prowess, or art' in their service, desiring to maintain 'My name – and the belief my ancestors / Left to my being' (7, 72–6). But when the men recruit Voada to their mission to convert Ward, he swiftly deserts his beliefs: 'Here comes an argument that would persuade / A god turn mortal' (7, 90–1). Ward's desire for her is of such strength that he is prepared to sacrifice everything – his position, his kingdom, even his religion – in order to possess her: 'Propose an oath to me / The breach wherof would at once sink me lower / Than hell knows being – I'll take it willingly' (7, 116–118).

In Voada, then, we have a kind of counsel offered to Ward that a contemporary audience would see as based on uncertain and arbitrary foundations: her advice is followed because Ward sexually desires the Turkish woman. There is little doubt that, in the world of the play, his appetite for a racial other stands as a metaphor for Ward's increasing distance from other orthodox, culturally appropriate positions. In particular, his desire for Voada represents a final betrayal of his national and religious allegiances. Hence, in the encounter with Voada, we see his judgement deteriorate line by line as his moral compass – always vulnerable – becomes even more corrupted by his sensual appetites. In particular, the strongly held racial binary of 'white' over 'black' becomes compromised in Ward's mind as he persistently represents Voada's black beauty as 'fair': 'she is all amorous, all fair!' (7, 149). His description is imbricated in the persistent cultural belief that darkness, black skin, evil and female sexuality were inter-connected, itself based on ideas that Africans, as well as other black people and women, were demonic, and that the devil was

black.[58] Though his championing of Voada's 'fairness' here appears to challenge the cultural stereotype, it remains intact since Ward's belief in Voada's sexual or moral purity is deeply misguided. Indeed, after the Governor and Benwash have importuned Ward unsuccessfully to turn Turk and have determined to fetch Voada to perform the task, Ward anticipates his moral degredation through his insistence on Voada's 'fairness':

> *Ward*: ... Until I saw her face,
> I never knew what men term beauty was;
> Besides whose fair, she hath a mind so chaste
> A man may sooner melt the Alps than her.
> *Governor*: We will along with you. When makes she hence?
> *Benwash*: The wind sits fair. The slaves are sending down
> Whom the next morn bears hence.
> *Governor*: We will aboard with you, fair sir. We'll leave
> Our love exchanged with you. Some happier time
> May perfect that good work I wish were mine. (7, 91–100)

In this exchange, both the Governor and Benwash deliberately use the word 'fair' as they gullingly and sarcastically draw attention to Ward's moral confusion. Voada is not 'fair' in any of the senses Ward intends; her beauty is dark, her chastity is imagined as she has just been wooing Fidelio/Alizia, and Ward's desire for her – despite his assertion 'the way that leads to love is no black way' (7, 280) – is, as the other Christian characters repeatedly point out, a sure way to damnation. As Ferdinand replies to Ward's hopeful statement, 'But thou will find it black: no hell I see's so low / Which lust and woman cannot lead us to' (7, 281–282).

Ward's moral confusion – his inability to distinguish between black and white – marks him as ripe for conversion to Islam. He views himself as already damned since 'with what brain can I think / Heaven would be glad of such a friend as I am? / A pirate? Murderer? Let those can hope a pardon care / To atone with heaven. I cannot; I despair' (7, 274–277). However, the fact Ward is offered good counsel by Christians – which he rejects – shows how seriously Ward's conversion is treated in *A Christian Turned Turk*. Alizia, for example, takes the role of Good Angel, in contrast to Voada's bad one, as she tries to reason with Ward. Indeed, one of the central points of Alizia's arguments is that the Turks' blandishments mask a darker purpose: when Crosman, Voada's brother, attempts to claim kinship with Ward, Alizia is adamant in her response that Crosman's motives are not as 'fair' as they seem, 'Too fair a name to cloak so great a foe' she says (7, 222). Yet, even here there is a marked contradiction in the

text since Alizia is herself disingenuous as she is disguised as a boy: she too is not what she seems. To the audience, who know she is a female Christian, she represents the legitimate sexual outlet for white men: to Ward, who sees a boy, her sexuality does not possess the same meaning since, by choosing Fidelio, he would be implicitly embracing a dissident sexual identity. Hence, even the most religiously stable character in the play appears implicated in the atmosphere of betrayal, counter-betrayal and ambivalent sexual identities. Alizia has her own reasons for wanting Ward to remain Christian, since his apostasy will further endanger her chances of being reunited with Raymond. Indeed, whilst believing she is male, Ward does initially choose Alizia/Fidelio over Voada, further revealing the text's dramatisation of the difficulties and ambiguities of sexual choice. Both Voada and Alizia/Fidelio represent dissident sexual partners for Ward. Gender-play is also present through the contemporary stage convention of boy actors performing female roles.[59]

The serious treatment of Ward's apostasy is, at one level, testimony to the perception of the threat that Islam represented to British, Christian identity in the early seventeenth century. Ward's piracy is certainly not supported in the early part of Daborne's text, but his damnation comes only with his religious desertion. As David Hebb points out, in the second decade of James's reign, the focus of royal hostility switched from English pirates to concentrate on a new threat to peaceful trade and commerce, specifically North African pirates whose ships preyed upon English vessels.[60] 'Turkish' ships made several raids on the English coastline to take captives from the West country and either ransomed them or sold them into slavery and, in October 1617, a Turkish pirate ship was captured in the Thames, placing the threat of Muslim incursion significantly closer to home.[61]

This interest in the connection between piracy and becoming a renegade revealed in this and other contemporary dramas (I discuss Massinger's views on the issue later) is connected to the expanding number of publications concerned with the Turks and Islam and the increased trading, travel, diplomatic and other contacts between the East and the English at this time. Hakluyt had naturally included in his collections many accounts of 'traffiques' with Turkey, the Levant and other Eastern regions: but there was also a growing fascination with the customs and government of Islam states attested to by, most conspicuously, Richard Knolles' compendious and widely read *The Generall Historie of the Turkes, from the first beginning of that Nation to the rising of the*

Othoman Familie which was first published in 1603, revised and issued in a second edition in 1610, and again in 1621, 1631 and 1638.[62] Not only had the Barbary regencies, as contemporary commentator Charles Molloy indicates, 'reduce[d] themselves into a Government or State' which could rival European countries and princes, they also attracted significant numbers of foreign nationals to their shores both as merchants and pirates. As Matar has shown, in this period many Christians converted to Islam.[63] For instance, in 1606, *Letters from the greate Turke lately sent unto the holy Father the Pope* asserted that the Turkish army enjoyed the services of the vast figure of 30,000 Christians who as 'Renegadoes' fought 'in defence of our lawe, and with us to conquer your country'.[64] There was a perception in England, then, that conversion to Islam – forced or voluntary – was a significant threat to the integrity of the nation, though it is impossible to know the exact number of English renegades. But the frequency of the appearance of English renegades in travellers' accounts is telling. For instance, the organ-builder Robert Dallam in the record of his voyage to Turkey in 1599 to give 'A great and curious present' of an elaborate organ to the 'Grand Turk', Sultan Mahomet III, described how the interpreter and guide, or 'drugaman', provided by the Sultan to show him the sights of Stamboul was 'a Turke but a Cornishman born'. Similarly, on a break in the return journey in Parnassos in northern Greece, his guide was another Englishman named Finch, 'in religion he was a perfit Turke, but he was our trustie frende' since he prevented Dallam from being attacked by other Turks.[65] These anxieties concerning the frequency of English conversion to Islam can be seen in Daborne's treatment of Ward as he mutates from pirate to renegade as his depravity escalates.

However, Ward's apostasy can also be read another way. It possesses a significant political current: specifically Ward's conversion can be seen as articulating fears about James's contamination by corrupt, arbitrary, and sensually inspired counsel. Counsel was seen as an important part of government; as 'T.B' argued in the 1590s, 'Without Counsel, no kingdom, no state, no private house can stand; for experience hath proved that commonweals have prospered so long as good counsel did govern'.[66] Curtis Perry has recently argued that good counsel, and the management by the king of his Council, or vice versa, were subjects that early Jacobean dramas frequently focused on. He cites examples such as Daniel's *Philotas* (1605), Marston's *The Fawne* (1604–6), Jonson's *Sejanus* (1603) and Greville's *Mustapha* (first written in the 1590s, but substantially revised 1607–10).[67] All these plays are concerned about the relationship between

counsel offered by favourites, and its intersection with legitimate or tyrannical kingship. Cumulatively, by showing the importance of counsel for the monarch, many early seventeenth-century dramas appear to undermine the belief in the King's God-given authority. Perry states 'The figure of the well-meaning, legitimate king made into an unbearable tyrant by counsel ... calls into question the political relevance of morality itself' and 'demystifies the moral person of the king, privileging good or bad results over moral timbre'. The consequence of this change, then, is to see an orderly realm as the only measure of the king's quality rather than seeing the kingdom as a passive reflection of the king's attributes. The shift in emphasis is important since in these dramas the audience witnesses good kings' metamorphosis into tyrants because they listen to bad counsel from favourites. When their influence over the monarch is based on sensual or sexual attraction then justifiable regicide might be conceived. Hence, Perry has argued, it becomes possible to see the lines on which an oppositional climate to James's beliefs might develop.[68]

The persona of Ward, the pirate king, in Daborne's *A Christian Turned Turk* raises similar issues of legitimate or tyrannical control through the kinds of counsel he receives. He refuses to listen to the advice of his shipmates and officers Gallop and Gismund, turning instead to foreign, perhaps Catholic, counsel in the persons of Ferdinand and Alizia (who are French), and being persuaded by the arguments of Turkish Voada. The play does not support Gallop and Gismund in their rebellion – far from it – since on repair to Benwash's they too become implicated in a sexual liaison with Moorish women, and Gallop – despite his crew's belief that the profits of piracy will be equally shared amongst them – decides to keep the money for himself (6, 104–131). In fact, Gallop's behaviour both mimics Ward's in its despotism, and anticipates his sexual dalliance with Voada as he seduces Agar. The rebels, then, are no better than the master they disobey. Yet, despite Gallop and Gismund's inability to provide new and just leadership – Gallop in particular repeats his commander's mistakes – we have, dramatised in their actions, a rebellion against a tyrant. Rebellion against a bad leader is, it seems, now conceivable, though it is not actively championed in the play.

Furthermore, during James's reign, concerns were frequently expressed concerning the strength of his commitment to Protestantism. With a Catholic-convert Queen (Anne, brought up a Lutheran in Denmark, converted to the Roman religion in the 1590s in Scotland), who repeatedly entered into negotiations with Spain concerning the religious upbringing and marriages

of the royal children, and speculated about the likelihood of her husband's conversion, James was personally vulnerable to anti-Catholic fears on the part of his Protestant subjects.[69] In 1608, for instance, there was something of a crisis about the firmness of James's religious beliefs when a 1599 letter to Clement VIII, signed by James, was published by Cardinal Bellarmine, implying that the king would consider conversion to Catholicism if the Pope would support his claim to the English throne when it became vacant.[70] The scandal the letter provoked concerning James's duplicity – despite the king's serious treatment of his role as defender of the Protestant faith in his kingdom, and his virtual estrangement from his wife by this time – exposed him to exaggerated fears concerning an apparently shaky commitment to Protestantism. Publicly, James's secretary Belarmino was blamed for the king's incriminatingly signed letter, just as Ward, when accused by Voada of murdering Raymond (he has in fact set her up to kill Fidelio) attempts to protect himself from the Turkish authorities by blaming his friend Francisco.

In the wake of the scandal of 1608, and after the Gunpowder Plot of November 1605, James publicly avowed a virulent anti-Catholic policy, creating the Oath of Allegiance and declaring 'that if he thought any of his Council were popish, or did favour the papists, or countenance them, he would remove them from his Council'.[71] In fact, James's council, despite his public professions, numbered amongst its members a considerable number of overt or crypto-Catholics – since it was normally chosen from the aristocracy, of which a significant percentage were Catholic.[72] In Daborne's representation of Ward's apostasy we can detect coded anxieties about the strength of James's religious principles and the influence of Catholics within his family and council. More generally, from the early years of his reign in Scotland, James was notorious for being swayed by favourites who used their sexual allure to control the king. In Crosman and the Governor of Tunis's use of Voada as bait, then, there is a displaced anxiety concerning the influence favourites, and their puppetmasters, could wield. Weldon, for instance, in his account of King James, describing the rise of Robert Carr to the monarch's favour in 1607, also evokes the panderish atmosphere of the court where the Countess of Suffolk was busily seeking out 'choyse young men, who she daily curled, and perfumed their breaths' to catch the King's romantic fancy.[73] Carr, later Lord Rochester, was himself under the sway of Sir Thomas Overbury, as Weldon put it, 'his Pythias'. The alignment of Carr/Overbury with the classical lovers/friends Damon and Pithias is not without political bite, since in R. Edwards's rhymed play

Damon and Pithias (1564) Damon is arrested on a baseless charge of spying by the tyrant Dionysis; all ends happily though, as Dionysis finally realises his error and asks to be admitted to Damon and Pithias' brotherhood. Even James himself was not ignorant of the the longstanding and widespread 'opinion that Rochester ruled him and Overburie ruled Rochester', as John Chamberlain reported in a letter in 1613.[74]

If the treatment of Ward reflects the kinds of concerns articulated about James in the second decade of his reign, the behaviour of the text's other pirate king, Dansiker, also poses a series of difficult political questions about royal conduct. Dansiker is a repentant pirate; the play charts his frustrated attempt to regain his French national identity by obtaining pardon from Henry IV. Before the action of the play begins, Dansiker has entered into negotiations with Henry, and the audience's first introduction to him describes Henry's reaction to his request: 'These letters from my wife bring certainty / Of our obtained pardons, on condition / We henceforth for the state of France employ / Our lives and service' (5, 2–5). It soon becomes clear that Dansiker's four years of piracy, which were filled with 'deeds so full of prowess', were not motivated by an intrinsically evil nature since he persuades his crew to 'redeem our honour / And not return into our country with the names / Of pardoned thieves, but by some worthy deed' (5, 9–16), specifically the firing of the pirate fleet. Furthermore, he makes it clear that his turning to piracy was motivated by 'want of employment, not of virtue' (5, 17).

Daborne's sympathetic representation of Dansiker and of the possibility of his re-assimilation into 'civil society' (5, 12) raises topical questions. As Daniel Vitkus outlines, in 1612 James also offered amnesty to British pirates, and hence Henry's pardon of Dansiker (which was issued in 1609) can be seen to refer to an important contemporary British issue.[75] The text's treatment of Henry's pardon is controversial since between the negotiation of the amnesty and Dansiker's arrival in Marseilles to avail himself of it, Henry is murdered: 'The agèd oak that Atlas-like sustained / The weight of France, that with his blood regained / Her wasted body (like the pelican), / By one that from his life took breath is slain' (14, 13–16). Even these lines, which ostensibly celebrate Henry's achievements and mourn his death, are ambiguous since it is possible to read them as a hostile comment on the French monarch. It is not clear whether it is the blood that Henry has spilt in his death that now rejuvenates France, or whether it is his past martial feats to which the text here refers. Certainly, Henry's pardon and wishes appear to carry little weight with the merchants that

besiege and threaten Dansiker on his return. The Governor of Marseilles is forced to intervene to protect the returning pirate, and the terms of the amnesty are then renegotiated as the merchants' demand that Dansiker revenge their losses on Benwash back in Tunis. The pirate – despite offering booty to the merchants on his return – is not here allowed to reassimilate into French society: the 'civil society' that he wished to rejoin in effect forces him to continue the lifestyle from which he wishes to withdraw. Despite a royal pardon, then, there is no way back to respectability for Dansiker as he acknowledges in his death speech: 'Let my example move all pirates, robbers, / To think how heavy thy revenging hand / Will sit upon them' (16, 233–235). Despite Henry's – and James' – policy allowing re-assimilation of pirates, the text makes it clear that there is a more powerful force, that of God, whose justice will be served. God's attitude to pirates at the end of the play is significantly different from that of his supposed representatives on earth. Implicitly, the demise of Dansiker draws attention to the limits of the powers of temporal kings: Henry would have had him back; God makes sure that he fails.

Daborne's *A Christian Turned Turk* is a double-voiced text. On one level, the punishment of Ward and Dansiker for piracy mirrors exactly James's hostility to it. Yet this orthodox reading is persistently compromised in the text by the similarities between Ward's situation and the anxieties circulating about James. Ward appears, in effect, not just to represent a warning to pirates. His story also issues a warning to tyrannical monarchs of the dangers of believing their word is law and being influenced by sensual and sexual counsel. Same-sex desire is not condemned *per se*; Ward's sexual orientation at the beginning of the play is less devastating in its effects than his later desire for Voada. Instead, it appears that the morality of particular sexual orientations in the play is superseded by a wider and more general concern about the influence of councillors on kings. Daborne's treatment of Dansiker is similarly ambiguous. Not only is the pirate sympathetically drawn, but his demise stages the limits of 'kingly' power. It is, of course, possible to read the tragic fates of both Dansiker and Ward as deeply orthodox – their deaths rid the seas of the pirates that James so deeply despised. Yet the ambiguities in Daborne's representation make this text available for oppositional readings to James' sexually motivated reliance on private counsel and favourites, as well as his beliefs about kingcraft. There is a final ambiguity and irony embedded in this text. Ward, torn apart 'piecemeal' by the angry Governor at the end of the play, was alive and well. According to the traveller William Lithgow's

account of 1615 he was living in luxurious retirement in a 'faire Palace, beautified with rich Marble and Alabaster stones'.[76] Ward continued to enjoy the fruits of his escapades until, at least, the early 1620s.

Kingship in crisis: miscegenation and sexual desire in Massinger's *The Renegado* (1623-24)

I conclude this chapter about masculine unruliness and its connections to, and intersections with, attitudes to Stuart monarchy by focusing on Massinger's *The Renegado*, which was written and first performed in the last years of James's reign. It includes pirate characters (Grimaldi and his men) and engages with Christian conversion to Islam. But it also reveals Massinger's fascination with contemporary debates concerning the monarchy since characters' unorthodox sexual desires offer access to perceptions of the behaviour of the Stuart royal family.

The Renegado was licensed for performance on 17 April 1624 and was performed by either Lady Elizabeth's or Queen Henrietta's Men at the Phoenix playhouse between December 1623 and October 1626: it may also have been performed before this at the Cockpit, and it was published in 1630.[77] During this period, under the control of Christopher Beeston, the Cockpit was starting to rival Blackfriars as the most prestigious and successful playhouse in London.[78] These dates of composition and performance, then, make Massinger's play contemporaneous with the sensational production of Thomas Middleton's *A Game at Chess* which was licensed by Herbert less than two months after *The Renegado*, and was performed to packed audiences (of about 3,000 people each day for nine days) later in the summer by the King's Men at the Globe theatre.[79] In Middleton's allegorical play the white chess pieces, the English, finally defeat the machinations of the predatory and sexually corrupt black house, the Spanish. At the end of the play, the Black Knight (Gondomar, the reviled Spanish ambassador until 1622) is tricked into revealing the Spaniards' plots, their 'vast ambition' (V, iii, 83), making them 'checkmate by discovery'. The context for the allegory was Charles and Buckingham's abortive mission to the Spanish court to negotiate a marriage between the English heir to the throne and the Spanish Infanta Maria. The trip was enormously unpopular – when Charles returned without a Spanish bride bonfires were lit in the streets of London in celebration – and Middleton's attacks on aggressive Jesuitical Spanish schemes and the hated Gondomar clearly champion the view that England had had a narrow escape.[80]

The controversy surrounding Middleton's text was intense: though the new Spanish ambassador, Don Carlos Coloma, complained to James about 'a comedy so scandalous, impious, barbarous, and so offensive to my royal master', and the play was then banned, and Middleton, perhaps, briefly imprisoned, nevertheless the fallout from the attack was relatively mild.[81] Of course, in the play, the English triumphed, so, on one level (in the plot concerning the White Knight and White Duke), the text can be seen as a patriotic celebration of Charles and Buckingham's abilities. Yet, on another (the plot of the attempted seduction of the White Queen's Pawn and her entanglement in a false contract of marriage), *A Game at Chess* is testament to the depth of the anxieties concerning James's desire to marry his son to a militantly Catholic bride from the country that was perceived as England's traditional enemy and most serious rival. Since the White Queen's pawn's plot is, arguably, the focus of emotional intensity, the play is noticeably ambiguous concerning the extent to which the text's presentation of the English royal family is critical of their policies. Certainly the White King, who represents James, cuts a weak figure in the play, and the question of why Herbert gave such an inflammatory text a licence has been answered by seeing Herbert as sympathetic to the war party who wanted hostilities with Spain to be renewed.[82] In what follows, I read Massinger's *The Renegado* in the light of these contemporary fears about Stuart dynastic alliances. Like *A Game at Chess*, Massinger's play shares a concern about the consequences of characters' choices of sexual partners.

The plot of *The Renegado* focuses on a Venetian gentleman Vitelli who, disguised as a merchant, has come to Tunis with his servant Gazet, and his friend and advisor, the Jesuit Francisco, to rescue his sister Paulina. Before the action of the play commences, the renegade pirate Grimaldi has kidnapped Paulina in Venice and sold her into slavery in the court of Asambeg, viceroy of Tunis. The play begins with Vitelli opening a shop in the Tunis market hoping to hear news of his sister while the city is full of people celebrating the arrival of Mustapha, basha of Aleppo, who has come to woo Donusa, niece of the Ottoman emperor. Chafing under the restrictive codes of behaviour prescribed for Muslim women, a disguised Donusa visits Vitelli's shop and, liking his looks, invites him to visit her at the Palace. Larded with money and jewels, Vitelli succumbs to Donusa's beauty and only later through discussions with the devout Francisco, does he realise with horror the religious implications of his relationship with a Turkish woman. In the meantime Gazet, made a free man by his master, decides to take advantage of Vitelli's Turkish connections by joining the

viceroy's court as a eunuch, but without understanding what he must lose
to take up the position. Asambeg meanwhile cashiers Grimaldi since the
pirate has been unsuccessful in his seaborne encounter with the Christian
Knights of Malta and, when the apostate angrily responds, the viceroy
seizes his property. Asambeg then visits the still chaste, imprisoned and
isolated Paulina, keeping everyone away from her because he is jealous of
the power her beauty has to inflame those with whom she comes into
contact. Donusa rejects Mustapha and he, suspicious that she has another
lover, forces her servants to betray their mistress's secrets. Mustapha, in
turn, tells Asambeg about Donusa's relationship, and the two watch her
next meeting with Vitelli who, following his discussion with Francisco,
now rejects her advances. Horrified by the relationship, Asambeg throws
them both into prison, torturing Vitelli – whose bravery impresses him –
and sending to the Ottoman emperor for a decision concerning a suitable
punishment for his niece's sexual liaison with a Christian. Grimaldi becomes
increasingly desperate, believing that his piracy, murder, apostasy and
sacrilege have ensured his damnation, and Francisco undertakes to counsel
him. The black box, which arrives at court, announces the Emperor's
decision that Donusa must die; however, according to Muslim law Donusa
is allowed an opportunity to persuade her lover to turn Turk, which she
invokes. Vitelli resists her persuasions so, according to Islamic law, both
are condemned, though his religious zeal is successful in convincing
Donusa to turn Christian. Paulina, through promising to consummate her
relationship with Asambeg, persuades the viceroy to delay the execution
for twelve hours which allows Francisco enough time to orchestrate an
escape for all the Christians in Grimaldi's ship. The play concludes with
Asambeg's acknowledgement of his humiliating defeat: 'I will hide / This
head among the deserts, or some cave / Filled with my shame and me,
where I alone / May die without a partner in my moan' (V, viii, 36–39).

Massinger's representation of the sexual intrigues and religious crises
of the Tunisian court needs to be seen in the context of the fears about the
Stuart monarchy articulated so powerfully in *A Game at Chess*. Though
there is only one 'English' character in the play (Carazie, Donusa's
eunuch), the Italians stand in for the English. That the events presented
are designed to be read against an English context is suggested early in the
play's action. For instance, when Donusa is contemplating a sexual relation-
ship with Vitelli, Carazie encourages her desires through reference to the
frequency with which sexual trafficking is used to gain rewards, such as
knighthoods, from James: 'Tis but procuring; / A smock employment,

which has made more Knights / (In a country I could name) than twenty
years / Of service in the field'(II, ii, 70–73).[83] Military prowess is clearly of
less importance than other forms of swordsmanship in James's England.
Furthermore, Vitelli's reply to Francisco's warning that he should not
become entangled with lustful 'Turkish dames' engages with the debate
about Charles's proposed marriage to a Catholic. Vitelli denies that sexual
dalliance is on his agenda, asserting that he would not be interested in such
'pleasure, though all Europe's queens / Kneeled at my feet and courted
me': he is particularly immune when there is a 'difference of faith' with the
prospective partner which 'Must of necessity … strangle such base desires'
(I, iii, 15–19). Here, then, is an articulation of the importance of shared
religion between marriage partners: hence the play's central plot concern-
ing Vitelli's sexual and religious temptation by Donusa can be seen as a
geographically displaced account of recent anxieties about Charles's
vulnerability to conversion to Catholicism whilst negotiating a marriage
with the Infanta.[84]

 The issue of the extent to which a 1624 London audience was invited
to see displaced versions of English debates in the religious and sexual
intrigues in Tunis is also explored. *The Renegado* addresses the difficulties
of art as representation and, allied to this, the importance of characters
gaining a full understanding of, and establishing control over, their
identities. The treatment of both these issues suggests that the English
monarchy is an available allegorical referent for this text. The terms of the
debate are established in the opening scene, which finds Gazet hawking
pictures of beautiful young women whom he claims are European prin-
cesses. In fact 'they are figures / Of bawds and common courtesans in
Venice' (I, i, 12–13). Gazet's lie about the pictures, and Vitelli's complicity
in it, sets up the control of the representation of these important dynastic
individuals as a significant issue. These fertile young women will act as the
brood-mares for the royal houses of Europe. That the 'princesses' are
really whores, and that their images are being fingered by all comers in a
Tunis market, undermines and satirises the practices of the European
royal marriage market. On one level, then, there is a considerable distance
between the absent 'real' princesses and the women represented on the
canvasses, the Venetian whores: yet the fact that whores can pass for
princesses simultaneously undermines any distance between the two
categories of women. Both sorts of women, whores and princesses, are
sexually available and most potential buyers, Gazet and Vitelli shrewdly
gamble, will not be able to tell them apart. The peddling of royal images in

a common market undermines the institution the pictures purport to represent and celebrate, and that those images are counterfeit merely compounds the problem.

The issue of the representation of monarchy is revisited with the arrival of Donusa on the scene. Gazet's repeated hawking cry 'What do you lack?' (I, iii, 1; I, iii, 33; I, iii, 97) confronts head-on the idea of a comparison between Tunis and Christendom, and Donusa responds to the challenge. She becomes competitive over her beauty relative to that of the European 'princesses', without realising that, in fact, her rivals are whores. Vitelli's introduction of a mirror with which the Ottoman princess can view herself takes the debate one step further (I, iii, 108–112). We have here a literal mirror for princes(ses), which Vitelli claims will allow the viewer to see him/herself as they really are ('neither taking from / Nor flattering the object it returns / To the beholder'(109–111)). At the point at which Vitelli offers the mirror to Donusa, she is veiled and hence the mirror cannot fully do its work; when she removes her mantilla to impress him, and he rushes off (suitably dazzled) to find an image that will answer her challenge 'Can you match me this?' (I, iii, 140), Donusa takes the opportunity to destroy the mirror (I, iii, 143). At no point, then, does she confront the non-distorting mirror herself; rather she seeks to use her beauty to influence others, specifically Vitelli, as she claims she possesses the power to 'bring you [Vitelli] to yourself' (I, iii, 143). There is a distinction drawn then between the royal Donusa who seeks to manipulate her image (revealed for instance when Mustapha arrives to woo her and she is anxious to 'Receive him like ourself' (I, ii, 55)) and Vitelli who embraces the philosophy of *nosce teipsum*, a process which involves a 'Study to be myself' (I, i, 88).

There are subtly different ideological premises behind Donusa's use of her image, which is about its power as a tool to manipulate others, and Vitelli's attempts to know himself and to show Donusa an accurate representation of herself. Donusa's aim to manipulate and control her subjects' behaviour is here represented as a kind of deceit; her breaking of the mirror reveals her to be supremely uninterested in self-knowledge. Indeed, she is morally and sexually similar to the counterfeit whore/princess pictures as she hawks and manipulates her own image to ensnare men. Vitelli, by contrast, offers the possibility of offering an image *to monarchy of monarchy* as it really is. It might be symbolically rejected as Donusa breaks the mirror, but in ideological terms the prospect of monarchy seeing itself as it really is has been evoked in the text.

From the beginning, then, *The Renegado* sets itself up as a mirror for princes in which they might view themselves. They can reject the reflection if they want (as Donusa does), preferring to rely on their own ability to control their image. But in Vitelli's search for self-knowledge and a true understanding of himself, the text attempts to offer to its audience (and to the monarchy) the possibility of seeing things as they really are. This analysis of the early scenes of *The Renegado*, begs the question of exactly what 'truth' Massinger is attempting to impart to his audience about the British monarchy.

Similar to the White Knight and Duke's defeat of the Black house in *A Game at Chess*, Vitelli's resistance to turning Turk, his conversion of Donusa to Christianity, and the Italians' eventual victory over the Muslims, make *The Renegado* available for a triumphalist reading of the supremacy of British value systems. The apostate pirate Grimaldi sees the error of his ways and returns to the Christian fold, and the luxury of the Tunis court is defeated by Francisco's counsel as Grimaldi becomes concerned to secure everlasting life through repentance. *The Renegado* can be seen as a positive response to the anxieties circulating in Daborne's *A Christian Turned Turk*. In the later play, Christian characters can resist the lure of Islam and, even when they stumble, there are ways back into the 'civil society' from which Dansiker was excluded despite his efforts to make amends.[85]

However, just as the use of two plots – one supportive of the monarchy, one revealing the limitations and dangers of monarchic policies – in *A Game at Chess* made an anti-establishment reading of Middleton's text possible, in *The Renegado* it is possible to detect tensions and anxieties that can be seen to reveal concerns over Stuart policies. Similar to the White Queen's pawn in *A Game at Chess*, Vitelli has a narrow escape from being trapped into a marriage with Donusa on terms that will damn him. He resists turning Turk, but the gusto with which he embraces Donusa and the sensual atmosphere of the Tunis court in Act II, Scene iv, and tries to argue to Francisco in Act II, Scene vi that he intends to use his gifts from Donusa to promote Christianity ('to redeem a thousand slaves / From the Turkish galleys, or at home to erect / Some pious work to shame all hospitals (31–33)) reveals just how precarious was the preservation of his faith. Just as Charles's desire to marry the Infanta Maria – as Kevin Sharpe puts it 'he dreamt of her; he cherished her portrait; he yearned to woo her' – made him prepared to accept concessions to English Catholics in the articles of the marriage treaty whilst in Madrid in 1623, Vitelli in the early scenes of *The Renegado* is so sexually attracted to Donusa that he is

prepared to forget other claims on his loyalties.[86] The debate between Donusa and Vitelli for the supremacy of their individual religious positions mirrors the Anglo-Spanish negotiations. Just as Asambeg allows Donusa to try and turn Vitelli Turk, so Philip IV encouraged the Infanta Maria to extract promises from Charles about receiving instruction in Catholic doctrine himself. Donusa 'undertakes to turn this Christian Turk and marry him' (IV, iii, 157–158) in the same way that the Infanta Maria proclaimed that she would never marry a heretic.[87] Similar to Asambeg's imprisonment of Vitelli, Charles too was kept a virtual prisoner by Philip in the Madrid court.

The resemblance between the two courtships is striking: in both romances the men are sorely tested concerning the strengths of their religious allegiances because of their romantic desires. And both Charles and Vitelli finally withstand the trial. However, although Charles returned to England without a Spanish bride, to the great relief of many of his countrymen, by contrast Donusa turns apostate in *The Renegado* and escapes with the Italians. This turn of events in the play would seem to end the resemblance between Vitelli and Charles, since the Infanta Maria remained true to her faith and family. Yet, in Vitelli's successful wooing of Donusa, and in the machinations and influence of the Jesuit priest Francisco on the lovers' relationship, there appears to be another frame of reference for Charles's marriage plans.

One of the key questions Massinger's *The Renegado* poses is how positively an audience should view the miscegenation between Vitelli and Donusa at the end of the play. Donusa appears wholeheartedly to reject the sensual and luxurious nature of the Muslim court and religion, declaring 'Then thus I spit on Mahomet' (IV, iii, 158) and, as she is converted, she acknowledges 'How long have I been blind! Yet on the sudden / By this blest means I feel the films of error / Ta'en from my soul's eyes' (V, iii, 123–125). The strength of her new Christian faith is not directly questioned, and she is instrumental in ensuring the success of Francisco's plot to free Vitelli. But, despite the apparent orthodoxy of the play's conclusion, as Christianity appears to trounce Muslim excess, there are noticeably discordant elements in the text.

At the time of *The Renegado*'s composition and production, the influence of the Jesuits – the strong arm of the Catholic Church – was deeply feared by British Protestants, making Massinger's inclusion of Francisco, Jesuit priest from Venice, as the apparent saviour of the Italians, a surprising one. In 1614, when Gondomar first became Spanish ambassador to

Britain, he estimated in correspondence with Philip III that the total number of Catholics and potential Catholics was 1,800,000 (half the entire population).[88] Not surprisingly, then, among Britain's Protestants there were strong anxieties concerning both visible and secret Catholic populations, bolstered by the network of Jesuit priests, who owed their first allegiance to the Pope. In 1623 the Pope appointed William Bishop as Bishop of Chalcedon, with episcopal jurisdiction over the Catholics of England and Scotland.[89] The Pope's intervention provoked considerable controversy in Parliament since, as Christopher Brooke commented in February 1624, the new Bishop 'hath power to make seminary priests in England, and so defeat the law which maketh it treason for them to come into the land'; Thomas Wentworth, the Recorder of Oxford, went even further, all seminary priests were traitors and 'the land [was] full of traitors and treason'.[90]

Massinger's use of Francisco, the Jesuit priest, as a heroic figure at a time when there was such strong anti-Catholic and anti-Jesuit feeling in Britain is unusual. It is so out of kilter with popular opinion that it is important to explore the extent of Massinger's support of this figure. There are certainly hints that Francisco's religious views are problematic: Paulina's rape by Asambeg has been prevented by the use of a magic relic which Francisco gave her ('I oft have told you / Of a relic that I gave her which has power, / if we may credit holy men's traditions, / To keep the owner free from violence' (I, ii, 146–148). Elsewhere in the text, hostile references to Donusa's Islamic 'powerful spells' (IV, iii, 58) and 'the sorceries / Of your seducer' (IV, iii, 125–126) reveal that superstitious practices, like Paulina's charm, are condemned. Furthermore, in order to dispel Grimaldi's despair, Francisco appears dressed up 'in a cope, like a bishop' in order to imitate the churchman in Venice that Grimaldi treated sacrilegiously (IV, i, 73). By impersonating this Bishop – fooling Grimaldi into believing that his sins are forgiven – Francisco is on highly dubious moral and religious ground. He has no right to pretend to be him, and his actions are both high-handed and exceed the authority of his position as a simple priest. Just as the Pope controversially imposed a Catholic Bishop upon England and Scotland, here Francisco's manipulation of religious office to serve his own ends, places him in the role of an untrustworthy machiavel (standard anti-Jesuit propaganda of the time).[91]

The representation of Francisco and Vitelli's friendship is also striking. Vitelli's confidence in Francisco's judgement, and his reliance on him, appear excessive: Francisco is, Vitelli claims, 'My friend, my father,

in that word, my all' (III, ii, 18). Vitelli's language here is, then, similar to that employed by James and Buckingham to describe the multiple subject positions within their relationship: Buckingham was James's bedfellow, his 'wife', his counsellor, his 'gossip', and 'child', and Buckingham replied in similar vein to his 'dear dad and master'.[92] The closeness between Vitelli and Francisco also mirrors the relationship between Buckingham and Prince Charles which, though hostile during Buckingham's rise to power, had, by the 1620s, become intimate and devoted, with Charles treating Villiers as a charismatic elder brother (the position Prince Henry would have occupied had he lived).[93] Certainly, Francisco in *The Renegado* guides Vitelli in all things in the same way that the White Duke and the White Knight, Buckingham and Charles respectively, operated together in *A Game at Chess*. Francisco's identity as Jesuit might then be seen as a satire on Buckingham since, in 1622, Buckingham's mother, the old Countess, publicly converted to Catholicism under the persuasions of a Jesuit minister, Father Fisher. Even Buckingham himself contemplated turning Roman Catholic, and only after James staged a series of debates between the Jesuit Fisher and two Anglican divines, Francis White and William Laud, did Buckingham profess himself secure in his religion.[94] Hence Francisco's machiavellian scheming and direct intervention in military operations such as masterminding the Italians escape from Tunis, show the way in which Jesuits were believed to be aggressive and violent in their determination to expand the Roman religion. And in Francisco's resemblance to an allegedly Catholic-tolerant Duke of Buckingham, it is possible to read fears about the influence of such a man and his ideas on Vitelli. Finally, in Francisco's desire to help Vitelli and Donusa – the converted Muslim – escape together, after trying to separate them until she converted, it is possible to detect a further reference to Charles's changing marriage plans and partners. From February 1624, Buckingham was busy negotiating with France about the marriage of Charles to the French king's sister, fifteen-year-old Henrietta Maria. Though the marriage was not finalised until after *The Renegado* was licensed and performed, the potential Anglo-French alliance was the subject of much gossip and debate since the bride was another Catholic. Hence, maybe, in Donusa's conversion speech when she, full of religious wonderment, exclaims 'I am another woman' (V, iii, 121–122), there can be seen a reference to Charles's prospective (Catholic) brides, as Infanta Maria gave way to Henrietta Maria.

The Renegado might be seen then as, in Peacham's terms, an aenigmatic allegory, since it creates so many different levels of meaning without

184 | Voyage drama and gender politics

offering a straightforward conclusion. There are certainly strong resemblances between the ideological and religious issues James and Charles confronted in their marriage plans for England's future king and the problems of the Vitelli/Donusa relationship in *The Renegado*. Characters' own sexual choices and their responses to other people's desires can be read politically in this play: as Vitelli indicates in Act I, he intends to hold up a mirror to princes. *The Renegado*, like *A Game at Chess*, is ambiguously available to be seen as reflecting contemporary anxieties concerning Charles's marriage. In *The Renegado*, Donusa's conversion and implied future assimilation into Italian society can be seen as the articulation of anxieties about the unpredictable implications of marriage with a woman from an alien culture. *The Renegado* does not appear to be actively hostile to Charles's marriage plans, but there is a sense of uncertainty about what the consequences of his choice will be.

Notes

1 Thomas Heywood and William Rowley, *Fortune by Land and Sea*, Herman Doh, ed. (New York: Garland, 1980): Daborne's *A Christian Turned Turk* and Massinger's *The Renegado* have recently been published in Daniel J. Vitkus, ed., *Three Turk Plays from Early Modern England* (New York: Columbia University Press, 2000): all references will be to these editions and are given parenthetically in the text.

2 Curtis Perry, *The Making of Jacobean Culture: James I and the Renegotiation of Elizabethan Literary Practice* (Cambridge: Cambridge University Press, 1997), p. 1.

3 For discussion of the problems of Elizabeth's reign in the 1590s see John Guy, ed., *The Reign of Elizabeth I: Court and Culture in the Last Decade* (Cambridge: Cambridge University Press, 1995); see also Godfrey Goodman, *The Court of King James I*, 2 vols (London: R. Bentley, 1839), I, p. 96.

4 James VI and I, *Political Writings*, Johann P. Sommerville, ed. (Cambridge: Cambridge University Press, 1994), p. 65. For a discussion of 'Free and Absolute' monarchy under James see Constance Jordan, *Shakespeare's Monarchies: Ruler and Subject in the Romances* (Ithaca and London: Cornell University Press, 1997), pp. 14–29.

5 See Alan G. R. Smith, ed., *The Reign of James I and VI* (London: Macmillan, 1973), pp. 15–18; see also Perry, *The Making of Jacobean Culture*, pp. 153–187.

6 Jonathan Goldberg, *James I and the Politics of Literature: Jonson, Shakespeare, Donne and Their Contemporaries* (Baltimore: John Hopkins University Press, 1983). See also, Jonathan Dollimore, *Radical Tragedy: Religion, Ideology and Power in the Drama of Shakespeare and His Contemporaries* (Chicago: University of Chicago Press, 1984).

7 See Kathleen E. McLuskie, *Dekker and Heywood: Professional Dramatists* (New York: St. Martin's Press, 1994); see also Perry, *The Making of Jacobean Culture*, pp. 172–184.

8 See Kenneth R. Andrews, *Trade, Plunder and Settlement* (Cambridge: Cambridge University Press, 1984); Kenneth R. Andrews, *Elizabethan Privateering: English Privateering during the Spanish War, 1585–1603* (London: Cambridge University Press, 1964).

9 Quotation taken from David Delison Hebb, *Piracy and the English Government, 1616–1642* (Aldershot: Scolar, 1994), p. 9. In the first decade of his reign, the King's increasing hostility towards pirates was made explicit in the approximately annual proclamations issued against those involved in piracy in English waters or by Englishmen such as, in 1604, 'A Proclamation for the search and apprehension of certaine Pirats', followed by, in March 1605, 'A Proclamation for revocation of Mariners from forreine Services'. See *Stuart Royal Proclamations*, vol. I, *Royal Proclamations of King James, 1603–1625*, J. F. Larkin and P. L. Hughes, eds, 2 vols (Oxford: Clarendon, 1973), nos. 15, 28, 46, 50, 53, 97, 93, all contain policies forbidding piracy. A copy of James' 1609 proclamation against pirates is appended to Vitkus, *Three Turk Plays from Early Modern England*, pp. 353–356.

10 See also Lois Potter, 'Pirates and "turning Turk" in Renaissance drama', in Jean-Pierre Maquerlot and Michele Willems, eds, *Travel and Drama in Shakespeare's Time* (Cambridge: Cambridge University Press, 1996), pp. 124–140 (p. 126).

11 'A Proclamation concerning Warlike ships at Sea', Greenwich, 23 June 1603, in Larkin and Hughes, *Stuart Royal Proclamations*, I, pp. 30–31.

12 'A Proclamation concerning Warlike ships at Sea', Greenwich, 23 June 1603, p. 31.

13 See Jaques Lezra, *Unspeakable Subjects: The Genealogy of the Event in Early Modern Europe* (Stanford: Stanford University Press, 1997), pp. 272–273.

14 C. M. Senior, *A Nation of Pirates* (Newton Abbot: David and Charles, 1976), pp. 7–42.

15 Captain John Smith, *The Complete Works of Capt. John Smith*, Philip L. Barbour, ed., 3 vols (Chapel Hill: University of North Carolina Press, 1986), II, p. 914.

16 See Samuel Chew, *The Crescent and the Rose: Islam and England During the Renaissance* (New York: Octagon Books, 1965), pp. 340–386 (p. 345). See also Nabil Matar, *Turks, Moors and Englishmen in the Age of Discovery* (New York and Chichester: Columbia University Press, 1999); Roslyn L. Knutson, 'Elizabethan Documents, Captivity Narratives, and the Market for Foreign History Plays', *English Literary Renaissance* 26 (1996), 75–110.

17 On Elizabethan nostalgia see Anne Barton, 'Harking Back to Elizabeth: Ben Jonson and Caroline Nostalgia', *English Literary History* 48 (1981), 706–731.

18 Barbara Fuchs, 'Faithless Empires: Pirates, Renegadoes and the English Nation', *English Literary History* 67 (2000), 45–69, 51.

19 See Richard Helgerson, *Forms of Nationhood: The Elizabethan Writing of England* (Chicago: University of Chicago Press, 1992), pp. 107–147.

20 Fuchs, 'Faithless Empires', 51.

21 Robert Daborne, *A Christian Turned Turk*, in Vitkus, *Three Turk Plays*. See Fuchs, 'Faithless Empires', 51–52.

22 On the dating of *Fortune by Land and Sea* see Herman Doh, 'Introduction', in *Fortune by Land and Sea*, pp. 32–37; see also Potter, 'Pirates and "turning Turk" in Renaissance drama', p. 127; Andrew Gurr, *The Shakespearean Stage, 1574–1642* (Cambridge: Cambridge University Press, 1980), p. 222. Whether *Fortune by Land and Sea* was acted by Henrietta Maria's Company or that of Queen Anne (or both) is not certain, though most critics date the play to 1607–9, which would indicate it to have been in the repertory of Queen Anne's. The 1655 edition of the text merely says 'As it was Acted, with great Applause, by the Queen's servants'. See Gurr, *The Shakespearian Playing Companies* (Oxford: Clarendon, 1996), pp. 317–336, 432.

23 Fuchs, 'Faithless Empires', 54.

24 *A Royal Proclamation By the King. A Proclamation against Pirates, Whitehall, 8 January 1609*, in Vitkus, *Three Turk Plays*, p. 353.

25 R. Holinshed, *The Chronicles of England, from William the Conqueror ... vntill the yeare 1577* (London: John Hooker, 1587), p. 1354.

26 Richard Hakluyt, *The Principal Navigations, Voyages, Traffiques and Discoveries of the English Nation* (London: J.M. Dent & sons, 1927–28), I, p. 13; see Helgerson, *Forms of Nationhood*, pp. 171–181.

27 Anon., *A True Relation, of the Lives and Deaths of the two most famous English Pyrats, Pursur, and Clinton; who lived in the Reigne of Queene Elizabeth* (London: Io. Okes, 1639), Sig C1. See Lezra, *Unspeakable Subjects*, pp. 276–280; Potter, 'Pirates and "turning Turk" in Renaissance drama', pp. 126–127.

28 See Fuch's reading of the Pursivant and the Clown, 'Faithless Empires', pp. 56–57.

29 Fuchs, 'Faithless Empires', p. 52.

30 Senior, *A Nation of Pirates*, p. 21.

31 For a similar, though less developed, point see Potter, 'Pirates and "turning Turk"', p. 127.

32 Michael Drayton, *The Works of Michael Drayton*, William J. Hebel, ed., 5 vols (Oxford: Blackwell, 1931–41), IV, pp. 337–338, lines 341–353. For a more detailed analysis of this passage see Perry, *The Making of Jacobean Culture*, pp. 168–169.

33 Previous critics have frequently commented on Philip's passivity, but have not read it as a reflection of Jacobean *Rex Pacificus*. Otelia Cromwell, for instance, describes Philip's 'apparent meekness'. See *Thomas Heywood: A Study in the Elizabethan Drama of Everyday Life* (Yale: Yale University Press, 1928), pp. 169–170. See also Fuchs, 'Faithless Empires', p. 56.

34 On the debate about the power of the law in ensuring subjects' rights see Jordan, *Shakespeare's Monarchies*, pp. 27–28.

35 Sir Edward Coke, 'To the Reader', *Reports*, 7 vols (London: Nutt and Gosling, 1738), the fourth part, vol. 2, f. xix. Quoted by Jordan, *Shakespeare's Monarchies*, p. 28.

36 Coke, 'To the Reader', *Reports*, the fifth part, vol. 3, f. iii. See Jordan, *Shakespeare's Monarchies*, p. 28.

37 On Ralegh see Stephen Greenblatt, *Sir Walter Ralegh: The Renaissance Man and His Roles* (New Haven and London: Yale University Press, 1973); Anna Beer, *Sir Walter Ralegh and his Readers in the Seventeenth Century* (London and New York: Macmillan and St. Martin's Press, 1997).

38 See Beer, *Sir Walter Ralegh*, pp. 1–21.

39 Beer, *Sir Walter Ralegh*, pp. 7–8.

40 See D. H. Willson, *King James VI and I* (London: Jonathan Cape, 1956), p. 274.

41 Quotation taken from J. Nichols, *The Progress and Public Processions of Queen Elizabeth*, 2 vols (London: John Nichols and Son, 1823), II, p. 50.

42 Vitkus, 'Introduction', *Three Turk Plays*, p. 24. See also Gurr, *The Shakespearian Playing Companies*, pp. 356–361.

43 Nabil Matar, for instance, reads the play in this way: 'There was no redeeming quality in Ward, and much like Faustus in Marlowe's play, the renegade pirate met with a violent and fully deserved death – torn to pieces and thrown into the sea'. See Matar, 'The Renegade in English Seventeenth-Century Imagination', *Studies in English Literature*, 33 (1993), 489–505, pp. 494–5; see also Fuchs, 'Faithless Empires', pp. 51–52; Potter, 'Pirates and "turning Turk"', pp. 130–134.

44 See Chew, *The Crescent and the Rose*, pp. 347–354, 357–362.

45 John Donne, *Complete English Poems*, C. A. Patrides, ed. (London: Everyman, 1994), p. 107; Thomas Dekker, *The Dramatic Works of Thomas Dekker*, Fredson Bowers, ed. (Cambridge: Cambridge University Press, 1958), III.

46 Andrew Barker, *A True and Certaine Report of the Beginning, Proceedings, Overthrows, and now present Estate of Captaine Ward and Danseker, the two late famous Pirates: from their first setting foorth to this present time* (Amsterdam: Da Capo Press, 1968 [1609]), title-page; *Newes from Sea, Of Two Notorious Pyrates, Ward and Dansiker* (London: E. Allde for N. Butter, 1609); see Vitkus, 'Introduction', *Three Turk Plays*, pp. 24–39.

47 Barker, *A True and Certaine Report*, pp. 1–2.

48 Barker, *A True and Certaine Report*, p. 4.

49 Barker, *A True and Certaine Report*, p. 4.

50 Barker, *A True and Certaine Report*, p. 14.

51 Barker, 'To His Worshipful, Worthy and singular good friend Master T.I. these faithfull commendations', *A True and Certaine Report*, A2v.

52 *The Seaman's Song of Captain Ward, the Famous Pirate of the World, And an Englishman Born* (London: F. Coles *et al.*, 1609), in Vitkus, *Three Turk Plays*, pp. 345–348.

53 *The Seaman's Song of Captain Ward*, p. 346.

54 Barker, *A True and Certaine Report*, p. 15. See B. R. Burg, *Sodomy and the Pirate Tradition: English Sea Rovers in the Seventeenth-Century Caribbean* (New York and London: New York University Press, 1984).

55 See Potter, 'Pirates and "turning Turk" in Renaissance drama', p. 131; Matar, 'The Renegade in English Seventeenth-Century Imagination', pp. 492–495.

56 On James's concerns see Willson, *King James VI and I*, pp. 271–287.

57 James VI and I, *Political Writings*, p. 181. For discussion see Roger Lockyer, *The Early Stuarts: A Political History of England, 1603–1642*, (London and New York: Longman, 1999), pp. 11–30.

58 See Harry Levin, *The Power of Blackness* (New York: Alfred Knopf, 1958); Winthrop Jordan, *White over Black* (Chapel Hill: University of North Carolina Press, 1968); Dympna Callaghan, 'Re-reading Elizabeth Cary's The Tragedie of Mariam, Faire Queene of Jewry', in Margo Hendricks and Patricia Parker, eds, *Women, Race and Writing in the Early Modern Period* (London: Routledge, 1994), pp. 163–177.

59 See Mary Bly, *Queer Virgins and Virgin Queans on the Early Modern Stage* (Oxford: Oxford University Press, 2000).

60 See Hebb, *Piracy and the English Government*, pp. 10–20.

61 See Vitkus, 'Introduction', *Three Turk Plays*, p. 4.

62 Richard Knolles, *The Generall Historie of the Turkes, from the first beginning of that Nation to the rising of the Othoman Familie: with all the notable expeditions of the Christian Princes against them. Together with the Lives and Conquests of the Othoman Kings and Emperours. Faithfully collected out of the best Histories, both auncient and moderne, and digested into one continual Historie until this present yeare 1603* (London: Adam Islip, 1603): on the history of the popularity of this text see Chew, *The Crescent and the Rose*, pp. 111–115.

63 Matar, 'The Renegade in English Seventeenth-Century Imagination', 489–505: see also Nabil Matar, 'Turning Turk: Conversion to Islam in English Renaissance Thought', *Durham Universirty Journal*, 86 (1994), 33–41.

64 Quoted by Matar, 'The Renegade in English Seventeenth-Century Imagination', 490.

65 Robert Dallam, 'An Account of an Organ Carried to the Grand Seigneur ads Other Curious Matter', in J. Theodore Bent, ed., *Early Voyages and Travels in the Levant*, (London: Hakluyt Society, 1893), pp. 1–99.

66 *The Cabinet-Council: Containing the Chief Arts of Empire and Mysteries of State,* wrongly ascribed to Walter Ralegh, is quoted from *The Works of Walter Ralegh, Kt.*, 8 vols (Oxford: Oxford University Press, 1829), VIII, p. 55. For a discussion of early-modern attitudes to counsel see Perry, *The Making of Jacobean Culture*, pp. 83–85.

67 Perry, *The Making of Jacobean Culture*, pp. 83–114.

68 Perry, *The Making of Jacobean Culture*, pp. 113–114; see also Rebecca W. Bushnell, *Tragedies of Tyrants: Political Thought and Theater in the English Renaissance* (Ithaca and London: Cornell University Press, 1990).

69 On Anne's religion see Willson, *King James VI and I*, pp. 221–222; see also J. Leeds Barroll, 'The Court of the First Stuart Queen', in Linda Levy Peck, ed., *The Mental World of the Jacobean Court* (Cambridge: Cambridge University Press, 1991), pp. 191–208. On the possibility of James's conversion and his

treatment of Catholics see Lockyer, *The Early Stuarts*, pp. 191–211. On Anti-Catholic paranoia see Carol Z. Weiner, 'The Beleagured Isle: A Study of Elizabethan and Early Jacobean Anti-Catholicism', *Past and Present*, 51 (1971), 27–62; Raymond D. Tumbleson, *Catholicism in the English Protestant Imagination, Nationalism, Religion and Literature, 1600–1745* (Cambridge: Cambridge University Press, 1998), pp. 17–40.

70 Willson, *King James VI and I*, pp. 234–235.

71 W. P. Baildon, ed., *Les Reportes del Cases in Camera Stellata 1593–1609* (London: priv. print, 1894), p. 190.

72 See Lockyer, *The Early Stuarts*, pp. 198–199.

73 Sir Anthony Weldon, 'The Court and Character of King James', in Sir Walter Scott, ed., *Secret History of the Court of James the First*, 2 vols (Edinburgh: J. Ballantyne, 1811), I, p. 376.

74 Weldon, 'The Court and Character of King James', pp. 377; *Letter from John Chamberlain to Sir Dudley Carleton, English Ambassador at Venice, 29 April 1613*, quoted in Robert Ashton, ed., *James I By His Contemporaries* (London: Hutchinson, 1969), p. 120.

75 See Vitkus, 'Introduction', *Three Turk Plays*, pp. 31–32. As Hebb points out, the measure was partially successful, since approximately 12 pirate captains and their crews took up the king's offer. See Hebb, *Piracy and the English Government*, p. 16.

76 William Lithgow, *The Totall Discourse of the Rare Adventures and Painefull Peregrinations of Long Nineteene Yeares Travayles* (London: Nicholas Okes, 1632), p. 315.

77 Vitkus, *Three Turk Plays*, p. 40; see also Gurr, *The Shakespearean Stage*, p. 224.

78 Gurr, *The Shakespearian Playing Companies*, p. 407.

79 See T. H. Howard-Hill, 'Introduction', in Thomas Middleton, *A Game at Chess* (Manchester: Manchester University Press, 1993), pp. 17–23. References are to this edition and are given parenthetically in the chapter.

80 For further details of the anti-Spanish context see Howard-Hill, 'Introduction', pp. 24–48; T. Cogswell, 'Thomas Middleton and the Court, 1624: *A Game of Chess*', *Huntingdon Library Quarterly* 42 (1984), 273–288; Janet Clare, *'Art made tongue-tied by authority': Elizabethan and Jacobean Dramatic Censorship* (Manchester: Manchester University Press, 1999), pp. 211–220; Richard Dutton, 'Receiving Offence: *A Game at Chess* Again', in Andrew Hadfield, ed., *Literature and Censorship in Renaissance England* (Basingstoke: Palgrave, 2001), pp. 50–74.

81 Don Carlos Coloma to James I, Saturday [7] 17 August, 1624, *State Paper (Spain)*, PRO SP94/311, fol. 132, printed in P.G. Phialas, 'An Unpublished Letter About *A Game at Chess*', *Modern Language Notes*, 69 (1954), 398–399.

82 Margot Heinemann, 'Middleton's *A Game at Chess*: Parliamentary Puritans and Opposition Drama', *English Literary Renaissance* 5 (1975), 232–250.

83 Elizabeth I created only 878 knights during her whole reign; in the first four months of James's rule, 906 new knights were created. See Ashton, *James I by his Contemporaries*, p. 105.

84 See Willson, *King James VI and I*, pp. 429–440.

85 On *The Renegado* as a response to *A Christian Turned Turk*, see Vitkus, 'Introduction', pp. 39–43.

86 See Kevin Sharpe, *The Personal Rule of Charles I* (New Haven and London: Yale University Press, 1992), p. 4; Lockyer, *The Early Stuarts*, pp. 199–201.

87 See Howard-Hill, 'Introduction', pp. 12–17.

88 Gondomar estimated 300,000 were committed, non-conforming Catholics, 600,000 were Catholic at heart but conformed out of fear and worldly considerations, and 900,000 were 'favourably inclined' though they had no religious beliefs and were mainly concerned with the pursuit of pleasure. See Lockyer, *The Early Stuarts*, pp. 201–202.

89 Lockyer, *The Early Stuarts*, p. 204.

90 Lockyer, *The Early Stuarts*, p. 204.

91 See Felix Raab, *The English Face of Machiavelli: A Changing Interpretation 1500–1700* (London: Routledge and Kegan Paul, 1964).

92 Sharpe, *The Personal Rule of Charles I*, p. 4; Willson, *King James VI and I*, pp. 384, 426.

93 On Buckingham see Roger Lockyer, *Buckingham: The Life and Political Career of George Villiers, First Duke of Buckingham 1592–1628* (London and New York: Longman, 1981).

94 Willson, *King James VI and I*, p. 427.

New worlds and old worlds: gender performance and social allegory in travel drama

S o far this book has concentrated on political allegories of royalty embedded – often in complex and subtly indeterminate ways – in travel drama. My focus has been to explore the ways gendered colonial writing did domestic work in relation, specifically, to the highest levels of early modern society. Consequently, this study runs the risk of privileging allegories of courtly politics at the expense of those geographic dramas concerned with other domestic issues. In this chapter, I broaden this perspective through reading three travel dramas against different contemporary debates, concentrating on Fletcher and Massinger's *The Sea Voyage* (1622), Massinger's *The City Madam* (1632) and Richard Brome's *The Antipodes* (1638). All of these texts are read allegorically, but the nature of the domestic work undertaken is different, since their focus is on broader social targets than courtly politics. Similar to my reading in Chapter 3 of the colonial 'Virginian' context shaping Fletcher's representation of the Roman invasion in *Bonduca*, in this chapter I explore the use of New World locations in *The Sea Voyage* and *The City Madam*. In both these plays, characters' gender behaviour and sexual performance are used as a measure of the success or otherwise of British colonial and commercial endeavour. Both texts are suffused with information (and misinformation) about distant geographical locations, and the establishment of commercial, social and sexual relations with these regions and their inhabitants are topics of persistent concern. In these plays, I argue, the correct management of sexual appetite figures as an important gauge for national colonial performance.

Brome's play is also concerned with sexual appetite, but *The Antipodes* is a travel drama that is, paradoxically, not interested in any sustained way

in the kinds of new information or experiences, wealth, or 'virtuous conversion' of indigenous inhabitants that travel and empire formation offered. In Brome's drama the allegorical functions of the text are taken to an extreme since the strange, supposedly New World antipodean customs the play describes, in fact, solely operate as satiric reflections of contemporary London. In other words, there is nothing but allegory in Brome's engagement with colonial discourse; the idea of the antipodes merely offers him a vehicle to comment on domestic behaviour. In what follows, I trace the different ways Massinger, Fletcher and Brome used dramas about travel and colonialism to offer gendered social and political allegories.

'Her flesh must serve you': gender, commerce and the New World in Fletcher and Massinger's *The Sea Voyage* and Massinger's *The City Madam*

I examine here the interaction between gender behaviour and colonialism in two early to mid-seventeenth-century comedies, Fletcher and Massinger's collaborative *The Sea Voyage* and Massinger's single-authored *The City Madam*.[1] Both texts engage with the Virginian enterprise and the troubled history of the Jamestown venture. Characters' attitudes towards, and behaviour in, colonial situations are used to measure their conformity to normative gender behaviour and roles. I argue that characters' gender performance – specifically their attitude to sexual commerce – figures as a metaphor for a larger set of commercial relations with the New World. The men and women in these dramas are represented as conforming to, or deviating from, a male or female ideal in terms of sexual congress, which, in turn, acts as a measure of their moral, social, cultural and national worth. The correct management of appetite is crucial in determining commercial, sexual and social position and success. More particularly, Fletcher and Massinger use their characters' attitudes to native inhabitants – particularly the prospect of miscegenation or the adoption of savage, native patterns of behaviour – as especially significant indices of their relationship with the dominant social order. Put another way, colonial situations are used here as a means to debate the proprieties of gender behaviour for both men and women, but characters' effective performance of these gender roles is then used to measure the success and merit of the colonial project itself.

Though the action of *The City Madam* takes place in Renaissance London, and that of *The Sea Voyage* is solely located on castaway islands, both plays engage with the Virginia project. Massinger's *The City Madam*

draws explicitly on a Virginian context in the second half of the play, since the profligate and proud Lady Frugal and her two daughters, Mary and Ann, are threatened with a violent, sacrificial death in Virginia because they transgress accepted class and gender behaviour. Like *The Tempest*, the play with which *The Sea Voyage* is most frequently compared, Fletcher and Massinger's text is less obvious in its engagement with Virginia.[2] Nevertheless, *The Sea Voyage* is full of the most potent but unsettling images culled from recent English explorers' and settlers' accounts: Amazonian women, endemic starvation, fomenting rebellion, European rivalry, and, of course, easy riches represented by caskets of jewels strewn lavishly across the colonial landscape. Although the text's most recent editor, Anthony Parr, suggests that 'the very abundance of analogy ... refutes any attempt to tie it exclusively to a particular place or venture', the presence of European women on board Portuguese and French ships is significant in locating this play within a Western rather than an Eastern context, since the former was concerned with permanent settlement and the latter with temporary trading posts.[3] Women passengers indicate that these voyages were likely to be concerned with Western plantation and settlement. Aminta is on board ship through coercion, but Rosellia and her women were shipwrecked while on an expedition 'to seek new fortunes in an unknown world' (V, iv, 31) in the 'happy islands', in other words the 'Fortunate Isles' or the Canaries (V, ii, 88). Though Aminta is blamed for the storm that wrecks the ship in the opening scene of *The Sea Voyage* (signalling that tension is still generated by women invading the tradition-ally male environs of seafaring), the presence of European women on ships and in colonies offers London playgoers at the Blackfriars theatre in 1622 a fairly accurate representation of the demography of the Virginia colony. As the purpose of travel shifted from male-dominated exploration and fortune-seeking to permanent settlement, growing numbers of women joined the migrations to North America.[4] During the seventeenth century, the ratio of white males to females emigrating to North America never went below three-to-one (and was frequently much higher), and the Virginia company was advertising heavily for female settlers to marry male colonists in this period.[5] Yet despite this demographic imbalance, European women were becoming a significant presence in the colonies, and *The Sea Voyage* reflects beliefs about the importance of women for the maintenance of well being in the colonies of the early 1620s.[6]

The Virginian plot of *The City Madam* does not appear until late in this play and it is clear from the casual way in which Lady Frugal and her

daughters are mentioned as potential Virginian colonists that, in the ten years since *The Sea Voyage* had been written, the female population of the colony increased further. The plot mainly concerns the domestic arrangements of the Frugal family. The women of the family, despite belonging to the prosperous city merchant classes, dress and behave far more excessively than even the most luxurious of the nobility, and demand 'absolute sovereignty' for women (II, ii, 85). They assert their power over Luke, the supposedly repentant wastrel brother of Sir John Frugal, for example, by treating him as their 'slave' (I, i, 102) and forcing him to run demeaning errands. Encouraged by their mother, the daughters also demand mastery over prospective husbands (II, ii, 165–167). As a result of their overweening pride, Lady Frugal's husband, Sir John, feels disempowered by his opinionated and unruly family: 'What's wealth, accompanied / With disobedience in a wife and children? / My heart will break' (II, iii, 46–48). He also distrusts his prodigal brother Luke's conversion to virtue and determines to discover whether 'he prove / true gold in the touch' (II, i, 158–159). Like the Duke in *Measure for Measure* (1603), Sir John pretends to retreat to a monastery whilst, in fact, he continues to orchestrate events from the sidelines.

Sir John's plot to test Luke involves him masquerading as a Native American *sachem*, or king, whom he had previously sent to London to be converted to Christianity. Sir John tells his brother that in fact the group of native Americans are devil worshippers and that their real reason for being in Britain is to procure three British women, 'Two Christian virgins ... and a third Married' 'that with their pure blood / Might dye his horrid altars' (V, i, 36–39). This representation of native Americans as devil worshippers is one that frequently appeared in Virginian travel literature and propaganda: Captain John Smith, for example, asserted in 1624 'their chiefe God they worship is the Devill. Him they call Okee, and serve him more of feare than love'.[7] The presence of the 'sachems' in London because of Sir John thus represents him, like Massinger's Puritan patron Lord Pembroke, as philanthropically concerned to forward in his New World interactions the ethos of virtuous conversion as well as trade. We have here an example of what Stephen Greenblatt has termed 'Christian imperialism'; Sir John is involved in the exchange of New World riches for Old World Christianity.[8] Indeed the Virginia Company proclaimed in 1610 that their first goal was to 'preach and baptize into the Christian Religion and by propagation of the Gospell, to recover out of the armes of the Divell, a number of poore and miserable soules, wrapt up unto death, in almost invincible ignorance'.[9]

The City Madam gives competing and contradictory accounts of Virginian life. Though colonial discourse claimed authorisation by divine mandate to spread God's word amongst heathen peoples, Massinger questions whether colonists' own sexual behaviour lives up to Godly standards. The native Americans' mission to Britain is necessary only because female virginity 'was not to be purchas'd' in the New World (V, i, 9). Female virginity, like any other form of goods, is represented as a commercial asset whose price becomes inflated when demand exceeds supply. Furthermore the reputation of the colony more generally is invoked. When Luke deviously offers to send his sister-in-law and nieces to Virginia to be 'Queens in another climate' (V, i, 98), the women protest at the thought of keeping company with:

> *Anne*: Condemn'd wretches,
> Forfeited to the law.
> *Mary*: Strumpets and bawds,
> For the abomination of their life,
> Spew'd out of their country. (V, i, 106–109)

The women here refer to the fact that many of the colony's settlers were perceived to be either convicts, or those unemployed or underemployed in Britain; hence Virginian society was often described as lawless by the inhabitants of seventeenth-century London.[10] Stories about Virginian malpractice and licentiousness were common: for example, in 1609 some 'unruly youths' stowed away on the same vessels that deposited them in Jamestown, after swearing an oath to denigrate the colony on their return to England: they circulated 'in all places ... (to colour their owne misbehaviour, and the cause of their return with some pretence) most vile and scandalous reports, both from the countrey it selfe and the carriage of businesse there'.[11] The contradictory nature of reports about early America is captured in Luke's promise to the women that they will be 'Queen's' since Mary, with her comments about the number of prostitutes in Virginia, clearly understands him to mean that they will become 'queans'. The women fear that their sexual honour will be compromised by their presence in such a supposedly licentious place and that they too will become 'strumpets and bawds'.

As a result, Luke and the disguised Sir John have to make it yet more explicit that they are being sent to a place in which all their social ambitions will be fulfilled:

> *Sir Maurice*: You shall be ador'd there
> As goddesses.

Sir John: Your litters made of gold
 Supported by your vassals, proud to bear
 The burden on their shoulders.
Plenty: Pomp and ease,
 With delicates that Europe never knew,
 Like pages shall wait on you. (V, i, 118–123)

The men again emphasise the elite status the women will enjoy. But, of course, such an image is a ruse, a fantasy, and a dream. The text, then, is highly ambiguous concerning how 'Virginia' should be understood. Should it be seen as merely a dumping ground for the socially undesirable elements of British society? Certainly Sir John's disguise as a sexually predatory native *sachem* is believed by Luke. In order for Sir John's scheme to work, Luke has to believe that it is a place of debauched licentiousness and irreligion, populated by those excluded from Britain and devil-worshipping natives. This representation of Virginia allows the men in the text to use it as an imaginary site in which to contain, punish and murder unruly women. The fantasy of sending the women to their death in Virginia is, importantly, one that is created by their husband and father. It is a scheme that is hatched by the man who ought to be the moral centre of the play, Sir John, not the text's villain, Luke (though of course he warmly embraces it). In this version of Virginia the colony is a depraved and dystopic society: it is used as a kind of spectre to deter women from socially unacceptable behaviour. Like the branks, or scold's bridle, the threat of life in Virginia will school all but the most depraved and unruly woman into docility.[12] There is also the contradictory version of Virginia as a world in which characters' (and colonists') pleasurable fantasies will be fulfilled (the Frugal women will be 'ador'd there as Goddesses'). By making both these versions of 'Virginia' imaginary (Sir John is only pretending to be a *sachem*), Massinger never privileges one story over the other.

The complexities inherent in Massinger's representation of Virginia in *The City Madam* find their precedent in Fletcher and Massinger's earlier drama *The Sea Voyage*, which also sees sexuality – specifically reproductive capacity – in terms of commercial value. Concerned with the shipwreck of a band of French privateers on castaway islands, who discover the surviving inhabitants of a previous Portuguese venture where the men and women have been marooned separately, *The Sea Voyage* satirises both the behaviour and roles of European men and women. Through much of the play the colonists are separated from each other in small, single-sex groups and the plot focuses on the establishment of

cordial relations between these factionalised groups as they discover that they need each other to survive. The text draws a distinction between resources needed for immediate survival – food and water – and those necessary for medium- and long-term colonisation – children to be new generations of settlers. Initially, each group possesses different resources and, importantly, no group possesses everything necessary to ensure their long-term survival. The Portuguese women inhabit fertile terrain and hence have food and water but they cannot reproduce without men; the other two groups inhabit a barren wasteland and are about to starve. Though the mixed-sex French group originally possessed a boat – an escape route from the island – they swiftly lose it to the starving but uselessly treasure-laden Portuguese men. Indeed, colonists' greed for easy riches is satirised in Act I, Scene iii where Sebastian reveals that gold lust was the downfall of the earlier Portuguese expedition: 'This gold was the overthrow of my happiness' (175). Furthermore, at the sight of all the 'gold and jewels' (162) the Frenchmen descend to violent squabbling concerning their portions and abandon their boat. Consequently, the starving Portuguese steal their ship leaving the French, miserable and without food, possessing only 'damned enticing gold' (221) and jewels to eat.

The gender of the members of these separate groups is important, since, in order to establish a secure colony with a future, there needs to be sexual commerce to produce future generations. Gender, specifically reproductive capacity, is just as much of a resource as food or any other commodity necessary for the maintenance of life. Hence the plot of *The Sea Voyage* follows the haphazard and hostile interaction between these separate colonies until, finally, an understanding among the groups is achieved which enables them to pool resources. Among the separate factions there are enough resources to ensure a sustainable lifestyle, but the play documents the misunderstandings that mean, until the conclusion of the play, that no group is prepared to foster cordial relations. For much of the play, each group acts as though it is in competition with the others rather than working in tandem for the mutual benefit of all.

The romance of the play's central characters, Captain Albert and Aminta, explicitly addresses the issue of establishing secure and lasting relationships through the maintenance of gender-appropriate behaviour in colonial contexts. Albert's masculinity comes under scrutiny after he is shipwrecked on the barren terrain. When Aminta appears to be in a better condition than him ('my weakness / Is not for what I suffer in myself / But

to imagine what you endure'; II, i, 2–4), Albert immediately becomes
concerned about his masculinity:

> Do not add
> To my afflictions by your tender pities.
> Sure we have changed sexes: you bear calamity
> With a fortitude would become a man;
> I like a weak girl suffer. (II, i, 5–9)

In the beginning of this scene it is clear that gender roles have been
reversed, since Aminta appears brave and solicitous as Albert lies supine
and helpless. Next, Aminta decides to 'play the surgeon' (II, i, 15) – a
masculine role – and bind his gaping (female) wounds. She does this by
cutting off her hair and using the 'pure locks' (II, i, 19) for the purpose. By
cutting her hair, Aminta removes a culturally significant indicator of gender.
Indeed, the contemporaneous pamphlets *Hic Mulier* and *Haec Vir*
emphasise that women's appropriation of masculine hairstyles is one of the
key factors in the troubling and fashionable obfuscation between genders.[13]
The woodcut illustration on the title-page of *Hic Mulier*, for example,
shows the toilet of a fashionable lady, a 'monstrous' 'man-woman', as her
servant, brandishing a sexually meaningful open pair of scissors asks
'Mistris, will you be trim'd or truss'd?' (see Figure 7).[14] The pamphlet
continues to make the connection between short hair and transgression;
masculine-women have given up 'the glory of a faire large hayre, to the
shame of most ruffianly short lockes' and such behaviour is indicative of
sexual depravity as 'womens modestie' has been transformed to 'apish
incivilitie'.[15] Aminta's actions here simultaneously conform to and trouble
established patterns of gender behaviour.

The rest of this scene attempts to restore the hero and heroine to more
traditional gender roles. Albert, revived by Aminta's ministrations,
becomes appropriately masculine once more as he kisses Aminta and
declaims against Nature for her cruelty in making 'a virgin' (Aminta) 'pine
for hunger' (II, i, 35–50). The play's repeated emphasis on the connection
between appetite for food and sexual desire is focused on here since
Aminta's kisses represent a 'banquet' to the starving Albert. Though
Aminta asserts she 'could eat to bear you company' – that is have sex with
him – the real starvation they face means that for now she must remain a
virgin. At this point the intimate scene is interrupted by the sound of 'free
hunters' music' and Albert becomes determined to discover 'Another
island … the seat of fortunate men' from where the noise emanates.

7 Anon., *Hic Mulier*, title page

Though mistaken in his belief that the hunters he hears are male (they are, in fact, women) Albert appears for the rest of the scene in traditional heroic male role, comforting the now 'wretched' Aminta who fears being left alone. The sound of what he takes to be males hunting for food revives his own masculinity as he becomes determined to secure some of the food for

Aminta. He cajoles her like a child with imaginary scenarios and the
promise of good 'dreams':

> when that sleep
> Deceives your hunger with imagined food
> Think you have sent me for discovery
> Of some most fortunate continent, yet unknown,
> Which you are to be queen of. (II, i, 91–93)

Noticeably, Fletcher represents the retreat into fantasy to sustain colonial
ambitions as only suitable for the female Aminta; Albert promises to resist
the allure of such pleasures: 'I would not eat nor sleep till I returned' (II, i,
86). As we have seen before, in the same way that Edmund Spenser in
Book 2 of the *Faerie Queene* (1590) celebrated restraint and deferred
gratification in 'The Legend of Sir Walter, or of Temperance', and as John
Smith and Ralegh boasted about their own self-control, here Albert's
abstinence marks him as superior to his compatriots.[16]

This scene represents a crisis in the performance of appropriate
gender roles for the two main characters. Both Aminta and Albert behave
in ways that, at times, defy accepted gender indicators. Neither character
is able to rest secure in conventional gender performance in the hostile and
difficult to understand colonial environment where European rules of
conduct must be adapted to meet the needs of new situations. The fact that
Albert instinctively interprets the noise he hears across the water as made
by men rather than women – he's proved incorrect almost immediately –
playfully resonates with the ways colonists' expectations concerning what
they would find were constantly challenged by their actual experiences in
travel writing. When he stumbles 'staggering and collapsing' onto the
Portuguese women's island, Albert is unable to distinguish between
fantasy and reality, questioning whether he is still alive, 'Do I yet live?' (II,
ii, 73) or has arrived in the Elysian fields of classical tradition, before con-
structing the women as 'goddesses' (II, ii, 81). Albert cannot make sense of
his environment and, as a consequence, understands the Portuguese
women through the filter of an earlier, book-learned, set of beliefs.[17] His
views reveal him to be socially elite since they show his conventional classi-
cising, but the limits of this education are gently set up by the dissonance
between Albert's expectations and an audience's prior knowledge of the
earthiness of the women he thinks are goddesses. Here Albert must look
beyond classical models in order to understand that the women are in fact
libidinous, thoroughly human, Portuguese castaways merely mimicking

Amazonian practices.[18] His idealistic identification of the women as 'nymphs of Dian's train' (II, ii, 83) is, of course, partly explained by the appearance and demeanour of the women, since Rosellia, finding herself, her daughter and her servants isolated from their menfolk, has revived an Amazonian way of life. Like Albert, the Portuguese women have reverted to fabled ancient ways of life which, through the development of hunting skills, have enabled them to survive in the short term. But the all-female colony knows that they face problems: they are sexually frustrated and, of course, in the long term without men their group will die out. Both the Amazonian women and Albert are shown with light humour to be confused in some way. No one reveals him- or herself to be able either to understand, or to adapt successfully and in sustainable ways to the environment.

In fact Rosellia is facing both rebellion from her band of women who, increasingly dissatisfied with their chaste existence, find their only relief in erotic dreams ('For if I have any pleasure / In this life but when I sleep, I am a pagan' II, ii, 43–44), and destruction from the fact that without offspring her colony will inevitably die out. Albert, although he had intended to secure himself a share of the hunters' victuals, finds himself to be the women's prey. Besieged by the women's obvious sexual frustration and anxious to find food for 'a virgin almost pined' (II, ii, 249), Albert cannot acknowledge Aminta as anything more than a sister and lies to Clarinda's direct question 'She's not your wife?' (II, ii, 250), promising ignominiously to 'live your slave' (II, ii, 257) if Aminta's hunger is relieved. Rosellia and her followers have – the text encourages us to believe – appropriated a way of life that is doomed to failure and, moreover, one that forces Albert to lie dishonourably concerning the real nature of his relationship with Aminta.

Native inhabitants are only directly mentioned in one context in *The Sea Voyage*. Rosellia, the leader of the shipwrecked Portuguese Amazonian women, in order to persuade the others to continue to shun men, describes how their present lifestyle imitates that of the previous inhabitants: 'this blest place' she says was 'inhabited heretofore by warlike women / That kept men in subjection' that have since died out (II, ii, 196–198). The erasure of troublesome natives in the text is particularly topical since the play was first performed when relations between indigenous Americans and British colonists were becoming increasingly hostile. Though Company instructions of 24 July 1621 had encouraged colonists to cement friendly relations with native Americans by allowing them into their settlements, the expanding number of English colonists, their needs for land and food, and their murder of the warrior-priest Nemettanow all meant

relations were worsening.[19] The conflict culminated in the massacre of approximately 347 Jamestown colonists by a confederation of tribes marshalled by chief Opechancanough on the morning of 22 March 1622, and as a result all policies of cultural accommodation were ended. According to Edward Waterhouse's *1622 A Declaration of the State of the Colony in Virginia* this 'divellish murder' was achieved through 'treacherous dissimulation' on the part of the native Americans.[20] In April 1622 the council at Jamestown sent word of the murder of 'above three hundred men women and Children' and the news arrived in London in July.[21] *The Sea Voyage* was licensed for performance by Sir John Astley on 22 June 1622, performed later that year at either the Globe and/or Blackfriars playhouses by the King's Men, but it was not published until 1647.[22] It is therefore possible that emendations were made to the play-text in the wake of news of the massacre, and that certain scenes, for example Rosellia's frenzied plan to sacrifice the French, had additional resonances for a 1622 audience. Given the crisis such news provoked for the fortunes of the Virginia Company, and also given, as Gordon McMullan argues, that it is likely Fletcher was a shareholder in the Company in 1620 at least, it is no surprise that, if he knew of it, he balked at the direct treatment of such subject matter in *The Sea Voyage*.[23] It was not until 1623 that a play, *A Tragedy of the Plantation of Virginia* (now lost), was performed at the Curtain (censored so that the 'prophaness [was] left out') which focused on the massacre.[24] Direct responses to the calamity can be found earlier in John Donne's sermon preached to members and friends of the Virginia Company on 13 November 1622, his friend Christopher Brooke's 'A Poem on the Late Massacre in Virginia', and the Virginia council replied to the Jamestown council on 1 August declaring that 'replanting ... is of absolute necessitie'.[25] Brooke's poem concentrates on the depraved nature of the Indians: they are 'the very dregs, garbage, and spawne of Earth' and he calls for their complete annihilation.[26] Donne's sermon, though less explicitly blood-thirsty, is concerned with an English evangelical mandate to spread the word of God among heathen peoples that simultaneously argues for native American dispossession under the Roman Law argument known as *res nullius*.[27] According to this argument, the (Christian) colonist is obliged to make all arable land productive: hence, the removal of a people that fail to fulfil this responsibility is justified as long as it is placed in the hands of others who do not allow it to go to waste:

In the Law of Nature and Nations, A Land never inhabited, by any, or utterly derelicted and immemorially abandoned by the former Inhabitants, becomes

theirs that wil posesse it. So also is it, if the inhabitants doe not in some measure fill the Land, so as the Land may bring foorth her increase for the use of men: for as a man does not become proprietary of the Sea, because he hath two or three Boats, fishing in it, so neither does a man become Lord of a maine Continent, because hee hath two or three Cottages in the Skirts thereof.[28]

However, the convenient emptying out of the colonial terrain of its native inhabitants and their replacement with a different Other, European women, is significant in *The Sea Voyage*. In the wake of continuing tensions between colonists and natives and, of course, the Virginia massacre of 1622, the disappearance of natives from colonial landscapes is a powerfully seductive fantasy as it, of course, immediately solves what has become a deeply problematic relationship. In *The Sea Voyage*, then, European women occupy the space in which colonists would expect to find native inhabitants. Thus the threatening force of a native population is textually contained through their absence, and a more palliative substitute, European women, put in their place. Just as Pocahontas represented for male English colonists a heady blend of exotic race and different gender, so European women's appropriation of titillating Amazonian behaviour represents an equally potent fantasy.[29] The distrust with which English colonists now viewed Algonkian Indians is displaced onto Rosellia and her band at the same time as their erotic appeal and reproductive capacities mean that, unlike native Americans, they will ultimately be assimilated rather than annihilated. For example, Rosellia shows some familiarity with the sexual practices of the fabled Amazons since, when her women persist in their desire to have traffic with men, she suggests the following 'resolution':

> If you like their persons
> And they approve of yours – for we'll force nothing,
> And since we want ceremonies, each one
> Shall choose a husband, and enjoy his company
> A month, but that expired you shall no more
> Come near 'em. If you prove fruitful
> The males ye shall return to them, the females
> We will reserve ourselves. (II, ii, 234–241)

This is a diluted version of Amazonian practices since, where Amazons were believed to kidnap their partners or even mutilate them to make them more amenable to their advances, here no 'force' will be used.[30] Amazonian brutality is curbed because, in the aftermath of the Virginia massacre, threats of direct violence would make the eventual reassimilation of the women more difficult. Intensely aggressive European women would appear

too much like the natives they simultaneously mimic and replace, and would, like them, have to be destroyed. Fletcher's representation uneasily straddles the ambivalence of Otherness as seductively exotic and violently threatening. Indeed, Stephen Greenblatt sees this conflation of desire and violence as symptomatic of European relations with the New World: 'Europeans destroyed Indian culture not despite those aspects of it that attracted them but in part at least because of them'.[31] After the Virginia massacre, as Waterhouse's comments starkly reveal, colonists were licensed to annihilate native Americans 'by pursuing and chasing them with our horses, and blood Hounds to draw after them, and Mastives to teare them'.[32] White women, even as they appear in lieu of natives, in order not to suffer the same fate as the now extinct native inhabitants, must remain recognisably European. They simulate natives, but must remain sanitised versions; to 'go native' fully would result in the violent treatment Waterhouse recommends. In *The Sea Voyage* the women must not demonstrate violence too explicitly since it will inevitably escalate beyond their control until, like Waterhouse's plan, a sustained policy of extermination is put into practice. The violent yet paradoxically 'civilising' forces of European patriarchy and colonialism will not allow subordinate groups – indigenous peoples and women – to use aggression more successfully than they do. In other words, the odds are stacked in favour of colonial/patriarchal authority since it has determined the rules of the game and has the best equipment: guns beat bows and arrows. Colonial/patriarchal discourse thus constructs natives/women as inexplicably violent or unruly in order to be able to control them all the more successfully through increased levels of violence, and, simultaneously, justifies the use of such violence. In the face of what Waterhouse called the Algonkians' 'treacherous dissimulation', English colonists needed to be ever vigilant. Female/native violence remains a threat in *The Sea Voyage* because it is – paradoxically – necessary to colonial/patriarchal discourse. Rosellia's Amazonian customs may, at any time, descend into savagery: hence there is the ever present erotic prospect that male (sexual) control through violence will need to be exerted over the band of women.

The text's difficulties with female/native violence explain Rosellia's claims that the temporary nature of the couplings is motivated by a lack of 'ceremonies' (II, ii, 236), or civilised religious marriage practices, on the island. Such a description shows that she is implicitly comparing island practices with European ones: Europe is still the measure of civilised behaviour, the women are only pretending to be Amazonian, their efforts

here are ridiculous and grotesque rather than so threatening and violent that they must be killed. Consequently, Fletcher and Massinger make much of the humour of the community of women's discontent with their sexual isolation as well as of the ironies of Rosellia's woefully misguided appropriation of the practices of a dead civilisation. Similarly, when Rosellia agrees to sexual commerce between her women and the French, her innately European mindset is shown by the way she gives the men their choice, abdicating from the patriarchal position of disposer of females in marriage (III, 257–262); and when complimented by Tibalt and singled out as his choice of partner, she appears flattered and pleased (III, 310–335). Rosellia's Amazonian practices, then, are bluff and bluster: she remains firmly within a European frame of reference.

The play wittily engages with the notorious difficulties of survival for Europeans in colonial locations. Specifically, it focuses on the difficulties of maintaining adequate supplies of food and the need to ensure that colonists are able to breed and produce new generations. Fletcher and Massinger persistently yoke these two issues together. Starvation is an ever-present threat as, for example, hunger forces the French gallants to contemplate eating both the unpleasant detritus of the landscape and, more importantly, the only woman that they number amongst their band at this point. In a parody of the blazon – which, as Nancy Vickers has shown, was thoroughly inscribed in commercialism as it displays and merchandises a female body for other men – the French discuss the attributes of their female quarry before agreeing to 'divide her, every man his share' (III, 112).[33] The men's plot to eat Aminta is explicitly described in sexual language as they all wish to consume her 'hinder parts' (III, 132) in particular. When Tibalt and the Master of the ship discover the gallants' scheme they initially think that the plan is one of ravishment (III, 146). The Frenchmen confess to an 'appetite' (III, 150), and Tibalt suddenly realises that their desires are in fact cannibalistic. With grotesque humour, he shows the folly of the gallants' desires. He sarcastically represents himself as being more dismayed at the thought of eating women than raping them as he violently chastises the men: 'Are ye so sharp set that her flesh must serve you?' and 'why did you not / Begin with one another handsomely, / And spare the woman to beget more food on?' (III, 151–156). In these exchanges it is not ideas of rape or cannibalism that are the focus of Tibalt's sarcasm. He advocates that Aminta be spared in the hope that she will prove fertile, and her consent to such congress is immaterial. Furthermore, his reaction to the notion of cannibalism is also gender specific: it is

the senseless stupidity of eating the only woman in the group that is the
crux of the sarcasm. In a survival-driven economy Aminta is important as
the mother of future generations and the men are threatening to destroy
what they most need: European women. There is a painful and horrible
logic to Tibalt's reasoning here that would not be lost on a London
audience in 1622 who would know about the outbreak of wife-murder and
cannibalism amongst Jamestown colonists in the starving time of 1609–
10.[34] Tibalt here is parodying the merchants and gallants by sarcastically
advocating that they follow the most horrific form of food production
possible, the eating of their own babies. Through Tibalt, Fletcher and
Massinger take the cannibalistic metaphor to its most literal extreme.

 The stupidity of the French gallants' cannibalistic desires directly
parallels the situation of Rosellia's misguided Amazons who, if they main-
tain Rosellia's policy of avoiding sexual congress, will inevitably become
extinct. Rosellia's policy represents a distorted and unnatural form of
female behaviour to the other women in her group: Crocale, Hippolita and
Juletta represent their isolation from men as 'more than tyranny' (II, ii, 23)
since it forces them to be less than full women. In *The Sea Voyage* women
are judged, and judge themselves, by their heterosexual activity, which is
associated with the ability to bear children. As a corollary to this, the
Frenchmen's cannibalism represents a failure of commercialism since
cannibalism – as the direct or physical incorporation of the desired object
– is an act which precludes any future communion with that desired object.[35]
The men's intention to eat Aminta is hopelessly inadequate not only
because it is cannibalistic but because it fails to treat women and their off-
spring as important and sustainable resources. Cannibalism here represents
commercial deficit and Fletcher's French gallants – unlike Tibalt and Albert
– stand for those colonials that fail to understand that survival is only
ensured through the correct husbandry of resources. Through wishing to
eat female flesh, Fletcher represents the Frenchmen as unmediated con-
sumers and that makes them the wrong kind of consumer. This failure is
also gender specific. It represents the Frenchmen as inadequate males
who, in contrast to Albert and Tibalt, cannot control their appetites or,
more correctly, possess the wrong appetite. To put it crudely, these men
desire to eat women rather than have sex with them and consequently
reveal themselves to be inferior males. The grotesque humour does not, of
course, advocate 'rational' cannibalism. Rather, cannibalism – an index of
savagery – is here used to differentiate between male colonial leaders and
those colonists that are meant to be subordinate.

In *The City Madam* too, the male characters' attitudes to women – and the sorts of appetites they demonstrate – are key indicators of their self-mastery and internal discipline, in other words, of their effective masculinity. The planned treatment of Lady Frugal and her daughters is a case in point. The punishment Sir John describes is, importantly, not meant to be carried out: he only wants to threaten his wife with death, not actually have her murdered. Massinger draws a distinction between the threat of violence against women and the reality of murdering them. The former, since it is a policy endorsed and created by Sir John, is clearly supported in this text as a useful disciplinary tool: it is a form of social control. Similarly, the male fantasy of murdering one's wife – as long as one doesn't actually do it – is represented playfully by Massinger since it serves as a safety valve for male aggression against unruly women. Sir John, Plenty and Sir Maurice's collective fantasy of sending their womenfolk to New World death paradoxically allows them to live successfully with women in the Old World as, for the men, images of violence against women in America neutralise their aggression in Britain. Luke's eagerness to make the threat real, though, is represented as morally reprehensible. Luke's appetite for money is so intense and uncontrollable that he will sell his nearest female relations into, he believes, their certain death at the hands of native Americans. He is prepared to betray his race and nation for money and enter into the wrong sort of trade with a savage and inferior people: his trafficking in British women with indigenous American men undermines a colonial nation's innate sense of superiority. Hence, Luke's projected despatch to Virginia in the final scene is fitting since he has, through his anti-English trading policies, symbolically already deserted his own culture (V, iii, 134, 144). Similar to the French gallants in *The Sea Voyage*, only in less obvious ways, Luke is an inadequate male. But whereas Franville, Morillat and Lamure are inadequate because of their failure to understand the most basic economic principles (sound businessmen eat the profits not the capital), Luke fundamentally betrays British colonial ambitions since they were predicated on and justified through beliefs in the superiority of white men over black men which were, in turn, predicated on the exclusive sexual access of white men to white women. When John Rolfe married Pocahontas in 1614, the bridegroom was clearly exercised by miscegenation through 'marrienge of strange wyves'.[36] But at least such a union marked, as Rolfe argued, 'the converting [of] an irregenerate to a regeneration' and, significantly, the relationship did not trouble gender hierarchy since an inferior woman was embracing the

culture of her superior husband.[37] Luke's sale of his female relatives to
savage, devil-worshipping native Americans betrays his religion, his
culture and his gender. His interests should be, like his brother's, in the
conversion of heathen peoples, the commercial exploitation of America
through legitimate trade, and, as patriarch, the protection of his female
relatives. Luke's appetite for money is unrestrained. As Thomas Elyot
puts it in his 1534 conduct book *The Castle of Health*, a man must control
his 'passion' and appetite since they 'bring a man from the use of reason',
and Luke signally fails to exercise such self-discipline through his greedy
desires to 'surfeit in my store' (V, i, 146).[38]

The distinction drawn between men who can and men who cannot
control their appetites in these two plays is not simply based on class. The
way control of appetite rather than social position determines effective
masculinity is strikingly revealed in *The Sea Voyage* when Tibalt takes
control of the parcelling out of the women in Act III, telling the gallants
and merchants to 'Stand back and give your betters leave, your betters, /
And grumble not' (268–269). His superior strength of character, demon-
strated by his abilty to endure privations, allows him to take command
over men that prior to the shipwreck had been richer or of equal or higher
rank (I, ii, 115–148): it is in this sense alone that he is their 'better'. This
moral hierarchy contrasts to the situation in Virginia in 1609 when John
Smith contemplated breaking ties with the Company's London headquarters.
New officers of higher social standing than himself were appointed, lead-
ing to repeated stand-offs between the experienced Smith and the new
arrivals, so that Smith wished that the new men 'had never arrived, and we
for ever abandoned and left to our fortunes'.[39] As in to Virginia under the
stringent control of the 1610 *Lawes Divine, Moral and Martial* which were
designed to make the colonists work together, in *The Sea Voyage* all the
factions in the play – Sebastian and Nicusa, Rosellia and the woman, and
the shipwrecked French – have no possible future unless rapprochement
is achieved.[40] The fact that harmony is needed to make survival a possi-
bility in colonial locations becomes, as we shall see, the reason why in the
last scene all the colonists can finally forgive each other, even the French
gallants and Rosellia, for the violence threatened against them.

The text continually represents the characters retreating into sleep or
fantasy since the reality of colonial life is a nightmare. The Amazonian
women have erotic dreams as their escape from sexual frustration, and
Aminta is counselled by Albert to sleep while he tries to find food for them,
promising that in her dreams she will be able imaginatively to recreate

herself as 'a queen' sponsoring his mission of discovery of a 'fortunate continent' (II, i, 92–93). Sleep is thus represented as a way for the characters to recreate their environment according to colonial fantasies of ease and abundance. Yet the wisdom of such a retreat from reality is consistently questioned by the text. Albert faints through pain and exhaustion, but when he comes round he is so disorientated that he is unable to distinguish fantasy from reality. His questioning of the status of the women he sees on regaining consciousness shows him to be in a liminal state between real and imagined worlds. His subsequent loss of integrity through his denial of Aminta and his promise to be a subservient 'slave' to Clarinda further reveal the dangers of fantasy. Indeed, Aminta's sleep makes her vulnerable to the cannibalistic desires of her compatriots. She asserts that 'sleep is a salve for misery' (III, iii, 75), yet the men see her sleep as further insult: 'Why should she have this blessing / And we wake still, wake to our wants?' (III, iii, 78–79). The pleasure of sleep and its status as safe retreat from present miseries is challenged. Furthermore, when she wakes, she is aware that she has experienced a nightmare ('What cruel dreams have I had') but is unable to understand that this is a reflection of current danger as she believes the French men are no threat to her: 'Who are these? / O they are my friends!' (III, iii, 114–115).

Sleep, then, is represented in *The Sea Voyage* as a dangerous phantasm into which characters retreat when their circumstances become too difficult to confront. Though supposed to offer an escape from reality, unconsciousness in fact compounds the situations in which characters find themselves. The seductive fantasy of a sensual New World Paradise so optimistically articulated in contemporary promotional texts and which, in different ways, all the characters expect to find, has, to quote Anthony Parr, gone 'sour'.[41] The French gallants expect to inhabit 'happy places and most fertile islands / Where we had constant promise of all things' (III, 83–84) in the same way that, for example, Arthur Barlow's description of the first Roanoke voyage imagined that the colonial landscape would yield 'all things in abundance, as in the first creation, without toil or labour'.[42] Arcadia, or a munificent paradisical landscape, is a phantasm: the New World Eden is full of unexpected pitfalls.[43]

The concluding scene in *The Sea Voyage*, where heterosexual relations are resumed and, superficially at least, all misunderstandings resolved, shows the characters finally confronting the realities of their situation. However, before the denouement, tragedy is only narrowly averted. Rosellia discovers that Aminta and Raymond's, as well as Albert's, fathers were

originally responsible for dispersing the Portuguese and then attacking again to wrest from them 'the last remainder of their wealth' (V, ii, 96). She resolves to take her revenge and plans to execute the children of the men who caused her misfortune. Rosellia here prepares to sacrifice the French in a frenzied manner. She requests 'Infernal music, / Fit for a bloody feast' (V, iv, 2), and commands 'Set out the altar. I myself will be / The priest, and boldly do those horrid rites / You shake to think on' (V, iv, 8–10). Rosellia also refuses to listen to her victims' denials. She insists on avenging the death of her husband through the execution of the children of his alleged murderers even though such actions are unjust because Sebastian still lives (V, iv, 50–55). It is only the Portuguese men's entrance in the nick of time that prevents Rosellia's murderous revenge. The distrust between the French and the Portuguese is of such a pitch that Rosellia disbelieves everything her enemies say, preferring to act accord-ing to savage customs: for the first time Rosellia appears more savage than European. Rosellia's aggression and her violent threats mark her out as unacceptably Other both in terms of her gender and racial behaviour since she is treacherous and unruly, yet she is not punished for these trans-gressions. Once her husband reappears, Rosellia immediately reverts to subservient female behaviour. She quickly abdicates 'those arts not usual to our sex' (V, iv, 41), and gives up 'Herself, her power and joys and all to you, / To be discharged of 'em as too burdensome' (V, iv, 96–97), and yet nothing further is said or done about her. Given the hostilities between colonists and indigenous Americans, and the violent responses contem-porary commentators such as Waterhouse and Brooke recommended, we need to explore why Fletcher and Massinger chose to be so restrained in their treatment of the women who, on one level, stand in for native inhabitants in the play.

There are two ways of reading this restraint. The first is that one of the central concerns of the text has been to show that enmity between factions destroys colonial futures. The raw material from which new colonies are to be fashioned is not promising in *The Sea Voyage*. As the barren nature of Sebastian and Nicusa's land reveals, the terrain is often inhospitable, and the settlers were, more often than not, a feckless and inadequate lot. Lamure, Franville and Morillat signify the recalcitrant and unruly wastrels who made up a large proportion of New World colonists. As Nicholas Canny has argued, 'a majority of those who took ship to Virginia were making the final of a series of moves in an unsettled and rootless exist-ence'.[44] And, as we have seen, in terms of commercial sense, Lamure,

Franville and Morillat are spectacularly incompetent since they plan to eat the only female in their group rather than husbanding her as a resource since 'younge, handsome, and honestly educated Maides' were in short supply in Virginia.[45] Rosellia and her women represent simultaneously European women and native inhabitants. And though racial and sexual Others, they are necessary for the colony's future. The women figure as textual traces for native inhabitants, whom British colonists might imagine did not exist, or, following Brooke and Waterhouse, wish had been annihilated. But by representing native inhabitants as female, and emphasising how reproduction was necessary for any colony's future, Fletcher and Massinger stage contemporary debates about the nature of relationships between colonists, natives and women required to create a successful colony. Just as Prospero was shown 'all the qualities 'o'th'isle' (I, ii, 327) by Caliban in *The Tempest*, and hence survived shipwreck in an unfamiliar world, native Americans are still going to be important to the Jamestown settlers even after the Virginia massacre.[46] Brooke and Waterhouse fantasised about their extermination, Donne and Purchas created moral and legal justifications for dispossessing native Americans, but throughout the 1620s and well into the 1630s English colonies in North America were not self-supporting. However unpalatable her violence, Rosellia's reabsorption into the colonial group makes it momentarily possible that the colony might be sustainable.

Yet would the survival of this French-Portuguese colony (however resonant, on some levels, with Virginia) be something that a 1620s London audience of merchants, gentry, and citizens at Blackfriars would want? In fact, this play can be read as both attempting to define the basis of a viable colony and as being deeply uncertain about colonial futures. The final rapprochement between characters and separate groups of colonists is achieved incredibly swiftly in the final scene of *The Sea Voyage*: after Rosellia's sacrificial oblations there are only fifty lines in which Clarinda and Raymond, Crocale and Tibalt, Aminta and Albert, Rosellia and Sebastian all pair up, and amity is finally achieved between the previously competitive French and Portuguese colonists. The tension created by Rosellia's intended violence so near to the end of the play simply does not have enough time to disperse. The horror in which her actions so nearly resulted cannot be dispelled within so short a space of time. The ambiguous nature of the text's conclusion is similarly shown by the fact that the final lines are not concerned with the future of the islands on which these colonists have been shipwrecked. Rather, as Sebastian states, 'When

awhile / We have here refreshed ourselves, we'll return to our several homes' (V, iv, 110–112). It appears that the hard-won understanding that has been achieved between the French and Portuguese by the end of *The Sea Voyage* will not result in the development of a joint French and Portuguese colony that might avoid the endemic factionalism and competition that has plagued the characters throughout the course of the play. The French and the Portuguese might, the text tells us, once more be 'friends', but that understanding does not result in a lasting joint colony where resources would be pooled. As the French and Portuguese represent the British this outcome marks a failure; as they represent colonial competitors, the fact that there is no future for the colony is more of a cause of celebration than regret.

The conclusion of *The Sea Voyage* is ambiguous. Throughout the course of the play, we witness the misunderstandings and competitive rivalry between and among groups of people that need to be overcome to create a harmonious and tenable colonial future. However, at the moment in which such a positive outcome becomes, for the first time, a real possibility, it becomes clear that there is, in fact, no future for this embryonic Portuguese and French colony. As soon as the colonists are able, they intend to abandon the islands and return home. How should this conclusion be read? The painful seasoning that the colonists have experienced appears, at the very end, utterly pointless in terms of securing lasting colonies. Perhaps the newly created Portuguese–French alliances will pay dividends in future jointly inspired endeavours, but the audience is given no hint by the text that such missions are planned and would in 1622 London have had mixed feelings about such plans. Instead, despite the ostensibly happy ending, a lot of hard work and suffering has occurred to achieve nothing in terms of colonial success. Of course, the fact that it is French and Portuguese colonists that abandon the islands might be seen to some extent to ameliorate this anti-colonial reading since supporters of British colonies could take satisfaction in the failure of their European rivals. The play's emphasis, though, on the need for understanding and co-operation among and within groups, and the use of other nationalities as stand-ins for the British as we have seen in other contemporary dramas, complicates any straightforward reading of the text as either praising British endeavour or supporting British territorial claims through French and Portuguese colonial failure. Indeed, British exclusion from the colonial terrain this play describes might be seen as an indictment since the British have failed to secure New World territory in the way that other European

nations had. As Francis Bacon enviously commented in 1622, the Iberians possessed an Empire on which 'the sun never sets'.[47] Consequently, the contemporary crisis in British colonialism is implicated in several ways in this play. The French and Portuguese fail in the play, as the British have done in 1622 Virginia, to harness tangible benefits from their New World experiences even though one of the most obvious indicators of tension in colonial environments – native peoples – are partially tamed through their incarnation as assimiliable European women. But, at the same time, the fact that the English are absent from the colonial terrain of the play's world while other nations are present can be seen, as Jeffrey Knapp argues more generally, as an indication of the failure of British colonial policy at this time.[48] The French and Portuguese might not be successful, but in 1622 the British are not even there.

By contrast, in Massinger's 1632 *The City Madam* the casual and matter of fact references to the Virginia colony show the much more established nature of the settlement. Britain has a clear presence in the New World. Yet, problems with the colony are still apparent. Sexual licentiousness is represented as endemic, and Sir John's descriptions of indigenous Americans' desires for white women reveal the level of anxieties concerning miscegenation and the threat that black male sexual access to white females represents to British males. Indeed, in these two dramas sexual appetite is used to measure commercial success and effective masculinity. Gender is as much a commercial resource as any other New World commodity and its proper manipulation is the central concern of these dramas. Fletcher and Massinger reveal the continued problems of English colonialism at this time, which needs the endeavours of appropriately masculine men such as Tibalt, Albert or Sir John. In order to be successful, English colonialism needs men that both demonstrate the correct appetite and are simultaneously able to control their desires. *The Sea Voyage* and *The City Madam* function, then, as an indictment of British colonialism since Tibalt and Albert are French and Sir John exists in an Old World setting: neither of these plays represents potent British manhood in the New World. At an allegorical level, Fletcher and Massinger show the importance of normative gender performance, since only social control through the correct management of appetite – which characters in the plays imperfectly demonstrate – will lead to colonial success.

'Antipodean tricks': travel, gender and monstrousness in Richard
Brome's *The Antipodes*

I want to conclude this book with a discussion of the gender politics of
Richard Brome's *The Antipodes* (1638). Brome's text is startling in its
refusal to engage with new information in circulation about New World
experiences yet, paradoxically, it uses the idea of a New World, speci-
fically the antipodes, in order to focus on Renaissance London. The
fantasy continent of *Terra Australis Incognita* or the antipodes is used as a
vehicle through which to discuss domestic issues of gender identity and
performance, as well as the relationship between new and old worlds.[49]
During the sixteenth and seventeenth centuries, detailed cartographic
representations of a southern continent proliferated though no certain dis-
covery took place.[50] In consequence of Pomponius Mela's and Ptolemy's
arguments that a southern continent was needed to balance the one in the
north, increasingly elaborate representations circulated of the land and
peoples expected to be found in *Terra Australis Incognita*. Ortelius's 1570
Theatrum Orbis Terrarum, for instance, shows a meticulously drawn
antipodean coastline complete with promontories and local names.[51] In
what follows I argue that Brome's decision to describe an imaginary voyage
to an imaginary southern continent rather than engaging with the New
World of the Virginia colonies and the Jamestown settlement is important
for an understanding of the text's representation of the pointlessness of
travel. I also explore Brome's representation of transgressive gender
behaviour, specifically in relation to sexual appetite, false pregnancy and
monstrousness. Initially, deviant sexual and gender characteristics seem
to be associated with exotic fantasy locations but, as we shall see, they are
in fact already endemic to Renaissance London.

Brome's text departs from other contemporary travel-inspired dramas,
which consistently show playwrights' familiarity with travel literature and
accounts of the New World. Instead Brome's text follows a different, and
satiric, tradition of writing about imaginary New Worlds. Similar to
Lucian's comic and grotesque fantasy voyage *A True Story*, the exotic
Mandeville's Travels (1356), and the more recent text by Joseph Hall
Mundus Alter et Idem (1605), in Brome's *The Antipodes*, we have pointless
travel, or travel that gets the traveller nowhere.[52] In other words, Brome's
text charts a fantasy voyage to a fantasy kingdom: a journey nowhere. This
is crucial in switching the focus of the drama from the assimilation of new
ideas and knowledge concerning the New World to the values and

behaviour of the inhabitants of the Old World. Despite being framed by the idea of travel, the emphasis in this text is very much Renaissance London in the 1630s.

The play describes how, following the retreat of the plague epidemic in London in 1636–37, the Joyless family come to London in an attempt to cure the son of the family, Peregrine, who has lost his wits through the reading of exotic travel writing. Brome's text is particularly indebted to Hall's satiric, anti-travel text where in 'Terra Australis Incognita' Hall's narrator, Mercurius Britannicus, travels through a supposedly new continent that represents in exaggerated form the vices of Renaissance Europe; in other words he meets 'a world, another and the same'.[53] Because his parents have not allowed him to become an explorer, Peregrine in *The Antipodes* has become so obsessed with imaginary travel that he is guilty of succumbing to the condition against which Jerome Turler warned his readers in his influential travel manual *The Traveiller* (1574). In his chapter 'the preceptes of traveyling', Turler's principal point was that travellers must not forget the morals and social customs of their own society whilst abroad since promiscuous cultural intermingling will result in their no longer fitting into their home society on return.[54] In *The Antipodes*, this is precisely what has happened since Peregrine has grown so demented through thinking of nothing but strange customs and countries that he has become a social misfit. He is only interested in travel and neglects everything else, even his marital duties towards his young wife Martha so that the marriage remains unconsummated after three years. As the other characters comment, it is Peregrine, rather than his wife, that has conceived since he suffers from a 'tympany' (I, i, 178) meaning a monstrous swelling or a pregnancy. This condition requires the services of a man-midwife, so Peregrine's father, Joyless, consults Hughball, a famous doctor who takes on the case. The doctor lives with Letoy, a 'plaine' but 'fantastic lord' (I, ii, 83), who keeps a well-equipped private stage, and a group of men-servants who are trained actors.

As part of Peregrine's cure, the doctor and Letoy orchestrate a series of scenes from the antipodes before Peregrine, who, through a drug-induced sleep, is persuaded that he has travelled there. In the midst of scenes of supposed inversion concerning life in the antipodes, designed to restore Peregrine to his wits by making him recognise the natural and correct order of things, Peregrine invades the property-room backstage, and, after a fight with pasteboard monsters, makes himself king of the antipodes. He intends to reform antipodean manners, but is persuaded to

take an antipodean wife, Martha in disguise, as his queen. The couple
retire to bed and emerge hours later cured of their maladies since they are
now sexually satisfied. The plot is also concerned with the curing of
Joyless's excessive jealousy of his young wife, Diana. In order to effect
Joyless's cure, he is placed in a position from which he overhears Lord
Letoy amorously proposition Diana, who firmly repulses Letoy main-
taining her love for her husband. Joyless is further convinced of Diana's
chastity by Letoy's revelation that he is Diana's father. After all these explan-
ations, the play ends with a masque of Discord replaced by Harmony and,
superficially at least, correct relations are re-established for the inhabitants
of Renaissance London.

Perhaps unsurprisingly, given that the first performances of this play
at the Salisbury Court theatre were when the playhouses reopened after a
plague outbreak, *The Antipodes* is obsessed with ideas of disease and
contagion.[55] But *The Antipodes* is also concerned with issues of paternity,
gender and sexual relations and these concerns cannot be explained as
merely a reflection of the recent London health crisis. Critics such as Ian
Donaldson, Martin Butler and Ira Clark have argued that *The Antipodes*
should be seen as making comments about the strengths and weaknesses
of Caroline rule and society.[56] Extending these readings, I focus on the
representations of gender in this text and examine the ways these ideas
influence debates about the resemblance between the antipodes and
Renaissance London. Brome's treatment of sexuality and appetite, and the
connections between these issues and the text's representation of the
apparent pointlessness of travel through its staging of a pretend voyage to a
fantasyland, are also explored.

In *The Antipodes*, Brome represents the characters' various social
problems and health issues as types of madness or moral sickness: Pere-
grine is travel mad, Martha is full of love melancholy, Joyless is horn-mad,
etc. But, as becomes apparent, it is not just the Joyless family that is
suffering from different forms of madness: virtually all the characters suffer
from psychological ill health. The married couple Blaze and Barbara,
mutual friends of Letoy and the Joyless family, have themselves previously
been through Doctor Hughball's somewhat radical cure for a husband's
horn-madness, which involves accepting that he has already been cuck-
olded and ceasing to worry about it. Even Letoy, at the end of the play,
describes the way that his marriage with Diana's mother was soured through
his belief in her unfaithfulness, and his doubts about his daughter's legiti-
macy were only answered on his wife's death-bed. All these illnesses are

connected to problems regarding gender behaviour or sexual relations in one form or another

The most striking image in this play, and the one upon which the plot of *The Antipodes* revolves, is the removal of Peregrine Joyless's 'tympany'. The sexually experienced Barbara asks Doctor Hughball, in his role as 'man-midwife' to deliver the travel-obsessed and sexually dysfunctional Peregrine of his 'tympany'. She asks that he be delivered of his fantasies of:

> monsters,
> Pygmies and giants, apes and elephants,
> Griffins and crocodiles, men upon women,
> And women upon men, the strangest doings –
> As far beyond all Christendom as 'tis to't. (I, i, 178–182)

In the seventeenth century, 'tympany' meant pregnancy or a disease of the belly and it referred to a literal or a metaphorical condition.[57] 'Tympany' here uses all of these meanings and the image is part of the text's gender play and debate about resemblance between the antipodes and Renaissance London.

Gender play is clearly present in this passage since, rather ironically, Barbara asks Doctor Hughball to take the specifically female role of midwife in order to deliver a man, Peregrine, of his 'strange', non-Christian interests in exotic and salacious 'monsters' and hermaphrodites 'men upon women, And women upon men'. Though 'men-midwives' were to become common in the eighteenth century as men took over the profession, in the seventeenth century they were not welcome at births. Indeed, the taboo against male attendance was such that in 1552 a physician in Germany was condemned to death when it was discovered that he had attended a birth cross-dressed, and in 1646 in Massachusetts Francis Rayus was fined fifty shillings 'for presuming to act the part of a midwife'.[58] Hence Hughball, as a male midwife, is inverting accepted gender roles just as much as does Peregrine with his tympathic pregnancy. In terms of appropriate gender behaviour, there is no difference between patient and doctor as both are transgressive figures. Furthermore, Barbara's speech – which asserts that Peregrine has digested exotic travel literature that has made him sick – shows the potentially destabilising nature of the influence of New Worlds. Accounts of New World life will, as Barbara's comments about 'news' or information makes clear, of necessity affect those left at home. More particularly, when those accounts are fantastic ones – 'of the strangest doings' – then their effects will be particularly acute. Peregrine's tympany

is just an extreme manifestation of a common condition; it is, crucially, one from which the Doctor also suffers.

Peregrine's 'tympany' not only represents a physical condition, but it also might be seen to reflect moral one, since at this time tympany was a metaphorical term referring to 'a swelling, as of pride, arrogance, self-conceit, [which was] figured as a disease'.[59] Like Falstaff's tumescent belly in *Henry IV, Part II*, Peregrine's stomach has become 'puffed up'.[60] He has internalised or consumed the strange and exotic travel stories he has read so that he is unable to pay his marriage debt.[61] And his disease appears contagious in the world of the play. Martha, his sex-starved and still virgin wife, meanders through scenes making embarrassing, misdirected sexual remarks as she tries to discover the secrets of married love. Indeed, when Martha appears in the play almost immediately after Barbara's earlier speech, both Martha and her situation are described as 'monstrous'.[62] It appears that Peregrine's obsession with travel and his lack of attention to his wife have driven her out of her wits. The lure of the exotic and the unknown is so strong that established social and sexual relations are undermined and inverted both for the travel-obsessed individual, for those with whom he comes into contact, and the characters who attempt his cure: the worlds of seventeenth-century London and the antipodes are not far apart.

The play goes on to problematise the superficially easy identification of the character that caused the contagion. As Martha tries to find out about sex from all that will listen to her, she starts to ruminate on her past experiences:

> For were I now to die, I cannot guess
> What a man does in child-getting. I remember
> A wanton maid once lay with me, and kissed
> And clipped and clapped me strangely, and then wished
> That I had been a man to have got her with child. (I, i, 252–256)

The woman-to-woman sexual relationship described here is obviously not a celebration of same-sex desire, rather it is predicated on the need of a(n absent) man to father children and thus fulfil women's biological and social roles. Desire flickers here between Martha and the 'wanton maid' because of the absence of any available man. Such a situation is strikingly similar to the one in which Martha now finds herself as she wants Peregrine to father a child on her, confessing to having searched 'Parsley beds, Strawberry banks, or rosemary beds' in the hope of finding elusive off-spring, 'Because I would fain have one' (I, i, 242–244). Moreover, she then

asks Barbara whether she can share a bed with her: 'I'll lie with you and practise, if you please. Pray take me for a night or two' (I, i, 264–265). Martha's desires for pregnancy or 'tympany', which were awakened by the wanton maid, connect to the moral disorder of Renaissance London. Peregrine's disease should thus be viewed as a consequence rather than a cause of the moral malaise described in the text. The contagion, represented in Martha's case as same-sex desire, was already fully present prior to Peregrine's reading of travel accounts. Indeed, as the play progresses it becomes clear that the character who attempts to be the moral and sexual arbiter in the world of the play, the 'fantastic' Lord Letoy, is in fact the most deviant and excessive.

With Doctor Hughball, Lord Letoy organises a dramatic production to cure Peregrine of his 'tympany'. This play-within-a-play – where Peregrine thinks he has indeed travelled to the Antipodes – tries to present the Antipodean world as a place of inverted class, gender, and sexual relations, but it soon becomes apparent that such a discrete separation cannot be maintained. The character of Letoy in particular who, since he sets himself up as the instigator of Peregrine's cure, would be expected to be morally beyond reproach, is by far the most socially, sexually and morally ambiguous. For example, during the play-within-the-play in Act IV (167–205), we are confronted with a knock-about, satirical scene involving three antipodean courtiers and sodomitical relationships, which attempts to condemn such practices. However, through much of the play, Letoy himself is obsessed with one of the actors, his servant Byplay, a name which, as Parr comments, means 'action carried on aside … while the main action proceeds'.[63] Letoy insistently talks of his 'love' for Byplay and his other male servants, dresses effeminately in the manner of Richard II, employs the gender-inverting male midwife Hughball, and, at the end of the play, describes his unhappy marriage. These factors undermine Letoy's position as self-proclaimed guardian of normative sexual and gender relations, a role in which his attempts to cure Peregrine would initially seem to place him. Peregrine's tympany – his phantom pregnancy, his morbid swelling, and the moral malaise it figuratively represents – is symptomatic, then, of a much more pervasive condition. Significantly, it does not appear to be a disease that originated in the Antipodes. Rather, the moral and social decay that the tympany represents was already endemic to Renaissance London.

At the end of the play, it appears to be Letoy who is suffering from a moral 'tympany'. The final act contains a strange twist where Letoy admits

that he is the father of Diana. For most of the play he has been relentlessly sexually pursuing her, claiming to be attempting to cure Joyless's jealousy. The revelation and miraculous delivery of Diana as Letoy's daughter – another bloodless male birth which echoes Peregrine's tympany – is unprepared for by the text and comes as a complete surprise to both Diana and the audience. The sense of disquiet caused by this disclosure is especially strong since Letoy's confession immediately follows an attempted seduction of her that seems serious in tone. Letoy has threatened Diana with financial and social ruin if she will not succumb to his charms:

> I'll … not spare
> To boast thou art my prostitute, and thrust ye
> Out of my gates, to try't out by yourselves. (V, ii, 115–118)

Letoy's tympany, then, represents an excessive and indiscriminate sexuality. He incestuously tries to seduce his daughter, the text makes it clear he has already had an affair with Barbara, and his relationship with his servants, especially Byplay, is sexually orientated. Brome's play, then, urges its audience and readers to question where anti-establishment social and sexual practices originate. The play makes it clear that the excessive and monstrous sexuality associated with foreign parts is, in fact, rather tame compared with the activities of the inhabitants of seventeenth-century London.

This analysis demonstrates, then, that London and the Antipodes are interchangeable in Brome's drama. In contrast to other contemporary travel and travel-inspired plays, this voyage drama does not actually travel anywhere in the sense of engaging with experiences from life in colonial and foreign locations.[64] Other voyage dramas are all either set in colonial regions, juxtapose Virginia or Virginia-inspired locations against London, or engage with the hardships and vicissitudes of mercantile adventuring and sea-life in ways that Brome's text deliberately avoids. In these other 'geographic' plays, of course, the locations and issues with which they engage are available to be read as allegories about aspects of the culture out of which they emerge, but *The Antipodes* is unusual in that the only meaning of travel is as a lens to focus on the behaviour of the population of Renaissance London. In *The Antipodes*, the fantasy new world Peregrine visits is merely an exaggerated version of Britain: antipodean natives are recognisably European since, though their customs are supposedly inversions of British ones, these practices are derived from the same conceptual framework. The discovery in the antipodes of lawyers that are honest, for instance, is not a representation of radical difference. Consequently,

Brome's play demonstrates virtually no interest in contemporary America or any other current British territorial ambitions or spheres of interest. In fact, there is only one direct reference to New England when Peregrine contemplates asking the American Puritan regime for advice on the reformation of antipodean manners:

> *Peregrine*: Before I reign
> A month among them, they shall change their notes,
> Or I'll ordain a course to change their coats.
> I shall have much to do in reformation.
> *Doctor*: Patience and counsel will go through it, sir.
> *Peregrine*: What if I craved a counsel from New England?
> The old will spare me none.
> *Doctor*: [*Aside*] Is this man mad?
> My cure goes fairly on. (IV, 260–267)

Peregrine's request for counsel from New England marks a stage in his return to something approximating psychic health. The remark satirically attacks Charles' government since Peregrine says 'the old will spare me none': in other words, the butt of the joke is Britain's undemocratic rule since under Charles no Parliaments were called in the 1630s and hence it was impossible to get any sort of counsel. Because British colonies were from the start administered by a Governor and Council, New England is here represented as enjoying more liberty than Charles's Britain. However, Peregrine's request for New World counsel should not be seen as praise for the Puritan regime. Peregrine may be on the mend when he makes this request, but as both Letoy and Hughball make clear in their commentary and explanations on the actions of the inset play to the other characters and the audience, Peregrine is still at the 'folly' stage of mental health (IV, 495–506). Consequently, Peregrine's request for New World counsel whilst a fool needs to be seen as a satiric attack on the Puritan reformers and their government in New England as well as an attack on the Stuart monarchy.[65] Yet at no other time in the drama does this play engage with the harsh realities or perceived sexual excesses of British colonial life in the 1630s or the kinds of issues that specifically affected New World colonists and with which, as we have seen, other texts engage.[66] Instead, in *The Antipodes*, we have a bowdlerised version of travel in which by falling asleep a would-be traveller can painlessly awake on another continent, and where, paradoxically, the traveller finds his own culture.

This conflation of new and old worlds means that this travel drama does not explore any culture apart from the British one. The main result of

Peregrine's sojourn is that as a couple he and his wife become sexually active, but this merely enables them to become part of the deviant and unwholesome sexual atmosphere of Caroline London. Peregrine's Mandevellian interests and fears are no more strange or bizarre than the behaviour of the rest of the characters outside the inset play. For example, when Peregrine meets Martha in disguise as a native Antipodean Queen he is initially reluctant to couple with her because he is worried that she is a Mandevillian Gadlibrien that 'stings oft-times to death' the man she has married (IV, 468). But on being assured by Hughball 'She's no Gadlibrien, sir, upon my Knowledge' (IV, 469) – presumably a boast designed to announce that he has had sexual knowledge of her – Peregrine is persuaded to further the relationship. Here Peregrine's virginity – his lack of, as Diana puts it, 'the real knowledge of the woman' (IV, 514) – makes him credit Mandevillian stories concerning the practice of hiring 'another man to couple with his bride, / To clear the dangerous passage of a maidenhead' (IV, 464–465) because, as Mandeville writes, Gadlibrien women had 'snakes within them, which stung their husbands on their penises inside the women's bodies; and thus many men were slaine'.[67] Peregrine's sexual inadequacy – his failure to consummate his marriage earlier – make him prone to fantastic and exotic stories about women's threatening sexuality. Similarly, his desire to allow another man to have sexual relations with his wife – his positive willingness to be cuckolded – marks Peregrine as an example of failed masculinity.[68] Yet Peregrine's inadequacy is no more striking – in fact somewhat less so – than the strangeness of Letoy attempting to seduce his own daughter. Brome does not encourage the audience to have any faith in the moral conclusion of his drama; Diana is reunited with her father, Peregrine and Martha have had sex, Joyless and Diana are reconciled, as are Barbara and Blaze. Nevertheless, there is a sense of pointlessness about the whole text since what the characters are moving towards through Hughball's and Letoy's machinations is not necessarily better than their previous situations. Martha and Peregrine may have finally consummated their marriage, but the examples of married life around them are not such as to recommend the condition. Just as in the inset play nobody actually travels anywhere, the play's resolution is equally pointless. This play represents a paradox then; it is a travel drama that is not about travel and offers a resolution where supposed normative values are re-established, but they turn out, on closer inspection, to be as strange as the ones they replaced. The fantasy of the antipodean New World is in this drama filled with the Old World; there is nothing new about it.

The final point I wish to make in relation to *The Antipodes* brings me back to the subject of this study – the allegorical representation of monarchy in travel drama. It is noticeable that Peregrine and Martha are described as monarchs in the fantasy world of the antipodes. In Britain their marriage has been a complete failure, but when they play-act (Martha knowingly, Peregrine unknowingly) as rulers of a fantasy world, the marriage becomes a sexual success. In this situation we can trace the ambivalent representation of royalty that we have seen elsewhere. Both Martha and Peregrine are represented negatively in this play, since Peregrine as 'King' is involved in a ridiculous and demeaning fight with pasteboard monsters in the prop-cupboard and Martha's sexuality is represented as a dangerous force. Furthermore, the imaginary status of the continent they rule over can be seen as a satiric reflection of Charles's personal rule. The King governed through proclamation rather than Parliament, and through the 1630s was increasingly perceived as isolated and authoritarian. Private and aloof, Charles generally shied away from 'the festive celebrations, entries and pageants' of earlier reigns with the result that his entertainments focused on the court: as Joad Raymond has argued Charles, in the 1630s, 'might be described as an impersonal monarch'.[69] In Martha and Peregrine's marital satisfaction at the end of the play – as they ignore all other characters and concerns – there is an echo to Charles's uxoriousness, as Henrietta Maria was perceived to hold an excessive sway over her husband. As Ann Baynes Coiro has shown, even court poets represented their relationship in ambivalent analogic ways, since the royal couple's sexual relationship was imagined and celebrated in explicit and astonishingly intimate terms. Jonson, for instance, uses a graphic jousting pun 'See, see our active King / Hath taken twice the Ring / Upon his pointed Lance' (37–39) in a epigram to celebrate the Queen's birthday in 1630, but tensions and unease are apparent in the repeated reference to the Queen's fertile Catholicism.[70] The intimacy of Brome's treatment of Peregrine and Martha's sexual relationship, then, and the fact that the consummation of their marriage does nothing to improve the anti-establishment sexual world of Caroline London, both might be seen as allegorically available as they undermine the prestige and influence of the Caroline monarchs.

I offer this sketch of a possible allegorical representation of Charles and Henrietta Maria as an addendum to the other levels of meaning suggested by Brome's text. As such, it demonstrates the kind of complex negotiation travel drama was capable of performing. For much of this study, I have concentrated on tracing one particular layer of allegory –

gendered perceptions of monarchy – in travel drama. Yet in the contrast between *The Sea Voyage* and *The City Madam* on the one hand, and *The Antipodes* on the other, we have allegories of travel that operate in different ways to reveal contrasting perceptions of the project of empire. In the earlier plays, commercial relations and native inhabitants are the central topics, as colonial discourses attempted to incorporate, explain and 'own' new information, regions, and people. Fletcher and Massinger show the problems generated by these processes of absorption, and reveal the difficulties inherent in the process of challenge and redefinition to the European conceptual 'grid' (as Anthony Pagden terms it).[71] In *The Antipodes* we find a different process at work. Brome's text refuses to engage with the real experiences of travel. It shows instead a retreat from a nightmare 'New World', which, on closer inspection, is no different from the traveller's home nation. Peregrine, unhappy at home, wants to travel, but travel is neither individually mind-expanding nor used to increase national territory. Rather, it is a represented as a tool to be used to reform the traveller's home. As a means to effect social, sexual or political change it is completely ineffectual. Simultaneously, in the depiction of Martha and Peregrine, Brome also humorously hints at some of the problems facing Charles and his Queen. As a result, despite such different responses to new worlds and the divergent social and political meanings allegorically embedded in these travel dramas, they are united in showing the complex and competing ways in which gendered colonial discourses perform domestic work.

Notes

1 John Fletcher and Philip Massinger, *The Sea Voyage*, in Anthony Parr, ed. *Three Renaissance Travel Plays* (Manchester: Manchester University Press, 1995), pp. 135–216; Philip Massinger, *The City Madam*, Cyrus Hoy, ed. (London: Edward Arnold, 1964). All references are to these editions. For a detailed discussion of this text see Martin Butler, 'Massinger's The City Madam and the Caroline Audience', *Renaissance Drama*, 13 (1982), 157–187; Michael Neill, '"The Tongues of Angels": Charity and the Social Order in The City Madam', in Douglas Howard, ed. *Philip Massinger: A Critical Reassessment* (Cambridge: Cambridge University Press, 1985), pp. 193–220; Ira Clark, *The Moral Art of Philip Massinger* (London and Toronto: Associated University Press, 1993), pp. 41–49.

2 The colonial context for *The Tempest* has been extensively explored in recent years. See, for instance, Ronald Takaki, 'The "Tempest" in the Wilderness', in Gerald Graff and James Phelan, eds, *Shakespeare, The Tempest* (Boston:

Gender performance and social allegory

225

Bedford, 2000), pp. 141–172; and, most recently, see Peter Hulme and William H. Sherman, eds, *The Tempest and Its Travels* (London: Reaktion, 2000). For an alternate – non-colonial – reading see Douglas L. Peterson, *Time, Tide and Tempest: A Study of Shakespeare's Romances* (San Marino CA: Huntington Library Publications, 1973), pp. 214–249.

3 Anthony Parr, 'Introduction', in *Three Renaissance Travel Plays* (Manchester: Manchester University Press, 1995), p. 22. On the differences between Eastern and Western European colonial ambitions see A. D. Innes, *The Maritime and Colonial Expansion of England under the Stuarts, 1603–1714* (London: Sampson Low, 1931), pp. 81–124; Jerry Brotton, *Trading Territories: Mapping the Early Modern World* (London: Reaktion Books, 1997).

4 See Sara M. Evans, *Born for Liberty: A History of Women in America* (New York: Free Press, 1989), pp. 7–45; Robert V. Wells, *The Population of the British Colonies in America before 1776* (Princeton: Princeton University Press, 1975).

5 Parr, 'Introduction', p. 27; Sylvia R. Frey and Marion J. Morton, *New World, New Roles: A Documentary History of Women in Pre-Industrial America* (New York: Greenwood Press, 1986).

6 Evans, *Born for Liberty*, pp. 25–26; see also David R. Ransome, 'Wives for Virginia, 1621', *William and Mary Quarterly*, 3rd series 48 (1991), 3–18.

7 Captain John Smith, *The General History of Virginia* (London: Michael Sparkes, 1624), p. 35

8 Stephen J. Greenblatt, *Marvellous Possessions: The Wonder of the New World* (Oxford: Clarendon Press, 1988), pp. 70–72.

9 Quoted by Butler, 'Massinger's The City Madam', p. 179.

10 On the social status of women colonists see Ransome, 'Wives for Virginia', pp. 12–13.

11 Quoted by Nicholas Canny, 'The Permissive Frontier: The Problem of Social Control in English Settlements in Ireland and Virginia 1550–1650', in *The Westward Enterprise: English Activities in Ireland, the Atlantic, and America, 1480–1650*, K. R. Andrews et al., eds (Liverpool: Liverpool University Press, 1979), pp. 17–45 (p. 29).

12 See D. E. Underdown, 'The Taming of the Scold: The Enforcement of Patriarchal Authority in Early Modern England', in A. Fletcher and J. Stevenson, eds, *Order and Disorder in Early Modern England* (Cambridge: Cambridge University Press, 1985), pp. 116–136.

13 Anon., *Hic Mulier* (London: Eliot's Court Press, 1620); Anon., *Haec Vir* (London: Eliot's Court Press, 1620).

14 Anon., *Hic Mulier*, A2r.

15 Anon., *Hic Mulier*, A4v. It is also noticeable that Sebastian and Nicusa's excessive facial hair ('They have horse-tails growing to 'em, Goodly long manes') makes them 'seem monsters' (I. iii. 98, 108). Men as much as women can seem 'monstrous' and animalistic.

16 On the connections between temperance, continence and gendered behaviour see Louis Montrose, 'The Work of Gender in the Discourse of Discovery', *Representations*, 33 (1991), 1–41 (pp. 11–12).

17 In the previous scene, Albert on first seeing Sebastian and Nicusa had thought that they were 'wand'ring shadows', or ghosts (I, iii, 104–106).

18 See John Steadman, 'Beyond Hercules: Francis Bacon and the Scientist as Hero', *Studies in the Literary Imagination*, 4 (1971), 3–47.

19 See David R. Ransome, 'Village Tensions in Early Virginia: Sex, Land, and Status at the Neck of Land in the 1620s', *The Historical Journal*, 43:2 (2000), 365–381.

20 As critics such as Peter Hulme, Stephen Greenblatt, and Mary Fuller have argued, in the wake of this native violence, the colonialists felt licensed to undertake the violent 'conquest' of indigenous inhabitants 'by force, by surprize, by famine in burning their Corne, by destroying and burning their Boats, Canoes, and Houses, by breaking their fishing Weares by assailing them in their huntings', rather than continuing with the much more onerous policy of encouraging 'civilitie ... the effect of long time, and great industry'. See Edward Waterhouse, *A Declaration of the State of the Colony in Virginia* (New York: Da Capo, 1970 [1622]), pp. 13, 24; Peter Hulme, *Colonial Encounters: Europe and the Native Caribbean* (London and New York: Routledge, 1986), pp. 136–173; Mary Fuller, *Voyages in Print: English Travels to America 1576–1624* (Cambridge: Cambridge University Press, 1995), pp. 85–140; Stephen Greenblatt, 'Invisible Bullets: Renaissance Authority and its Subversion', in Jonathan Dollimore and Alan Sinfield, eds, *Political Shakespeare: New Essays in Cultural Materialism* (Manchester: Manchester University Press, 1985), pp. 18–47.

21 Ransome, 'Village Tensions in Early Virginia', 370–371.

22 N. W. Bawcutt, ed., *The Control and Censorship of Caroline Drama: The Records of Sir Henry Herbert, Master of the Revels 1623–73* (Clarendon: Oxford, 1996), p. 137; see also Parr, 'Introduction', pp. 50–51.

23 See Gordon McMullan, *The Politics of Unease in the Plays of Beaumont and Fletcher* (Amherst: University of Massachusetts Press, 1994), pp. 235–256. For an alternate reading, arguing against reading *The Sea Voyage* against a Virginian context see Michael Neill, *Putting History to the Question: Power, Politics and Society in English Renaissance Drama* (New York: Columbia University Press, 2000), pp. 312–315.

24 See Bawcutt, *The Control and Censorship of Caroline Drama*, p. 141.

25 Quoted by Ransome, 'Village Tensions in Early Virginia', 371.

26 Quotation taken from Walter S. H. Lim, *The Arts of Empire: The Poetics of Colonialism from Ralegh to Milton* (London and Delaware: Associated University Presses and University of Delaware Press, 1998), p. 73.

27 For further details concerning colonists' moral obligation to dispossess those that failed to make a landscape yield its full potential see Anthony Pagden, 'Dispossessing the Barbarian: The Language of Spanish Thomism and the Debate over the Property Rights of the American Indians', in Anthony Pagden,

 ed., *The Languages of Political Theory in Early-Modern Europe* (Cambridge: Cambridge University Press, 1987), pp. 79–98.

28 John Donne, 'A Sermon Preached to the Honourable Company of the Virginian Plantation', in *The Sermons of John Donne*, Evelyn M. Simpson and George R. Potter, eds, 10 vols (Berkeley and Los Angeles: University of California Press, 1953–62), IV, pp. 264–282 (p. 274).

29 On the significance of Pocahontas see Philip L. Barbour, *Pocahontas and her World* (Boston: Houghton Mifflin, 1970); Fuller, *Voyages in Print*, pp. 120–122; Hulme, *Colonial Encounters*, pp. 143–147.

30 Michel de Montaigne, for example, described the way 'Scythian women were wont to thrust out the eies of all their slaves and prisoners taken in warre, thereby to make more free and private use of them', *Essays*, trans. J. Florio, intro. L. C. Harmer (London: Dent, 1965), pp. 91–92.

31 Stephen Greenblatt, *Renaissance Self-Fashioning: From More to Shakespeare* (Chicago and London: University of Chicago Press, 1980), p. 183.

32 Waterhouse, *A Declaration of the State of the Colony in Virginia*, p. 13.

33 The blazon is the rhetorical equivalent of the display and merchandising of the female body, deployed within a triangulated discourse in which a male seller praises his female wares to a potential male buyer. See Nancy Vickers, '"The blazon of sweet beauty's best": Shakespeare's Lucrece', in Patricia Parker and Geoffrey Hartman, eds, *Shakespeare and the Question of Theory* (New York: Methuen, 1985), pp. 95–115. See also Patricia Parker, *Literary Fat Ladies: Rhetoric, Gender, Property* (London: Methuen, 1987), pp. 126–154; Joan Pong Linton, *The Romance of the New World: Gender and the Literary Formations of English Colonialism* (Cambridge: Cambridge University Press, 1998), pp. 104–130.

34 See Maggie Kilgour, *From Communion to Cannibalism: An Anatomy of Metaphors of Incorporation* (Princeton: Princeton University Press, 1990), pp. 33–19.

35 Kilgour, *From Communion to Cannabalism*, pp. 17–19.

36 'Copy of John Rolfe's Letter to Sir Thomas Dale Regarding His Marriage to Pocahontas', in Barbour, *Pocahontas and her World*, p. 247.

37 Philip Barbour, *The Three Worlds of Captain John Smith* (London, Macmillan, 1964), p. 329.

38 Cited by Anthony Fletcher, 'Manhood, the Male Body, Courtship and the Household in Early Modern England', *History*, 84 (1999), 419–436 (p. 423).

39 John Smith, *Travels and Works of Captain John Smith*, Edward Arber and A. G. Bradley, eds (Edinburgh: John Grant, 1910), p. 479.

40 Peter Force, ed., *Lawes Divine, Morall and Martiall, in Tracts and Other Papers Relating Principally to the Origin, Settlement and Progress of the Colonies in North America*, 4 vols (Gloucester MA: Peter Smith, 1963), III.

41 Parr, 'Introduction', p. 25.

42 *Arthur Barlowe's Discourse of the First Voyage*, in D. B. Quinn, ed., *The Roanoake Voyages, 1584–1590*, 2 vols. (London: Hakluyt Society, 1955), I, p. 108.

43 See Erwin Panofsky, 'Et in Arcadia Ego', in R. Klibansky and H. J. Paton, eds, *Philosophy and History* (New York: Harper and Row, 1963), pp. 223–254; see also Michael Zuckerman, 'Identity in British America: Unease in Eden', in Nicholas Canny and Anthony Pagden, eds, *Colonial Identity in the Atlantic World, 1500–1800* (Princeton, Princeton University Press, 1987), pp. 115–159.

44 Nicholas Canny, 'The Permissive Frontier', p. 29.

45 David Ransome, 'Wives for Virginia', p. 4.

46 William Shakespeare, *The Tempest*, Anne Barton, ed. (Harmondsworth, Penguin, 1968).

47 Francis Bacon, *Advertisement touching an Holy War*, in *Works of Francis Bacon*, J. Spedding *et al.*, eds, 14 vols (London: Longman, Green and Co, 1857–74), VII, pp. 20–21.

48 Jeffrey Knapp, *An Empire Nowhere: England, America and Literature from Utopia to the Tempest* (Berkeley: University of California Press, 1992).

49 Richard Brome, *The Antipodes*, in Parr, *Three Renaissance Travel Plays*. All references are to this edition.

50 On the history of the discovery of Australia see Robert Hughes, *The Fatal Shore: A History of the Transportation of Convicts to Australia 1787–1868* (London: Pan, 1988), pp. 43–46.

51 For discussion of the satiric exploitation by writers of the inconsistency between the representation of a detailed Terra Australis Incognita on maps and certain knowledge of the continent see Richard McCabe, *Joseph Hall: A Study in Satire and Meditation* (Oxford: Oxford University Press, 1982), pp. 85–88.

52 See Joseph Hall, *Mundus Alter et Idem*, Joseph Millar Wands, ed. and trans. (New Haven: Yale University Press, 1982), 'Introduction', xxvii–xxxii.

53 For discussion see Claire Jowitt, 'Old Worlds and New Worlds: Renaissance Voyages of Discovery', unpublished Phd dissertation, University of Southampton, 1996, pp. 133–152; Ruth Gilbert, *Early Modern Hermaphrodites: Sex and Other Stories* (London: Palgrave, 2002), pp. 146–159.

54 Jerome Turler, *The Traveiller*, D. E. Baughan, ed. (Gainesville FL: Scholars Facsimiles and Reprints, 1951), pp. 19–22. For a consideration of the traveller's iconoclastic potential see Wayne Franklin, *Discoverers, Explorers, Settlers? The Diligent Writers of Early America* (Chicago: University of Chicago Press, 1979), pp. 11–12.

55 For information about the history of stage performance in this period see Andrew Gurr, *The Shakespearean Stage 1574–1642* (Cambridge: Cambridge University Press, 1980), pp. 21–22. See also Ann Haaker, 'The Plague, the Theater and the Poet', *Renaissance Drama*, 1 (1968), 283–306.

56 Ian Donaldson, for instance, has seen Brome's play as essentially conservative: Peregrine's exposure to the inverted world of the Antipodes, 'presenting to him the things he imagined he most wished to see, forces him to see them not as desirable but as repugnant, drives him steadily back to normality' (p. 94). In Donaldson's view the drama stages a reassuring catharsis where the characters emerge purged of their unhealthy humours through their sojourn in anti-

London. However, other critics persuasively argue that the 'normality' of the play's representation of London is not as assured as Donaldson suggests. Martin Butler, for instance, sees the play as an attack on Charles I's autocratic rule in which any demarcation between anti-London and London is unstable. Brome's anti-London draws attention to Charles' financial abuses and the corruption of monarchical rule without a Parliament, but at the same time makes it clear that there are aspects of anti-London (honest lawyers, merciful sergeants, cultured aldermen and paid poets) from which Caroline London could profitably learn (pp. 216–217). Ira Clark's account also argues that the play demonstrates the need for 'healing reform' in social, political and familial arenas of 1630s London, but suggests that Brome doesn't specify what exactly these reforms should be, instead exemplifying 'a process of extemporaneous free play, of improvisation, of vicarious trial of potential reforms' (p. 183). According to Clark, the play is not programmatic since it fails to suggest a direct course of action to be followed, but it shows the processes by which change and reform become possible. See Ian Donaldson, *The World Turned Upside Down: Comedy from Jonson to Fielding* (Oxford: Clarendon, 1970), pp. 78–98; Martin Butler, *Theatre and Crisis 1632–1642* (Cambridge: Cambridge University Press, 1984), pp. 211–220; Ira Clark, *Professional Playwrights: Massinger, Ford, Shirley and Brome* (Lexington: University of Kentucky Press, 1992), pp. 155–196; see also Parr, 'Introduction', *Three Renaissance Travel Plays*, pp. 34–52.

57 *Oxford English Dictionary*, James A. H. Murray *et al.*, eds (Oxford: Oxford University Press, 1989), XVIII, pp. 783–785.

58 The generally accepted explanation of the origin of man midwifery is that it began for the lying in of Louis XIV's mistress Louise de Vallière in 1663 when the King's need for secrecy lead to the exclusion of the 'gossiping' midwives. See Jane B. Donegan, *Women and Men Midwives: Medicine, Morality and Misogyny in early America* (London: Greenwood Press, 1978), pp. 18–19; see also Elaine Hobby, 'Introduction', in *Jane Sharp's The Midwives Book* (Oxford: Oxford University Press, 1999), xi–xxxv.

59 *OED*, 2nd edn, XVIII, p. 785, and Elaine Hobby, 'Gender, Science and Midwifery: Jane Sharp, The Midwives Book (1671)', in Claire Jowitt and Diane Watt, eds, *The Arts of Seventeenth-Century Science: Representations of the Natural World in European and North American Culture* (Aldershot: Ashgate, 2002).

60 Falstaff in Shakespeare's *Henry IV, Part II,* also seems to be an example of a character suffering from a tympany: 'I have a whole school of tongues in this belly of mine, and not a tongue of them all speaks any other word but my name. And I had but a belly of any indifferency, I were simply the most active fellow in Europe: my womb, my womb, my womb undoes me' (IV, iii, 18–23). For a reading of Falstaff's sexual ambiguity – which is reliant on the dual meaning of 'womb' as both uterus and stomach which was available at the end of the sixteenth century – see Colin MacCabe, *Theoretical Essays: Film, Linguistics, Literature* (Manchester: Manchester University Press, 1985), pp. 116–117.

61 For a discussion of Mandeville and his influence in the period see Stephen Greenblatt, *Marvellous Possessions*, pp. 26–51; see also Mary Baine Cambell, *The Witness and the Other World: Exotic European Travel Writing 400–1600* (Ithaca: Cornell University Press, 1988), pp. 122–162.

62 'Poor heart, I guess her grief, and pity her. / To keep a maidenhead three years after marriage / Under wedlock and key! Insufferable, monstrous!' Brome, *The Antipodes*, I, i, 202–204.

63 Brome, *The Antipodes*, p. 220.

64 For a selection of readings of travel dramas from this period see Jean-Pierre Maquerlot and Michele Willems, eds, *Travel and Drama in Shakespeare's Time* (Cambridge: Cambridge University Press, 1996).

65 The ridiculous nature of Peregrine's assumption of the Antipodean throne, and his fight with the paste-board monsters whilst 'King', further undermines the institution of monarchy.

66 See Canny, 'The Permissive Frontier', pp. 22–28; Ransome in 'Wives for Virginia' argues against the liscentious image of Virginia, 11–15.

67 John Mandeville, *The Travels of Sir John Mandeville*, trans. C. W. R. D. Moseley (Harmondsworth: Penguin, 1983), p. 175.

68 On appropriate masculinity in this period see Fletcher, 'Manhood, the Male Body, Courtship and the Household in Early Modern England'.

69 Joad Raymond, 'Popular Representatins of Charles I', in Tom Corns, ed., *The Royal Image: Representations of Charles I* (Cambridge: Cambridge University Press, 1999), pp. 47–73 (p. 51).

70 Ann Baynes Coiro, 'A ball of Strife: Caroline poetry and Royal Marriage', in Corns, *The Royal Image*, pp. 26–46 (pp. 33–34).

71 Anthony Pagden, *European Encounters with the New World* (New Haven and London: Yale University Press, 1993), p. 10.

Abu-Baker, Mohamed Hassan, 'Representations of Islam and Muslims in Early Modern English Drama from Marlowe to Massinger', unpublished PhD thesis, University of Glasgow, 1997.

Ammerman, David L., ed., *The Chesapeake in the Seventeenth Century: Essays on Anglo-American Society* (Chapel Hill: University of North Carolina Press, 1979).

Anderson, Benedict, *Imagined Communities: Reflections on the Origin and Spread of Nationalism* (London: Verso, 1983).

Andrews, Kenneth R., *Elizabethan Privateering: English Privateering during the Spanish War, 1585–1603* (London: Cambridge University Press, 1964).

Andrews, Kenneth R. *et al.*, eds, *The Westward Enterprise: English Activities in Ireland, the Atlantic and America, 1480–1650* (Liverpool: Liverpool University Press, 1979).

Andrews, Kenneth R., *Trade, Plunder and Settlement* (Cambridge: Cambridge University Press, 1984).

Anon., *The Execution of Justice in England* (London: Christopher Barker, 1583), reprinted *Harleian Miscellany*, 8 vols (London: T. Osborne, 1744–46), II, pp. 137–155.

Anon., *The Famous Historye of the life and death of Captaine Thomas Stukeley*, Judith C. Levinson, ed. (Oxford: Malone Society, 1975).

Anon., *Haec Vir* (London: Eliot's Court Press, 1620).

Anon., *Hic Mulier* (London: Eliot's Court Press, 1620).

Anon., *Newes from Sea, Of Two Notorious Pyrates, Ward and Dansiker* (London: E. Allde for N. Butter, 1609).

Anon., *The Seaman's Song of Captain Ward, the Famous Pirate of the World, And an Englishman Born* (London: F. Coles *et al.*, 1609).

Anon., *Tom Tell-Troath: or a Free Discourse Touching the Manners of the Time, Directed to his Majesty* (London, 1642 [?1622]), reprinted *Harleian Miscellany*, 10 vols (London: John White *et al.*, 1808–13), III, pp. 428–439.

Anon., *A True Relation, of the Lives and Deaths of the two most famous English Pyrats, Pursur, and Clinton; who lived in the Reigne of Queene Elizabeth* (London: Io. Okes, 1639).

Archer, Gabriel, 'The Discription of the Now Discovered River and Country of Virginia', in D. B. Quinn, ed., *New American World: A Documentary History of North America to 1612*, 5 vols (New York: Arno Press and Hector Bye, 1979), V, pp. 285–287.

Armitage, David, 'John Milton: Poet Against Empire', in David Armitage *et al.*, eds, *Milton and Republicanism* (Cambridge: Cambridge University Press, 1995), pp. 206–225.

Armitage, David *et al.*, eds, *Milton and Republicanism* (Cambridge: Cambridge University Press, 1995).

Armitage, David, 'Literature and Empire', in Nicholas Canny, ed., *The Origins of Empire: British Overseas Enterprise to the Close of the Seventeenth Century* (Oxford: Oxford University Press, 1998), pp. 99–123.

Armitage, David, *The Ideological Origins of the British Empire* (Cambridge: Cambridge University Press, 2000).

Ashton, Robert, ed., *James I by his Contemporaries* (London: Hutchinson, 1969).

Aske, James, *Elizabetha Triumphans*, in J. Nichols, *The Progress and Public Processions of Queen Elizabeth*, 2 vols (London: John Nichols & Son, 1823).

Bach, Rebecca Ann, *Colonial Transformations: The Cultural Production of the Atlantic World, 1580–1640* (New York and Basingstoke: Palgrave, 2000).

Bacon, Francis, *Works of Francis Bacon*, J. Spedding *et al.*, eds, 14 vols (London: Longman, Green and Co., 1857–74).

Bagwell, Richard, *Ireland under the Tudors*, 3 vols (London: Longman, Green and Co., 1895–1890).

Baildon, W. P., ed., *Les Reportes del Cases in Camera Stellata 1593–1609* (London: priv. print, 1894).

Bamford, F., ed., *A Royalists Notebook. The Commonplace Book of Sir John Oglander of Nunwell, 1622–1652* (London: Constable, 1936).

Barbour, Philip L., *The Three Worlds of Captain John Smith* (London: Macmillan, 1964).

Barbour, Philip L., *The Jamestown Voyages Under the First Charter 1606–1609*, 2 vols (Cambridge: Cambridge University Press/Hakluyt Society, 1969).

Barbour, Philip L., *Pocahontas and her World* (Boston: Houghton Mifflin, 1970).

Barbour, Philip L., ed., *The Complete Works of Captain John Smith*, 3 vols (Chapel Hill: University of North Carolina Press, 1986).

Barker, Andrew, *A True and Certaine Report of the Beginning, Proceedings, Overthrows, and now present Estate of Captaine Ward and Danseker, the two late famous Pirates: from their first setting foorth to this present time* (Amsterdam: Da Capo Press, 1968 [1609]).

Barroll, J. Leeds, 'The Court of the First Stuart Queen', in Linda Levy Peck, ed., *The Mental World of the Jacobean Court* (Cambridge: Cambridge University Press, 1991), pp. 191–208.

Bartels, Emily C., 'Making More of the Moor: Aaron, Othello, and Renaissance Refashionings of Race', *Shakespeare Quarterly*, 41 (1990), 433–454.

Bartels, Emily C., *Spectacles of Strangeness: Imperialism, Alienation and Marlowe* (Philadelphia: University of Pennsylvania Press, 1993).

Barton, Anne, ed., *The Tempest* (Harmondsworth: Penguin, 1968).

Barton, Anne, 'Harking Back to Elizabeth: Ben Jonson and Caroline Nostalgia', *English Literary History*, 48 (1981), 706–731.

Bates, Catherine, *The Rhetoric of Courtship in Elizabethan Language and Literature* (Cambridge: Cambridge University Press, 1992).

Bawcutt, N. W., ed., *The Control and Censorship of Caroline Drama: The Records of Sir Henry Herbert, Master of the Revels 1623–73* (Clarendon: Oxford, 1996).

Beer, Anna R., *Sir Walter Ralegh and his Readers in the Seventeenth Century* (London and New York, Macmillan and St. Martin's Presses, 1997).

Belsey, Catherine and Belsey, Andrew, 'Icons of Divinity: Portraits of Elizabeth I', in Lucy Gent and Nigel Llewellyn, eds, *Renaissance Bodies: The Human Figure in Renaissance Culture c.1540–1660* (London: Reaktion, 1990), pp. 11–35.

Bent, J. Theodore, ed., *Early Voyages and Travels in the Levant* (London: Hakluyt Society, 1893).

Bentley, Gerald, *The Jacobean and Caroline Stage*, 4 vols (Oxford: Clarendon, 1956).

Berry, Phillipa, *Of Chastity and Power: Elizabethan Literature and the Unmarried Queen* (London: Routledge, 1989).

Bjurström, Per, 'Rubens' St. George and the Dragon', *Art Quarterly*, 18 (1955), 27–42.

Bly, Mary, *Queer Virgins and Virgin Queans on the Early Modern Stage* (Oxford: Oxford University Press, 2000).

Boesky, Amy, *Founding Fictions: Utopias in Early Modern England* (Athens and London: University of Georgia Press, 1996).

Boling, Ronald J., 'Fletcher's Satire of Caratach in *Bonduca*', *Comparative Drama*, 33:3 (1999), 390–406.

Borris, Kenneth, *Allegory and Epic in English Renaissance Literature: Heroic Form in Sidney, Spenser and Milton* (Cambridge: Cambridge University Press, 2000).

Bowers, Fredson (gen. ed.), *The Dramatic Works in the Beaumont and Fletcher Canon*, 10 vols (Cambridge: Cambridge University Press, 1979–).

Brady, Ciaran, 'Shane O'Neill Departs from the Court of Elizabeth: Irish, English, Scottish Perspectives and the Paralysis of Policy, July 1559 to April 1562', in S. J. Connolly, ed., *Kingdoms United? Great Britain and Ireland since 1500: Integration and Diversity* (Dublin: Four Courts, 1999), pp. 13–39.

Breitenberg, Mark, *Anxious Masculinity in Early Modern England* (Cambridge: Cambridge University Press, 1996).

Brome, Richard, *The Antipodes*, in Anthony Parr, ed., *Three Renaissance Travel Plays* (Manchester: Manchester University Press, 1995), pp. 217–307.

Brotton, Jerry, *Trading Territories: Mapping the Early Modern World* (London: Reaktion Books, 1997).

Brown, John Russell, ed., 'Introduction', in John Webster, *The Duchess of Malfi* (Manchester: Manchester University Press, 1997).

Burg, B. R., *Sodomy and the Pirate Tradition: English Sea Rovers in the Seventeenth-Century Caribbean* (New York and London: New York University Press, 1984).

Burnett, Mark Thornton, 'Tamburlaine and Marlowe – An Elizabethan Vagabond', *Studies in Philology*, 84 (1987), 308–323.

Burns, J. H., *Lordship, Kingship and Empire: The Idea of Monarchy 1400–1525* (Oxford: Oxford University Press, 1992).

Bushnell, Rebecca W., *Tragedies of Tyrants: Political Thought and Theater in the English Renaissance* (Ithaca and London: Cornell University Press, 1990).

Butler, Martin, 'Massinger's The City Madam and the Caroline Audience', *Renaissance Drama*, 13 (1982), 157–187.

Butler, Martin, *Theatre and Crisis 1632–1642* (Cambridge: Cambridge University Press, 1984).

Callaghan, Dympna, 'Re-reading Elizabeth Cary's The Tragedie of Mariam, Faire Queene of Jewry', in Margo Hendricks and Patricia Parker, eds, *Women, Race and Writing in the Early Modern Period* (London: Routledge, 1994), pp. 163–177.

Cambell, Mary Baine, *The Witness and the Other World: Exotic European Travel Writing 400–1600* (Ithaca: Cornell University Press, 1988).

Candido, Joseph, 'Captain Thomas Stukeley: The Man, the Theatrical Record and the Origins of Tudor "Biographical" Drama', *Anglia-Zeitschrift fur Englische Philologie*, 105 (1987), 50–68.

Canny, Nicholas, 'The Permissive Frontier: The Problem of Social Control in English Settlements in Ireland and Virginia 1550–1650', in K. R. Andrews *et al.*, eds, *The Westward Enterprise: English Activities in Ireland, the Atlantic and America, 1480–1650* (Liverpool: Liverpool University Press, 1979), pp. 17–45.

Canny, Nicholas, and Pagden, Anthony, eds, *Colonial Identity in the Atlantic World, 1500–1800* (Princeton: Princeton University Press, 1987).

Canny, Nicholas, ed., *The Origins of Empire: British Overseas Enterprise to the Close of the Seventeenth Century* (Oxford: Oxford University Press, 1998).

Canny, Nicholas, 'The Origins of Empire: An Introduction', in Nicholas Canny, ed., *The Origins of Empire* (Oxford: Oxford University Press, 1998), pp. 1–33.

Carleton, George, *A Thankful Remembrance of God's Mercy* (London: Printed by I. D. for Robert Mylbourne, 1624).

Chamberlain, John, *The Letters of John Chamberlain*, N. E. McClure, ed., 2 vols (Philadelphia: American Philosophical Society, 1939).

Chapman, George, *De Guiana carmen Epicum*, in Richard Hakluyt, *Principal Navigations*, 12 vols (Glasgow: J. M. Dent and Sons, 1927–28), X, pp. 446–451.

Chew, Samuel, *The Crescent and the Rose: Islam and England During the Renaissance* (New York: Octagon Books, 1965).

Clare, Janet, *'Art Made Tongue-Tied by Authority': Elizabethan and Jacobean Dramatic Censorship* (Manchester: Manchester University Press, 1999).

Clark, Ira, *Professional Playwrights: Massinger, Ford, Shirley and Brome* (Lexington: University of Kentucky Press, 1992).

Clark, Ira, *The Moral Art of Philip Massinger* (London and Toronto: Associated University Press, 1993).

Clark, Sandra, *The Plays of Beaumont and Fletcher: Sexual Themes and Dramatic Representation* (New York and London: Harvester Wheatsheaf, 1994).

Clarke, Arthur Melville, *Thomas Heywood: Playwright and Miscellanist* (Oxford: Blackwell, 1931).

Cogswell, T., 'Thomas Middleton and the Court, 1624: *A Game of Chess*', *Huntingdon Library Quarterly*, 42 (1984), 273–288.

Coiro, Ann Baynes, 'A Ball of Strife: Caroline Poetry and Royal Marriage', in Tom Corns, ed., *The Royal Image: Representations of Charles I* (Cambridge: Cambridge University Press, 1999), pp. 26–46.

Coke, Sir Edward, *Reports*, 7 vols (London: Nutt and Gosling, 1738).

Coles, Paul, *The Ottoman Impact on Europe* (London: Thames and Hudson, 1968).

Collinson, Patrick, 'The Monarchical Republic of Queen Elizabeth I', *Bulletin of the John Rylands University Library of Manchester*, 69 (1986–87), 394–424.

Collmann, Herbert L., ed., *Roxburgh Ballads and Broadsides* (Burt Franklin, New York, 1971).

Congreve, William, *The Way of the World* (London: A. & C. Black, 1994).

Conley, Tom, 'De Bry's Las Casas', in René Jara and Nicholas Spadaccini, eds, *Amerindian Images and the Legacy of Columbus* (Minneapolis: University of Minnesota Press, 1992), pp. 103–131.

Connolly, S. J., ed., *Kingdoms United? Great Britain and Ireland since 1500: Integration and Diversity* (Dublin: Four Courts, 1999).

Corns, Tom, ed., *The Royal Image: Representations of Charles I* (Cambridge: Cambridge University Press, 1999).

Crawford, Julie, 'Fletcher's *The Tragedie of Bonduca* and the Anxieties of the Masculine Government of James I', *Studies in English Literature*, 39:2 (1999), 357–381.

Cromwell, Otelia, *Thomas Heywood: A Study in the Elizabethan Drama of Everyday Life* (Yale: Yale University Press, 1928).

Crupi, Charles, 'Subduing Bess Bridges: Ideological Shift in the Two Parts of *The Fair Maid of the West*', *Cahiers Elisabethains*, 54 (1998), 75–87.

Daborne, Robert, *A Christian Turned Turk*, in Daniel J. Vitkus, ed., *Three Turk Plays from Early Modern England* (New York: Columbia University Press, 2000).

Dallam, Robert, 'An Account of an Organ Carried to the Grand Seigneur and Other Curious Matter', in J. Theodore Bent, ed., *Early Voyages and Travels in the Levant* (London: Hakluyt Society, 1893), pp. 1–99.

D'Amico, Jack, *The Moor in English Renaissance Drama* (Tampa: University of Florida Press, 1991).

Daniel, Norman, *Islam, Europe and Empire* (Edinburgh: Edinburgh University Press, 1966).

Dekker, Thomas, *The Dramatic Works of Thomas Dekker*, Fredson Bowers, ed., 4 vols (Cambridge: Cambridge University Press, 1953–61).

Dictionary of National Biography, Sir Lesley Stephen and Sir Sidney Lee, eds (London: Smith, Elder, 1885–1900).

Doh, Herman, 'Introduction', in Thomas Heywood and William Rowley, *Fortune by Land and Sea* (New York: Garland, 1980), pp. 1–53.

Dollimore, Jonathan, *Radical Tragedy: Religion, Ideology and Power in the Drama of Shakespeare and His Contemporaries* (Chicago: University of Chicago Press, 1984).

Dollimore, Jonathan, and Sinfield, Alan, eds, *Political Shakespeare: New Essays in Cultural Materialism* (Manchester: Manchester University Press, 1985).

Dollimore, Jonathan, *Sexual Dissidence: Augustine to Wilde, Freud to Foucault* (Oxford: Clarendon Press, 1991).

Donaldson, Ian, *The World Turned Upside Down: Comedy from Jonson to Fielding* (Oxford: Clarendon, 1970).

Donegan, Jane B., *Women and Men Midwives: Medicine, Morality and Misogyny in early America* (London: Greenwood Press, 1978).

Donne, John, *The Sermons of John Donne*, Evelyn M. Simpson and George R. Potter, eds, 10 vols (Berkeley and Los Angeles: University of California Press, 1953–62).

Donne, John, *Complete English Poems*, C. A. Patrides, ed. (London: Everyman, 1994).

Doran, Susan, *Monarchy and Matrimony: The Courtships of Elizabeth I* (London and New York: Routledge, 1996).

Drayton, Michael, *The Works of Michael Drayton*, William J. Hebel, ed., 5 vols (Oxford: Blackwell, 1931–41).

Dutton, Richard, 'Receiving Offence: *A Game at Chess* Again', in Andrew Hadfield, ed., *Literature and Censorship in Renaissance England* (Basingstoke: Palgrave, 2001), pp. 50–74.

Elton, G. R., *The Tudor Constitution: Documents and Commentary* (Cambridge: Cambridge University Press, 1982).

Evans, Sara M., *Born for Liberty: A History of Women in America* (New York: Free Press, 1989).

Findlay, Alison, *A Feminist Perspective on Renaissance Drama* (Oxford: Blackwell, 1999).

Finkelpearl, Philip J., 'John Fletcher as Spenserian Playwright: *The Faithful Shepherdess* and *The Island Princess*', *Studies in English Literature*, 27 (1987), 285–302.

Fitzmaurice, Andrew, 'Classical Rhetoric and the Promotion of the New World', *Journal of the History of Ideas*, 58 (1997), 121–144.

Fleming, Juliet, 'The Renaissance Tattoo', *Review of English Studies*, 31 (1997), 35–52.

Fletcher, A., and Stevenson, J., eds, *Order and Disorder in Early Modern England* (Cambridge: Cambridge University Press, 1985).

Fletcher, Angus, *Allegory: The Theory of a Symbolic Mode* (Ithaca: Cornell University Press, 1964).

Fletcher, Anthony, 'Manhood, the Male Body, Courtship and the Household in Early Modern England', *History*, 84 (1999), 419–436.

Fletcher, John, *Bonduca*, W. W. Greg, ed. (Oxford: Malone Society, 1951).

Fletcher, John, *The Tragedie of Bonduca*, Cyrus Hoy, ed., in Fredson Bowers, gen. ed., *The Dramatic Works in the Beaumont and Fletcher Canon*, 10 vols (Cambridge, Cambridge University Press, 1979–) IV, pp. 149–259.

Fletcher, John, *The Island Princess*, George Walton Williams, ed., in Fredson Bowers, gen. ed., *The Dramatic Works in the Beaumont and Fletcher Canon*, 10 vols (Cambridge: Cambridge University Press, 1979–) V, pp. 539–651.

Fletcher, John, and Massinger, Philip, *The Sea Voyage*, in Anthony Parr, ed., *Three Renaissance Travel Plays* (Manchester: Manchester University Press, 1995), pp. 135–216.

Foakes, R. A. *Illustrations of the English Stage, 1580–1642* (London: Scolar, 1985).

Force, Peter, ed., *Tracts and Other Papers Relating Principally to the Origin, Settlement and Progress of the Colonies in North America*, 4 vols (Gloucester MA: Peter Smith, 1963).

Fossen, R. W. van, ed., *Eastward Ho* (Manchester: Manchester University Press, 1999).

Franklin, Wayne, *Discoverers, Explorers, Settlers? The Diligent Writers of Early America* (Chicago: University of Chicago Press, 1979).

Frey, Sylvia R., and Morton, Marion J., *New World, New Roles: A Documentary History of Women in Pre-Industrial America* (New York: Greenwood Press, 1986).

Frye, Susan, 'The Myth of Elizabeth at Tilbury', *Sixteenth Century Journal*, 23 (1992), 95–114.

Fuchs, Barbara, 'Faithless Empires: Pirates, Renegadoes and the English Nation', *English Literary History*, 67 (2000), 45–69.

Fuller, Mary, *Voyages in Print: English Travel to America, 1576–1624* (Cambridge: Cambridge University Press, 1995).

Gilbert, Ruth, *Early Modern Hermaphrodites: Sex and Other Stories* (London: Palgrave, 2002).

Goffman, Daniel, *The Ottoman Empire and Early Modern Europe* (Cambridge: Cambridge University Press, 2002).

Goldberg, Jonathan, *Endlesse Worke: Spenser and the Structures of Discourse* (Baltimore: John Hopkins University Press, 1981).

Goldberg, Jonathan, *James I and the Politics of Literature: Jonson, Shakespeare, Donne and Their Contemporaries* (Baltimore: John Hopkins University Press, 1983).

Goodman, Godfrey, *The Court of King James I*, 2 vols (London: R. Bentley, 1839).

Graff, Gerald, and Phelan, James, eds, *Shakespeare, The Tempest* (Boston: Bedford, 2000).

Green, Paul D., 'Theme and Structure in Fletcher's Bonduca', *Studies in English*, 22:2 (1982), 305–316.

Greenblatt, Stephen J., *Sir Walter Ralegh: The Renaissance Man and His Roles* (New Haven and London: Yale University Press, 1973).

Greenblatt, Stephen J., *Renaissance Self-Fashioning: From More to Shakespeare* (Chicago and London: University of Chicago Press, 1980).

Greenblatt, Stephen J., 'Invisible Bullets: Renaissance Authority and its Subversion', in *Political Shakespeare: New Essays in Cultural Materialism*, Jonathan Dollimore and Alan Sinfield, eds (Manchester: Manchester University Press, 1985), pp. 18–47.

Greenblatt, Stephen J., *Marvellous Possessions: The Wonder of the New World* (Oxford: Clarendon Press, 1988).

Greg, W. W., *Two Elizabethan Stage Abridgements* (Oxford: Malone Society, 1923).

Gurr, Andrew, *The Shakespearean Stage, 1574–1642* (Cambridge: Cambridge University Press, 1980).

Gurr, Andrew, *Playgoing in Shakespeare's London* (Cambridge: Cambridge University Press, 1987).

Gurr, Andrew, *The Shakespearian Playing Companies* (Oxford: Clarendon Press, 1996).

Guy, John, ed., *The Reign of Elizabeth I: Court and Culture in the Last Decade* (Cambridge, Cambridge University Press, 1995).

Haaker, Ann, 'The Plague, the Theater and the Poet', *Renaissance Drama*, 1 (1968), 283–306.

Hackett, Helen, *Virgin Mother, Maiden Queen: Elizabeth I and the Cult of the Virgin Mary* (London: Macmillan, 1995).

Hadfield, Andrew, and McVeagh, John, eds, *Strangers to that Land: British Perceptions of Ireland from the Reformation to the Famine* (Gerrard's Cross: Colin Smythe, 1994).

Hadfield, Andrew, *Literature, Politics and National Identity: Reformation to Renaissance* (Cambridge: Cambridge University Press, 1994).

Hadfield, Andrew, *Literature, Travel, and Colonial Writing in the English Renaissance 1545–1625* (Oxford: Clarendon, 1998).

Hadfield, Andrew, ed., *Literature and Censorship in Renaissance England* (Basingstoke: Palgrave, 2001).

Hakluyt, Richard, *The Principal Navigations, Voyages, Traffiques and Discoveries of the English Nation*, 12 vols (London: J. M. Dent and sons, 1927–28).

Hakluyt, Richard, *The Original Writings and Correspondence of the Two Richard Hakluyts*, E. G. R. Taylor, ed., 2 vols (London, Hakluyt Society, 1935).

Hakluyt, Richard, *Voyages and Discoveries*, Jack Beeching, ed. (London, Penguin, 1972).

Hakluyt, Richard, *Virginia Voyages from Hakluyt,* D. B. Quinn and A. M. Quinn, eds (London: Oxford University Press, 1973).

Hall, Joseph, *Mundus Alter et Idem*, Joseph Millar Wands, ed. and trans. (New Haven: Yale University Press, 1982).

Hammer, Paul E. J., 'Patronage at Court, faction and the earl of Essex', in John Guy, ed., *The Reign of Elizabeth I: Court and Culture in the Last Decade* (Cambridge, Cambridge University Press, 1995), pp. 65–86.

Hammer, Paul E. J., *The Polarisation of Elizabethan Politics: The Political Career of Robert Devereux, 2nd Earl of Essex, 1585–1597* (Cambridge: Cambridge University Press, 1999).

Hamor, Ralph, *A True Discourse of the Present Estate of Virginia* (New York: Da Capo, 1971 [1615]).

Hebb, David Delison, *Piracy and the English Government, 1616–1642* (Aldershot: Scolar, 1994).

Hebel, William J., ed., *The Works of Michael Drayton*, 5 vols (Oxford: Shakespeare Head Press, 1931–41).

Heinemann, Margot, 'Middleton's *A Game at Chess*: Parliamentary Puritans and Opposition Drama', *English Literary Renaissance*, 5 (1975), 232–250.

Helgerson, Richard, *Forms of Nationhood: The Elizabethan Writing of England: The Elizabethan Writing of England* (Chicago: University of Chicago Press, 1992).

Hendricks, Margo and Parker, Patricia, eds, *Women, 'Race' and Writing in the Early Modern Period* (London and New York: Routledge, 1994).

Heywood, Thomas, *The Exemplary Lives and Memorable Acts of Nine of the Most Worthy Women of the World* (London: Tho. Cotes, 1640).

Heywood, Thomas *If You Know Not Me You Know Nobody*, 2 vols, Madeleine Doran, ed. (Oxford: Malone Society, 1934–35).

Heywood, Thomas, *The Fair Maid of the West*, Robert K. Turner, ed. (London, Edward Arnold, 1968).

Heywood, Thomas, and Rowley, William, *Fortune by Land and Sea*, Herman Doh, ed. (New York: Garland, 1980).

Hickman, Andrew, 'Bonduca's Two Ignoble Armies and The Two Noble Kinsmen', *Medieval and Renaissance Drama in England*, 4 (1989), 143–171.

Hobby, Elaine, ed., 'Introduction', in *Jane Sharp's The Midwives Book* (Oxford: Oxford University Press, 1999).

Hobby, Elaine, 'Gender, Science and Midwifery: Jane Sharp, The Midwives Book (1671)', in Claire Jowitt and Diane Watt, eds, *The Arts of Seventeenth-Century Science: Representations of the Natural World in European and North American Culture* (Aldershot: Ashgate, 2002), pp. 146–159.

Hogan, James, 'Shane O'Neill comes to the court of Elizabeth', in *Féilscríbhinn Tórna: Essays in Honour of Tadhg Ua Donnchadha*, Séamus Pender, ed. (Cork: Cló Ollsoile, 1948), pp. 154–170.

Holinshed, R., *The Chronicles of England, from William the Conqueror ... vntill the yeare 1577* (London: John Hooker, 1587).

Hourani, Albert H., *Europe and the Middle East* (London: Macmillan, 1980).

Howard, Douglas, ed., *Philip Massinger: A Critical Reassessment* (Cambridge: Cambridge University Press, 1985).

Howard, Jean E., 'An English Lass Amid the Moors: Gender, Race, Sexuality, and National Identity in Heywood's *The Fair Maid of the West*', in Margo Hendricks and Patricia Parker, eds, *Women, 'Race' and Writing in the Early Modern Period* (London and New York: Routledge, 1994), pp. 101–117.

Howard, Jean E., *The Stage and Social Struggle in Early Modern England* (New York and London: Routledge, 1994).

Howard-Hill, H., ed., 'Introduction', in Thomas Middleton, *A Game at Chess* (Manchester: Manchester University Press, 1993), pp. 1–59.

Hoy, Cyrus, ed., 'Textual introduction', in John Fletcher, *The Tragedie of Bonduca*, Fredson Bowers, gen. ed., *The Dramatic Works in the Beaumont and Fletcher Canon*, 10 vols (Cambridge, Cambridge University Press, 1979–) IV, pp. 151–154.

Hughes, Robert, *The Fatal Shore: A History of the Transportation of Convicts to Australia 1787–1868* (London: Pan, 1988).

Hull, Suzanne, *Chaste, Silent and Obedient: English Books for Women 1475–1640* (San Marino, California: Huntington Library, 1982).

Hulme, Peter, *Colonial Encounters: Europe and the Native Caribbean* (London and New York: Routledge, 1986).

Hulme, Peter, and Sherman, William H., eds, *The Tempest and Its Travels* (London: Reaktion, 2000).

Hyland, Peter, 'Moors, Villainy and *The Battle of Alcazar*', *Parergon*, 16 (1999), 85–99.

James VI and I, *Political Writings*, Johann P. Sommerville, ed. (Cambridge: Cambridge University Press, 1994).

Innes, A. D., *The Maritime and Colonial Expansion of England under the Stuarts, 1603–1714* (London: Sampson Low, 1931).

Jara, René, and Spadaccini, Nicholas, eds, *Amerindian Images and the Legacy of Columbusm* (Minneapolis: University of Minnesota Press, 1992).

Jonson, Ben, *et al.*, *Eastward Ho*, R. W. van Fossen, ed. (Manchester, Manchester University Press, 1999).

Jordan, Constance, *Shakespeare's Monarchies: Ruler and Subject in the Romances* (Ithaca and London: Cornell University Press, 1997).

Jordan, Winthrop, *White over Black* (Chapel Hill: University of North Carolina Press, 1968).

Jowitt, Claire, 'Old Worlds and New Worlds: Renaissance Voyages of Discovery', unpublished Phd dissertation, University of Southampton, 1996.

Jowitt, Claire, 'Imperial Dreams? Margaret Cavendish and the Cult of Elizabeth', *Women's Writing*, 4 (1997), 383–399.

Jowitt, Claire and Watt, Diane, eds, *The Arts of Seventeenth-Century Science: Representations of the Natural World in European and North American Culture* (Aldershot: Ashgate, 2002).

Kahn, Coppélia, *Roman Shakespeare: Warriors, Wounds and Women* (London and New York: Routledge, 1997).

Kantorowitz, Ernst H., *The King's Two Bodies: A Study in Mediaeval Political Theology* (Princeton: Princeton University Press, 1957).

Keymis, Laurence, *A Relation of the Second Voyage to Guiana: Performed and written in the yeere 1596*, in Richard Hakluyt, *Principal Navigations*, 12 vols (London: J. M. Dent and Sons, 1927–28).

Kilgour, Maggie, *From Communion to Cannibalism: An Anatomy of Metaphors of Incorporation* (Princeton: Princeton University Press, 1990).

Klein, Bernard, *Maps and the Writing of Space in Early Modern England and Ireland* (Basingstoke: Palgrave, 2001).

Klibansky, R., and Patten, H. J., eds, *Philosophy and History* (New York: Harper and Row, 1963).

Knapp, Jeffrey, *An Empire Nowhere: England, America and Literature from Utopia to the Tempest* (Berkeley: University of California Press, 1992).

Knolles, Richard, *The Generall Historie of the Turkes, from the first beginning of that Nation to the rising of the Othoman Familie: will all the notable expeditions of the Christian Princes against them. Together with the Lives and Conquests of the Othoman Kings and Emperours. Faithfully collected out of the best Histories, both auncient and moderne, and digested into one continual Historie until this present yeare 1603* (London: Adam Islip, 1603).

Knutson, Roslyn L., 'Elizabethan Documents, Captivity Narratives and the Market for Foreign History Plays', *English Literary Renaissance*, 26 (1996), 75–110.

Kupperman, Karen Ordahl, 'Apathy and Death in Early Jamestown', *Journal of American History*, 66 (1979), 24-40.

Laidhin, Tomás Ó, ed., *Sidney State Papers 1565-70* (Dublin: Irish Manuscripts Commission, 1962).

Larkin, J. F., and Hughes, P. L., eds, *Stuart Royal Proclamations*, 2 vols (Oxford: Clarendon, 1973).

Lemay, J. Leo, *The American Dream of Captain John Smith* (Charlottesville: University of Virginia Press, 1993).

Lestringant, Frank, *Mapping the Renaissance World: The Geographical Imagination in the Age of Discovery* (Berkeley: University of California Press, 1994).

Levin, Harry, *The Power of Blackness* (New York: Alfred Knopf, 1958).

Levinson, Judith C., ed., *The Famous Historye of the life and death of Captaine Thomas Stukeley* (Oxford: Malone Society, 1975).

Lezra, Jaques, *Unspeakable Subjects: The Genealogy of the Event in Early Modern Europe* (Stanford: Stanford University Press, 1997).

Lim, Walter S. H., *The Arts of Empire: The Poetics of Colonialism from Ralegh to Milton* (London and Newark: Associated University Presses and University of Delaware Press, 1998).

Linton, Joan Pong, *The Romance of the New World: Gender and the Literary Formations of English Colonialism* (Cambridge, Cambridge University Press, 1998).

Lithgow, William, *The Totall Discourse of the Rare Adventures and Painefull Peregrinations of Long Nineteene Yeares Travayles* (London: Nicholas Okes, 1632).

Loades, D. M., *Politics and the Nation 1450-1660* (London: Fontana, 1992).

Lockyer, Roger, *Buckingham: The Life and Political Career of George Villiers, First Duke of Buckingham 1592-1628* (London and New York: Longman, 1981).

Lockyer, Roger, *The Early Stuarts: A Political History of England, 1603-1642* (London and New York: Longman, 1999).

Loomba, Ania, *Gender, Race, Renaissance Drama* (Manchester: Manchester University Press, 1989).

Mackenthum, Gesa, *Metaphors of Dispossession: American Beginnings and the Translation of Empire 1492-1637* (Norman and London: University of Oklahoma Press, 1997).

Mandeville, John, *The Travels of Sir John Mandeville*, C. W. R. D. Moseley, trans. (Harmondsworth: Penguin, 1983).

Maquerlot, Jean-Pierre, and Willems, Michele, eds, *Travel and Drama in Shakespeare's Time* (Cambridge: Cambridge University Press, 1996).

Marcus, Leah, *Puzzling Shakespeare: Local Reading and Its Discontents* (Berkeley: University of California Press, 1988).

Marshall, Tristan, *Theatre and Empire: Great Britain on the London Stages under James VI and I* (Manchester: Manchester University Press, 2000).

Massinger, Philip, *The City Madam*, Cyrus Hoy, ed. (London: Edward Arnold, 1964).

Massinger, Philip, *The Renegado*, in Daniel J. Vitkus, ed., *Three Turk Plays from Early Modern England* (New York: Columbia University Press, 2000).

Matar, Nabil, 'The Renegade in English Seventeenth-Century Imagination', *Studies in English Literature, 33* (1993), 489–505.

Matar, Nabil, 'Turning Turk: Conversion to Islam in English Renaissance Thought', *Durham University Journal*, 86 (1994), 33–41.

Matar, Nabil, *Turks, Moors and Englishmen in the Age of Discovery* (New York and Chichester: Columbia University Press, 1999).

MacCabe, Colin, *Theoretical Essays: Film, Linguistics, Literature* (Manchester: Manchester University Press, 1985).

McCabe, Richard, *Joseph Hall: A Study in Satire and Meditation* (Oxford: Oxford University Press, 1982).

McClure, N. E., ed., *The Letters of John Chamberlain*, 2 vols (Philadelphia: American Philosophical Society, 1939).

McEachern, Claire, *The Poetics of English Nationhood, 1590–1612* (Cambridge: Cambridge University Press, 1996).

McLaren, A. N., *Political Culture in the Reign of Elizabeth I: Queen and Commonwealth, 1558–1585* (Cambridge: Cambridge University Press, 1999).

McLeod, Bruce, *The Geography of Empire in English Literature* (Cambridge: Cambridge University Press, 1999).

McLuskie, Kathleen E., *Dekker and Heywood: Professional Dramatists* (New York: St. Martin's Press, 1994).

McMullan, Gordon, *The Politics of Unease in the Plays of Beaumont and Fletcher* (Amherst: University of Massachusetts Press, 1994).

Middleton, Thomas, *A Game at Chess*, H. Howard-Hill, ed. (Manchester: Manchester University Press, 1993).

Mikalachki, Jodi, 'The Masculine Romance of Roman Britain: *Cymbeline* and Early Modern English Nationalism', *Shakespeare Quarterly*, 46:3 (1995), 301–322.

Mikalachki, Jodi, *The Legacy of Boadicea: Gender and Nation in Early Modern England* (London and New York: Routledge, 1998).

Miles, Geoffrey, *Shakespeare and the Constant Romans* (Oxford: Clarendon, 1996).

Milton, John, *Poetical Works*, Douglas Bush, ed. (Oxford: Oxford University Press, 1966).

Montaigne, Michel de, *Essays*, trans. J. Florio, intro. L. C. Harmer (London: Dent, 1965).

Montrose, Louis, 'The Work of Gender in the Discourse of Discovery', *Representations*, 33 (1991), 1–41.

Montrose, Louis, *The Purpose of Playing: Shakespeare and the Cultural Politics of the Elizabethan Theatre* (Chicago: University of Chicago Press, 1996).

Moody, T. W., *et al.*, eds, *A New History of Ireland*, 10 vols (Oxford: Clarendon, 1976).

Morgan, Edmund S., *American Slavery, American Freedom: The Ordeal of Colonial Virginia* (New York and London: Norton, 1975).

Morgan, Hiram, *Tyrone's Rebellion: The Outbreak of the Nine Years War in Tudor Ireland* (Woodbridge, Suffolk: Boydell and Brewer, 1993).

Neill, Michael, '"The Tongues of Angels": Charity and the Social Order in The City Madam', in Douglas Howard, ed., *Philip Massinger: A Critical Reassessment* (Cambridge: Cambridge University Press, 1985), pp. 193–220.

Neill, Michael, *Putting History to the Question: Power, Politics and Society in English Renaissance Drama* (New York: Columbia University Press, 2000).

Nichols, J., *The Progress and Public Processions of Queen Elizabeth*, 2 vols (London: John Nichols and Son, 1823).

Oglander, Sir John, *A Royalists Notebook. The Commonplace Book of Sir John Oglander of Nunwell, 1622–1652*, F. Bamford, ed. (London: Constable, 1936).

Ohlmeyer, Jane H., '"Civilizinge of those rude partes": Colonization within Britain and Ireland, 1580s–1640s', in Nicholas Canny, ed., *The Origins of Empire* (Oxford: Oxford University Press, 1998), pp. 124–147.

Orgel, Stephen, *The Illusion of Power: Political Theater in the English Renaissance* (Berkeley: University of California Press, 1975).

Osborne, Francis, 'Traditionall Memoryes on the Raigne of King James the First', in Sir Walter Scott, ed., *Secret History of the Court of James the First*, 2 vols (Edinburgh: J. Ballantyne, 1811), I, pp. 1–298.

Oxford English Dictionary, James A. H. Murray *et al.*, eds (Oxford: Oxford University Press, 1989).

Pagden, Anthony, 'Dispossessing the Barbarian: The Language of Spanish Thomism and the Debate over the Property Rights of the American Indians', in Anthony Pagden, ed., *The Languages of Political Theory in Early-Modern Europe* (Cambridge: Cambridge University Press, 1987), pp. 79–98.

Pagden, Anthony, ed., *The Languages of Political Theory in Early-Modern Europe* (Cambridge: Cambridge University Press, 1987).

Pagden, Anthony, *European Encounters with the New World* (New Haven and London: Yale University Press, 1993).

Panofsky, Erwin, 'Et in Arcadia Ego', in R. Klibansky and H. J. Paton, eds, *Philosophy and History* (New York: Harper and Row, 1963), pp. 223–254.

Parker, Patricia, and Hartman, Geoffrey, eds, *Shakespeare and the Question of Theory* (New York: Methuen, 1985).

Parker, Patricia, *Literary Fat Ladies: Rhetoric, Gender, Property* (London: Methuen, 1987).

Parr, Anthony, ed., 'Introduction', in *Three Renaissance Travel Plays*, Anthony Parr, ed. (Manchester: Manchester University Press, 1995), pp. 1–54.

Parry, J. H., *The Age of Reconnaissance: Discovery, Exploration and Settlement, 1450–1650* (London: Weidenfield and Nicolson, 1973).

Patterson, Annabel, *Censorship and Interpretation: The Conditions of Writing and Reading in Early Modern England* (Madison: University of Wisconsin Press, 1984).

Peacham, Henry, *The Garden of Eloquence* (London: H. Jackson, 1577).

Peck, Linda Levy, ed., *The Mental World of the Jacobean Court* (Cambridge: Cambridge University Press, 1991).

Peele, George, *A Farewell. Entituled to the famous and fortunate generalls of our English forces: Sir John Norris and Syr Frauncis Drake Knights* (London: John Charlewood, 1589).

Peele, George, *An Eglogue. Gratulatorie. Entituled: To the right honorable, and renowmed shepheard of Albions Arcadia: Robert earle of Exxex and Ewe: for his vvelcome into England from Portugall* (London: J. Windet for Richard Jones, 1589).

Peele, George, *The Battle of Alcazar*, in John Yoklavich, ed., *The Dramatic Works of George Peele* (New Haven and London: Yale University Press, 1961), pp. 293–347.

Pender, Séamus, ed., *Féilscríbhinn Tórna: Essays in Honour of Tadhg Ua Donn-chadha* (Cork: Cló Ollsoile, 1948).

Penrose, Boies, *Travel and Discovery in the Renaissance, 1420–1620* (Cambridge MA: Harvard University Press, 1952).

Perry, Curtis, *The Making of Jacobean Culture: James I and the Renegotiation of Elizabethan Literary Practice* (Cambridge: Cambridge University Press, 1997).

Peterson, Douglas L., *Time, Tide and Tempest: A Study of Shakespeare's Romances* (San Marino CA: Huntington Library Publications, 1973).

Phialas, P. G., 'An Unpublished Letter About *A Game at Chess*', *Modern Language Notes*, 69 (1954), 398–399.

Plowden, Edmund, *The Commentaries and Reports of Edmund Plowden, originally written in French, and now faithfully translated into English* (London, 1779).

Potter, Lois, 'Pirates and "turning Turk" in Renaissance drama', in Jean-Pierre Maquerlot and Michele Willems, eds, *Travel and Drama in Shakespeare's Time* (Cambridge: Cambridge University Press, 1996), pp. 124–140.

Purchas, Samuel, *Hakluytus Posthumus: or Purchas His Pilgrimes: Containing a History of the World in Sea Voyages and Lande Travells by Englishmen and others*, 20 vols (Glasgow: James Maclehose & Sons, 1905–7).

Quilligan, Maureen, *The Language of Allegory: Defining the Genre* (Ithaca: Cornell University Press, 1992).

Quinn, D. B., ed., *The Roanoake Voyages, 1584–1590*, 2 vols (London: Hakluyt Society, 1955).

Quinn, D. B., ed., *New American World: A Documentary History of North America to 1612*, 5 vols (New York: Arno Press and Hector Bye, 1979).

Quinn, D. B. and Ryan, A. N., *England's Sea Empire, 1550–1642* (Boston: Allen and Unwin, 1985).

Raab, Felix, *The English Face of Machiavelli: A Changing Interpretation 1500–1700* (London: Routledge and Kegan Paul, 1964).

Ralegh, Walter, *The Works of Walter Ralegh, Kt.*, 8 vols (Oxford: Oxford University Press, 1829).

Ralegh, Walter, *The Discoverie of the Large, Rich, Bewtiful Empyre of Guiana*, Neil L. Whitehead, ed. (Manchester: Manchester University Press, 1997).

Raman, Shankar, 'Imaginary Islands: Staging the East', *Renaissance Drama*, 26 (1995), 131–161.

Ransome, David R., 'Wives for Virginia, 1621', *William and Mary Quarterly*, 3rd series, 48:2 (1991), 3–18.

Ransome, David R., 'Village Tensions in Early Virginia: Sex, Land and Status at the Neck of Land in the 1620s', *The Historical Journal*, 43 (2000), 365–381.

Raymond, Joad, 'Popular Representations of Charles I', in Tom Corns, ed., *The Royal Image: Representations of Charles I* (Cambridge: Cambridge University Press, 1999), pp. 47–73.

Richards, I. A., *The Philosophy of Rhetoric* (London: Oxford University Press, 1936).

Rodríguez-Salgado, M. J., *Armada 1588–1988: An International Exhibition to Commemorate the Spanish Armada* (London: Penguin and National Maritime Museum, 1988).

Ronan, Clifford, *Antike Roman: Power Symbology and the Roman Play in Early Modern England, 1585–1635* (Athens and London: University of Georgia Press, 1995).

Rowley, Samuel, *When You See Me, You Know Me* (London: N. Butter, 1605).

Rutter, Carol Chillington, ed., *Documents of the Rose Playhouse* (Manchester: Manchester University Press, 1999).

Sanders, Eve Rachel, *Gender and Literacy on Stage in Early Modern England* (Cambridge: Cambridge University Press, 1999).

Scanlan, Thomas, *Colonial Writing and the New World, 1583–1671* (Cambridge: Cambridge University Press, 1999).

Schleiner, Winifried, '"Divina Virago": Queen Elizabeth as an Amazon', *Studies in Philology*, 75 (1978), 163–180.

Scott, Sir Walter, ed., *Secret History of the Court of James the First*, 2 vols (Edinburgh: J. Ballantyne, 1811).

Seall, Robert, *A Commendation of the adventerus viage of the wurthy Captain. M. Thomas Stutely Esquyer and others, towards the Land called Terra florida*, in Herbert L. Collmann, ed., *Roxburgh Ballads and Broadsides* (New York: Burt Franklin, 1971), pp. 326–339.

Senior, C. M., *A Nation of Pirates* (Newton Abbot: David and Charles, 1976).

Shakespeare, William, *Cymbeline*, J. M. Nosworthy, ed. (London and New York: Methuen, 1955).

Shakespeare, William, *The Tempest*, Anne Barton, ed. (Harmondsworth: Penguin, 1968).

Sharpe, Kevin, *The Personal Rule of Charles I* (New Haven and London: Yale University Press, 1992).

Shepherd, Simon, *Amazons and Warrior Women: Varieties of Feminism in Seventeenth-Century Drama* (Brighton: Harvester, 1981).

Shepherd, Simon, *Marlowe and the Politics of Elizabethan Theatre* (Brighton: Harvester, 1986).

Simpson, Evelyn M., and Potter, George R., eds, *The Sermons of John Donne*, 10 vols (Berkeley and Los Angeles: University of California Press, 1953–62).

Simpson, Richard, *The School of Shakespeare* (New York: J. Bouton, 1878).

Smith, Alan G. R., ed., *The Reign of James I and VI* (London: Macmillan, 1973).

Smith, Alan G. R., *The Emergence of a Nation-State: The Commonwealth of England, 1529–1660* (London: Longman, 1984).

Smith, Bruce R., *Shakespeare and Masculinity* (Oxford: Oxford University Press, 2000).

Smith, John, *The General History of Virginia* (London: Michael Sparkes, 1624).

Smith, John, *Travels and Works of Captain John Smith*, Edward Arber and A. G. Bradley, eds (Edinburgh: John Grant, 1910).

Smith, John, *The Complete Works of Captain John Smith*, Philip L. Barbour, ed., 3 vols (Chapel Hill: University of North Carolina Press, 1986).

Sommerville, Johann P., ed., *Political Writings of James VI and I* (Cambridge: Cambridge University Press, 1994).

Steadman, John, 'Beyond Hercules: Francis Bacon and the Scientist as Hero', *Studies in the Literary Imagination*, 4 (1971), 3–47.

Strong, Roy, *The Cult of Elizabeth: Elizabethan Portraiture and Pageantry* (London: Thames and Hudson, 1977).

Strong, Roy, *Henry, Prince of Wales, and England's Last Renaissance* (New York: Thames and Hudson, 1986).

Stuart, Roxana, 'Dueling on Travestie: Cross-dressed Swordfighters in Three Jacobean Comedies', *Theatre Studies*, 38 (1993), 29–43.

Symonds, William, *Virginia. A Sermon Preached at Whitechapel* (London: I. Windet, 1609).

Takaki, Ronald, 'The "Tempest" in the Wilderness', in Gerald Graff and James Phelan, eds, *Shakespeare, The Tempest* (Boston: Bedford, 2000), pp. 141–172.

Tumbleson, Raymond D., *Catholicism in the English Protestant Imagination: Nationalism, Religion and Literature, 1600–1745* (Cambridge: Cambridge University Press, 1998).

Turler, Jerome, *The Traveiller*, D. E. Baughan, ed. (Gainesville, Florida: Scholars Facsimiles and Reprints, 1951).

Turner, Robert K., ed., 'Introduction', in Thomas Heywood, *The Fair Maid of the West* (London: Edward Arnold, 1968), pp. ix–xx.

Underdown, D. E., 'The Taming of the Scold: The Enforcement of Patriarchal Authority in Early Modern England', in A. Fletcher and J. Stevenson, eds, *Order and Disorder in Early Modern England* (Cambridge: Cambridge University Press, 1985), pp. 116–136.

Vickers, Nancy, '"The blazon of sweet beauty's best": Shakespeare's Lucrece', in Patricia Parker and Geoffrey Hartman, eds, *Shakespeare and the Question of Theory* (New York: Methuen, 1985), pp. 95–115.

Vitkus, Daniel J., ed., *Three Turk Plays from Early Modern England* (New York: Columbia University Press, 2000).

Wands, Joseph Millar, ed. and trans., *Mundus Alter et Idem* (New Haven: Yale University Press, 1982).

Waterhouse, Edward, *A Declaration of the State of the Colony in Virginia* (New York: Da Capo, 1970 [1622]).

Webster, John, *The Duchess of Malfi*, John Russell Brown, ed. (Manchester: Manchester University Press, 1997).

Weiner, Carol Z., 'The Beleagured Isle: A Study of Elizabethan and Early Jacobean Anti-Catholicism', *Past and Present*, 51 (1971), 27–62.

Weisner, Merry E., *Women and Gender in Early Modern Europe* (Cambridge: Cambridge University Press, 1993), pp. 117–145.

Weldon, Sir Anthony, 'Court and Character of King James', in Sir Walter Scott, ed., *Secret History of the Court of James the First* (Edinburgh: J. Ballantyne, 1811), I, pp. 299–482; II, pp. 1–89.

Wells, Robert V., *The Population of the British Colonies in America before 1776* (Princeton: Princeton University Press, 1975).

Wentworth, Peter, *A Pithy Exhortation to Her Majesty* (Edinburgh: Robert Waldegrave, 1598).

Wernham, R. B., *After the Armada: Elizabethan England and the Struggle for Western Europe 1588–1595* (Oxford: Clarendon Press, 1984).

Williams, George Walton, ed., 'Introduction', in John Fletcher, *The Island Princess*, in Fredson Bowers, gen. ed., *Dramatic Works in the Beaumont and Fletcher Canon*, 10 vols (Cambridge, Cambridge University Press, 1979–), V, pp. 539–651.

Willson, D. H., *King James VI and I* (London: Jonathan Cape, 1956).

Wilson, Derek, *Sweet Robin: A Biography of Robert Dudley, Earl of Leicester, 1533–1588* (London: Hamilton, 1981).

Wilson, Edward M., 'Did John Fletcher Read Spanish?', *Philological Quarterly*, 27 (1948), 187–190.

Wright, Louis B., 'Colonial Developments in the Reign of James I', in Alan G. R. Smith, ed., *The Reign of James I and VI* (London: Macmillan, 1973), pp. 123–139.

Yachnin, Paul, *Stage-Wrights: Shakespeare, Jonson, Middleton and the Making of Theatrical Value* (Philadelphia: University of Pennsylvania Press, 1997).

Yoklavich, John, ed., *The Battle of Alcazar*, *The Dramatic Works of George Peele* (New Haven and London: Yale University Press, 1961).

Zuckerman, Michael, 'Identity in British America: Unease in Eden', in Nicholas Canny and Anthony Pagden, eds, *Colonial Identity in the Atlantic World, 1500–1800* (Princeton: Princeton University Press, 1987), pp. 115–159.

INDEX